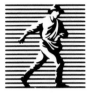

The Abstract Expressionists

and the Transformation

of American Art

THE TURNING POINT.

SIMON & SCHUSTER

NEW YORK LONDON TORONTO SYDNEY TOKYO SINGAPORE

SIMON & SCHUSTER
SIMON & SCHUSTER BUILDING
ROCKEFELLER CENTER
1230 AVENUE OF THE AMERICAS
NEW YORK, NEW YORK 10020

DESIGNED BY KAROLINA HARRIS
MANUFACTURED IN THE UNITED STATES OF AMERICA

10 9 8 7 6 5 4 3 2 1

LIBRARY OF CONGRESS CATALOGING-IN-PUBLICATION DATA
KINGSLEY, APRIL.
 THE TURNING POINT: THE ABSTRACT EXPRESSIONISTS AND THE
TRANSFORMATION OF AMERICAN ART / APRIL KINGSLEY.
 P. CM.
 INCLUDES BIBLIOGRAPHICAL REFERENCES (P.) AND INDEX.
 1. ABSTRACT EXPRESSIONISM—UNITED STATES. 2. PAINTING,
AMERICAN. 3. PAINTING, MODERN—20TH CENTURY—UNITED STATES.
I. TITLE.
ND212.5.A25K56 1992
759.13'09'045—DC20 92-15359 CIP
ISBN 0-671-63857-2

The author acknowledges permission to reproduce illustrations from:

ACA Galleries, New York, for Grace Hartigan's painting *Months and Moons,* 1950, oil and collage on canvas, 50 x 70½ inches, collection of the artist, photo by Michael Korol.

Archives of American Art, Smithsonian Institution, Washington, D.C., for the photographs of Willem de Kooning's studio, David Smith welding, and the Pollock family reunion in the summer of 1950, and Candida and Rebecca Smith/VAGA, New York, for the photograph of David Smith's studio at Bolton Landing.

The Art Institute of Chicago for Hans Hofmann's painting *Blue Rhythm,* 1950, oil on canvas, 48 x 36 inches, gift of the Society for Contemporary American Art, 1952.200.

Berry-Hill Galleries, Inc., for James Brooks's paintings *Number 42-1950,* 1950, oil on canvas, 81 x 105 inches, Estate of the artist, and *Number 36,* 1950, oil on canvas, 41 x 45 inches, Estate of the artist.

Jeanne Bultman for the photograph of Fritz Bultman in his Provincetown studio and for Fritz Bultman's painting *Orbes,* 1950, tempera on paper, 22 x 30 inches, Estate of the artist.

Rudolph Burckhardt for his photographs of Willem and Elaine de Kooning in Willem de Kooning's studio in 1950, Hans Hofmann in 1950, Jack Tworkov in his studio around 1950, and two stages of Willem de Kooning's painting *Woman I* in progress.

The Conservatorship of Willem de Kooning/ARS, N.Y., and The Museum of Modern Art, New York, for Willem de Kooning's painting *Woman I,* 1950–52, oil on canvas, 75⅞ x 58 inches, photo © 1992 The Museum of Modern Art, New York; and The Art Institute of Chicago for de Kooning's painting *Excavation,* 1950, oil and enamel on canvas, 80⅛ x 100¼ inches, gift of Mr. and Mrs. Noah Goldowsky and Edgar Kaufman, Jr.; Mr. & Mrs. Frank G. Logan Prize Fund, 1952.1, copyright © 1991 The Art Institute of Chicago.

Dedalus Foundation, Inc., for Robert Motherwell's painting *Yellow Still Life,* 1950, oil on canvasboard, 18 x 24 inches, photo © by Zindman/Fremont; and Helen Frankenthaler for Motherwell's painting *At Five in the Afternoon,* 1949, casein on composition board, 15 x 20 inches, collection of Helen Frankenthaler, New York, photo by Peter A. Juley & Son; for the

(Continued on page 415.)

Acknowledgments

This book is a hybrid—both biography and art history. I am comfortable with such a composite because one of my earliest role models was the great art historian Meyer Schapiro, who never lost sight of the human factor when he looked at a work of art. Robert Motherwell, incidentally one of Schapiro's students, gave me the inspiration for this book with one of his own, *Modern Artists in America,* but he also gave me purpose. He once said that "the function of the artist is to make actual the spiritual so that it is there to be possessed." My function has been to make his kind of passion actual to the reader. If I have succeeded it has been largely because of the help I received from so many people.

For sharing information of a personal nature with me, I am grateful to Mary Abbott, Peter Agostini, Elise Asher, Sally Avery, Ethel Baziotes, Rosemarie Beck, Arthur Berger, Peter Blake, Leonard Bocour, Paul Bodin, James Brooks, Jeanne and Fritz Bultman, Rudolph Burckhardt, Nick Carone, Giorgio Cavallon, Fielding Dawson, Dorothy Dehner, Ted Dragon, Elsie Driggs, Eadie and Ed Dugmore, Herbert Ferber, Lillian Orlowsky Fried, Sideo Fromboluti, Robert Goodnough, Esther and Adolph Gottlieb, John Grillo, Stephen Greene, Philip Guston, David Hare, Lily Harmon, Grace Hartigan, Clinton Hill, Sanford Hirsch, Budd Hopkins, Buffie Johnson, Lillian Kiesler, Max Kozloff, Katharine Kuh, Stanley Kunitz, Ellen G. Landau, Ernestine and Ibram Lassaw, Michael Loew, Leo Manso, Conrad Marca-Relli, Max Margulis, Nicholas Marsicano, Mercedes Matter, Musa Mayer, Robert Motherwell, George McNeil, Hans Namuth, Annalee and Barnett Newman, I. David Orr, Stephen Pace, Joan Pachner, Charlotte Park, Patricia Passlof, Philip Pavia, Renate Ponsold, Richard Pousette-Dart, Milton Resnick, Dan Rice, Leatrice Rose, Mark Rothko, Judith Rothschild, Nene Schardt, Sally and William Scharf, Sidney Simon, Aaron Siskind, Joseph Solman, Herman Somberg, Nora Speyer, Joseph Stefanelli, Hedda Sterne, Yvonne Thomas, Selina Trief, Wally and Jack Tworkov, Esteban Vicente, and Elisabeth Zogbaum.

For cutting paths through the dense thickets of this art historical territory before me and making my way so much easier I have to thank Lawrence Alloway, Dore Ashton, Alfred H. Barr, Jr., E. A. Carmean, Jr., Barbara Cavaliere, Anna Chave, Jeanne Chenault, David James Clarke, Bonnie Clearwater, Annette Cox, Magdalena Dabrowski, Elaine de Kooning, Jimmy Ernst, Ross Feld, Jack D. Flam, B. H. Friedman, Stephen C. Foster, Harry Gaugh, Henry Geldzahler, Ann Eden Gibson, Robert Goldwater, Cynthia Goodman, Eugene Goossen, Clement Greenberg, Mona Hadler, Thomas B. Hess, Robert Hobbs, Sam Hunter, Carroll Janis, Sidney Janis, Jim Jordan, Gladys Shafran Kashdin, Weldon Kees, Rosalind E. Krauss, Katharine Kuh, Donald Kuspit, Ellen G. Landau, Gail Levin, Julien Levy, Stanley E. Marcus, Joan Marter, Robert Mattison, Musa Mayer, Mary Fuller McChesney, Garnett McCoy, Mary Davis McNaughton, Mollie McNickle, Kynaston McShine, Dorothy C. Miller, Karlen Mooradian, Eleanor Munro, Steven Naifeh, Francis V. O'Connor, Brian O'Doherty, Frank O'Hara, Stephen Polcari, Jeffrey Potter, David M. Quick, Eliza E. Rathbone, Barbara Rose, Harold Rosenberg, Robert Rosenblum, Clifford Ross, William S. Rubin, Irving Sandler, Cecile Schapiro, David Schapiro, Meyer Schapiro, Ann Schonfeld, Ethel Schwabacher, William Seitz, Michel Seuphor, Gregory White Smith, Deborah Solomon, Robert Storr, Stephanie Terenzio, Maurice Tuchman, Diane Waldman, and Sally Yard.

For their help with my research I want to thank Jemison Hammond and William McNaught of the Archives of American Art, the Smithsonian Institution, Washington, D.C., Janis Ekdahl and Terry R. Myers of The Museum of Modern Art Library, Joan Benache, Robert Motherwell's curator, and Sanford Hirsch of the Adolph and Esther Gottlieb Foundation. Tavia Fortt, Sideo Fromboluti, Terry R. Myers, Ann Schonfeld, and Nora Speyer have been kind enough to read the manuscript at various stages. Bob Bender, Senior Editor at Simon & Schuster, skillfully handled the heavy-duty editing, and Gerry Sachs did the fine-tuning of the manuscript. I also want to thank Eleanor Munro for suggesting me to Bob Bender for this book in the first place, and my literary agent, Phyllis Wender, for watching over it for me so well. But the principal source of inspiration, guidance, support, and editorial advice on this book from its inception has been my husband, Budd Hopkins. Without his firsthand knowledge of the people involved, his super-human patience, and his unflagging faith in me, this book might never have been.

TO BUDD AND GRACE

PHOTO: HENRY ELKAN

PHOTO: HENRY ELKAN

Abstract Expressionism arrived with the atomic age. It was an American art movement—the first to wrest control of the art world from Europe—born of Depression era survivors, a generation shaken by World War II and the Holocaust and now living with the threat of nuclear destruction. People all over the earth shared these artists' feelings of anxiety, of seeming to be hanging on to existence by their fingertips. Yet, at the same time, they also shared the artists' sense of exhilaration at the chance to start over at war's end. Jackson Pollock, Mark Rothko, Franz Kline, Adolph Gottlieb, and others in the New York School, as it also came to be known, were able to embody these seemingly contradictory emotions in more powerful images than could artists in an exhausted Europe because the Americans were freer of history and of art history. They found it more natural to take risks. The painted world they invented was apocalyptic, explosive, tension-wracked. Much of their imagery was stark black-and-white, reflecting the all-or-nothing mentality of those years when the world seemed out of control.

"Action painting," another name for this movement, speaks of its physicality, its base in the process of making, rather than in an intellectual esthetic position. The paintings have an improvised, rough-and-ready, almost haphazard look. An Abstract Expressionist approached the canvas head-on, in direct, unpremeditated confrontation, and left it strewn with drips and splatters, accidental gestures and studio debris. Chance, gravity, and paint viscosity were, for the first time in the history of art, important factors in making a painting. New techniques of apply-

ing paint were exploited—dripping, throwing, squirting, squeegeeing, and spattering—using crude, untraditional tools like unwieldy house-painters' brushes, sticks, basting syringes, and trowels. Cheap enamels substituted for tube colors. Yankee ingenuity replaced standard text-book studio practice for sculptor and painter alike. What did all those centuries of precision-controlled creation have to do with making art in such a jittery, uncertain time anyway? New and bigger scale, a new forthrightness, seemed essential, a boldness that was distinctly Ameri-can. Our pioneering spirit craved breadth, open expanses, new territory to explore. There was so little time and so much nervous energy charg-ing the air.

The artists called Abstract Expressionists became legendary figures around whom myths were woven that are still being embellished, de-spite sporadic attempts to de-heroicise them, particularly, as one might expect, in France. Only one of the major artists is still alive in 1992—Willem de Kooning. Robert Motherwell died suddenly of a stroke in 1991 at the age of seventy-six, but many died prematurely, some by their own hand. Substance abuse and marital difficulties seemed to be en-demic. Some of the eighteen core artists of the movement led lives suitable for movie treatment—Jackson Pollock, Arshile Gorky, and Franz Kline, for instance—while others such as Robert Motherwell, Philip Guston, and Mark Rothko would make ideal subjects for extensive psy-cho-historical analysis. Close working relationships between the artists on the order of Picasso and Braque's in 1911 were rare but pivotal: Rothko, Gottlieb, and Newman together developed and defined a new "mythical" kind of abstraction at the beginning of the forties; Motherwell and Pollock worked together on their first collages at the same time; de Kooning and Kline were in and out of each other's studios in the late forties when Kline was benefiting from de Kooning's long apprentice-ship to modern art, and then, in 1954, shared a studio in East Hampton when de Kooning began to benefit from Kline's able handling of large scale.

Looser friendship groupings also existed along similar lines. The up-town contingent—Rothko, Gottlieb, and Newman—were the moraliz-ing intellectuals; the downtown, Cedar bar contingent—Kline, de Kooning, and Pollock—were the hard-living, hard-drinking swashbuck-lers, the "stars" of the movement. Motherwell and his friend David Smith moved freely between the two groups, fitting into both, while

the others had friendships that only occasionally overlapped either group.

The year 1950, the twentieth century's turning point, was a crucial year for subsequent American history. It was the year that saw the outbreak of the Korean War, following the victory of Communism in China, the first American production of hydrogen bombs, the Hiss case, the beginning of the McCarthy rampage, and unusually widespread labor violence. Nineteen fifty was also the pivotal year for Abstract Expressionism. It was its "moment" in much the same way that the end of the first decade of the century was defined by John Berger as "the Moment of Cubism," because all of the political, economic, scientific, and psychological factors that influenced Cubism came together at that point in time. But like the hidden symmetry in a Barnett Newman painting, the crucial importance of this particular year, the mid-century marker, has largely been perceived subliminally, if at all. Vast tremors went through the Dark Ages at the birth of the new millennium, and the end of every century seems to be marked by conscious and unconscious upheaval, but mid-centuries have also been felt as critical turning points. For the subsequent history of world art, 1950 represents such a fulcrum. Abstract Expressionism took final shape; its artists, born at different times between 1900 and 1915 and in far different places, all came together to play their parts in the events of 1950 as if on cue, on a stage of international significance.

During 1950 the artists and their public became aware that something extremely important was going on in New York, something that wasn't happening anywhere else. The excitement was palpable; to be in the art world in that time and place was to be at the center of it all. Sometime in the forties art students had already begun to talk of plans to go to New York rather than Paris to study. By then anyone deeply involved with art knew that New York offered the best facilities in the world for studying the masterpieces of modern art. It wasn't until the Beaubourg opened in 1976 that a Parisian museum began systematically to collect and exhibit modern art in anything approaching the manner of New York's Museum of Modern Art, and by then it was too late to do so in comparable depth or quality. The Modern had been in operation since 1929, establishing and refining ever since the canonical list of modernist artists and movements under the brilliant guidance of Alfred Barr, as well as creating the ground rules of connoisseurship for this art. It was

(and remains) especially strong in Picasso and Matisse, Miró and Brancusi.

In addition, the Museum of Non-Objective Painting, later and now known as the Solomon R. Guggenheim Museum, and the A.E. Gallatin Collection, which was then established at New York University in Greenwich Village, were the two major repositories of twentieth century abstraction in the world. In their precincts Mondrian and Kandinsky and their followers could be seen in depth. And as if this were not abundance enough, the major European commercial galleries had branches in New York or had relocated there because of the war. One might more easily have seen major Matisse, Giacometti, Kandinsky, or even Picasso exhibitions in New York than in Paris. New York artists could be, and some were, the most knowledgeable artists in the world when it came to modern art. None knew better than they how tremendously important the European Modernist contribution had been, and none were more keenly disappointed by the relative weakness of its postwar manifestation. By 1950 it was clear that the art public's continuing great expectations for French Modernism were simply not being fulfilled by the new "stars"—Dubuffet, Balthus, and Giacometti—or even by Picasso, whose new work, in most everyone's eyes, was less vital and inventive than before. Contemporary French art, alas, was now typified by the decorative abstractions of people like Bazaine and Manessier and by the figure paintings of Bernard Buffet.

In 1950 the American Abstract Expressionists constituted a group which could be referred to as a "New York School" the way one could previously talk about a "School of Paris." It was, in fact, the only year such a designation is completely accurate. During this twelve-month period almost all the artists we have come to see as crucial had breakthrough exhibitions in New York of the very works that made them famous; in retrospective surveys of artist after artist, 1950 turns out to be the year they established their "signature images." It was the year of greatest interaction among them, and the only year they all lived and worked together in New York City. Jackson Pollock and Lee Krasner spent the winter there instead of in their Springs studios; Philip Guston and Clyfford Still moved temporarily into Manhattan before committing themselves permanently to Woodstock and Baltimore, respectively.

Though by 1950 a few of the Abstract Expressionists had been singled out for attention—Pollock especially, with purchases by The Museum of

Modern Art (MOMA) and *Life* magazine coverage—it was still too soon to feel that fame or fortune were anywhere in sight. Most of the artists, including Pollock, were desperately poor, borrowing kerosene from one another to light their studio heaters (de Kooning was especially generous in this regard); nursing cups of coffee in Bickford's Cafeteria for a half-hour of warmth; detouring gas and electricity from Con Ed and hiding their elaborate systems for doing so from the inspectors; cadging showers, rides, drinks, and meals. (Kline's friend, the painter Earl Kerkam, whose living conditions made those of Gulley Jimson seem regal, ate regular weekly dinners with a series of families, each of whom believed they were the only thing between him and starvation.) The poverty they shared equalized them; their ambitions and struggles brought them together in a common bond against everything outside their orbit. The artists were their own audience, all showing up for one another's openings, then going off to a coffee shop or the Cedar Tavern to vent their reactions. Artists are ordinarily individualists to the extreme, staunch competitors out for themselves and their own idiosyncratic visions, yet for a short time even these fierce American loners managed to work together in something approximating a team effort.

When this group sense solidified in 1950, the artists spent a great deal of energy both defining and denying it in print and in person on Friday evenings at Studio 35, the site of the former "Subjects of the Artists" school at Thirty-five West Eighth Street, and later at "The Club" where the tradition of interchanging ideas was continued on a less formal basis for many years. During three important days of roundtable discussion sessions at Studio 35 in April 1950, Motherwell, de Kooning, David Smith, William Baziotes, James Brooks, Hans Hofmann, and others sat around a table drinking beer, munching on pretzels, and arguing about when a painting was finished, whether they shared a style, and, if so, what to call it, and whether they weren't in danger of becoming an academy. At the end of the roundtable they joined forces in common cause against the recent policy decisions at the Metropolitan Museum of Art. On the front page of *The New York Times,* Sunday, January 1, 1950, it had been announced that after years of "token activity" in the field of contemporary art, the Metropolitan Museum of Art was about to take the first step in its "new policy on Modern Art—an open competition every two years with eight thousand five hundred dollars in prizes, the first to be shown in December"; the use of the George A. Hearn Fund (an

accumulated hundred thousand dollars) to "fill in gaps" in the collection including "certain advanced trends now missing"; and finally, an exhibition during the summer of *American Painting 1900–1950*.[1]

On the surface it would seem that the Met was doing a good thing. Why then were the roundtable discussants so opposed to the museum's plans? What was wrong with the American art being canonized in this and other American museums? For the most part this officially sanctioned painting was conservative and unchallenging. It was compromise art, a pastiche of previous European and American styles, an art of recognizable subject matter overlaid with quasi-modern clichés of diverse sorts—yet it was frequently praised for this eclecticism. When not wallowing in religious or homely sentiment it was at the very least nostalgic for a past long gone. Farmers and cowpokes, fishermen and blank-faced children playing in the streets—these thirties American Scene painters' subjects now appeared "contemporary," tarted up beneath an overlay of "Modernist" painting styles. Watered-down Cubism, Expressionism, and Surrealism served to convey an acceptable modernity on otherwise old-fashioned, homespun subjects. The worker was still being glorified (though less stridently) on the Right (in a sort of updated Currier & Ives manner) and on the Left (by a "concerned" Super-Realism), but propaganda was still propaganda, whether it was in the cause of the American way or the Communist crusade. The true Modernists of the early twentieth century—Marin and Hartley, Demuth, Sheeler, O'Keeffe, and Stuart Davis—were still respected, but no longer in the avant-garde.

In May 1950, eighteen of America's most "advanced" painters and ten such sculptors sent a letter of protest to the Met's president about their new jurying and prize-giving system. They protested it on principle and for its extremely conservative choice of regional jurors. After all, it was supposed to be an "open" exhibition. Most of these same artists were excluded from the summertime survey of the last fifty years of American art even though some of them had been showing for more than twenty years. Then, too, they, along with most of the other contemporary "advanced" artists not painting representationally, were not deemed to be "gaps" the Met's curators felt it essential to fill in the collection. By the end of the year the artists we call Abstract Expressionists had become the radicalized "Irascibles" who posed (looking extremely serious, if not downright angry) for the now famous *Life* magazine group portrait.

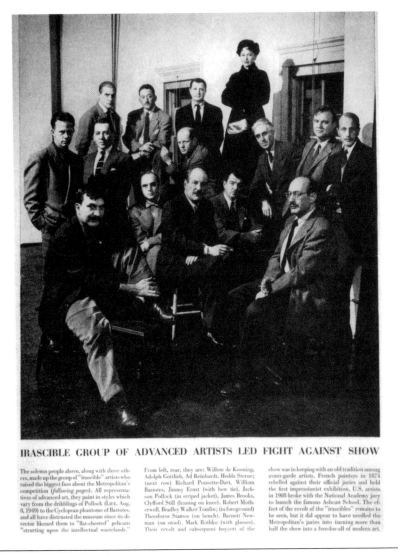

IRASCIBLE GROUP OF ADVANCED ARTISTS LED FIGHT AGAINST SHOW

The solemn people above, along with three others, made up the group of "irascible" artists who raised the biggest fuss about the Metropolitan's competition (*following pages*). All representatives of advanced art, they paint in styles which vary from the dribblings of Pollock (LIFE, Aug. 8, 1949) to the Cyclopean phantoms of Baziotes, and all have distrusted the museum since its director likened them to "flat-chested" pelicans "strutting upon the intellectual wastelands."

From left, rear, they are: Willem de Kooning, Adolph Gottlieb, Ad Reinhardt, Hedda Sterne; (next row) Richard Pousette-Dart, William Baziotes, Jimmy Ernst (with bow tie), Jackson Pollock (in striped jacket), James Brooks, Clyfford Still (leaning on knee), Robert Motherwell, Bradley Walker Tomlin; (in foreground) Theodoros Stamos (on bench), Barnett Newman (on stool), Mark Rothko (with glasses). Their revolt and subsequent boycott of the

show was in keeping with an old tradition among avant-garde artists. French painters in 1874 rebelled against their official juries and held the first impressionist exhibition. U.S. artists in 1908 broke with the National Academy jury to launch the famous Ashcan School. The effect of the revolt of the "irascibles" remains to be seen, but it did appear to have needled the Metropolitan's juries into turning more than half the show into a free-for-all of modern art.

The photograph of "The Irascibles" as it appeared in Life *on January 15, 1951. (Photo by Nina Leen,* Life *Magazine © 1951 Time Warner Inc.)*

In establishment American art the forties were a period of marking time. Conservative critics noted with dismay that abstraction was taking over the art world, but what they called "abstraction" was entirely different from the meaning of the term today. For us it is what Pollock and his friends were painting, but at the time "abstraction" was usually a linear network decoratively applied to a desert landscape, an elegantly cubified still life, or a surrealistic distortion. The truly abstract, flatly

painted constructivist art of right angles, limited colors, and no subject matter that was being produced by a group known as the American Abstract Artists was a marginal and unthreatening category. The American Abstract Artists (A.A.A.) were for the most part followers of the pioneer Dutch abstractionist Piet Mondrian; they borrowed his forms, but the feeling now was secondhand. The war had demolished the usefulness of Mondrian's art as a utopian model of the future; reduced to purely formal exercise, his kind of painting turned into decoration. Machine-replicable-seeming geometric forms in primary colors placed here and there, echoed here and paralleled there, seemed dry as a dust bowl and completely beside the point in postwar America.

Pollock, de Kooning, and the others rejected all of these outmoded, dead-end styles. They demanded that art be subjective, that it result from and communicate emotion but not story—neither the sentimental, glorify-the-worker content of Social Realism nor the labyrinthine literary content of Surrealism. The latter was a European movement born in the twenties out of a marriage between Freud and art.[2] The unconscious was seen to hold one's true emotions, however irrational. Art (or literature) which could bypass the control of the conscious mind and tap into this realm would have the potential to communicate directly with the viewer/reader's unconscious. Surrealism manifested itself in two visual modes: a hand-painted dream imagery (Salvador Dali's melting watches being typical) and an unpremeditated, automatist, or doodlelike approach to the creation of images arrived at ostensibly without the controlling intervention of consciousness.

The Surrealist presence had been large in New York since the early thirties when Julien Levy opened a gallery to promote it and MOMA put it on exhibition. It washed over the New York artists in two waves. During the thirties, Dali's kind of Surrealism held sway; in the forties the other kind took over. André Breton, the patriarchal leader of the movement, was in New York during the war, as were Max Ernst, Matta, and, upon occasion, Joan Miró, the most important practitioners of automatism. Arshile Gorky, William Baziotes, and Robert Motherwell were in particularly close contact with the European emigrés, though the Chilean Matta had the most direct influence on their work. They spread the word among their friends about this new way to approach the blank canvas and its potential for releasing subjective content. The Americans appropriated these procedures, but the morbidly sexual content of the

Europeans remained their own private property; it seemed foreign to the American experience. The automatist method was the last art device America took from Europe. Having jettisoned everything else they could not tolerate about both European and American Modernism, the Abstract Expressionists set off on their mission—their journey into the unknown, as they so often phrased it in the forties.

Even though the artists would have imagined this metaphorical journey taking place on the sea, an airborne mission might make a more appropriate image. Looking at various early group photographs of the Abstract Expressionists, an amusing (though somewhat misleading) analogy comes to mind with a popular cliché of World War II movies: the socially and ethnically balanced bomber crew—Jew and gentile, rich man and pauper, native son and immigrant—brawling and quarreling among themselves, yet all pulling together for victory. And there they are: Jackson Pollock, the Westerner in denim jacket and jeans, jaw set and brow furrowed, a cigarette dangling from his lips; Franz Kline, handsome, athletic, a head full of shaggy-dog stories and a warm hand-clasp for everyone; the dashing blond Dutchman Willem de Kooning, an illegal alien who, years before, had jumped ship in New Jersey. Others are immigrants too: Arshile Gorky from a politically defunct Armenia, Mark Rothko, a doubt-wracked escapee from a Jewish ghetto in Russia, and the old German, Hans Hofmann, who had experienced both world wars. Chain-smoking Philip Guston had been born in Canada, but he grew up in Southern California surrounded by bizarre cults, his paintings actually shot at by the Ku Klux Klan. Adolph Gottlieb, a tough street-smart painter from the Bronx, was the opposite in just about every way of moneyed, cultivated Californian Robert Motherwell. William Baziotes seemed as suave as a motion-picture gangster, but was deeply introspective. Bradley Walker Tomlin was debonair but as quiet and gentle as his friend James Brooks. Buddha-like Ad Reinhardt, the nay-saying moralist who was always in the picture but never really joined the group, contrasted sharply with Clyfford Still, a gaunt and taciturn son of a farmer from North Dakota, except for the similarity of their severe, puritanical styles. Both contrasted with former steelworker David Smith, who swilled beer and swapped stories with longshoremen, and he was very different from sophisticated city-slickers Lee Krasner and Barnett Newman, the latter of whom rushed to join the group, monocle in place.

The pilot in this "bomber crew" image had to have been Pollock, striding out of the American West in cowboy boots and Levi's, swinging loops of paint wildly onto the canvas. He became the artist-hero personified when *Life* magazine asked "Is this the greatest painter in America?" The image of a pioneer-style existentialist emerged because of the risks he took throwing himself into the void of the canvas, trusting chance, self-taught skills, and a native intelligence to bring him through each encounter with the recalcitrant materials of his art. If he was obsessive and depressive, if he drank excessively, talked too little, and was out of control except when he was painting—so much the better for this image. Mythic heroes are sacrificed while they are still young, and Pollock complied by driving himself drunkenly to his death in 1956 at the age of forty-four.

No other of these artists was a legend on such a Bunyanesque scale as Pollock, but many died young—William Baziotes at fifty-one (of cancer), Arshile Gorky at forty-four (a suicide), Kline at fifty-two, Bradley Walker Tomlin and Ad Reinhardt at fifty-four (all of heart problems), and David Smith, his powers finally at their peak, at fifty-six, also in an automobile accident. Rothko committed suicide at the age of sixty-seven, conflicted and miserable about his financial success when what he wanted was to redeem the world through his art. Many of these artists felt something of his missionary urge. They weren't just making art. They believed they were remaking the world in a new image, an image that came out of their souls and could be communicated to everyone, because we all shared a collective unconscious. While not dour, their mien was intensely serious. "We all had hard times," de Kooning said. "It was like a cloud hanging over us." They didn't bother to ask one another how they were making out, since they knew that outside of what was happening in the studio, it wasn't going well. Finances didn't improve for most of them until the middle fifties. Only Kline actually seemed cheerful, always ready to laugh or tell a joke. But he was on the state dole as late as 1953, and, with his wife residing in a psychiatric hospital ever since 1946, he had as much personal tragedy in his life as any of the others. As he once put it, "Mirth is the mail of anguish."

All of the major Abstract Expressionists were born by the end of 1915; they were mature human beings and artists by 1950. The forties was the critical decade for most of them. The foundations of their world were shaken by World War II, personally as well as esthetically. "The Bomb"

shattered everything. Three days after the *Enola Gay* dropped an atomic bomb on Hiroshima, a second explosion took place on Nagasaki. William Laurence, a science writer for *The New York Times,* described the event as though it were a visionary moment. After "a bluish-green light illuminated the entire sky," he wrote, "a giant ball of fire rose as though from the bowels of the earth, belching forth enormous white smoke rings." Next came a "giant pillar of purple fire 10,000 feet high" that seemed alive, "a new species of being born right before our incredulous eyes."[3] Traditional esthetic means and subject matter no longer seemed adequate after such astounding and abstract visual experiences. Each in their separate ways, the American Abstract Expressionists found relevant images which did convey a sense of responding to the world that had been born with the bomb.

If de Kooning, Rothko, Pollock, and the others looked new and different to the postwar art world, there was one central transitional figure who built the bridge between the old Modernism and the new American painting. That artist was Arshile Gorky, though his contribution did not become generally evident until his 1950 memorial exhibition at the Kootz Gallery. It was then that Pollock and some of the other Abstract Expressionists saw a large amount of his work for the first time. Gorky's mature paintings were larger than most contemporary easel paintings. They were charged over their entire surface with organic forms which seemed to be evolving before one's eyes in a dense, palpitating, ambiguous atmosphere that was neither landscape nor interior, neither spatially deep nor flat. His beautiful lines meandered in and out of space, creating shapes and abandoning them in an anarchically doodlelike manner. The paint was allowed to run down the surface in streams, oblivious to any obligation to coincide with the linear activity. His imagery seemed as unpremeditated and uncontrolled as a reverie.

Gorky had managed to assimilate the Parisian mode so thoroughly that his work seemed at first indistinguishable from its sources. But later he was able to translate its vocabulary into our language, on a scale and with an exhilarating impulsiveness and freedom that felt genuinely American even though nothing like it had ever been created here before. He delivered modern art safely to these shores, and then, without credit or reward, at the height of his powers, he died—the first of many tragic deaths among the Abstract Expressionists. Not understanding how much Gorky had done to bring about the new art, one reviewer of his

memorial exhibition wrote that de Kooning had been one of his many influences. "Now that is plain silly," de Kooning responded in a letter to the editor of *Art News.* He went on to describe his first visit to Gorky's studio saying ". . . the atmosphere was so beautiful . . . I got a little dizzy. I come from 36 Union Square. I am glad that it is about impossible to get away from his powerful influence. As long as I keep it with myself I'll be doing all right. Sweet Arshile, bless your dear heart."[4]

Arshile Gorky's life had been the stuff of which legends are made. Born Vosdanik Adoian in Turkish-controlled Armenia, he didn't speak until he was four years old. By then his father had escaped to America to avoid the Turkish army draft, leaving his family to fare as they might for the next twelve years before he'd see them again. Gorky's mother was one of the estimated 15 million who did not survive the Turkish atrocities, death marches, and persecution. She died, in Gorky's arms, it is said, of starvation in 1919. When he painted his famous portrait of *The Artist and His Mother,* he gave her a sanctified, iconic presence. Later, in this country, Gorky took his name from Maxim Gorky and even stole some of the famous Russian writer's words to woo a ladylove. He made his own persona out of those of others by becoming them, just as he made his art out of Cézanne, Picasso, and Miró in turn by putting himself so completely inside them that he could see with their eyes, paint with their hands.

Gorky was mordantly romantic. He was very tall, with stooped, care-weighted shoulders, a drooping mustache, and enormous, sad, dark eyes. He wore a full-length black cape, swooping through the streets inside it as though it were protective armor. His studio, where he struggled so painfully for so long, was a mecca for modern art's faithful. When, in the early forties, he finally found love and marriage, his painting life suddenly burst forth in song, to a tune of his own at last. A succession of dazzling paintings streamed off his brush based on dreams and memories and on experiencing nature anew, as if as a child with his face buried in a bank of wild flowers, or a young lover with his body in a sexual ferment. The paintings didn't look like anybody else's, and they didn't look like anything in the museums he haunted, not even The Museum of Modern Art.

After a few years of happiness, two lovely daughters, and some small measure of professional success, in 1946 his world began to fall apart. In January a fire in his studio reduced most of his life's work to ashes. Two gray-and-black paintings—*Charred Beloved I* and *II*—are poi-

gnantly elegiac summations of his feelings about that trauma. An operation for colon cancer the following month reduced him to psychological ashes. His sense of self impaired, impotence replaced virility, and his marriage began to tremble. *Agony,* 1947, speaks of his pain in blood reds and incendiary yellows, its exquisitely vulnerable visceral shapes pierced by needle-sharp thorns. On June 26, 1948, his neck was broken in an automobile accident, paralyzing his painting arm. Shortly after his release from the hospital his wife left him, taking the children, and he wandered from friend to friend seeking relief from his profound despair. No one was with him, though, when he chalked "Goodbye My Loveds" on a crate in his Connecticut studio the morning of July 21 and hanged himself. As if fate were not hard enough on him in life, a large group of drawings was lost in a plane crash a few years later, and one of his greatest paintings, *Calendars,* was destroyed by fire in Governor Nelson Rockefeller's Albany, New York, mansion.

Compared with this, the life of Gorky's friend Willem de Kooning appears charmed. It has been long—he was also born in 1904—but it has never been interrupted by disaster, either personal or impersonal. Even though it was a keenly hard life until the last few decades, he has spent it painting. "Vat else is der?" he would say in his charming Dutch accent. And unlike his friend Arshile, he has always been lucky in love. His wife was Elaine Fried, a beautiful woman, a talented painter, and an astute art critic. Although they officially separated in 1956 after thirteen years of marriage, she again became his companion in the seventies. De Kooning's daughter, Lisa, and her mother, Joan Ward, live near him in The Springs, Long Island, and see him often. When a young artist was complimenting him profusely on the early paintings in a retrospective exhibition not long ago, he responded, "Ya. And the new ones are good too!"—which, in fact, they are. The flaw in this idyllic picture is his drinking problem, which is symptomatic of an anxiety so profound that it fueled an art life of enormous dimensions. This anxiety wouldn't allow him to finish the early paintings. Unable to decide either/or—whether to put it in, take it out, put it back—it made a battlefield out of *Woman I,* and it embedded his entire approach to making art in ambiguity. As Søren Kierkegaard, a favorite of his, once wrote:

> Hang yourself, and you will regret it. Do not hang yourself, and you will also regret it. Hang yourself or do not hang yourself, you will regret it either way. Whether you hang yourself or do not hang your-

self, you will regret it either way. This, gentlemen, is the quintessence of all the wisdom of life.[5]

Mark Rothko, the epitome of uncertainty, also loved Kierkegaard. Death was the only thing he could count on, and, ultimately, that is where he put his trust. He once told a fellow artist, Alfred Jensen, that he didn't know whether he had witnessed the pogroms firsthand or whether he had just heard tales of them as a child, but that he had an image of the mass graves Jews had to dig for their own bodies in Russia during the pogroms, and that he thought maybe he had been painting those gaping rectangles all his life. Perhaps this explains why Rothko intended his paintings—even the most brightly colored of them—to evoke tremendous sadness in the viewer. Tears of quiet confirmation were the response he expected to his canvases, and he always wanted his work exhibited in dim, isolated, meditation-conducive settings in order to achieve this result. He abhorred formalist talk of color fields and sensual veils of pigment. Certainly the bleak gray and black symbolic landscapes of death painted during the last year of his life are as devoid of hope as anything ever created. They exist on a plane with Samuel Beckett's profound inertia and despair.

Rothko's friend Barnett Newman's negativism took a bizarrely different cast, despite their parallel thinking. A devoted disciple of Kropotkin, the Russian anarchist, Newman believed the world had to be revolutionized, and that art was capable of bringing about the necessary changes. He even ran for mayor of New York City in the thirties on an independent artists' ticket. The artist's role, as he saw it, was that of a godlike, powerful leader; the actual work was less important than what the artist stood for. These notions were fused with Jewish mysticism, the Kabbala, numerology, and his own private interpretation of the Old Testament to form a coherent, though barely comprehensible, conceptual base for his paintings. The hidden symmetries, mathematical proportions, and portentously biblical titles of his mature paintings all stem from this mix. He felt that he was getting at primal truths by stripping his paintings down to only a few critical elements, two or three vertical "zips," as he termed them, through a field of solid color. "The basis of the esthetic act," he wrote, "is the pure idea . . . that makes contact with mystery—of life, of man, of nature, of the hard bleak chaos that is death or the grayer, softer chaos that is tragedy—for it is only the pure idea that has meaning."[6]

Rothko and Adolph Gottlieb (with editorial assistance from Newman) wrote an often quoted letter to *The New York Times* in 1943 to explain their work. In it they made a crucial connection between Modernism and Primitivism which was relevant for many other Abstract Expressionist painters and sculptors:

> If we profess kinship to the art of primitive man, it is because the feelings they expressed have a particular pertinence today. In times of violence, personal predilections for niceties of color and form seem irrelevant. All primitive expression reveals the constant awareness of powerful forces, the immediate presence of terror and fear, a recognition of the brutality of the natural world as well as the insecurities of life. That these feelings are being experienced by many people throughout the world today is an unfortunate fact and to us an art that glosses over or evades these feelings is superficial and meaningless.[7]

Philip Guston had been a highly acclaimed representational artist during the thirties when the others were struggling to find their painting identities and simply to stay alive. During the forties he nearly suffered a nervous breakdown trying to reconcile his success with world realities. Paintings that spoke so eloquently about tragic conditions during the Great Depression were inadequate to voice the emotions of wartime and its aftermath. The human figure as metaphorical vehicle broke down when its integrity was being so brutally violated in the real world. With the help of James Brooks and Bradley Walker Tomlin, Guston finally found a path through to abstraction by 1950, but he didn't seem to embrace it wholeheartedly or trust it completely. He never found his signature image the way the others did—only a sensibility, a sense of touch. After about fifteen years of applying paint so sensually and beautifully to canvas that he was constantly being called an Abstract Impressionist instead of the Expressionist he felt himself to be, he began to shift back into representation. Guston's great late paintings of the decade before his death in 1980 are tragicomically autobiographical: black skies above bloodshot earth, a desolate plain strewn with rocks, shoes lying sole up, empty canvases, cigarette butts, empty whiskey bottles, and decapitated heads. Burroughs and Beckett, Kafka and Krazy Kat, would all feel at home here. The paintings are resolutely antiformalist, antiesthetic, embodying as they do Barnett Newman's famous remark, "Esthetics is for the artist as ornithology is for the birds."

The Abstract Expressionists' painted statements are equally truthful as self-revelations and as responses to the time. One critic wrote that in all of Bradley Walker Tomlin's mature work painted during the five years between his conversion to the methods of Abstract Expressionism in 1948 and a fatal heart attack in 1953, "there is the mirror-like reflection of his own personality, his sensitive, precise yet romantic mind, his lyrical spirit with its strain of muted sadness, elegiac and remote."[8] The spectral backlighting of his breakthrough paintings, their tremulous forms shaking with dread in an airless space, evoke a pervasive sense of doubt and pain which probably resulted as much from the world situation in the post-Hiroshima late forties as it did from his personal loss— the death of the artist Frank London, with whom he had shared a studio ever since he was a young man.

Guston, Gottlieb, and Robert Motherwell were the three principal artists to whom Tomlin clung after his loss of London. Tomlin got his pictographlike maze compositions from Gottlieb, gave his jittery brush stroke to Guston, and literally shared his palette with Motherwell during the period at the end of the forties when they worked in the same studio during the winters. Motherwell, who called Tomlin a "dandy . . . from his military moustache to his Brooks Brothers scarf," wrote that his "lifework portrays an effort to overcome the sense of style that every dilettante has with a sense of existence that every artist has," adding that his was a "genuine human drama, a genuine existential problem in art." Allying himself with Guston and Pollock, who also grew up in California, Motherwell felt that the three of them were "filled with a self-torment and an anxiety that were alien to Tomlin, but to which he must have deeply responded to have loved us so much in turn."[9]

Gentle Tomlin and Brooks represent the exceptions that prove Motherwell's rule that something inherently violent in the American character came out in Abstract Expressionism. The crashing brutality one feels in Motherwell's best work and in Kline's, the seething anger in some Rothkos, the slashing, slicing fury in so many de Koonings all but demand biographical interpretation. Such interpretation is certainly permissible for the sculptures of Motherwell's friend David Smith, whose ferocious rages cost him both of his marriages. De Kooning could turn viciously on even his best friends when he had had too much to drink, and Jackson Pollock's pugnacity was legend. Typical was the Cedar bar fracas that began with Pollock's dumping all the drinks off someone's

table and pulling the men's room door off its hinges. Some of the time, however, Pollock's behavior was for public consumption. One famous night the brawl ended when, wrestling on the floor with Franz Kline, Pollock whispered, "Not so hard, Franz, not so hard."

Motherwell's paintings alternated between Apollonian hedonism in the large-scale color paintings and Dionysian primitivism in the so-called monster paintings of the fifties and eighties. Both sides of him— a majestic calm like the measured cadences of Matisse, and a ruthless sexuality and morbidity that broods on death like Goya in the House of the Deaf Man—came together in his *Elegies to the Spanish Republic,* which were first exhibited as a group in 1950. This series was inspired by the line García Lorca so often repeated in his poetic lament for a Spanish bullfighter, "At Five in the Afternoon," and, like the rhythms of the poem, its forms repetitively intone the life force and its loss in alternations of bulbous black ovals and vertical bands. Bullfights seen in Mexico, where Motherwell married a ravishing Mexican actress, and memories of a lynching witnessed as a child, mingled in his mind with the images of sexuality and death in Lorca's poetry.

Motherwell was one of the most complex of the Abstract Expressionist artists. An intellectual who believed that art is a gut-wrenching, anti-intellectual endeavor; a Francophile who cringed at the suggestion that his paintings are at all elegantly Frenchified; a brilliant conversationalist who refused taped interviews because he felt that he stumbled over his thoughts when trying to put them in words—he woke up every morning unsure of his artistic identity. He would pull out an old canvas from storage to brood over, desperately trying to assess its relative merits in the light of surrounding works in progress. Which was the real Mother-well? The atavistic caveman or the sophisticate who spoke so eloquently about every modern artist being burdened by the baggage of the entire history of world art? What were his real strengths? Why was it such a struggle for him to convey his emotions on a large scale when he could readily get what he wanted in small ink drawings? And so it went. The doubts, the daily self-searches, the anxiety were pervasive.

Not since the Renaissance has there been a group of artists whose real lives have been so fascinating. Franz Kline is a perfect example. Orphaned as a boy by his father's suicide (or murder), a poor student, excelling only in sports, he was in his twenties before he graduated from high school. Sometime in his early teens he had had a bout with

rheumatic fever which would cost him his life some forty years later as the disease inevitably did in those pre-antibiotic days. Meanwhile, desperate to find a way to make a living, he tried to turn his natural drawing ability to advantage by studying cartooning and commercial art. He found his way to England, where he studied at the Heatherley School of Fine Art in London. There he fell in love with one of the models, a ballet dancer, whom he married. But when they were back in New York, the brutal life of a near-destitute artist who drew caricatures in the bars for beers, who performed any handyman jobs he could scrounge, and who was evicted for nonpayment of rent as often as three times in a year, proved to be too much for Elizabeth Kline, and before the end of the forties she had to be committed to a mental hospital. She remained there for fourteen years, but they never divorced.

In 1950, with just twelve years of life left to him, Kline finally broke through to a place in the art world sun with a shockingly stark exhibition of black-and-white paintings at the Egan Gallery. Never had work so raw, so dynamic, so large scale, and so threatening been shown in a New York gallery. Nothing in European painting, nothing in earlier American painting had prepared people for the violence of Kline's imagery. Pollock's webs of thrown paint suddenly seemed tame by comparison. *Wotan, Chief, Cardinal*—even the titles had power. Until the end of the fifties, however, his fame was limited to the art world, and there was still no income to speak of. He was thoroughly lionized in the artists' hangouts by fellow artists, students fresh from art school and art world groupies. A jazz-riff delivery style made his strings of stories and jokes spellbinding even when they went on intermittently for hours. He didn't talk about art directly—nobody did then. Instead he used baseball metaphors for artists' positions in the art game or made analogies using Borscht Belt comic routines.

After Pollock's death in 1956, the financial picture changed for all the Abstract Expressionists as their work began to be collected seriously. Kline, who once defined a bohemian as someone who could live in a place where an animal would die, and had been one himself for so long, finally began to live better. More certain of his finances, he replaced the housepaint enamels he'd been using with tube colors. More certain of his painterly means, he began to reintroduce color and tonal nuance, though the process was especially difficult and each success hard-won. His last work, *Scudera,* 1961, functions completely as a color painting.

In it, a central, black, open-centered square twists off and up into deep blue space beneath a spurt of red flame as though it were a figure in an Ascension by Titian.

All of the major and most of the minor artists of this group had one-person shows during the twelve months of 1950 on an exhibition schedule which almost perfectly recapitulates the history of the entire movement. The early, Surrealist-influenced Abstract Expressionists all showed in the first quarter of the year. January opened with exhibitions by the three key figures of the early years—Rothko, Gottlieb, and Newman—who created the first images of the new American painting and whose 1943 letter to *The New York Times* was the "first paper" of Abstract Expressionism. They had been close friends since the late twenties, remaining so into the fifties. Even though Newman didn't exhibit his own work until his famous January 1950 exhibition at the Betty Parsons Gallery, he had been writing introductions for his friends' catalogues and organizing theme exhibitions of the new work all during the forties.

Other Surrealist-influenced Abstract Expressionists were William Baziotes, whose February exhibition came next, and Arshile Gorky, whose big memorial show was held at the Kootz Gallery in March. Thanks to this important exhibition, Gorky, the bridge figure for the movement, was finally seen by the other artists and the critics as a major Abstract Expressionist. His early death had obscured that fact. Within the first three months of 1950, then, this important first phase of Abstract Expressionism is encapsulated.

The artists who evolved independently of the Surrealist circle during the forties showed in the second and third quarters of 1950. Clyfford Still, who had the next exhibition, in mid-April, taught in San Francisco, but he kept in close touch with developments in New York by making frequent visits and by correspondence, particularly with Rothko, whom he met in 1943. Still's example encouraged Rothko's slow but steady elimination of object imagery from his canvases in the late forties, and in turn, Rothko's large scale and breadth probably helped loosen Still's tight Gothic tracery. The pictures shown in 1950 were the grand-size, craggy canvases with which Still has ever since been identified.

The next two artists to exhibit in late April and May were David Smith, who had been equally influenced by both Cubism and Surrealism, and Bradley Walker Tomlin, who was untouched by Surrealism until he got it secondhand from friends such as Gottlieb. Both showed their recently

developed (now familiar) work, the best of their careers in many critics' opinions. Motherwell had been a good friend of Tomlin's for years, but he had just gotten to know Smith, whose work he had admired since the early forties. He wrote the statement for Smith's Willard Gallery exhibition catalogue.

Midpoint in that mid-century year the new-style American painting caused something of a brouhaha in Europe when it was part of the United States representation at the Venice Biennale. Then, as now, the Biennale defines international art. Radical new canvases by Pollock and de Kooning were shown in mini solo exhibitions, including the largest painting de Kooning would ever do, *Excavation,* six-and-a-half by eight-and-a-half feet, which he had finished, just in time for shipment over-seas. This was the first Abstract Expressionist painting to win a major museum prize and to be purchased for a then significant four-figure price. Nineteen fifty was also the year de Kooning began working on *Woman I,* the first in his celebrated series of monster-goddesses, the torn and tattered yet magisterial icons of male anxiety, anger, and am-bivalence in the presence of a female.

The fall season opened with an attempt to assess the comparative contributions of the European and American avant-gardes and, appro-priately, a one-man show by the German-American Hans Hofmann. Franz Kline's knockout black-and-white show at Egan was then followed by Motherwell's pivotal exhibition at the Kootz Gallery, his first New York one-man show in three years. Motherwell loved to tell the story of Kline throwing his arms around him in a big bear hug when he first saw Motherwell's black-and-white *Elegies* and exclaiming, "That's it!" as though Kline were learning the power of black-and-white from him. Motherwell's 1949 black-and-whites probably were a factor in Kline's evolution, but de Kooning's were surely even more significant, since Kline and de Kooning were very close at this time, and the success of de Kooning's so-called "Black" paintings in 1948 would have loomed large in Kline's mind. Besides, black-and-white was "in the air" then; Pollock, Brooks, Gottlieb, and Still were also very intense about it.

James Brooks developed his stain technique in part from Pollock's freewheeling drip when they were living in close proximity on eastern Long Island in the late forties and saw a lot of each other. Brooks was a latecomer to abstraction, having been, like his lifelong friend Guston, a successful figurative painter in the thirties and forties. Both Brooks and

Guston exhibited at the Peridot Gallery in the last months of 1950 and represent the later phase of Abstract Expressionism, the phase that had a strong influence in the sixties and seventies—Brooks in developing the stain image, which Helen Frankenthaler transformed into the color field painting of the sixties, and Guston in developing a highly eccentric and painterly figurative expressionism in his later years, which was an eloquent inspiration for more recent neo-Expressionist painting.

Pollock, who was the first of the New York School artists to gain critical and institutional support for his work, and who came to epitomize the popular image of the "new American artist," had the culminating exhibition of the season and, it might be argued, of Abstract Expressionism as a whole. It was *the* show of his life, the one that included all of the now famous paintings of his "best" years. Never again did Pollock reach the heights he did in that 1950 show, nor did Abstract Expressionism maintain the intensity of that year. Pollock's subsequent disintegration and death in 1956 spelled the beginning of the end for the movement. The other artists suddenly began to be taken seriously when his death caused a major rise in prices for their paintings, but that only seemed to be part of a general acceptance of something which had started out as an artistic revolution. The avant-garde became the mainstream, and in the normal sequence people began wondering what would happen next, once Abstract Expressionism was accepted.

In 1950, however, each month brought forth new surprises, new excitement, new exhibitions to ponder and discuss. It is fitting, then, that we consider those pivotal art world happenings as they unfold, month by historic month.

Now Yorkers saw in the New Year, 1950, with revelry that seems remarkably restrained for Times Square—observers reported that there was virtually no drunkenness or kissing.[1] Many went to Saint Patrick's Cathedral for Reverend Broderick's special service intended to "repair moral damage." In it he said:

> Paradoxically, this year is called a jubilee—a word that rings with merriment, but the Old Testament prophets and the vicars of the New sound the note of penance. We must imbue the whole year with the spirit of Lent. Even a denial of legitimate pleasures is in order, for the devil is cast out only by prayer and fasting.[2]

The priest was leading what he termed the "Crusade of 1950" in order to "bring Christ back to the world." Ironically, two days later and a few blocks north of Saint Patrick's, Mark Rothko, a Jew born Marcus Rothkowitz in Dvinsk, Russia, forty-seven years earlier, opened an exhibition of paintings which Reverend Broderick would surely have found unacceptably hedonistic in their beautiful colors, and incomprehensible in their abstract forms, but which nevertheless had the effect of bringing, if not God, at least a profoundly spiritual sense back to art.

The paintings Mark Rothko exhibited at the Betty Parsons Gallery on Fifty-seventh Street January 3–21 were icons for a new, never-to-be-named religion of the artist's own imagining. They represented quite literally the culmination of Rothko's lifelong quest for a painted image

that might transfer his thought directly into the viewer, with no intervening impediments to their communion. Interestingly, Alfred Kazin wrote a definition of art in his review of a new book about Herman Melville for the January 1950 *Partisan Review* which defines precisely what Rothko achieved with these new paintings: "Art is hardly the whole of reality, but it is a form of love, or perfected communication, in which everything depends on what is given and received between one person and another."[3]

Rothko had shown a few dramatically simplified paintings like these the year before, along with more diffused, multiform canvases, but in 1950 he made a total commitment to his new image: a hieratically austere, upright, frontal configuration of soft "blank" rectangular color-clouds hovering one above another. The viewer faces this simple image

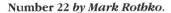

Number 22 *by Mark Rothko.*

head-on in a direct, one-to-one relationship, as if before an icon or an altarpiece. The painting's frontality, its glowing, hypnagogic rectangles, hold the viewer in place and a transference of energy occurs between artist and audience. Led instinctively to center oneself at a point where the atmosphere of colored light is most encompassing, one feels an upward sensation akin to what one senses inside a Gothic cathedral; it is an essential part of the transcendental nature of the experience. When upon occasion these images caused people actually to weep before them or to feel an ecstatic rush onto a higher emotional plane, the viewer was having what Rothko described as "the same religious experience I had when I painted them." [4]

It took Mark Rothko nearly half a century to arrive at this powerfully distilled image. In 1903 he was born into a successful, socially concerned, intellectual, Zionist family in one of the most respected, and least harassed, Jewish ghettos in Russia. His father was a pharmacist, a profession his two brothers would ultimately enter. Young Rothkowitz learned Hebrew, studied the Talmud, and was immersed in a religio-political nexus of thought from which he would never completely emerge. Even though he didn't attend synagogue after the twenties, he did conduct full, formal Seders in his home at Passover. In his fifties he once referred to himself as a "Bar Mitzvah boy" when he wanted to establish his Jewishness to the parent of a friend.[5] Though he despised the sentimentality which was often attached to the Jewish heritage, he was proud of his background and identified deeply with Jews.

Rothko(witz) emigrated to America in 1913 at the age of ten with his mother to join his father and elder brothers, who had arrived here earlier. They settled in Portland, Oregon, near his uncle, the sponsor of their immigration. Unfortunately his father died seven months later, and young Marcus had to work after school in his uncle's men's clothing business to help support the family. Even with that, and with lessons at a local art school occupying his spare time, he graduated with high honors in only three years. He was a devastating debater despite his only recently acquired command of English, and for a time he hoped to become a labor organizer. He listened intently to orators from the IWW (International Workers of the World, popularly known as "Wobblies") who were active in Oregon in those years organizing the lumber industry, and on one occasion he actually heard the famous anarchist Emma Goldman speak. Many years later when he'd lost all hope for

socialist reform, he claimed he was still an anarchist, adding, "What else?"

Ivy League colleges had quotas for the admission of Jews in those days, but his uncle had married into a family that had come to America in one of the mid-nineteenth century waves of immigration, and for them, attendance at Yale was already a tradition; so Rothko(witz) was given a full scholarship there for his freshman year. He lost that financial support in his sophomore year, probably because he didn't study (his friends claimed he was so brilliant he didn't need to), and paid scant attention to the professors and courses he didn't like. He left Yale without graduating, but, as his later reading shows, the subjects that fascinated him then remained with him for life. During his sophomore year he and a few friends had produced a liberal weekly publication which they called *The Yale Saturday Evening Pest.* This startlingly progressive pamphlet was highly critical of the sports-obsessed student body, which it claimed had "completely escaped all intellectual contamination." Under the newspaper's motto, "The Beginning of Doubt is the Beginning of Wisdom," Rothko and his friends insisted on their right to express their views on capitalism, socialism, the Soviet Union, immigration, and poverty. They also protested the university's requirement that students attend ecumenical chapel every day. While some Yale alumni called them "malcontents and foreign agitators" for doing so, one— Sinclair Lewis—praised their efforts. Although Rothko's enthusiasm for radical causes was dampened during the Coolidge and Hoover years, it enjoyed a renaissance during the mid-thirties when he joined the Artists Union and the American Artists Congress, and got on "The Project"— the easel division of the Works Progress Administration. Artists then, like all other workers, argued, picketed, marched, and otherwise actively engaged in the sociopolitical activities of the time. Rothko proudly claimed late in life that he'd been jailed more than once for his efforts.

Slowly but inexorably, Rothko sidled into art during his post-college years, though he later wryly claimed he had decided art was the life for him the first time he walked into a sketch class that had a nude model. He began studying at the Art Students League while working variously as a bookkeeper, a garment worker, and, strange as it may seem, an actor.[6] On a visit to his family's Portland home in 1924 he joined an acting company run by a woman named Josephine Dillon, soon to become Clark Gable's first wife. Rothko boasted in later years that Gable

had been his understudy in a play during that time.[7] He retained a love of things theatrical all his life, preferring opera to orchestral music and thinking of his paintings as dramas. "The shapes in the pictures are performers," he later said. "They have been created from the need for a group of actors who are able to move dramatically without embarrassment and execute gestures without shame."[8]

In 1929 Rothko met Adolph Gottlieb and moved with him into Milton Avery's sphere of influence. Avery painted figures and landscapes in which flat, unmodulated planes of color were silhouetted against the ground in the manner of Matisse. He was a marvelous colorist. Rothko's early work consisted of Avery-like bathers and John Marin–like seascapes. Gottlieb, Rothko, and others would often get together with Avery in the evenings, sometimes sketching or looking at one another's work, but usually just for a social time after a day alone in the studio. Sally Michel, Milton Avery's wife, also painted, as did Gottlieb's wife, Esther Dick. Sally worked as an illustrator and Esther taught school to help support their respective households. In 1932 Rothko married Edith Sachar, a costume-jewelry maker. That year she and Barnett Newman joined the Avery group on social occasions. Newman was never a regular at the group sketching sessions—a full-time job in his father's garment-manufacturing concern left him precious little time for painting. All of them would sometimes summer together in Gloucester, Massachusetts.

Avery encouraged his young friends to work out of their experience of the world around them, to work directly in watercolor or gouache, as freely and as quickly as possible. Under his influence they began to flatten their forms into outlined color areas (in the manner of Matisse) instead of modeling them in deep space. At a time when most of the painting being produced in New York seemed crowded with incident, Avery's example of extreme simplification was inspirational for his coterie. The lessons they learned in his non-school—that a few lines and even fewer hues were all that were needed to convey a figure's form and a landscape's colors—they remembered for life. The resultant paintings look vaguely like Avery's in each case, but with interesting personal differences. Rothko's watercolors (and the oils which he handled as if they were watercolors) seem perversely soft and muddy, with blurry edges and awkward, gentle distortions.

The look of Rothko's paintings had nothing of the harshness of Ger-

man Expressionism. Nevertheless, he and his fellow members of "The Ten"—a group of like-minded painters formed in 1935 to protest the conservatism of the art establishment—were considered radically Expressionist painters at that time. Some of The Ten, Rothko included, were sympathetic to aspects of abstraction and tended more in its direction as the thirties went on. His 1936–38 subway interiors are very abstract compositionally, their figurative elements reduced to near-stick figures inside rectilinear structures.[9]

During the thirties Rothko also painted dark, single-figure portraits, self-portraits, and poignant religious icons, all of which are by far the most profound works of that first full decade of his artistic life. They glow, gold behind purple, often accented by powdery blues and light-filled yellows and reds. Then, as always, Rothko's color did not depend on hard-edged primaries, but rather mood and atmosphere—evocation rather than construction and balance. Surprisingly, Rothko's overt religious subject matter wasn't Jewish but leaned toward Catholicism, if anything, perhaps because of the great art of the past which had glorified that religion. He had loved Italian primitives like Fra Angelico since his college days, when they were as much a subject of discussion as music and politics. In fact he never painted a single menorah, but he did paint at least one Madonna and Child, a Crucifixion and a Baptism, as well as several works based on the Passion of Christ. One can't help but wonder if, as a myopic Jewish boy in Dvinsk, he hadn't wandered by accident into a Russian Orthodox church one day and felt the warm-colored light on his face, seen the golden glow of the Byzantine icons on the altar, and heard the dissonant music and slow, droning incantations of the priests.

At heart Rothko was a moralist. Like his friends Barnett Newman and Clyfford Still, he spoke in absolutes, in lofty universals. "It is our function as artists to make the spectator see the world our way—not his way," he and Gottlieb stated in 1943.[10] The artist took risks to explore the unknown, the irrational world of the imagination, and then expressed the complex thoughts discovered during these explorations in simple, unequivocal shapes. By then Rothko had worked his way out of traditional figurative painting, albeit of a very personal sort, and into a much more abstract realm. Recognizable elements—faces, eyes, limbs, birds, and animals—could still be discerned, through sometimes with great difficulty, in the metaphorical abstractions of his "Greek tragedy"

paintings of the early forties. He and Adolph Gottlieb had made a delib-
erate decision to explore this new subject matter together in 1940 in the
hope that they might discover a whole new way of painting. They and
their friends had spent endless hours discussing the need to find an
escape route from both late European Cubism and the American Scene
manner, and these two artists finally found that way out. Perhaps sym-
bolically, Rothko began at this point—a major new beginning in his art
life—to use the name Rothko publicly instead of Rothkowitz.

But no matter how profoundly the ancient myths spoke to them,
Rothko and Gottlieb did not illustrate them in their paintings, but rather
attempted to parallel them evocatively. Speaking of one of his 1943
paintings which was based on a play by Aeschylus, Rothko said: "The
picture deals not with the particular anecdote, but rather with the Spirit
of Myth, which is generic to all myths at all times. It involves a pantheism
in which man, bird, beast, and tree—the known as well as the unknow-
able—merge in a single tragic idea." [11] Pale washes of color predomi-
nate in the tiered, friezelike paintings of the mid-forties. Within their
shallow, watery depths, amorphous abstractions of undersea creatures,
fossils, and mythological hybrids float and bob. Rothko's undergraduate
studies of geology and biology, his friend Barnett Newman's study of
ornithology, and a general interest among the artists in phylogeny and
ontology combined to fuel his image world at this time. The titles of
these paintings, however, were consistently literary and usually referred
to Greek myths or biblical events.

Aeschylus, Shakespeare, and Tolstoy were the authors Rothko read
and reread most often when he wasn't dipping back into Kierkegaard
or Nietzsche. He identified all their heroic subjects with the artist—with
himself as the artist—especially Kierkegaard's description of Abraham
in *Fear and Trembling,* as a "knight of infinity," a man who is capable
of making the "leap of faith," the unique act of sacrifice that goes beyond
society's ability to understand and accept. Reading a passage like the
following from Kierkegaard's slender volume, one can easily imagine
how it would have moved Rothko:

It is supposed to be the most difficult task for a dancer to leap into a
definite posture in such a way that there is not a second when he is
grasping after that posture. Perhaps no dancer can do it—that is what
the knight does. Most people live dejectedly in worldly sorrow and

joy; they are the ones who sit along the wall and do not join the dance. The knights of infinity are dancers and possess elevation. They make the movements upward, and fall down again.... But whenever they fall down they are not able to assume the posture, they vacillate an instant, and this vacillation shows that after all they are strangers in the world. This is more or less strikingly evident in proportion to the art they possess, but even the most artistic knights cannot altogether conceal this vacillation. One need not look at them when they are up in the air, but only the instant they touch or have touched the ground— then one recognizes them. But to be able to fall down in such a way that the same second it looks as if one were standing and walking, to transform the leap of life into a walk, absolutely to express the sublime in the pedestrian—that only the knight of faith can do.... To this end passion is necessary. Every movement of infinity comes about by passion, and no reflection can bring a movement about.[12]

"Absolutely to express the sublime in the pedestrian..." that is what Rothko achieved by 1950 when he finally put all of his faith into a single basic image. In doing so he took the last and most painful step away from the world as he knew it and into a world others termed abstraction. He resigned himself to the fact that a modern artist simply couldn't do what an artist could do in primitive society, where the transcendental was an experience with which all members of the community were familiar. The primitive artist was free to use recognizable elements as well as the most finely tuned abstract forms because everyone in the community spoke the language of the transcendental. They were in touch with the forces of magic which we call God. For the modern artist "the disguise must be complete," Rothko said. "The familiar identity of things has to be pulverized in order to destroy the finite associations with which our society increasingly enshrouds every aspect of our society."[13] He had already given up such specific themes of the earlier forties as *Baptism, Gethsemane,* and *The Sacrifice of Iphigenia,* paintings in which the mysterious drama being enacted was the transcendent cycle of life, death, and rebirth. By 1947 all he had left was relationships between soft-edged rectangular forms, shapes he referred to that year in the artists' review *Problems of Contemporary Art: Possibilities 1,* as "organisms with volition and a passion for self-assertion" which moved freely, anarchically about in the picture plane and which carried no

direct associations, but in which "one recognizes the principle and passion of organisms" (i.e., willful existence).[14]

As the forties came to an end, Rothko pared down these simplified, highly abstracted interactions even further. He jettisoned the following things from his paintings, one after another: titles, recognizable subject matter, objects, spatial illusion, complex formal relationships, even line and movement, to reach the utter stillness of color as light, vibration, and breath. "The magnitude of his renunciation" as curator Peter Selz later termed it, was made possible in part by the increasing distance between his and other advanced artists' work from the public. His 1947 statement in *Possibilities* was prophetic in this regard:

> The unfriendliness of society to his activity is difficult for the artist to accept. Yet this very hostility can act as a lever for true liberation. Freed from a false sense of security and community, the artist can abandon other forms of security. Both the sense of community and of security depend on the familiar. Free of them, transcendental experiences become possible.[15]

As he approached this distillation of his image world Rothko was, as always, thinking about his paintings' meaning in religious and symbolic terms, this despite the fact that he never wanted the implications of his work pinned down with specific references. He would undoubtedly have rejected the idea, for instance, that his magical, glowing rectangles of colored light—which seem so highly charged with the aura of ritual —could have anything to do with the Ark of the Covenant, the lighted holy place behind the altar in the synagogue where the precious Torah is kept protected. And yet they probably do, if from no other reason than the compelling power of his early childhood memories of Russia. Then, too, close friends feel that he wanted to be considered a great religious, spiritual artist in a world historical sense as much as he wanted to be remembered as a great modern artist. The meaning of his life's work was religious even though he no longer painted conventional religious subjects.

In his breakthrough 1950 exhibition Rothko made the ultimate reduction of his painting world to a single, stable organism, one might say, which breathed and strove, expanded and contracted, grew and decayed. But the "organism" is not resolved in the finished painting; the

viewer participates in its resolution. Many forces are in conflict within the image. The action takes place where the rectangles abut, shifting back and forth in the shallow space, nudging and pulling away from one another or invading one another's territory. Sometimes sparks seem to fly as the colors crackle against one another. Containment and measure attempt to control formlessness and dynamism; dissonance threatens harmony, darkness battles light. The viewer's active engagement in the drama going on within the painting finally brings about a conclusion in much the same way that the listener resolves a piece of music by reacting intuitively to the sequences and concordances of the notes being played.

It is important to be actually in front of a Rothko painting for it to perform its magic. Reproductions make his work look beautiful in a jewellike way, and the painterly nuances are lost in slide projections, though they are a fair substitute for the actual experience in size and transparency. Rothko formulated his thoughts on the crucial matter of scale around this time for *Interiors,* an architecture and design magazine:

> I paint very large pictures. I realize that historically the function of painting large pictures is painting something very grandiose and pompous. The reason I paint them, however—I think it applies to other painters I know—is precisely because I want to be very intimate and human. To paint a small picture is to place yourself outside your experience, to look upon an experience as a stereopticon view or with a reducing glass. However you paint the larger picture, you are in it. It isn't something you command.[16]

Standing in front of Rothko's *Number 10,* 1950, in the low-ceilinged, close and underlit space of the Betty Parsons Gallery in January 1950, where it was surrounded by its brothers and sisters in an environment the artist completely controlled, the viewer saw the painting under optimum conditions. Seeing it now in The Museum of Modern Art, where the ceilings are high, the walls washed with light, and the room filled with paintings by other people, is not nearly as conducive to its total appreciation.[17] But if you block out the surroundings and just focus into the picture for a space of time, you begin to be aware of the drama taking place within its borders. Your head is somewhere in the middle of the yellow rectangle which you sense as listing slightly to the right.

As you stare into the cool lemony light you become more and more conscious of the warm red it obliterates, especially along the lower edge. As strong as the yellow is, it is trapped by the red, which won't let it float up any farther at the top, and which seems to project in front of it along its lower edge. Only the wispy yellow drips falling over the top left corner of the white lend support to the primacy of the yellow's position. The heart of this painting, its most vulnerable place, is the invasive red on the right which threatens both the yellow and the white rectangles, and has already overcome some of the white. It nags at you like a wound that refuses to stop hurting. It spoils the "perfection" of the other rectangles. If the paler shapes are seen as representing the spirit (yellow is the spiritual color in many religions) and the pure, enlightened mind (symbolized by white), then the dark bluish red becomes the physical body we are ever struggling to transcend. The failure of yellow and white to do so registers as sadness.

In a typical Rothko, sometimes the forces of darkness win, sometimes they are fought to a standstill, and sometimes they lose. Just because bright hues dominate a painting—as they do *Number 10,* 1950—the work is not necessarily joyful. This is the case just as it is in Mozart's *The Magic Flute,* Rothko's favorite piece of music, where violence can sound melodic, desperation can be masked by bravura, and profound melancholy can be ever so sweetly expressed. Superficial listening to *The Magic Flute* gives an impression of great lyrical beauty, but a deeper appreciation reveals the tragedy lying at the heart of the opera. The Queen of the Night's dazzling coloratura passages plead with the Prince to save her daughter at one point, while later they are used to goad her daughter into patricide. The listener cannot know anything for certain but can only feel. In Rothko's mind, Mozart was the supreme tragic artist, and yet, with the exception of his *Requiem,* the colors of Mozart's music are rarely gloomy or depressing. The underlying tragedy of *The Magic Flute* is all the more profound for its sweetness. Rothko meant the same thing when he referred to even his sunniest-hued canvases as tragic. After he had found his image and began sounding out its emotional range he told a friend, "Everything I do now is different, as if I were writing *The Magic Flute*—one day Sarastro, one day Pamina, one day Queen of the Night." [18] How often Rothko said that he "became a painter because he wanted to raise painting to the level of poignancy of music and poetry."

At this mid-century point, prior to fame and fortune, but secure in the

knowledge that he had found himself as a painter, Rothko was probably at the apex of his own peculiar happiness scale—if happiness is an appropriate term with which to describe the state of mind of a man so congenitally morose. Thomas Hess had called his Parsons exhibition "this talented New Yorker's most brilliant show to date." Other critics concentrated (to his dismay) on the "sumptuous effects" of his color or bewailed his "vagueness and lack of control" over his "elephantine" canvases. One wit even said his paint handling seemed "more dubious than a cook's control of a melted cheese sandwich," but others were more sensitive, like the critic who empathized with the work and accurately observed that the paintings implied "states of being rather than modes of action or exuberance." Seven of the paintings were sold, including one that went to Mrs. John D. Rockefeller III for her new Philip Johnson–designed guest house, and another which, as we have seen, made its way into the collection of The Museum of Modern Art.

It is interesting that the word "elephantine" was used to describe Rothko's paintings when it was so often used to describe him as well. While not nearly as softly bloated in 1950 as he would be in the sixties, Rothko nevertheless had an oversized, underarticulated look. But his mustache and fringe of remaining hair were dark and his skin was not yet lined—he was as handsome as he would be in middle age. He had been divorced from his first wife, Edith Sachar, in 1945, and soon thereafter he had married Mell—Mary Alice Beistle—who was an illustrator of children's books. In 1950, their five-year-old marriage was going very well. Mell had inherited some money when her mother died a short while before, and they used it to finance their first trip to Europe later that spring. Rothko's mother also died shortly after his show closed, so the trip served as an antidote for both of their losses. Mell became pregnant with their first baby, Kathy Lynn (Kate), who was born in New York on December 30, 1950. Rothko loved to tell people that they left two and returned three. Kate was named for Rothko's mother, who had changed her name to Kate when she came to this country. Their second child, Christopher, was born thirteen years later.

In 1950 Rothko's studio was located on Manhattan's West Side within short walking distance of The Museum of Modern Art. Having been hard at work painting since 7 A.M. on a normal day, it was his habit to eat lunch at the museum—a marvelous oasis in the middle of the artless turbulence of city life—or at a nearby coffee shop, often in the company

of one or another younger artist or an old friend. He didn't tend to talk about his own work, except with artists of his own generation such as Motherwell and de Kooning, Wallace Putnam and Joseph Solman. Afternoons were customarily spent visiting galleries and other museums or dropping in at coffeehouses and meeting friends. Everyone knew Rothko in the art world because he spent so much time in it. He generally talked about current events, literature, or the theater instead of discussing art. Though he studied Matisse's *The Red Studio* in the museum almost daily for years after its acquisition in 1949, he doesn't seem to have discussed the painting with his friends.

If one had joined him for lunch the day after the Tuesday night opening of his January 1950 show, Rothko might have mentioned seeing an item in *The New York Times* about Rembrandt's *Denial of Christ* having arrived for an exhibition at Wildenstein's, and making plans to see it. Just as he later followed the Army-McCarthy hearings with intense interest, in the opening months of 1950 he would have read and talked about the Alger Hiss trial and the initial developments in Senator McCarthy's one-man war on President Truman's State Department. Though he wasn't political in the commonly accepted sense, his sympathies may well have been with Hiss. Rothko's lifelong friend, the artist Herbert Ferber, has said, "He had a mind which was exploratory and speculative, but not along the Marxist-Trotskyite political-sociological position which the *Partisan Review* and other people around *Partisan Review* were attached to."[19] Rothko's views on other matters also diverged from the norm. He loved Arthur Miller's *Death of a Salesman*,[20] which was still running on Broadway at this point, but he hated Clifford Odets's plays because of the way Odets sentimentalized poverty. Even back in the thirties he had entertained his friends with Yiddish parodies of Edna St. Vincent Millay's sentiment-ridden poetry.

Context was also of extreme importance to Rothko. Once, at the end of the forties, as he viewed an emotionally wrenching film of the Nazi death camps, Rothko claimed he didn't feel anything at all.[21] This reaction would seem to be impossible for someone who so intensely identified with the Jewish people, but he may have sensed a patronizing attitude in the film, or the situation may have placed him in the kind of forced intimacy he profoundly resented. Perhaps there was a perverse or deliberately shocking edge to his remark—something not unknown in Rothko's behavior—but most likely he did not want to expose his

emotions in the company of coolly intellectual non-Jewish acquaintances.

Intense public emotion over the plight of Jews was intolerable to him. His reaction to an incident around this time involving the famed art historian Meyer Schapiro was surprising, though typical. A young artist friend of Rothko's had attended a Schapiro lecture on the painter Chaim Soutine. Schapiro pointed out the interesting fact that Rothko, Soutine, and he himself all shared the same Russian-Jewish cultural legacy. He illustrated an amusing aspect of this legacy by citing at length a serious sociological study of the gestures Russian Jews characteristically make while talking. These gestures were different from those typical of Italians, the sociologist solemnly reported; Italian gestures are more spatial, more sculptural, while Jewish gestures are more logical, more "mathematical" in nature. Schapiro's authority went on to say that when two Italians gesture they often reduce the sweep of their arms, reining themselves in, as it were, while Jews in their zeal have been known to seize the hands of conversational opponents and use them to gesture with. Like many of Schapiro's lectures, there was a seamless flow between brilliant historical insights, keen psychological observation (in this case leavened with humor), and an acute sensitivity to the formal values of the paintings under discussion. Yet in this talk Schapiro returned again to his theme of the cultural heritage that he shared with Rothko and Soutine. It had been a wonderfully rich culture, he explained, and now, tragically, it was almost nonexistent. In Russia it had not survived Stalinist anti-Semitism and the Nazi Holocaust. The only place it might still have taken root and flourished was in the new state of Israel, but there, Schapiro said, it had been denigrated, pushed out of sight in Israel's desire to create a modern, efficient, Western-style industrial state. And in an instant Meyer Schapiro bowed his head and stopped speaking; the lecture hall was silent, but the audience knew that he was weeping. The young painter, relating this to Rothko, described the tension, the sadness, the empathy, as the silence deepened. It was minutes before Dr. Schapiro was able to master his emotion and continue. Rothko listened to the story with apparent detachment. His friend thought that he would be moved by Schapiro's obvious depth of feeling. Instead Rothko coldly responded with only three words: "He's so sentimental!"

The week Rothko's show opened, critic Howard Devree was writing in the Sunday *New York Times* art section that current art was frag-

mented and disparate. He maintained that the "Contemporary American Painting" exhibition on view at the Whitney Museum of American Art "reveals artists more or less reacting to the confusions and hopes and fears of a world in upheaval." "Beauty," Devree declared, "is relative to the needs of a generation." He added:

> One of the cases in point is Mark Rothko who is definitely in a period of transition. His big new canvases at the Betty Parsons Gallery are vibrant, even strident with color and without what we usually call subject matter. He seems to be trying to achieve a kind of fluid Mondrian effect, abandoning sharp edges and lines but keeping more or less such areas as Mondrian used geometrically. How far such a procedure can go and what goal it may reach is not yet clear.[22]

Mr. Devree missed the target. If he'd been writing about the 1949 show, he'd have hit it, but in the 1950 exhibition transition is over—Rothko had reached his goal. Instead of the relational paintings of the previous year, Rothko was now making fully resolved statements in holistic "unified fields," which just happened to parallel Einstein's latest, much-discussed ideas,[23] just as Cubism had miraculously "pictured" Einstein's theory of relativity in "four-dimensional" shifting forms forty years before. In 1910 few saw that, and at this time, too, no one could have identified this connection between science and art, not even the artists who were making it happen. Besides Rothko, Pollock and de Kooning created unified fields out of myriad small bits of visual incident, Gottlieb was beginning to unify the material he had previously distributed within the pictographic grid into monolithic images, and Newman was about to unveil the most extreme monochrome, monoform, monofield paintings ever created in American art. In fact, the holistic image or unified field has become one of the essential defining characteristics of Abstract Expressionism, along with gestural paint handling, large scale, and an improvisatory approach. But the single holistic image was not only stylistically and historically timely for Rothko—it was everything. As Kierkegaard insisted, one must have a single wish on which to concentrate one's whole life in order to make a passionate leap into the infinite. You must put all your soul's currency on one number instead of hedging your bets. The soul has to have that intensity or it will sink into the mire instead of making the leap.

With the iconic frontal paintings in the 1950 exhibition Rothko real-
ized his aim of painting *as* an experience, instead of as a picture of an
experience. He realized it so completely, or rather so perfectly, that he
didn't abandon this image for two decades, until the year before he
died. Two to four more or less soft-edged rectangular or squarish forms
were stacked on, against, or embedded in, a colored ground, which
extended around the edges of the stretcher. Sometimes the weight
seemed to be at the bottom, sometimes at the top; some were squarish
overall, a few were horizontal (particularly the ones for mural commis-
sions, which had uncharacteristic formal configurations as well), but the
overwhelming majority were vertical. Very often one horizontal edge of
a rectangle would just happen to lie across the center line of the canvas.
Whether Rothko knew it or not, this alignment gave the paintings
strength, either because of our bodily identification with it, or because
we sensed the stability of architecture from the agreement between the
artist's composition and the configuration of the stretcher upon which
it rests; in other words a congruence of image and structure. Paint was
applied in thin washes, stained into the canvas weave like watercolors
into paper. It was built up veil by transparent veil, without a final thick-
ness, so one can sometimes see what hues lie below the final layer. (At
least at the edges of forms, these layers are often clearly discernible.
Rothko, in fact, always believed that he was the inventor of "stain paint-
ing," and in a sense, he was.) He used warm colors—reds, oranges,
yellows—far more often than cool blues or greens. Over the years the
paintings got darker and darker as the color choices were reduced more
and more, until he seemed to be using only plums and browns, ma-
roons and oxblood reds. In his last works—the so-called Black paint-
ings—he reduced the number of rectangles to two, eliminated the
ground, and reduced color to shades of gray, leaving temperature
and tone to do all the work. Even his friends wondered how long he
could go on painting what they perceived as essentially the same
picture.

He felt morally able to do so because for him each picture *was* an
experience, a human experience, and there are an infinite number of
experiences to paint. Though he mentions tragedy, ecstasy, and doom
as his principal subjects, his own experience, and that of the people he
knew, included many more emotional narratives. As he told Elaine de
Kooning in 1957,

I exclude no emotion from being actual and therefore pertinent. I take the liberty to play on any string of my existence. I might, as an artist, be lyrical, grim, maudlin, humorous, tragic. I allow myself all possible latitude. Everything is grist for the mill.[24]

He called his pictures "portraits" as well as "presences." They were intended to convey the character, the emotions, the human drama of the immensely complex "inner self" in a postwar, post-Freudian time. He had said before that for him "the great achievements of the centuries in which the artist accepted the probable and the familiar as his subjects were the pictures of the single human figure—alone in a moment of utter immobility." Since the modern painter was no longer limited to depicting outward appearances, "the possibilities are endless," he said. "The whole of man's experience becomes his model."

Because he saw his work as a humanistic expression, Rothko despised references to architectural "walls of light," "windows with lowered shades," and "doorways to hell" when applied to his paintings, and yet he himself thought about others' art in similar terms. When he helped a young artist friend, Clinton Hill, write a statement for Hill's "Ladders and Windows" painting exhibition at the Zabriskie Gallery in 1955,[25] he spoke of Jacob's ladder as being "like the first thought, as it is used to climb higher and higher" and then went on to make a connection with the uses to which ladders were put by the Pueblo Indian cliff dwellers. Speaking of windows, he suggested to Hill that they were "apertures for seeing larger vistas," adding that "windows can be closed as well as open and a man must decide how many windows his facade will have." At Rothko's prompting, Hill wrote that "The question of how many windows one opens or how often one pulls down the blinds, is a decision concerning self-revelation and reticence. (It involves not only one's biography, but one's relationship to other men.) It becomes an issue of what things should be said and what should be left unsaid." While Rothko didn't exactly dictate Hill's statement, he formulated its content and phrased much of it for him. At the end Hill/Rothko states: "In most lives windows are forever curtained and levels of living are well concealed within the interior. It is the artist who now and then attempts to pull back the blinds." Since this was the way Rothko thought, and we know he worked through the night with Elaine de Kooning when she wrote her 1957 *Art News Annual* article "Two Americans in Action:

Franz Kline and Mark Rothko," it should come as no surprise that she discussed his work this way:

> He has had, since he began to paint at the age of twenty-three, numerous one-man shows, yet he continues to have an excruciating sense of privacy about his work. This sense of privacy, in a profound way, actually reaches into the painting itself. It is no accident that a painting by Rothko is a *facade,* almost as though his art were trying to hide behind itself.[26]

Indeed, Rothko was a very private man. He did not care about outward appearances or worldly possessions. During much of the fifties he wore an old overcoat that was a hand-me-down from Robert Motherwell. Though he surely could have afforded a new one, this aged and overly long coat harmonized perfectly with Rothko's generally rumpled appearance. Sometime in that decade he shaved off the mustache he'd worn since the forties, which, along with his glasses, made him look at times like a disturbingly morose Groucho Marx. He rarely laughed aloud and only chuckled silently to himself no matter how hilarious the situation. His own humor was sardonic, though not caustic, but he had a way of denigrating things without seeming to speak deliberately against them. As an artist friend remarked, Rothko was able to minimize someone's words by subtly flattening their effect. Urbane and extremely well read, he liked to remain conversant with the latest events and ideas, which he was often able to analyze with the sharpness of a lawyer. He was not a man for whom small talk came easily, though he expressed an interest in the daily events of his friends' lives. Everyone who knew him felt that he could formulate ideas and defend them with rabbinical zeal. In fact, overall, Rothko had a distinctly rabbinical mien. His bulging, burning eyes and his intense seriousness, coupled with his dark, imposing bulk, made him someone acquaintances never treated casually.

He always preferred to speak on lofty levels rather than to engage in painters' shoptalk. He didn't feel part of the brotherhood of artists on that plane—the craft of painting and its technical fine points. He often used to say that he hated to paint, that it wasn't a pleasurable activity for him. He was proud of having developed a technique of staining oil washes into the canvas, but he never seems to have thought of himself as a "fine artist" in the sense that Gottlieb, for instance, was a superb

craftsman or that de Kooning was a masterful paint handler. Rothko would also demean his own observational abilities, saying, "I'm not a visual person." Yet he was never unsure of his vision in the sense of the pictorial world he was creating in his mature work. If someone had said he was closer to being the Savonarola of painting than its Manet, he probably would have agreed. The more certain he was about the value of his vision, and the more isolated he became within that vision, the more profoundly insecure he seemed to become about his natural painterly gifts in relation to the skills of his colleagues.

This insecurity apparently extended to worries about his dealer's commitment to his work. In 1955, when Rothko was about to have his first show at the Sidney Janis Gallery, the artist Budd Hopkins encountered him along Fifty-seventh Street. Hopkins, a recent arrival "on the scene," had just been visiting the Janis Gallery and mentioned that Sidney had told him about Rothko's upcoming show. Rothko looked extremely nervous and asked with great urgency, "What did he say? What did he say?"

"Well," Hopkins answered, surprised by the sudden anxiety, "he said he was looking forward to it."

"Was he upset about it in any way?" asked Rothko.

"No," replied Hopkins. "He told me that you were going to have some very big paintings in the show, and that they would have to be taken off their stretchers and rolled because they wouldn't fit in the elevator, but that's all." Rothko was so obviously nervous about the reception of his over-large work at the gallery that it took Hopkins a while to convince him that Janis truly did not seem upset about anything. The younger artist thought of Rothko as a heroic, major figure and was astonished at his insecurity.[27]

Rothko had no patience either for niceties or felicities. The many successive studios he had were always lit by bare light bulbs, and a number of these rooms were without the natural north light that painters traditionally demand. (His spacious last studio was an exception. It had too much illumination from its skylights so he curtained them off.) In the forties and fifties his studios were often gloomy and small, and his later studios were cold and cavernous. All were austerely furnished, even when he lived in them. Plaster fell unheeded from the laths of once-white walls, and he contemplated his paintings from a hard bench or a wooden Adirondack chair. No reproductions of earlier art be-

decked his painting walls the way they normally do in artists' studios. He fed only on his own work, continually taking out older paintings to examine in the context of the new. He'd surround himself and studio visitors with huge canvases angled out from the wall like stage flats to create an environment. Since the lighting was dim and not directed at the paintings, this created a kind of magical, darkling space in the middle of which one viewed the paintings as an interrelated group. The viewer, like Rothko alone in his studio, was placed in the exact center of the artist's universe. It was the kind of studio experience that Rothko tried with rare success to reestablish in gallery and museum contexts by hanging the paintings close together and dimming the lights or directing them away from the canvases. In fact, he placed the paintings edge to edge when he began the installation of his 1961 MOMA retrospective, and only grudgingly allowed curator Dorothy Miller to hang them a few inches apart. The darker his paintings became, the more difficult they were to light by the standard museum-gallery fixtures, because less light was more effective than more light. Indirectly bounced light worked better than spots or floods, which caused glare, hot spots, and the mottling effects of a raking light. Less light maximizes the distinctions of hue and temperature, the crucial compositional elements in Rothko's late dark paintings. For these reasons, the paintings in the Rothko chapel only "work" at dusk. Friends had warned him of the intensity of Texas light, but not having experienced it himself, he could hardly have been expected to come to terms with it.

These paintings, his last major series, were for a proposed Catholic chapel in Houston, Texas, and were intended originally to represent the fourteen Stations of the Cross.[28] The interior placement of the dark, dried-blood-colored paintings was to be echoed numerically on the walls outside the chapel, the octagonal shape of which was derived from Byzantine baptistries in Torcello and Ravenna. These medieval buildings, which he greatly admired, are plain on the outside, but the interior walls are covered with gold and dark-hued glass mosaics that glow in the dim light. They are, like the Greek Orthodox theologian Theophilus's ideal House of God, "decorated with the utmost beauty," its ceilings like shining tissues, the walls an "appearance of paradise." In addition to having actually experienced such church interiors, Rothko was familiar with Theophilus's treatise *Concerning the Various Arts*. But during the years of work on the Houston chapel murals he was reread-

ing even earlier Greek patristic fathers, like Origen, who had attempted to reconcile Neoplatonism with Christianity.[29] Origen, apparently Rothko's favorite because of his "balletic" writing style, believed that the soul was holy before its union with the physical body created sinfulness, and that therefore salvation was at least within the realm of the possible. These complex theological ideas were apparently on Rothko's mind as he struggled to find the right proportions, shapes, and hues to express an increasingly dark view of life in his sixties chapel paintings. But he was undoubtedly also thinking of Søren Kierkegaard, always one of his foremost philosophical idols. Kierkegaard's words in *Either/Or* could have been Rothko's own at this point:

> The result of my life is simply nothing, a mood, a single color. My result is like the painting of the artist who was to paint a picture of the Israelites crossing the Red Sea. To this end, he painted the whole wall red, explaining that the Israelites had already crossed over, and that the Egyptians were drowned.[30]

Rothko became increasingly depressed during the sixties, largely because things were going all too well for him. "His temperament was always Russian and melancholy," according to his early dealer, Betty Parsons, and after his MOMA retrospective in 1961 he seemed to be increasingly so despite the satisfying increase in recognition and social activity in his life. By the time his son, Christopher, was born in 1963, Rothko was with the Sidney Janis Gallery and had been given a one-man show at the Venice Biennale. He had also attended a state dinner at President Kennedy's White House, executed a set of murals commissioned by Harvard University, and moved into a beautiful town house on East Ninety-fifth Street. But all of this only magnified Rothko's unease in the world. The small pleasures of everyday life still meant little or nothing to him. He was an unusual painter in that the natural landscape, flowers, visually attractive things held no interest for him. A story about a Rothko "garden" illustrates the point. His friend the poet Stanley Kunitz was fabled for his way with flowers, having created a glorious, richly varied and colorful garden at the Kunitz home in Provincetown. To everyone's surprise, Rothko one day asked the poet to design a garden for the backyard of his newly acquired Manhattan town house. In going over Kunitz's thoughtful proposals, he turned down every

shrub, one after another, and all perennials as "too fussy." Finally in exasperation Kunitz asked him what *would* he like to see back there, and after a moment's consideration Rothko replied, "Nothing. Maybe just one huge pine tree." At that point Kunitz gave up.[31]

In the mid-sixties Rothko moved into his last studio, a huge, high-ceilinged former carriage house on East Sixty-ninth Street, where he had space enough to execute his mural commission from Dominique and John de Menil for the chapel in Houston. This studio would become his home away from home when his affairs with other women and Mell's and his own heavy drinking finally destroyed their marriage. Rothko was, if anything, too successful, and success wasn't spoiling him, it was destroying him. He had a painting in every major American museum and a waiting list for pictures yet unpainted. But this didn't please him because he hated to lose his pictures and hated even more for them to live alone, one in each collection, away from their spiritual birthplace and companions. He often refused to sell paintings to people who didn't respond emotionally to them in the studio, or to institutions he didn't approve of—the Whitney Museum of American Art, for example, which he referred to as a junkpile. But the pressure to sell was enormous and had been steadily mounting since his MOMA retrospective. In the mid-sixties he signed a contract with Frank Lloyd, president of the prestigious, hard-selling Marlborough-Gerson Gallery on Fifty-seventh Street. When Rothko and Philip Guston met with Lloyd about joining the gallery, Guston, for the first time in fifteen years of friendship, saw Rothko drunk to the point of incoherence. It was a situation that had developed from agonizing over his MOMA retrospective, and which would be repeated with ever greater frequency in the final years of his life.

Starting in 1962, Pop art and Op art, minimal, lyrical, and color-field abstraction began to take over the walls of galleries and museums everywhere, and the kind of high seriousness and spirituality with which Rothko approached art-making disappeared. Many of the young abstract artists admired Rothko [32] enormously, but with the guidance of formalist critics like Clement Greenberg and Michael Fried, they tended to misread the older painter's work as decorative and contentless. In doing so they drained the life out of his form of Abstract Expressionism. Rothko visited galleries like Park Place, the first big downtown art space, in 1964 and followed the various new developments in the art world. "Those young artists are out to murder us," he told curator Sam Hunter. But to

a shipboard friend who was not involved with the art world he fleshed out what he meant by murder: "The kings die today in just the same way as they did in Frazer's *Golden Bough*."[33] And how is that? Sacrificially.

Death was uppermost in Rothko's mind from the time in 1968 when he developed an aortic aneurysm despite the success of the operation to repair the damaged blood vessel. Coming so close to death, he began to be obsessed by it. On February 25, 1970, Rothko cut open the veins of his forearms to pour his life's blood out onto the floor of his church-like studio. How else transcend the physical and achieve the spiritual like the patriarch Abraham, with whom he identified?

> With infinite resignation he has drained the cup of life's profound sadness, he knows the bliss of the infinite, he senses the pain of renouncing everything ... and yet, and yet the whole earthly form he exhibits is a new creation by virtue of the absurd. He resigned every-thing infinitely, and then he grasped everything again by virtue of the absurd.[34]

Perhaps, also, that is why Rothko left no explanatory note about his action. "Silence is so absolute," he once said.

It is no accident that Adolph Gottlieb's signature image—the Blast or Burst, which is comprised of a round, irregular mass above a roughly horizontal calligraphic unit—has the simplicity and iconic force of a typical Rothko. The two friends literally worked together to create a new kind of American painting. Their tight esthetic relationship in the early forties was the closest of any among the Abstract Expressionists, the only one, in fact, that bears comparison with Picasso's and Braque's around 1911. Together they formulated and articulated some of the basic themes that would become the hallmarks of Abstract Expressionism: mythic and primitive sources of inspiration, a freely associative ap-proach to painting, and subject matter without literal content.

Yet, despite similar backgrounds and ambitions, Rothko and Gottlieb were very different people: Rothko was morose where Gottlieb was aggressive, profound where Gottlieb was savvy. Rothko was soft-fleshed, Gottlieb lean and compact, built for action. Rothko's eyes smoldered behind smudged eyeglasses; they were the eyes of a man full of doubts and passion combined. Gottlieb's prominent nose, set in a smooth and handsome face, was like a jib sailing a straight course through troubled

waters. They complemented each other. Though their relationship didn't maintain this high a level of intensity after the forties, they remained friends for life.

In Gottlieb's Pictographs of the forties, irregular grids enclose cryptic signs and object fragments—often eyes, a nose, a handprint, a fish, a profile, or a pointing hand. These compartmentalized units are easy to recognize, but they don't cohere into a readable symbolic system. Rothko's paintings of the same period are much more amorphous, as we have seen, with only suggestions of objects, and are even more difficult to read for literal content, though both artists were working out of mythological themes. As a rule, Gottlieb's paintings have a harshness, a brutality that is lacking in Rothko's softer surfaces. Gottlieb's paint is opaque while Rothko's is transparent, heavy while Rothko's is buoyant, flaring while Rothko's smolders—but both were great colorists. They moved together out of thirties expressionist figuration through nearly a decade of compartmentalized canvases, and they developed powerful monolithic images by the fifties. Rothko (like Newman and Still) wrought infinite variations on a signature style for the rest of his life, while Gottlieb (like Motherwell) went on to develop a group of different images out of his—Unstill Lifes, Labyrinths, Imaginary Landscapes, and the Blasts and Bursts.

Being Jewish, neither Rothko nor Gottlieb escaped the direct emotional impact of the Holocaust and—like all who lived through the war and its tragic ending in mass annihilation—the dehumanization that resulted. Being committed humanists, they wanted to express their feelings about these horrors, but they chose to do so abstractly, knowing that nothing they painted could ever re-present these tragic events, nor should it. Their sublimated feelings ultimately emerged in a remarkably similar way in their basic compositions: both produced distantly abstracted equivalents of the mushroom cloud of an atomic explosion. Then, too, Rothko's late so-called Black paintings, where a single line divides the canvas into two registers with implications of dark sky above earth or sea, look a great deal like Gottlieb's Imaginary Landscapes: both are bleak post-Holocaust evocations of devastation and emptiness.

In 1950 Gottlieb opened at the Kootz Gallery a week after Rothko opened at Parsons, but his show was not the pivotal moment of complete commitment to an image that his friend's was. There is no question that Gottlieb was in a difficult position in 1950. He was forty-seven years

old and he'd been showing since the twenties. He was a "pro," as critic Thomas B. Hess put it, linked in everyone's mind with the "uptown," intellectual branch of Abstract Expressionism around moralists like Rothko and Newman, and international sophisticates like Motherwell and Tomlin. He was never part of the Cedar Tavern macho scene, even though he was probably the most streetwise, tough-minded artist in New York. He didn't drink like Pollock or talk in Kline's brilliant elliptical style. He spoke directly to the point at all times, dressed sharply, trimmed his mustache smartly, and was in every way the perfect image of the mid-century American urbanite. John Gruen, a critic very much on the scene at this time, said that "We always thought of Adolph Gottlieb as a painter apart from the art world of the fifties. He seemed so dapper, so well groomed. He just didn't seem to fit in. . . . His appearance was always that of a business man or someone totally removed from and even unsympathetic towards the dynamics of abstract expressionism."[35]

But this was not the case. Gottlieb was dead center in the movement and deeply serious about his commitment to the evolution of first-generation Abstract Expressionism. As he saw it, he and his friends faced two problems: existing as men and growth in the work. The collective social and emotional problems these artists had—being middle-aged and still not really successful, not being able to make a living from their work and having to depend on their wives' financial support[36]—ran counter to the norms of the day. The prestige of having their radical work accepted by the establishment—the museums, collectors, critics, and art historians—was still largely a tantalizing dream.

"Different times require different images," Gottlieb had said in 1947, but three years later he had still not found them, though he was getting close. He had made his first major breakthrough into the allover multiple-foci Pictographs so early—1941—that they were considered "old" by the time the rest of his generation made their personal breakthroughs at the end of the forties. Gottlieb didn't completely formulate his second signature image—the Burst or Blast—until the end of the fifties, but it is foreshadowed in the nongridded, condensed paintings of 1949–50 shown at Kootz during January 10–30. The critic Weldon Kees, also a poet and painter, who replaced Clement Greenberg as art critic at *The Nation* in the winter of 1949–50, recognized this fact with his customary acuteness. But, unlike Greenberg and some of the other

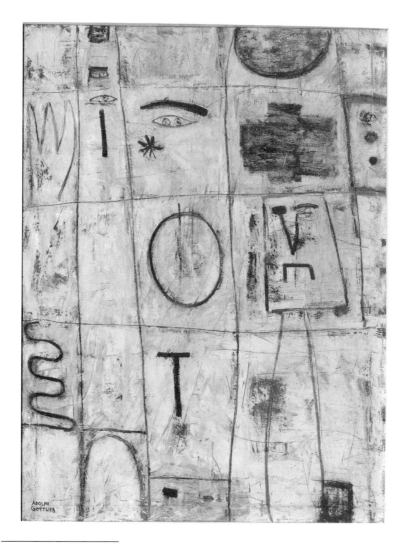

T _by Adolph Gottlieb._

critics who felt that Gottlieb's pictographic grid had long outlasted its usefulness, Kees still thought that Gottlieb "retain[ed] this formula without exhaustion."[37] One 1950 painting titled simply _T_ has the scrawled casualness of a graffiti-covered wall. The thick white paint is so scratched and smudged that even the most deliberate marks—the _T,_ an oval, eyes, a snaking line, and a squarish stick figure—seem to have been left in place by pure chance. The painting's unstudied innocence is its great sophistication. In the beautiful _Sounds at Night_ from 1948, which was included in the 1950 show, white arrows, arcs, circles, triangles, squig-

gles, Xs, and Vs disport themselves freely in a nocturnal ambience of softly modulated grays and blacks. One critic mistakenly suggested that Bradley Walker Tomlin influenced this painting[38]—and he did actually suggest its title—but, in fact, Gottlieb's freer Pictographs of the later forties, like this one, had been the major inspiration for Tomlin's work.

It is more important, however, that Kees was also aware of the major shift Gottlieb was beginning to make in his work. Kees noticed that Gottlieb's forms were breaking free of the enclosing grids and declaring their independence, calling these canvases the most striking in the show. He singled out *Ancestral Image,* 1950, as "a stunning isolated canvas of a single totemistic figure of black sand[39]—a figure that seems the sum of the pictograph's parts." [40] Indeed, the charred surface of the painting does suggest a crucible in which the separate units of the Pictographs have been fused into one powerful image. Something of a cross between a Hopi Kachina and a Chinese temple guardian, Gottlieb's *Ancestral Image* has a fire-breathing ferocity. Its pent-up explosive force will recur in the Bursts later in the decade. Critic Belle Krasne wrote of this painting that "Brought face to face with its immense, ineluctable horror, we realize how concentrated is the power of Gottlieb's totemic vocabulary." [41] This painting was often reproduced at the time, but it was destroyed in a disastrous fire in the artist's studio in 1966. (This fire on Twenty-second Street cost the lives of eleven firefighters and gutted a number of artists' studios.) *Castle,* also in the Kootz show, is equally monsterlike. The black "sand"-filled paint lends an ominous burnt look to the surface of the "body," a bull-like, looming form out of which reddish-brown "eyes" blaze. The black oval above the "castle" also seems oddly threatening. In these singular totemic images the grid is gone, and we are left wondering whether some such monsterlike personages weren't locked behind its bars all along.

In 1950 both Gottlieb and Rothko still retained the deep involvement with literature they had shared for two decades, but Gottlieb's titles had become less specifically literary (with some exceptions, such as *Castle,* a probable reference to Kafka's novel), and Rothko's paintings now were all numbered instead of titled. Rothko, as we have seen, was passionate about plays by Aeschylus and Shakespeare, and such "filmic" novelists as Tolstoy. (Tolstoy was a lifelong fixation; Rothko was reading Henri Troyat's depressing biography of the author shortly before he killed himself.) Gottlieb, on the other hand, was much more widely read, and

very interested in poetry. Their reading greatly affected the way they generally thought about their art and, especially during the forties, determined its particulars of form and content. Literature was much more a part of an artist's life in those days than it seems to be now. The painter Joseph Solman, who was one of the core members of The Ten with Rothko and Gottlieb in the thirties, relates that when he went to Oregon on a government-sponsored art education project, the first thing he did was to set up a series of poetry readings; then he organized the art classes. It's difficult to imagine a painter doing this today.

Rothko and Gottlieb were born the same year, 1903, but Gottlieb's parents were one generation away from their immigrant ancestors and were well established in the middle-class business and intellectual circles of the Bronx by the time of his birth. Like many others of his generation who were born in America, Gottlieb rejected most of what his parents stood for. He dropped out of high school at seventeen and, refusing to enter his father's stationery-supply business, took off to Europe to study art. Thus he saw historical art firsthand in the churches and museums of Europe, and modern European art in the Parisian galleries even before he went to art school. In France he spent a good deal of time in Sylvia Dietz's bookshop, a popular hangout for non-French-speaking Americans in Paris. Once back in New York and studying with John Sloan and Robert Henri at the Art Students League in the twenties, Gottlieb was at least as involved with writers as painters. In fact, he wrote poetry himself, though unfortunately none of it has survived.

Gottlieb's close friends in the early twenties were Otto Soglow, creator of the comic strip "The Little King," Alexander Borodulin, a writer and art critic who would later run for New York City comptroller on Barnett Newman's "artists' ticket," his own cousin, Cecil Hemley, a precocious young poet who became an important literary editor, and Barnett Newman, with whom he haunted the Metropolitan Museum of Art when they weren't discussing poetry. During the twenties and early thirties Newman, Hemley, and Gottlieb met weekly to read and talk about contemporary poetry and literature, particularly works by T. S. Eliot, Ezra Pound, William Carlos Williams, and James Joyce. Gottlieb's early paintings interpreted the poetry he was reading literally. A number of landscapes were based on Eliot's poems, including one that was actually entitled *The Waste Land*. That painting presented a perfect picture of the desolation in Eliot's "Unreal City under the brown fog of a

winter noon" where "the last fingers of leaf clutch and sink into the wet bank."[42]

Gottlieb's friendships with Milton Avery and Mark Rothko, both of whom he met in 1929, strengthened his interest in poetry in conjunction with painting. The three met practically daily to sketch together, to share the meals that Sally Michel, Milton's wife, would cook, and to talk about art and literature. Since Avery often painted at least one picture a day, there was always something new to look at in his studio. Avery read aloud at home nightly in those years, and so there was a literary bond among the three painters. In the eulogy Rothko delivered at Avery's memorial service, he said that "the walls were always covered with an endless and changing array of poetry and light," adding that in Avery's work "poetry penetrated to every pore of the canvas."[43] The three men worked, to some extent, within a shared esthetic style, using a common subject matter, and even worked from each other. Gottlieb sketched Rothko pretending to play Avery's studio-prop mandolin. Avery painted a portrait of Rothko with flat silvery ovals for glasses that is echoed by a very similar image in Gottlieb's *Eyes of Oedipus* years later.

In 1937, Gottlieb began to extricate himself from Avery's influence when he moved temporarily to Arizona for his wife's health. There, in addition to Averyish figures and interiors, he painted increasingly surreal still lifes of strange-looking objects he found in the desert. On his return to New York these objects found places within compartmentalized boxes located on very Surrealist beaches. In consequence his work was beginning to be considered highly abstract. "I was looking for subjective images, stemming from the subconscious," he later told critic Dorothy Seckler, "because the external world . . . had been totally explored in painting."[44] The breakthrough came early in 1940 when, as Gottlieb later explained, "Rothko and I temporarily came to an agreement on the question of subject matter."

> We embarked on a series of paintings that attempted to use mythological subject matter, preferably from Greek mythology . . . at that time a great many writers, more than painters, were absorbed in the idea of myth in relation to art . . . it seemed that if one wanted to get away from such things as the American scene or social realism and perhaps Cubism, this offered a possibility of a way out, and the hope was that given a subject matter that was different, perhaps some new approach to painting, a technical approach might also develop . . .[45]

Picking up from the writers, both men found that myth offered a concentrated image of the world and expressed "something real and existing in ourselves." In a 1943 joint radio broadcast they said that they used myths

> because they are the eternal symbols upon which we must fall back to express basic psychological ideas. They are the symbols of man's primitive fears and motivations, no matter in which land or what time, changing only in detail but never in substance. Modern psychology finds them persisting still in our dreams, our vernacular, and our art, for all the changes in the outward conditions of our life.[46]

Recapitulation theory was popular in the forties. It held that human beings recapitulate the evolutionary process psychically as well as physically during their development. Thus each person was viewed as being unconsciously in touch with the primitive self, an idea that figures importantly in the thinking of both Freud and Jung. Recapitulation theory may lie behind Rothko's and Gottlieb's statements, but their stated ideas also correspond to Ezra Pound's central concept that tradition is ever present. "All ages are contemporaneous," Pound wrote, and his poetry has elements of Greek, Latin, ancient English, and modern dialects, layered ply over ply to tell more than the age-old myths and rituals it narrates. "Make strong old dreams lest this our world lose heart"—the words Pound used to end his first book of poetry, *A Lume Spento,* and to begin his second, *Personae*—are an encapsulation of Gottlieb's Pictographs, where mythical-cultural layering is rendered graphically. Oedipus and Theseus (for Gottlieb), Antigone and Tiresias (for Rothko), are symbolically fragmented into abstract signs and placed inside the black bars of a rectilinear cage (Gottlieb) or organized into tiers (Rothko) by a dreamlike process of free association. "I was putting images into the compartments of my paintings as if I were doing automatic writing," Gottlieb later told art historian Gladys Kashdin.[47] At the time that he was still painting Pictographs he stated:

> The children of my imagination occupy the various compartments of my painting, each independent and occupying its own space. At the same time they have the proper atmosphere in which to function together in harmony and as a unified group.[48]

As did the Imagist poets, Gottlieb sought out the luminous detail and presented it without comment. The way he isolated these pictorial details within the Pictographic framework so that they resonated with meaning was exactly like the way these poets structured words. Once when Ezra Pound had an epiphanous experience of beauty in the Paris Metro stop at the Place de la Concorde—in a jostling crowd he saw one beautiful face after another within a matter of moments—he tried unsuccessfully for more than a year to put it into words. Finally, he found in haiku a highly pictorial way to express the emotions aroused by that experience:

> The apparition of these faces in the crowd;
> Petals on a wet, black bough.[49]

The kind of object that was essential to Gottlieb, Ezra Pound defined as a "thing that hath a code and not a core." Gottlieb despised nonobjective art, which he said was art about nothing, and, as he and Rothko wrote in an often-quoted 1943 letter to *The New York Times,* "there is no such thing as good art about nothing."[50] With Newman's editorial assistance, Gottlieb and Rothko were responding formally to *Times* art critic Edward Alden Jewell's admission that he was "befuddled" by their work. "The subject is crucial," they wrote, specifying "only that subject matter is *valid which is tragic and timeless,*" emphasizing this part with italics. Both painters' compacted object-images embody great complexity within simple forms, just as Imagist poetry does. Pound defined verbal Imagism as vortexes of ideas that are fused into clusters, intellectual and emotional complexes endowed with energy and directly, instantaneously presented to the viewer/reader. A perfect embodiment of Pound's concept can be found in this section of his poem "Middle-Aged":

> And so the space
> Of my still consciousness
> Is full of gilded snow . . .[51]

The impact of the painted "poetic" object-image is immediate, but its ramifications unfold in time as meaning after meaning emerges. When they were first painted, Gottlieb's Pictographs were interpreted in Jung-

ian terms, and later Freud's approach shed a different light on them. During the sixties, when a more "formalist" approach was in vogue, an attempt was made to drain them of psychological meaning. But recently these paintings have come to be seen as multileveled mythic metaphors for the wartime struggle to the death between the forces of good and evil. Titles like Gottlieb's *Expectation of Evil, The Prisoners,* or *Evil Omen* for paintings containing brutishly distorted faces and eyes trapped behind bars are now seen in the context of the mid-forties revelations of Nazi atrocities.

The forties *were* a violent time, and as Robert Motherwell says, "we are a violent race . . . so any American movement which established a very strong identity would have this quality."[52] Gottlieb (like Rothko), basing his paintings on violent myths and Greek tragedies, felt such content was demanded by the times. "Today, when our aspirations have been reduced to a desperate attempt to escape from evil, and times are out of joint," he wrote in the forties, "our obsessive, subterranean and pictographic images are the expression of the neurosis which is our reality."[53] As they had previously explained in their 1943 letter to *The Times* when they put forth their ideas about the contemporary relevance of ancient myths for the first time, Gottlieb's painting *The Rape of Persephone* "is a poetic expression of the essence of the myth; the presentation of the concept of seed and its earth with all its brutal implications; the impact of elemental truth." And they asked, "Would you have us present this abstract concept, with all its complicated feelings, by means of a boy and girl lightly tripping?"[54]

In 1950 Gottlieb was condensing his ideas into simpler, more powerful images, the most hieratic and iconic of which would later evolve into the upright Burst or Blast images that are generally divided into two parts across an imaginary horizon line. We can follow the progress of his thinking in the foreword he wrote for the catalogue of Arshile Gorky's March 1950 exhibition at Sam Kootz's gallery. As so often happens when one artist writes about another, the writer reveals more about his or her own work than about the subject under discussion. Speaking of Gorky's welding of abstraction and Surrealism, Gottlieb said, "Out of these opposites something new could emerge. . . . What he felt, I suppose, was a sense of polarity, not of dichotomy; that opposites could exist simultaneously within a body, within a painting or within an entire art."[55] Gottlieb himself soon reduced his image world to what is essen-

tially a two-part structure. "The most extreme thing I could think of doing at that time was to divide the canvas in half," he said later about his *Imaginary Landscapes.*[56] Such a horizontal division into two parts inevitably carries sea as well as landscape implications.[57] In fact, this division may have roots in one aspect of his life away from art.

Adolph Gottlieb was an obsessed racing sailor. He had begun to spend his summers in Provincetown, Massachusetts, in the mid-forties, painting during low tide and sailing at high. (In the late fifties he bought a house in East Hampton on Long Island, a location much closer to New York, which enabled him to get in even more sailing time.) By all reports he was a ruthless racer, determined to win and usually doing so, a captain who ran his hapless crew like Ahab in sight of the great white whale. Gottlieb never had children, though his wife, Esther, very much wanted them, and he didn't teach regularly or need to support himself outside the studio. As a result, painting and sailing were his two major activities. Spending so much time on the sea, aware only of his boat and

Adolph Gottlieb in his Provincetown studio during the summer of 1949, when Forum 49 took place. (Photo by Maurice Berezov)

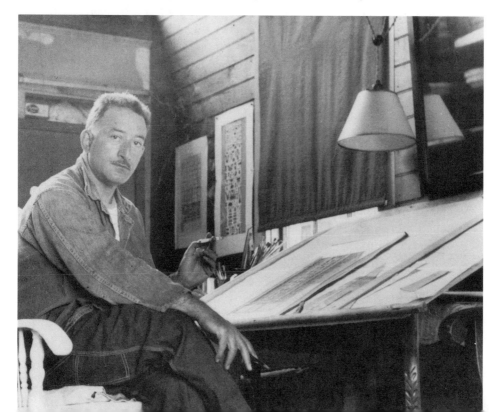

the horizon—the sea beneath him in all its active complexity and the sky above with its luminous isolated sun and clouds—had to have had a profound effect on his painting. Even though he denied this, insisting that his were imaginary landscapes, Gottlieb's own description of this group of paintings recalls the sea: "My intention was to divide the canvas roughly into two areas and in the lower part I would have some active, linear winds or shapes working . . . and then in the upper part I would have roughly round or oval shapes which would be completely separate and floating.[58]

Gottlieb handled paint with the kind of supreme assurance that in sailing made him so admired by the other owners of Lightning sailboats in the Provincetown races. He could place a unit with pinpoint accuracy on exactly the right spot, swell a shape here, tauten it there, just as if he were trimming a sail to eliminate the slight sag or wrinkle that would cost him the winning yard or two in a race. Gottlieb's color had pinpoint accuracy too. Daring in a Matissean way—and often, like that master, employing pink to great advantage—Gottlieb's colorism rarely involved primaries. He used earth colors to strong effect, frequently red-browns, oranges, and rich greens, hues with a hard, clear directness and specificity. This toughness separates his way of handling color from Rothko's atmospheric moodiness, though both were influenced by Matisse and Matisse's American acolyte, Milton Avery. Gottlieb also differs from Rothko in his frequent and vigorous use of blacks. A number of paintings in his 1950 Kootz show were, in fact, largely comprised of blacks. His blacks are wartime and postwar blacks—carbonized and dense in ways that make the viewer think of charred wood and bones.

The kind of distillation one associates with Imagist poetry is quintessentialized in Gottlieb's post-1950 paintings. The three canons of Imagism—direct treatment of the object, exclusion of all inessentials, and a free, unprogrammed musicality—find no more perfect expression than in Gottlieb's Blasts and Bursts. He focused ever more intently on coexisting opposites: open shapes and sealed-off sections; jagged and smoothly rounded forms; color and black, whether applied in washes or thickly saturated; molded shape or brusque, impetuous gesture; the ethereal and the density of mass; implosion and explosion—all of which seem symbolic of reason versus brute force. He wrought variations on this theme until his death in 1973.

Oscillating between figural and land or seascape implications, Gott-

lieb's Burst image is a blood brother both to Rothko's tiered-rectangle and to Newman's vertical-band signature images. All have the power of icons [59] because of their upright posture, their holistic compression, and their drastic simplification. They share a hieratic frontality which gives them a commanding aura, not unlike the mental picture we all have of an atomic explosion. "We are for the simple expression of complex thought," they wrote in their 1943 letter—and what more complex thought can there be than the atomic bomb in all of its ramifications? Gottlieb's Blast image comes closest to pictures of actual nuclear explosions, but Rothko's stacked units are very like the rolling "clouds of fire" that observers noted, and Newman's vertical bands, trembling along their edges, are readily likened to the "giant pillar of purple fire" viewers saw.

Science writer William Laurence was an eyewitness to the second bombing, that of Nagasaki on August 6, 1947, which was carried out by a B-29 named, ironically, *The Great Artiste*. In his description of the event Laurence made a comparison which would have fascinated Gottlieb, Newman, and Rothko because of their profound involvement with the primitive:

> At one stage of its evolution, the entity assumed the form of a giant square totem pole with its base about three miles long, tapering off to about a mile at the top. Its bottom was brown, its center was amber, its top white. But it was a living totem pole, carved with many grotesque masks grimacing at the earth.[60]

All three artists had, by 1950, worked their way through the realms of the primitive and the mythological and reached a point of such extreme distillation that their abstract imagery encompassed everything from totem poles to modern technology.

FEBRUARY

Five years after war's end, the threat posed by the atomic bomb had if anything only worsened. The Russians had exploded their own atomic bomb, and on February 1, 1950, by way of response and with the full support of Congress, President Truman ordered production of the even deadlier hydrogen bomb for U.S. "security" pending a nuclear arms treaty. The February 27 issue of *Life* was the second in the magazine's series on the hydrogen bomb, the danger of war, and our ability to withstand it. A photograph of an atomic explosion was on the cover, and an ad in that issue indicated "good bomb immunity" could be purchased in the form of a house in the country. Both the physiological and the psychological effects of the nuclear peril were, as this shows, less than clear-cut. Artists' feelings about the nuclear peril at that point were probably well articulated by Weldon Kees, himself a painter, in his first piece for this influential weekly:

> . . . art is not a weapon. . . . The man who looks at a painting and inquires about the political opinions of the artist may be an idiot or merely tiresome; he is totally unconcerned with the nature of painting. As painters we have no concern with politics; as men we are in the midst of them. Our world entails a vast individual schizophrenia . . .[1]

Because his politics was no politics—anarchism—Barnett Newman may well have been the least schizophrenic of the artists. Being very open to creative, metaphorical layering, he could make a natural con-

nection between the death-dealing nuclear fission of the bomb and the explosive "big bang" of creation itself. Newman was obsessed with the mystery of creation and had tried throughout the forties to symbolize it in a variety of biomorphic abstractions. It is surely no coincidence that not long after the A-bomb was dropped, he found the way to express the moment of creation in a flash of light that passed straight through the canvas, energizing it but leaving it otherwise inviolate. Newman's mature image was a "zip"—as he termed it—of color-light shooting up through the painting field. One can view this "zip" as a fusion of two metaphors—the modern "pillar of purple fire" that *New York Times* correspondent William Laurence described as zooming skyward out of a nuclear explosion "like a meteor coming from the earth instead of from outer space"[2] and the ancient biblical Pillar of Fire. The Old Testament associates the fire pillar with a cloud in much the same way as did the observer of the modern nuclear explosion, but the benevolent biblical Pillar of Fire and Cloud guided the Israelites through the desert and symbolizes the mystery of divine revelation. Newman had the kind of mind that was able to pull all this together into a single compelling image.

Barnett Newman developed his first vertical "zip" in *Onement,* a small 1948 canvas twenty-seven inches high by sixteen inches wide, covered evenly with dark mahogany red and bisected vertically by a flame-edged strip of cadmium red. This painting was the talisman to which he would return for inspiration from then on. No more condensed and luminous expression of his complex thoughts was possible. Recognizing that, Newman painted vertical "zips" through all but a few of his canvases from then until his death in 1971. (He experimented with a horizontal orientation for the "zip" in 1949, but soon abandoned it, probably because of its inevitable landscape implications.) Using the "zip," he said, "I feel that I activated the whole area as a field of life."[3] Whether loosely painted or hard-edged, colored, black or white, single or multiple, symmetrically placed or not—the "zip" was always there. It *was* Newman.

Newman was a "new" man in 1950, in the sense that few people in the art world of which he'd been an active part for two decades knew what his work looked like. He revealed himself in the guise of this "zip" image for the first time in his January 23–February 11 exhibition at the gallery of his friend Betty Parsons, the art dealer. She had insisted on the exhibition, saying, "It's the middle of the century, Barney, you have

to show."[4] Newman had been reluctant, finding it painful even to have his paintings displayed in her office. Perhaps he was also worried about the reception his work would receive. Few of his pre-*Onement* paintings and drawings were particularly interesting or daring, but the works in this, his first one-man show, were like nothing anyone would have seen before. They had the authority, the large scale and the powerfully distilled quality which the group of advanced artists to which he belonged in the forties had tried so hard to achieve, but they were even more radically austere and uncompromising than the paintings of Rothko, Gottlieb, and Still. The largest painting in the show, *Be,* was an eight-by-seven-foot solid expanse of intense red split down the middle by a thin white band. Its symmetry was blatant at a time when Mondrian's relational asymmetry dominated Constructivism. In *Abraham,* an all-black painting, the symmetry was hidden—the right edge of a wide, glossy black vertical band was located midway across the matte-black canvas—but it would be sensed by the viewer and was therefore radically post-Mondrian. The painting was so named to honor his recently deceased father, as well as to make reference to the biblical Abraham who was prepared to make the ultimate sacrifice for his God. Both the implications of this and his other titles and the drastic condensations in his work should have made Newman a hero among the most advanced artists of the day, but instead, the opposite happened. He was either ignored or ridiculed.

In his review of the show, Thomas Hess (not a fan of Newman's then, though he later made a 180-degree turn in the artist's direction) said that the average viewer would find nothing of interest in the show. "Newman is out to shock," he wrote, "but he is not out to shock the bourgeoisie—that has already been done. He likes to shock other artists."[5] And that is precisely what happened. His closest friends somehow either failed to understand what he was doing in the work or if, like Mark Rothko, they did understand, found it extremely disturbing. According to Annalee Newman, Barnett's wife, "Mark got very nervous after the show. He realized that Barney had found himself."[6] The very artists for whom Newman had written catalogue introductions, organized exhibitions, and reworded "manifestos" on which he naturally thought they all agreed—those very colleagues walked silently out of his first show shaking their heads. His old friends—, Still, Rothko, and Gottlieb—kept their thoughts to themselves, except for Motherwell who

reportedly said at the opening, "Barney, I thought you were one of us, but I see you are making a critique against us all."

This treatment was especially painful for Newman, who knew how important it still was in 1950 to stick together. The advanced artists saw themselves as a small embattled group struggling to stay afloat in a vast sea of indifference, and when one of their number was under attack in the press or by word of mouth, the others usually leaped to his or her defense. Certainly "Barney" could always be counted on to do so, even protesting *The New York Times*'s failure to review Clyfford Still's show later that spring. Ironically, the sole voice raised on Newman's behalf when his work was shown was that of *New York Times* art critic Aline Louchheim.[7] She "made the mistake" of actually talking to Newman about his work in the gallery and then going home to write her review while the memory of what he said was still fresh. While mindful that many viewers would probably "jeer mercilessly" at Newman's paintings, she found the work had "an undeniable attraction" for her—"vibrancy, mood, impact, wholly direct and visually induced." In her remark "Newman believes that line intensely concentrated upon can become a pure means of conveying emotion," she revealed the artist's intentions. Unlike conservative critic Judith Kaye Reed, who called the work "an intellectual game instead of an adventure in communication,"[8] Louchheim said it was "serious work which does evoke a genuine response." "Space as such is not defined," she wrote understandingly, "it is as if the colored surface were simply part of a continuum in which the sharp or wavering line exists as an emotive element. . . ."

Sculptors Philip Pavia and Tony Smith were among the few artists who stuck by Newman, and Jackson Pollock—unlikely though it may seem—became a friend. Pollock spent a long time studying Newman's new work before committing himself, but he was a strong supporter after that. (It was mainly Pollock's encouragement that convinced Newman to include his first sculpture in the second show he had at Parsons the following year, which Pollock helped him hang.) But for the most part, the downtown Cedar bar set had never considered Newman an artist in the first place. Jack Tworkov spoke for many painters when he described Barney as a "kibitzer"—that is, an observer, talker, and gadfly rather than an active participant. Willem de Kooning and Philip Guston were in the gallery for Newman's opening at the same time. "We left together in total silence," Guston told his daughter, Musa, "down the

elevator and through to the street. More silence. Then, after a coffee, he [de Kooning] said, 'Well, now we don't have to think about *that* anymore' "[9]

But just because they didn't think much of his paintings didn't mean these artists suddenly lost their affection for Barney. Perhaps in part because the show coincided with Newman's birthday, an after-opening party was quickly improvised at Philip Pavia's bailiwick, the Artists Club on Eighth Street. Sculptor Peter Grippe ran around the place putting tapes down every rectangular surface to mock the work, while Mercedes Matter and Elaine de Kooning, two young painters, mischievously decorated card tables with stripes of white tape or green feathers and propped them against the wall. It was all done in fun, with high spirits. Ironically recapitulating the Douanier Rousseau at his banquet, Newman, with tears in his eyes, thanked the artists for the dubious honor thus bestowed on him.[10]

"The Club," as it was called by everyone, was the only place an advanced artist in New York could always find the companionship of like minds. It was born at the close of 1949, the offspring of other, more public situations and places—restaurant-bars like Romany Marie's, the Cedar, and the San Remo, or coffee sources in various Village cafeterias, the most popular of which were the two Stewart's, Riker's on University Place at Eighth Street, and the Waldorf on Eighth Street at Sixth Avenue. Willem de Kooning, one of the Artists Club's founders, said he had had something like it in mind for years:

> We always wanted not exactly to start a club but to have a loft.... The Greeks and Italians each have their own social clubs along Eighth Avenue. We didn't want to have anything to do with art. We just wanted to get a loft, instead of sitting in those god-damned cafeterias. One night we decided to do it—we got up twenty charter members who each gave ten dollars and found a place on Eighth Street. We would go there at night, have coffee, a few drinks, chew the rag. We tried but couldn't get a name, so we called it The Club.[11]

The original members who rented the fifth floor loft at Thirty-nine East Eighth Street for their gathering place included sculptors Philip Pavia, Peter Grippe, Ibram Lassaw and James Rosati, painters Philip Guston and Franz Kline, Bill and Elaine de Kooning, Giorgio Cavallon,

Nicholas Marsicano, Mercedes Matter, Milton Resnick, Ad Reinhardt, and Jack Tworkov. Some of the painters had come from Hans Hofmann's school of Cubo-Fauvism; some worked in the AAA (American Abstract Artists) carefully constructed, Mondrianesque manner, others had recently become involved with the new painterly expressionism. Since none of these esthetic positions agreed with the others, there was no artistic agenda, no name on the door, and no paintings on the walls. Other charter members were art critic Harold Rosenberg and art dealers Charles Egan and Leo Castelli. Originally each member had a key, and meetings or group discussions were called spontaneously. When regular lectures and demonstrations, panels, and even symposia began to be organized, the members kept Wednesday nights for their in-house, free-for-all discussions. The Artists Club ultimately proved too popular, and by 1955 membership had to be limited to one hundred and fifty. Verbal battles were scathing to the point of insult and fistfights broke out on numerous occasions, particularly later in the fifties. But in the early days of The Club, Jack Tworkov, like many of the artists, was positively thrilled with it:

> The Club is a phenomenon. . . . I'm consciously happy when I'm there. I enjoy the talk, the enthusiasm, the laughter. . . . There is a strong sense of identification. I say to myself these are the people I love, that I love to be with. Here I understand everybody, however inarticulate they are. Here I forgive everyone their vices, and I'm learning to admire their virtues.[12]

Newman 's friend Philip Pavia was the self-appointed majordomo of The Club from the beginning, which was why Barney's birthday party was held there. After 1955, when Philip stepped down, others organized the events and kept the records until its demise in 1962. Approximately two hundred and fifty panels and events were held in all, including "evenings with" and parties for famous established artists like Alexander Calder, Marino Marini, and Max Ernst, and the poet Dylan Thomas. Talks were given by such well-known intellectuals as Hannah Arendt, Joseph Campbell, Paul Goodman, William Barrett, and Lionel Abel. Famous Japanese painters gave demonstrations of their sumi ink technique, Frederick Kiesler and Peter Blake spoke on architecture, Edgar Varese and John Cage on music. From the beginning, what the members dis-

cussed among themselves, for the most part, *was* themselves as they continually attempted to define the new art they were bringing into existence.[13] "The New York artist had learned to trust himself," art historian Robert Goldwater observed at the time. "He had learned to live with and rely upon his own kind."

> The consciousness of being on the frontier, of being ahead rather than behind, of having absolutely no models however immediate or illustrious, of being entirely and completely on one's own—this was a new and heady atmosphere.[14]

Barnett Newman, however, had crossed that frontier with the Parsons show his friends had celebrated hilariously at The Club. Because his work was so extreme that even the very artists with whom he had developed the ideas behind it were unable to go far along his path with him, Newman's work soon bore the brunt of numerous attempts at art world humor. A joke went around The Club and the Cedar during the ensuing years: Barney closed the elevator doors, Rothko pulled the shades, and Reinhardt, whose paintings were ultimately all black, turned out the lights. But the most famous story told and retold about Newman's severely simplified works originated with Franz Kline at the Cedar Tavern. A collector came up to Kline spouting with indignation at the show he had just seen.

> "There was nothing there! Absolutely nothing there! How simple can a painter be and still think he can get away with it?"
>
> Kline, who'd seen the show, asked, laughing, "Nothing there? In any of the pictures? How many were there?"
>
> "A dozen maybe, all the same. Nothing in any of them but one stripe down the middle."
>
> "Oh?," asked Kline. "All the same size?"
>
> "Well, no. Different sizes. Some sort of small, others huge, but all so damned simple."
>
> "Oh. Were they all the same color?" Kline asked.
>
> "No. Some were red, different reds. One was yellow, another green, I think, but there was really nothing there. All the color was put on flat like house paint."
>
> "Oh. Were the stripes all the same color and the same width?"

"Well, let's see," the man said. "No, some were real narrow and straight-edged, some were messy, and there were some that were almost a foot wide."

"And they were all vertical?"

"Uh, no. Some of the pictures were horizontal, not vertical, but all the stripes were vertical . . . no. One went horizontally, I think."

"Were the stripes darker than the backgrounds?"

"Well, yes, I guess so. Most of the stripes were darker, but sometimes they were lighter and some were white or other colors. Sometimes they were on the edges, so they weren't actually stripes . . . but it was just nothing, it was just all so damned simple."

"Well, I don't know," Kline interrupted. "It sure sounds complicated as hell to me." [15]

Kline's own work was moving toward greater austerity of means, so Newman's show might actually have struck a responsive chord in him, which he would naturally have hidden from his friends in the Cedar. His indirect defense of Newman's paintings was also simply the defense of an artist, any artist—even Newman—against a philistine.

How had Newman, in his first exhibition, achieved such a general rejection? How had someone who believed that "the first man was an artist"—an idealist who ran for mayor of New York in 1933 on an artists' ticket of his own devising—suffer such a generally disastrous response to his work that Aline Louchheim's review would be just about the only positive note sounded until the end of the fifties? Newman placed most of the blame on the fact that he had refused to go on the WPA during the thirties. "I paid a severe price for not being on the project with the other guys; in their eyes I wasn't a painter; I didn't have the label," [16] he said later. But it was more than that. His rampant individualism was one reason he remained an artist somewhat apart from his colleagues, even when he was working beside them. He was never an adherent to any established faction, dogma, or orthodoxy, preferring to work alone in open-ended situations. Newman was an active, highly vocal intellectual anarchist and had been one since the twenties, when he taught himself Yiddish in order to read the only anarchist newspaper then available in New York City. [17] He believed fervently in the primacy of the individual and the absolute necessity for personal freedom.

Newman rejected all political solutions right and left, Marxist or mon-

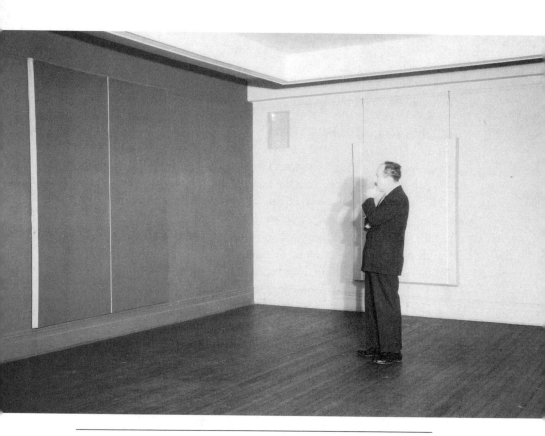

Barnett Newman in his 1950 Parsons Gallery exhibition, demonstrating the ideal viewing distance for appreciating his paintings. (Photo by Aaron Siskind)

archist, socialist or capitalist. (To be pro-art was his only politics.) Rothko agreed with him that anarchism was the only political possibility, but unlike Rothko, Newman carried his concept of freedom into every corner of his life. He refused to be drafted because killing under orders would violate his freedom to choose whom he wanted to kill. When a discussion with Harold Rosenberg and Robert Motherwell turned to politics, Newman pointed to a small yellow canvas of his that had been in his 1950 exhibition and said, "You know, *that* painting means the end of the capitalistic system!" He meant it. He intended his paintings to affect people directly by giving them a sense of their own individual existence, their presence in the world, and their autonomous—free— power. He even went so far as to put up a sign in the 1950 show to tell viewers to stand close to the work so it would surround them, giving them a sense of their own importance. It read: "There is a tendency to

look at large pictures from a distance. The large pictures in this exhibition are intended to be seen from a short distance."[18] The title of the largest painting in the show, *Be,* has both anarchistic and religious meaning. It can be read as a command to the viewer to simply "be," but it also implies that no one, no institution, no law can ultimately control a free human being—a person simply be-ing.

Apart from the emphasis on anarchism, Barnett Newman's background was not very different from that of Adolph Gottlieb. He was born in Manhattan in 1905, just two years after Gottlieb—to Jewish parents in the garment business. But unlike Gottlieb, who was committed full time to painting before he even left high school, Newman had gone to CCNY for a liberal arts education and took art classes only at night at the Art Students League. After graduation in 1927, he let his father, Abraham Newman, talk him into joining his clothing manufacturing firm for a few years to get enough money ahead to be able comfortably to devote himself to art, but the stock market crash in 1929 effectively put an end to that plan. Instead of going bankrupt, he and his father fought their way toward solvency for the next eight Depression years until his father's heart attack in 1937 freed Newman to liquidate the company at last. In addition to the business, Newman was a substitute art teacher in high schools between 1931 and 1939, and he studied botany, geology, and ornithology on his own.

In 1933 Newman ran for mayor of New York on an artists' ticket—his formal, if contradictory, expression of anarchism in politics—against Fiorello La Guardia. It was a futile effort, but he was determined that art should have a more important place in daily life. Among the demands in his "Program for Cultural Life" were clean air and water, municipal art galleries and concert halls, extensive free public education in art and music as well as other areas, automobile-free parks with inexpensive casinos,[19] playgrounds, sidewalk cafés, and facilities for restriction-free public forums. His commitment to anarchism runs through his entire program. "The artist is free," he explained to A. J. Liebling, when that renowned reporter covered Newman's mayoral campaign for the *New York World-Telegram.* "He doesn't belong in a government of expediency. Only a society entirely composed of artists would be really worth living in."[20]

Newman married schoolteacher Annalee Greenhouse in 1933, and they spent their honeymoon in Concord, Massachusetts, exploring Tho-

reau's haunts such as Walden Pond, Emerson's and Hawthorne's homes, and Bronson Alcott's utopian community. These New Englanders, with whose writings he was completely familiar by then, are to the revolutionary tradition in nineteenth century America what Peter Kropotkin and Alexander Herzen are to anarchism in nineteenth century Russia. Herzen's fiery writing style and Kropotkin's passionate and radical humanism, in which the individual is of transcendent importance, both found their way into Newman's personal philosophy and rhetorical style and remained there for life. In fact, in the late sixties, not long before he died, he convinced a publisher who wanted to put out a book of Newman's own collected writings to publish those of Kropotkin instead. He wrote a preface for the book, *Memoirs of a Revolutionist,* which he thought of as a handbook for the young radicals of the time with whose struggle for personal freedom he identified.

During the thirties Newman apparently painted in whatever spare time he had left from all those endeavors, though now there is no physical evidence to prove it. His early paintings were figurative, with silhouetted areas of flat color applied with a felt-tipped pastel pen (Hockney-like, he later claimed), and he destroyed them all either upon completion or later on. His friends Gottlieb and Rothko were struggling, too, during these years, but Newman kept saying the task was hopeless, that they should all give it up. He did just that by 1939, while they went on to discover a way into a whole new image world by working together. He took part in their activities more in word than in deed, as we have seen. Newman didn't resume making marks on paper or canvas until at least 1944, and didn't start painting in earnest until two years after that. His most productive period fell between his breakthrough in *Onement* and his disastrous second show at the Betty Parsons Gallery in 1951. From Newman's whole lifetime as an artist a mere eighty-three drawings remain and only one hundred and ten canvases, or about four a year on average. He stopped painting altogether in 1956, 1957, and 1959. Compared to the thousand-plus-item catalogue raisonné of Jackson Pollock's work and to de Kooning's prodigious production—compared to that of any artist of his time, in fact—Newman's output was minuscule. Is it any wonder, then, that he was called a "genial theoretician" by Tom Hess and a "homespun esthetician" by critic Belle Krasne when he first began showing?

Physically, Newman didn't look like anyone's image of an artist either.

By mid-century he had finely tuned his appearance. Impeccably garbed, snappily mustachioed, a monocle dangling from a black ribbon around his neck, and a boater or a fedora planted jauntily on his head, he looked positively debonair. He used his knowledge of haberdashery and fabrics to dress well—even in the studio. Then, too, Newman was extremely articulate. None of the Abstract Expressionists made more public statements, wrote more letters to the editor, introductions to catalogues, and manifestolike broadsides than Newman. Even Mother-well, who did more editing, wrote less. In fact, Newman was such a good talker that Motherwell would use him to loosen up the speakers for the Friday night sessions of the Subjects of the Artists School in 1949. (This artist-run, radically unusual art school had begun operation in the fall of 1948 with Motherwell, Rothko, and William Baziotes among the teachers, and ended with the spring 1949 semester.[21]) "They were always so nervous," Motherwell recalled recently, "and 'good ol' Barney,' the artist's friend, would put them at ease with his talk and his jokes. No one took him seriously. He was a born entertainer with a storyteller's enthusiasm."[22] According to Motherwell, one of Newman's favorite stories was the one about a Jewish Robinson Crusoe. Shipwrecked on an uninhabited island, he built out of driftwood and palm fronds an entire Main Street U.S.A. replete with a drugstore, a dry cleaner's, and a synagogue. Then he decided the opposite side of the street also needed a synagogue and built one there too. When his rescuers come to save him, he showed them Main Street and proudly pointed out his synagogue. Asked whom the other temple was for, he answered in a very deprecating tone, "It's for all the others!" The way Newman told the joke implied that the man was expressing the idea that he was special—for Newman, the emphasis was always on the individual.

Newman intended the direct confrontation with his work to make the viewer aware of his or her autonomy as a free individual. The esthetic experience was meant to be liberating, transcendent, even sublime. "The sublime is now," he wrote in the 1948 publication The *Tiger's Eye,* a short-lived journal of contemporary art.

> . . . here in America, some of us, free from the weight of European culture, are finding the answer, by completely denying that art has any concern with the problem of beauty and where to find it. . . . We are reasserting man's natural desire for the exalted, for a concern with our

relationship to the absolute emotions. . . . We are freeing ourselves of the impediments of memory, association, nostalgia, legend, myth, or what have you, that have been the devices of Western European painting. Instead of making *cathedrals* out of Christ, man or "life," we are making it [sic] out of ourselves, out of our own real feelings. The image we produce is the self-evident one of revelation, real and concrete, that can be understood by anyone who will look at it without the nostalgic glasses of history.[23]

Be was painted a year later, after he and his wife, Annalee, spent their 1949 summer vacation in the Indian mound country of eastern America. Giant earthworks in the forms of geometric shapes or animals remain intact there since the Adena culture of the first wave of trans-Siberian migration across North America. Newman later described the experience: "I was confounded by the absoluteness of the sensation, [the mounds'] self-evident simplicity . . . a sense of place, a holy place. Looking at the site you feel, Here I am, *here* . . . [and outside of this place] there is chaos, nature, rivers, landscapes . . . but here you get the sense of your own presence. . . . I became involved with the idea of making the viewer present: the idea that 'Man is Present.' "[24] This trip apparently only confirmed Newman's previous commitment to the anarchistic concept of individual primacy.

Be, 1949, is the essence of *esse*—being. A white "zip" passing down the center line from top to bottom. No frames bound the canvas to trap the red expanses or the white line. The "zip" divides the painting in half, declares the space, but does not separate it into two parts. Instead it fuses them into a seamed whole, in much the same way that a zipper does with fabric. The "zip" is simultaneously in front of, behind, and co-planar with the red it inflects. It is both there and not there; the red expanse is both whole and halved. The "zip" is an anthropomorphic thing with which we identify—erect, straight, firm, and sure. We exist in the painting as it, it exists in the world as us. (It may be helpful here to imagine the congruence of a tall, knife-thin Giacometti figure and a Newman "zip.") In fact, as if to stress this association of body and painted line, Newman extracted the "zip" from the painting field and presented it as pictorially and sculpturally sufficient in itself when he created a spearlike canvas he titled *The Wild,* an eight-foot-high painting that was only one and a half inches wide, and *Here I,* his first sculpture

—two physicalized eight-foot "zips," one rough-edged plaster on wood, the other a smooth milled board painted white, set in plaster on a wooden milk crate.

Both of these 1950 works were included, at Jackson Pollock's urging, in Newman's 1951 exhibition at Parsons. They were apparently inspired, along with a coppery orange 1950 canvas titled *Tundra,* by a movie Newman and Pollock saw together in 1950, *The Valley of the Eagles.* Thinking they were going to see a humorous British thriller, they were overwhelmed by the visual effects in this strange movie about a Swedish scientist chasing the thieves of his research data across the bleak and

Be I *by Barnett Newman.*

treeless dreamlike arctic landscape. Set in the golden orange land of the midnight sun, the film featured Laplanders encased in furs, riding across endless waves of snow on reindeer, hunting with eagles on their wrists instead of falcons, and carrying the lances with which they killed their prey. The effect of the film on both artists was apparently profound.[25]

Be was the largest painting Newman could make in his old Nineteenth Street studio. He had to walk it out the door and back in again when he wanted to turn it. This 1949 painting is now titled *Be I,* since there is a *Be II,* painted in 1961 and reworked in 1964. *Be I* (which was, for a time, apparently called *Resurrection*) was exhibited at the end of Newman's later fourteen *Stations of the Cross* as the fifteenth canvas signifying the event following the Crucifixion and Entombment. The first canvas he worked on in the new, larger studio he began to occupy in the summer of 1950 was *Vir Heroicus Sublimis*—heroic, sublime man. It remains one of the masterpieces of Abstract Expressionism. And again, the social context is extremely interesting.

In 1950 artists and intellectuals were still viewed as heroes, as were ordinary people who did great deeds—during World War II, for instance. In the popular realm, war films like *Battleground,* about the tragic Battle of the Bulge, and *Twelve O'Clock High,* with Gregory Peck playing the role of a tight-lipped heroic airman, had immense appeal, and books about the war were still best-sellers. On February 26, two weeks after Newman's show closed at the Betty Parsons Gallery, John Hersey's *The Wall,* a book about heroism and hope among doomed people who refused to die in the Warsaw ghetto, was given a rave review in *The New York Times,* which was also serializing sections of Winston Churchill's memoirs of the war years. *The Titan,* a newly released documentary film about Michelangelo's life and art, was highly successful, and *Life* had recently published "The Dark Wine of Genius," a long picture essay on the life of Maurice Utrillo. In it, R. Coughlan, the author, described Utrillo as "a debauched alcoholic, obsessed with his strange mother, [who] has painted some of the most serenely lovely pictures of the modern era."[26] Another, more complex vision of the artist-hero was published in this country at this time as well—Englishman Joyce Cary's *The Horse's Mouth.* The painter Gulley Jimson is portrayed as an anarchistic bohemian with an "unquenchable delight in life itself" who "didn't give a hoot for security, society, respectability, custom or law,"[27] according to *New York Times* critic Orville Prescott. In a review pub-

lished two days after Newman's opening, Prescott wrote that Jimson was majestically defiant of convention, convinced of his genius, and superbly devoted to his artistic vision—all qualities Newman would have valued. Whether or not he identified with the hero's comedic aspects, Newman undoubtedly appreciated the rest of Jimson's anarchic personality. He would have loved Gulley's statement, quoted by Prescott, "The only satisfactory form of communication is the good picture. Neither true nor false, but created."

Vir Heroicus Sublimis was shown with the radical white-on-white canvases *The Voice,* 1950, and *The Name II,* also from 1950, and the extracted "zips" in both painted and sculpted form. This was arguably the most radical exhibition of abstraction ever seen in New York and this time the public was as shocked as the critics and artists. It was such a disaster—most of his artist friends didn't even bother to show up for the opening and the press was universally hostile—that he removed his paintings from the gallery and vowed to cease exhibiting. Until 1955 Annalee supported herself and her husband by teaching while Barney painted a few pictures a year. Having turned fifty, he then decided he had to start earning the family income. He came up with a betting system for the racetracks, which worked for a while, he pawned their jewelry and unneeded equipment such as his bird-watching binoculars, and in a final act of renunciation he decided to give up painting and work as a tailor. Annalee vetoed that idea. They moved to a cheaper apartment in Brooklyn. Newman painted one painting in 1955, none in 1956 or 1957. That last, bleak year he suffered a heart attack which performed "instant psychoanalysis" for him, he later said, and after a long recuperation, he began to paint again. Significantly, given his close brush with death and his long purgatorial rejection by the art world, he began work with the series of stark black-and-white canvases which he ultimately named *The Stations of the Cross.* (The series' alternate title is *Lema Sabachthani,* Christ's unanswerable question to his Father, "Why hast thou forsaken me?")

Although Newman hadn't been very religiously active after childhood, and even though he despised traditional mysticism per se, he was, like Rothko, thoroughly conversant with the writings of the Jewish mystics. He frequently consulted books on the Kabbala by Gershom Scholem and Rabbi Herbert Weiner. Typical of Newman, who would never conform to any single view of anything, he enjoyed the illuminations he

gained even if they were contradictory. The art critic Harold Rosenberg, who was a good friend, believed that "Newman's enthusiasm for Jewish mystics and their sayings was a matter of poetic delight in their eloquent symbolism . . . rather than a matter of religious or philosophical solidarity." He felt they gave his work "a kind of metaphysical hum."[28] Besides providing pleasure, Newman's readings contributed additional layers of meaning to his paintings which can be excavated through his titles: *Cathedra, White Fire, Black Fire, Uriel,* and *Covenant,* among others.

According to Motherwell, Newman visited his mother daily while she lived; the rest of his life he went to synagogue twice a year on the anniversaries of his parents' deaths, said the Kaddish, the prayer for the dead, and gave the temple its symbolic payment of eighteen dollars. The number 18 is *heth yud* in Hebrew, which equals *chai;* it means life, and it brings good luck. The eighteen-foot *Vir Heroicus Sublimis* is only one of many of Newman's paintings that incorporate the number 18 in their dimensions, either simply or in multiples, in feet or in inches. In his last studio he covered the walls with nine-inch-square linoleum tiles to have eighteen-inch dimensions visually available at all times. In terms of religious commitment he made a walk-through sculpture, *Tsim Tsum,* which expressed the tension of the moment of creation, and he even went so far as draw plans and make a model for a (never built) synagogue, an act of reverence Rothko touched upon in his paintings for the Houston chapel.

Once he recovered from his heart attack, Newman's life and work began, by fits and starts, to improve. Younger artists started to flock around him after his 1958 Bennington College retrospective when he used the opportunity to remount the radical work that had been included in his 1950–51 exhibitions. When the Bennington show was reinstalled in New York at French and Company, his peers slowly began to accept Barney's innovative importance as well. Though he never again hit the 1949–50 peak rate of creativity, he worked steadily from 1960 until his death ten years later, creating many large major paintings and a few sculptures. One of the most powerful of these, *Broken Obelisk,* stands in a pool outside the Rothko chapel in Houston, and is acknowledged by nearly every critic as a masterpiece. Inspired by his youthful hookey-playing trips to the Metropolitan Museum and Cleopatra's Needle, the famous obelisk on the hill behind the museum, Newman in-

verted the point so that it touched tips with a pyramidal base. The point of their touching, drastically minimized in terms of its physical size, creates the kind of drama Michelangelo intended for God's moment of sparking life into Adam on the Sistine ceiling.

Some people have difficulty seeing Newman as an Abstract Expressionist because of the marginal role that gesture and facture (the physical character of the painting surface) play in much of his work. Except when a "zip" is demonstrably freely painted, Newman's work *seems* exactingly executed, even premeditated, a notion which he vigorously denied:

> My concern is with the fullness that comes from emotion, not with its initial explosion, or its emotional fallout, or the glow of its expenditure.[29] The fact is, I am an intuitive painter, a direct painter. I have never worked from sketches, never planned a painting, never "thought out" a painting. I start each painting as if I had never painted before. I present no dogma, no system, no demonstrations. I have no formal solutions. I have no interest in the "finished" painting. I work only out of high passion.[30]

His heart was Expressionist, if not his hand.[31] He believed he was as spontaneous as any of his peers, creating only when he felt a pressure to give an idea physical form—not just to paint more Newmans—and working directly on the canvas using everything he knew about the technique of painting to achieve luminosity or density, consistency or variegation, in his color areas.

Newman built up his surfaces out of layer upon layer of pigment (not in washes of thinned paint like Rothko or transparent glazes like Baziotes) and was extremely concerned with getting the exact color intensities he sought, the right amount of blueness or redness. "More blue," he said, updating Matisse, "is bluer than less blue." For Newman, color was quantifiable, not ineffable; solid, not evanescent. However abstruse his thoughts, he was a materialist concerned with the effect of his work here and now, and spontaneity was as crucial to him, whether it seemed that way to others, as it was to Pollock or to Kline. Spontaneity was one of the key concepts of anarchism, the free play of human impulses being the only way to release the natural forces within the human being. True harmony could only occur, he believed, when these

forces were unfettered by rules and restrictions. Then humanity could be as intrinsically harmonious as nature itself. Newman's rejection of classification is stated in his witty and deservedly famous epigram: "Esthetics is for the artist like ornithology is for the birds."

Abstract Expressionism was like a mansion with many rooms, each occupied by an artist of a different temperament. Newman's ultrasimplification, his radical rejection of traditional Western art and its methods, placed him in a wing far to the north with doors that opened onto the future. The consequences of his artistic actions, ridiculed in 1950 and for most of the decade, weren't felt until the sixties, when they were not only accepted but revered. At the farthest remove—in the south wing—was William Baziotes, whose quasi-figurative paintings were tied most closely to traditional art in an Old Master sense. The compositional complexity, literary implications, and exquisite technical mastery of Baziotes's work linked it firmly to the past. The consequences of his artistic actions (in loosening rationality's hold on painting through the use of Surrealist procedures of psychic automatism) were highly praised in the forties and fifties, but largely forgotten by the sixties. Esthetics, which meant everything to Baziotes, was "for the birds" by then.

William Baziotes's paintings have a surface calm that bears comparison with Newman's minimally articulated paintings, but this calm is like a skin pulled taut to cover seething passions. Often described as a poet-painter, Baziotes loved French poetry and found repeated inspiration in Baudelaire and the Symbolists. His first artist friends were among the French Surrealists and the Americans around Peggy Guggenheim, such as Robert Motherwell, who were likewise deeply influenced by Symbolist poetry. Flowers *and* evil. Baudelaire's stars were the "fires of fancy that shine brightly only in the deep mourning of the night"; his poor child's toy, a living rat in a cage. Image after image in the Frenchman's poetry finds an echo in Baziotes's paintings. Like Newman, and like William Laurence, the writer whose description of the Nagasaki bombing for the *Times* was so pictorially gorgeous, William Baziotes could readily see the beauty within the horror; he was well aware of such disturbing conjunctions. He once wrote:

> My work is like the Caribbean—
> Above the Blue Sky and below the Blue Water—
> beneath the Sharks.[32]

Moon Animal, a 1950 painting, is typically deceptive in its lyrical, becalmed appearance. An undulating flow of lines defines the poignant bird-seal creature afloat in a phosphorescent sea of moonlight. But its haunted eye is echoed by the moon, which is a circle at the center of a radiating web of lines. The moon is thus a trap which has transfixed the creature in its glow, ensnared it with its ghostly brilliance. A psychological mix of desire and dread is expressed in the painting, a contradictory emotional state which has parallels in the work of some of Baziotes's peers. Unlike theirs, however, the look of Baziotes's paintings is smoothly finished and classically calm—without even the energy of the "zips" cutting across Newman's canvases or the quivering, throbbing palpitations of Rothko's rectangles. Baziotes's work is not impassioned in execution, but in its imaging. He expressed his deeply internalized emotions in disturbingly subversive ways.

The period around 1950 was probably the time when Baziotes's paintings exhibited the most focused and emotional expression of his dual obsession with horror and beauty. Earlier in the forties, his paintings had been couched in the language of either Cubism or Surrealism—or both—and before that, in the late thirties, his subjects had been the more classical ones—nudes and sad clowns in the tradition of Watteau's *Gilles* and Picasso's Blue Period *saltimbanques.* After this mid-century period and until his death in 1963, Baziotes's paintings came to seem quite serene and carried land-and seascape overtones. This later work has an elegiac sinuousness and is painted much more smoothly than the rougher, more aggressive chimerical monsters of 1947–52. When The Museum of Modern Art acquired a 1947 work with the unsettling title of *Dwarf,* Baziotes told the director, Alfred Barr, that "it expresses a quiet horror and an overall sensuous feeling."[33] He added that he used to own a book of pictures of horribly maimed soldiers from World War I, and he kept returning to one particular image of a "basket baby," an armless man amputated at the hips, which he drew over and over. In painting *Dwarf,* however, he exploited the sensuousness of the anatomical suggestions of a woman's body that he found in the image. He said, "I try to paint every inch as though it were the flesh of a woman." The eye and its sister shape below, a female sexual symbol, suggested targets in their concentricity. "An ice pick flying through the air and landing into a target is a picture that flashes across my mind when I am in a highly excited and optimistic state about my work," he explained. In

The Mummy *by William Baziotes*.

Dwarf the eye was also meant to be lizardlike and, with the crocodile teeth, to connote prehistoric creatures and a deadly kind of passivity, as well, perhaps, as a perverse ludicrousness.

The Mummy, Moon Animal, Dying Bird, and *Dragon* were among the subject titles in his 1950 Kootz Gallery exhibition, February 7–27. Typically Baziotes's creatures are hybrids, humanoid, animal, piscatorial, vegetal, and sculptural all at once. The *Dragon* is like an imaginary Aztec sculpture of a serpent-dog, while the *The Mummy* resembles a seal. *Moon Animal* could be a manifestation of the dread goddess Baudelaire described in "The Moon's Favors"—Baziotes's favorite prose-poem—as "downily descending her stairway of cloud" and pervading "the whole room like a phosphoric atmosphere, like a luminous poison," while she "grasped your throat so tenderly that you have wanted to weep ever since."[34] Weldon Kees, a poet and painter as well as an art critic, was impressed by Baziotes's ability to share "soul states" with literature without being literary. In his review of Baziotes's show at Kootz, Kees

wrote that Baziotes achieved this consonance with poetry because "his work is saturated with scene, situation, movement, atmosphere, weather."[35]

Like Baudelaire's poetry, Baziotes's multiform images carry dual, often opposed, connotations. They can seem both frightening and laughable, magisterial and absurd, tragic and silly. His friend, sculptor David Hare, wrote of him that all his jokes and stories about himself were told with a "sense of the inherently ridiculous in the role of a human being. The immutability of situation which traps man, making him lovable and ridiculous, not because of who he is, but because of where he is, fascinated him. Under his humor was an awareness that this was not the best of all possible worlds."[36]

An incessant awareness of the dark side of life haunted Baziotes after a fire destroyed his father's Greek restaurant on Thanksgiving Day in 1919. A relatively well-off seven-year-old boy in Reading, Pennsylvania, was turned by this tragedy into a scrabbling street urchin. Literally overnight the family residence shifted across the tracks to the wrong side, and instead of playing hide-and-seek with neatly attired children in park-like front yards, he was pitching pennies against tenement walls and betting on mumblety-peg[37] with hard-boiled slum kids. Running errands for gamblers and prostitutes, he soon knew his way through the city's sleazy streets. Baziotes came to admire the superstitious Greek gamblers he knew in Reading. In later years he loved to tell his friends how these fierce men attended church only once a year on Easter when gambling was permitted as part of the ritual reenactment of the Crucifixion. Betting was always heavy then, and at midnight, Christ's eternal life assured, they shot off their revolvers in furious and deafening jubilation. He admired these gamblers' belief in the sensuality of that kind of moment and their constant questioning of what the Fates held in store for them with the next throw of the dice, both literally and figuratively. His own strong belief in fate's role in human affairs extended into his artmaking as he anxiously searched his canvases for clues in the chance marks he found there as to what direction he should take for the next moves of his brush.

Sensuality and violence were always coupled for Baziotes. As a young man living in Reading after being expelled from high school, he did *very* odd jobs during the day, one of which may have been as a lookout against revenue agents and rival gangsters for Dutch Schultz's trucks—

or so he told his friend the painter Jimmy Ernst.[38] He also pored over books for and about women, read detective novels, and studied art on his own. At night he boxed in order to calm down. His wife, Ethel, later said he was the most tense person she ever met. He smoked three packs of cigarettes a day from the age of nine without ever relieving that tension. (When she met him in 1940 his skin was already pale gray and he coughed heavily. She thinks he always knew smoking so much was probably going to kill him—which it ultimately did.) Nor did frequenting bars do much to calm his nerves, probably because he preferred the toughest, seediest dives. His appearance and mannerisms—particularly the smooth and sophisticated way he handled his cigarette—led friends and strangers alike to compare him to Humphrey Bogart or George Raft. He had a "somber and quizzical mien, [like] that of a truck driver intent on the road,"[39] wrote Jimmy Ernst, and a defiant, stiff-necked, chin-up posture with one hand tucked in his overcoat pocket as though it held a gun always at the ready. Motherwell said Baziotes wasn't actually like Humphrey Bogart, but he was exactly that vivid: at the mention of either man's name, "a whole vision of his face, his movement, his cigarette, his tone of voice comes right up."[40]

Baziotes was not a man to whom his colleagues ever became extremely close. He treasured his privacy, his daily routine, and his idyllic relationship with his lovely dark-haired and delicate wife. They were an inseparable couple, "Philemon and Baucis lovers," according to Thomas Hess, "one bone and one flesh," in Jimmy Ernst's eyes. She decorated their home with wonderful antique and exotic objects: an angel from a medieval choir screen, a Persian miniature, a worn wooden toy horse, bison horns, reproductions of Velázquez and Titian, an astrolabe, a photograph of Proust. Formal ideas taken from these objects constantly found their way into Baziotes's paintings. Motherwell, one of the few artists allowed into their fifth floor walk-up apartment-studio, said "the whole apartment was like a dream of the real inner life that he really didn't want anyone to know."[41] Baziotes was also not a man to be told what to do. Motherwell made that mistake when he presumed to advise Baziotes about which Surrealists he ought to keep as friends. "For God's sake, abandon the second-raters,"[42] he wrote, handing over a personal list. According to Baziotes's wife, he never responded one way or the other to this unwelcome bit of advice, but their relationship cooled noticeably thereafter. Baziotes was opposed to careerism of any kind,

feeling that an artist's only important battles were waged in the studio, and that posterity's evaluation counted more than that of the present generation. He prophesied in 1945 that by 1950 art and artists would become much more public, destroying the sanctity of the studio, and he wanted no part of it.[43]

Sir Winston Churchill, an amateur painter, was quoted in the February 12 *New York Times* as follows: "Painting a picture is like fighting a battle."[44] His observation would certainly have applied to Baziotes's terrible struggles with his art. As far as Baziotes was concerned, facing the canvas alone in one's studio was like facing an opponent in a boxing ring. It took an entire morning's preparation consisting of a lengthy, three-newspaper breakfast, a period of warm-up drawing, and a session of meditation to induce a trancelike state of total concentration before he was ready to enter the studio. There he usually had a dozen or so unfinished paintings to choose to work on, depending on his mood. "Today it's possible to paint one canvas with the calmness of an ancient Greek, and the next with the anxiety of a Van Gogh. . . . Some speak, some do not," he wrote. "They are my mirrors. They tell me what I'm like at the moment."[45] This process of interaction with the canvas, this give and take between the creator and the object being created, sounds very much like Harold Rosenberg's description of action painting as a drama in which the artist-actor lives out the dramatic action on the stage of the canvas. It also recalls Pollock's comment: "When I am *in* my painting [it] has a life of its own. I try to let it come through. It is only when I lose contact with the painting that the result is a mess."[46]

Like Pollock, Baziotes was acutely aware of the risk he was taking with every move toward the canvas. Each one was a gamble that he wouldn't destroy something valuable already there by adding something new that didn't belong. Twenty-five or thirty paintings might have been on a canvas and then partially or completely rubbed off before a final painting came into life. He kept applying colors and shapes more-or-less automatically until a subject suggested itself and the background was set for some kind of dramatic action. "Once I sense the suggestion, it becomes a phantom that must be caught and made real," he told interviewer Donald Paneth in 1952. "If it goes alright, I feel relieved. If it goes wrong, I feel terrified."[47] When it went "wrong" a few days in a row, he'd be in a very bad state, depressed, argumentative, and insomniac. Should his finances also be in bad shape at the time, the added

stress would cause him to suffer the physical indignity of prolonged periods of vomiting as well.[48] His constitution wasn't strong, and it was further weakened by episodes of uncontrollable coughing. The daily bout in the studio took its toll. A couple of hours a day was all he could manage. When Baudelaire discussed his own esthetic experience in his "Artist's Confiteor," he said that "energy in voluptuousness creates uneasiness and actual pain." Baziotes, well aware of the "pain" part of a painter's life, must have loved the poet's subsequent words: "The study of beauty is a duel in which the artist shrieks with terror before being overcome."[49]

Weldon Kees ended his review of Baziotes's 1950 exhibition by noting the artist's "remoteness from fashion and distraction." This seems an odd thing to say given Baziotes's relatively high stature in the art world at that time because he had forged a bridge between European Modernism and Abstract Expressionism. What Kees meant was that even though these canvases were among the most loosely painted and disturbing of Baziotes's life, their sensual surfaces and serpentine shapes were painted primarily to give esthetic pleasure, and that was not an aim shared by many of Baziotes's peers. Then, too, Baziotes rejected success that was measured in terms of patrons and sales, museum shows, and acceptance within a group. Like Newman, Baziotes paid a price for keeping his distance. Over time, the conservative nature of Baziotes's approach to painting and the objectlike silhouettes he created seemed less and less like Abstract Expressionism. He went into a kind of artistic limbo.

The period around mid-century produced artists who led dramatic lives and to whom history has assigned huge reputations based upon large and impressive bodies of work. Others, like Baziotes, are not now so famous, though they were major figures at the time. History hasn't treated them quite fairly for various reasons—early death, not doing their best work during the years the spotlight was on, veering away from the dominant trend, or not presenting a consistent, comprehensible image to the public. The latter situation was epitomized by Weldon Kees, who thought of himself and was thought of by others as "the most versatile artist now working in America."[50] His paintings look a good deal like those of Baziotes, and he was sympathetic to the Surrealist side of the New York style. He liked its literary aspects and its psychic energy. Linear rhythms crisscross his textured surfaces in a musically measured

manner not unlike that of Miró. But Kees was also a functioning poet, novelist, and literary critic, which diffused his reputation. So much so, in fact, that even though he was one of the signatories to "The Irascibles' " famous letter denouncing the Metropolitan Museum's policies on contemporary art, few ever notice his absence from the group photo of the protesters published by *Life*.

But Weldon Kees's combination of talents made him particularly sympathetic to the most advanced art of his time. Recently published collections of Kees's writings demonstrate his interesting, subtle mind. Unlike many of the other regular reviewers, Kees recognized and praised those painters who were producing at a high level, a level that far exceeded "the gray, empty, static cultural situation" around them. He had called this "new school of abstractionists" original and serious in *The Nation* on January 7 and "truly *international,*" but he noted that "the demand for their work is infinitesimal. A hypothetical gallery that depended solely on the sales of the works of the nine or ten best known advanced painters would do well to show the profits of a neighborhood candy store." Sales were so rare, he said, that one almost had to "agree with Herbert Read when he asserted that cabinet painting [for the private delectation of the connoisseur] has lost all economic and social justification." "From an economic standpoint," Kees went on to say, "the activities of our advanced painters must be regarded as either heroic, mad or compulsive. . . . One is continually astounded that art persists at all in the face of so much indifference, failure, and isolation."[51] Along with Elaine de Kooning, Thomas Hess, Eugene Goossen, Meyer Schapiro, and Robert Goldwater, Kees was one of the few art critics to see the intellectual and emotional depth of the advanced art he reviewed. Harold Rosenberg tended to focus on art's role in society, and Clement Greenberg, the formalist critic who had been an active force for the new American painting during the forties—primarily because of his strong support of Pollock—had temporarily shifted to writing about Old Masters and European artists in his columns for *Partisan Review*.

Unfortunately, most of the critical minds being brought to bear on the developments in contemporary art at mid-century were not of such high caliber as Kees's and these others. Judith Kaye Reed's reaction to the 1950 Whitney Annual, that perennial barometer of the nation's art climate, which was on view from December 1949 to February 1950, demonstrates the common run of critical thinking among the regular

reviewers. The Whitney Museum of American Art had started as a club in sculptor Gertrude Vanderbilt's Greenwich Village studio. Hence it was always supportive of American artists and was the one Manhattan viewing space in which many of them could count on exhibiting their work. The 1950 Annual included some of the most advanced new art along with the entire range of already accepted alternative styles. Reed's reaction to it was typical in its conservatism. She recognized that a new type of abstraction had been crowned "king" by the Whitney—an "abstraction of form and ideas that no longer have any identification with a familiar world"—and she bemoaned a lack of content in this new art by Gottlieb, Baziotes, Motherwell, Pollock, Tomlin, and Rothko. She deemed their work emotionally nonobjective, nihilistic, confused, and empty, and found their vague and arbitrary, indifferently applied forms "incredible as fare offered for aesthetic contemplation." [52] What she did approve of in the Whitney's selection was the kind of work most of the art-interested public preferred, namely thirties-style painting: Robert Gwathmey's hyperstylized picture of a black woman sowing grain, Anton Refregier's dull-witted children playing on a cellar stairway, and Karl Knaths's Cubistically rendered Provincetown clam diggers. With a nod to the by then comfortable, mildly surrealistic, and expressionistic figurative styles of the forties, she praised conservative portraits by Raphael Soyer and Henry Varnum Poor, saying they are "both sober works, high in integrity and substantial achievement of mood and characterization."

Weldon Kees's level of sophistication, like that of the artists he praised, was undeniably higher. He always seemed wiser and more mature than his years, perhaps because of his Brian Donleavy mustache and "I've seen it all" savoir faire. The painter Fritz Bultman's wife, Jeanne, remembers Kees as "a very attractive young man with that bright, smart humor, a kind of black mischief, that was so appealing then." [53] The winter of 1949–50 was a particularly rough one for Kees. He and his wife, Ann, spent six weeks trying to turn a Lower East Side factory loft on Stanton Street into a habitable studio and gave up without fully succeeding. Kees's last book of collected poems, *The Fall of the Magicians,* had done well, but the proposal for his next one had been firmly and brusquely turned down by two publishers. He'd also been rejected yet again for a Guggenheim fellowship. Kees's painting style reflected those of Baziotes, Motherwell, and Hofmann, and he showed at the Peridot Gallery along with Philip Guston and James Brooks. (This

gallery was then located in Greenwich Village, a radical move which was a harbinger of things to come in the fifties with the Tenth Street scene.) Painting seemed to be the only part of Kees's life that was going right at this point, but he wasn't making a living at it (nothing sold in his November 1949 show). Even though he claimed his pieces for *The Nation* hung over him "like so many vultures," at least he got thirty-five dollars for each. Long periods of near-freezing cold due to a faulty heater made painting difficult and added to his recurrent cycles of depression.

The current situation in the world of literature only added to his gloom. T. S. Eliot's poetry had been a mainstay of existence when Kees was young, but an evening at a performance of Eliot's *The Cocktail Party* (which opened on January 29) depressed him enormously. "A sorry affair," he called it, "appallingly amateurish and redolent of corn."[54] Ezra Pound, the other great poet formerly revered by Kees's generation, had been incarcerated in St. Elizabeth's Hospital, near Washington, D.C., as mentally incapable of standing trial for treason as a result of his activities on behalf of Italian Fascism. Kees visited him around this time with the poet Elizabeth Bishop, and Pound seemed pleased when *The Cocktail Party* was not praised by his visitors. Kees found the experience to be "like visiting a museum." Then, too, Ernest Hemingway seemed to be losing his eloquent, laconic touch. *Across the River and Into the Trees,* which was published in 1950, seemed so much a cliché of Hemingway's cool, snappy repartee style that it engendered a wry retitling as "Across the River and into Harry's Bar."

Nineteen fifty was Kees's last year in New York. In the fall he traded in the 1938 Plymouth he had bought the year before from Mark Rothko (the interior of which he said looked like "an unmade bed in a Bowery fleabag") for a 1946 Lincoln and "escaped" to San Francisco from that "dark and dreadful place"—New York. There his passion for jazz took over his creative and critical life. He had looked forward to starting all over again, but five years later, in 1955, he abandoned his car by the Golden Gate Bridge and was never seen again—apparently a suicide.

When Kees reviewed Baziotes's and Fritz Bultman's February 1950 shows in *The Nation* on February 4, he demonstrated his unique openness both to Surrealism and to the highly structured, fusion modernism of Paris-trained Hans Hofmann. For Hofmann, Matisse and Picasso, Mondrian and Kandinsky, were of relatively equal importance as he mixed them together in the stew of his own paintings. Kees was in Hofmann's

Pythagorean *by George McNeil.*

circle in Provincetown and New York, along with Bultman and George McNeil, both of whom studied with Hofmann. McNeil is one of the survivors of the movement still painting vigorously today, but he changed into a semiabstract figurative mode long ago. The paintings in his 1950 exhibition at the Egan Gallery, February 6–25, however, were both abstract and expressionist, and characterized by a "painterly touch" which the *Art News* reviewer remarked seemed to be common to all the painters in the Egan stable.[55] In his paintings of 1950, looping, brightly hued forms thickly brushed onto the surface are locked into solid rectilinear structures; the whole is comprised of vigorously interactive parts. As always, his color had an expressionist fervor marked by clamorous yellows and clashing reds and greens.

Fritz Bultman's "darkly brooding totemic abstraction," as reviewer Belle Krasne described it, was as marked by aggressive painterly touch and rigorous structure as McNeil's work. Krasne said Bultman's paint-

ings had a "blood on the moon fierceness that strikes at the heart with plunging spears of juicy red on splaying black and white." [56]

In his review of Bultman's Hugo Gallery show (January 30–February 19), Kees wrote that Bultman was one of the "more significant advanced artists in this country." [57] There were fourteen largely black-and-white paintings in the exhibition, some more tightly constructed than others. Black bars on roughly scumbled white areas and white shapes on triangular black planes are interspersed with some curvilinear forms and patches of gray within eccentric geometrical structures. Dark and spectral *Orbes,* 1950, though, is all circles and arcs, thickly encrusted with paint. Bultman's paint surfaces seem aggressively applied and have a harsh, uningratiating quality. Most of the critics concentrated on the violent energy in the work, one citing it for overconfidence, while another worried about how long Bultman could sustain this fever pitch.

Orbes *by Fritz Bultman.*

Weldon Kees very astutely predicted Bultman's future involvement with sculpture when he described the work as "concerned with massive sculptural forms and employing few colors and relatively few basic shapes." Bultman built up his surfaces with sand and then brusquely gouged them out, using tools associated more with sculpture than with painting.

Decades later, not very long before Bultman's death in 1986, Robert Motherwell remarked that Fritz Bultman was the most underrated senior artist in America. Bultman had a long and productive career as a painter, sculptor, collagist, and draftsman, but this kind of versatility worked against him as it had against Weldon Kees. Bultman's huge free-form collages are without doubt among the finest works ever produced in the medium, and his sculpture from the seventies makes a powerful, if delayed, contribution to Abstract Expressionism in three dimensions. He was a brilliant, complex man of unpredictable behavior. As an example, shortly after making this much-praised debut as a painter in 1950, he left for Italy on a grant to study bronze casting and began working in that medium as well.

Born in 1919 in The House of Bultman, a New Orleans funeral establishment, he was raised in a lush and languidly eccentric atmosphere. (The two-story glass-enclosed tropical forest made famous by Tennessee Williams in *Suddenly Last Summer* was part of the family compound. Williams, a close friend of Bultman's, wrote the play after a visit there.) Bultman studied informally with Morris Graves in New Orleans, and then, at the age of sixteen, he set off for Germany to study at the Bauhaus with Hans Hofmann and Walter Gropius—only to find that the famous institution had been closed by the Nazis.[58] Bultman stayed on in Germany for a while, boarding with Hans Hofmann's wife, Miz, beginning a friendship that lasted all their lives. It was typical of Bultman, for whom the unusual was the norm, that one day while he was in Germany hiking in the mountains with other students, he ran into the American Nazi Putzie Hofstaengle, Hitler's informal emissary to Americans abroad. Hofstaengle insisted that Bultman and his young friends come to Berchtesgaden, where a few days later they shook hands with a stolid and staring Adolf Hitler.

Back in this country in 1937, and unhappy with the transplanted Bauhaus as it was set up in Chicago by Laszlo Moholy-Nagy and Alexander Archipenko, Bultman decided to study with Hofmann in New York and

Provincetown. By 1941 he was painting on his own, but, instead of becoming an active participant in the New York art scene as one might have expected, he moved to the tiny fishing village of Provincetown in 1945 with his wife, Jeanne, a former exotic dancer, to raise a family. His friend Tony Smith, later to become famous as a sculptor, but then an architect, designed and helped him build a studio there in the shape of a roughly pentagonal solid. The cultural high point of Bultman's six-year sojourn in Provincetown undoubtedly was a forum which he helped organize with Weldon Kees, Cecil Hemley, and Adolph Gottlieb in the summer of 1949. Known as "Forum 49," it occasioned an intense period of working together in a common cause punctuated by violent arguments. Ultimately, Forum 49 consisted of a large art exhibition, panel discussions (forums) on art, literature, psychiatry, and politics, a talk by Dwight MacDonald on "The Dream World of Soviet Bureaucracy," lec-

Fritz Bultman around 1950 in his Provincetown studio designed by Tony Smith. (Photo by Maurice Berezov)

tures on architecture, and films from Joseph Cornell's marvelous collection.

Fritz Bultman was thirty in 1949, but he looked barely twenty. All his life he had a boyish, animallike alertness that signaled his incessant curiosity about the world. If a book was interesting and obscure—say, D'Arcy Thompson's *Life of Forms in Art* or George Soule de Morant's *The Passion of Yang Kwei-Fei*—it was on his bookshelf; if a new art concept was emerging, he was discussing it (on his deathbed he was talking about Michel Foucault). His library would serve as the perfect model of what the erudite mid-century artist would ideally have been reading. His art collection, which ran the gamut of the new American painting from John Graham to Franz Kline, was interspersed with objects of any and every kind with formal links to his own work—be it horn furniture, a decorated wooden door from Surinam, a huge tooth made as a dentist's office sign, or a mosaic-covered sculpture by Jeanne Reynal.

Even though he was deeply involved with the New York art world, Bultman maintained a separate life with his family and his very private studio world in Provincetown. He usually spent half the year there. This distancing of himself from New York, along with his changing style and interest in working in different media, have tended to diminish the general awareness of Bultman's place in the Abstract Expressionist movement. The single most damaging factor, however, was that he was in Italy during the winter of 1950–51 and thus was not included in the famous photograph of "The Irascibles" taken for *Life* in November 1950. This picture subsequently came to serve as the vehicle for identifying the New York School. Not being in it became tantamount to not being considered an Abstract Expressionist. In actuality, however, the picture is not a canonical group portrait of the movement. Three of those who were included—Ad Reinhardt, Hedda Sterne, and Jimmy Ernst—were not Abstract Expressionists, and two major painters who were—Franz Kline and Hans Hofmann—were not among those photographed. Despite all this, had the young Bultman been included in the photograph, one imagines that his subsequent reputation might have been quite different.

Bultman was not alone in the austerity of the color choices in his Hugo Gallery exhibition; black-and-white were very much "in the air" in 1950. They predominated in much of de Kooning's nonfigural work

at the end of the forties; *Excavation* is the culmination of this series of coloristically reduced abstractions. As 1950 progressed, Pollock seemed to include less and less color in his work. From the myriad pastel hues that proliferate in *Lavender Mist* at the outset of the year, he moved by summertime to *Number 32, 1950,* a painting that is only black on white. The announcement for his December exhibition was a long, lyrical study in black enamel on paper, and the following year, 1951, almost everything he painted was black-and-white. A significant number of the works in Hofmann's, Still's, Brooks's, and Gottlieb's 1950 exhibitions were black-and-white. On top of this, Franz Kline's startling October exhibition consisting of entirely black-and-white paintings, and the equally reduced *Elegies* in Robert Motherwell's show the following month, served to firmly fix black-and-white in the public's mind as an Abstract Expressionist idea.

In fact, New York School painters Baziotes, Bultman, de Kooning, Gottlieb, Hofmann, Kees, Motherwell, and Tomlin, as well as the West Coast artist Mark Tobey, were included with Europeans Braque, Dubuffet, Miró, Mondrian, and Picasso in a farsighted exhibition entitled *Black or White* that was held at the Kootz Gallery from February 28 to March 20. Critics found the show stunning, singling out Baziotes and Bultman for mention and Gottlieb's *Ancestral Image* as well as Motherwell's stark *Granada* for special attention. In his catalogue introduction to the exhibition Motherwell wrote that dealing with such a simple relation as black and white was a relief once in a while, but he also saw the white of the canvas as a void, like the poet's blank sheet of paper, a fearful void which only the painter's love for pigment can fill. He saw black pigment as full of dark implications in itself, coming as it did from the charred bones of animals, while most of the whites came from poisonous leads. "Sometimes, I wonder," he wrote, "laying in a great black stripe on a canvas, what animal bones (or horns) are making the furrows of my picture." [59] He closed his statement by saying that "if the *amounts* of black and white are right, they will have condensed into quality, into feeling."

Motherwell's eloquence is exceptional, but, just as each of these mid-century artists invented a signature image and painting technique, each also had an idiosyncratic way of talking about art and his or her singular experiences of life. None of the artists affected either the ironic verbal mannerisms of the Surrealists or the philosophical dialectics of the lit-

erary intellectuals of the day. By 1950, even the occasional dialogues with European Surrealists in exile living in the United States were but a memory and no longer directly relevant. The New York artist was winging it, inventing art all over again after his or her own image *and* inventing the language with which to describe that new art. This was more true of New York in 1950 than of, say, Paris in 1912, because the Cubists had the whole long, rich history of European painting behind them. As the American Cubist Stuart Davis once pointed out, it might be wonderful to be Picasso in Paris, but in a small Illinois town everyone would think you were crazy. Even in New York in 1950, the American artists were regarded as, well, crazy.

Though they shared a commonality of esthetic dissatisfaction with the art of the immediate past in Europe and in America, their personal styles of discourse were richly various. Pollock was given to brutal directness: "I am nature." Kline had a circuitous, but surprisingly precise way to express his thoughts about art, and when he told the following story about his summertime teaching gig in 1950, he performed the same act of subtle condensation he did in his art:

> There's this comedian I know in the borscht circuit. They had a theater group and everything up there and my friend asked me to go there and teach. I told him I didn't have the money to get there and he said he'd send it to me. I got up there and talked with this comedian. He had studied with Raphael Soyer and painted, but he never could sell anything, so he took this job as a comedian and never got back to painting. He loved Jackson Pollock and had such marvellous heart about it all that he could never have been popular at either painting *or* comedy. Somebody did an imitation of my drawing on a napkin, laughing, six lines, and said, "That's all there is to it." My friend said, "That's why I like it."[60]

Feisty Barnett Newman never missed an opportunity to attack or rebut anti-artist critics, or to defend himself and his friends. His style was litigious, literally so; on the rare occasions that words failed, he gleefully resorted to lawsuits. When Aline Louchheim's positive review of Newman's show was criticized by arch-conservative critic Peyton Boswell in *Art Digest*—he accused her of using both "too many words" and confusing double-talk to describe the work—Newman immediately fired back

a salvo which was published in the March 15 issue of the magazine. He accused Boswell of being "yellow" for attacking Louchheim instead of him directly, and then went on to question whether Boswell had been the person responsible for mutilating one of the pictures on view! De Kooning's style, on the other hand, was fragmentary and poetic; it took a while to put the pieces together into an idea, but the resulting complex beauty was astonishing. For example:

> Today some people think that the light of the atom bomb will change the concept of painting once and for all. The eyes that actually saw the light melted out of sheer ecstasy. For one instant everybody was the same color. It made angels out of everybody. A truly Christian light, painful but forgiving.[61]

The artists invented their personas along with their art because there was no established image of an artist for them to assume in New York the way there was Paris. They weren't the next wave of anything—they were an entirely new era.

Although there was as yet no clear-cut and generally accepted definition of the Abstract Expressionist movement, by early 1950 artists were aware that some major storm was swirling through the world of art. Museum curators and art critics were also beginning to feel its force, and that year three major books on contemporary artistic developments in America were being written. Appearing in bookstores the following year were: *Modern Artists in America,* edited by Robert Motherwell and Ad Reinhardt, *Abstract Painting* by Thomas B. Hess, and *Abstract Painting and Sculpture in America* by Andrew Carnduff Ritchie. The latter two books assessed contemporary abstraction in the context of earlier European and American art. *Modern Artists in America* attempted an overview of 1949–50 art world events and ideas, and of the works, the exhibitions, the collections, and the publications then available on modern art.[1] One of the very few books on avant-garde abstract art available prior to 1950 (although only in French) was Michel Seuphor's 1949 study *L'art abstrait.* In 1950 the author came to America to research an issue of the French magazine *Art d'aujourd'hui* dedicated to "Painting in the United States" and went away with "the very clear impression" that abstract American art had "entered its apogee" that year.[2] American avant-garde art was now recognized internationally.

Today, practically buried under an avalanche of art books and magazines, one finds it difficult to appreciate the extreme paucity of reading material about modern art in 1950. Only six books were likely to be found on many artists' bookshelves: Museum of Modern Art curator

Alfred Barr's *Cubism and Abstract Art,* 1936, and his *Picasso, Fifty Years of His Art,* 1948; art dealer Sidney Janis's *Abstract and Surrealist Art in America,* 1944; art historian Robert Goldwater's *Primitivism in Modern Painting,* 1938; MOMA curator James Thrall Soby's *Contemporary Painters, 1948;* and English critic Herbert Read's *Art Now,* 1948. Professor Meyer Schapiro's brilliant analysis of Van Gogh's paintings would join them when it was published in 1950. The kind of close formal analysis of pictorial composition at which Schapiro excelled had not been done before; he virtually invented the methodology. Though slender—and not very informative—exhibition catalogues were available, there were no major monographs available in English on, for example, Mondrian, Brancusi, Léger, or Kandinsky. Reproductions of modern works were less difficult to acquire, and in 1949–50 Skira had begun to publish their line of gorgeously color-illustrated art books. As a result, though visual material was plentiful, there was no common language in which to discuss it. Artist, art historian, critic, and curator alike lacked a vocabulary, or terminology, for this new abstract art.

The Abstract Expressionist was an esthetic anarchist. Personal freedom was the primary necessity, truth to one's inner world the only moral code. There were no rules or guidelines for this. The esthetic was the opposite of an academic art school, where there is a programmatic way of looking at things and a system for making them, remaining fixed in both techniques and conventions. Some of the New York Abstract Expressionists created an art school of their own in 1948, calling it "The Subjects of the Artists School," but, true to their esthetic, what they created was the opposite of a traditional academy. It was exactly what one might have expected—spontaneous, free, and improvisatory. The "faculty" taught no techniques, set no problems for the students to solve or projects for them to execute, and gave no specific, how-to-fix-it critiques of their work. In fact, it wasn't even absolutely certain who the teachers were. One night apiece each week Motherwell, Baziotes, and Rothko were supposed to teach painting, and David Hare, sculpture, but they were often all there at once. (Clyfford Still was originally expected to be the fifth teacher, but he dropped out of the project before it even got going.) On Friday nights different speakers were invited to address the students. Barnett Newman undoubtedly named the school, and he handled the Friday speakers, but at first he wasn't officially one of the

THE SUBJECTS OF THE ARTIST:

a new art school

35 East 8th Street, New York 3, New York.

Catalogue for 1948-49

ARTISTS: William Baziotes, David Hare, Robert Motherwell, Mark Rothko.

THEORY OF THE SCHOOL: The artists who have formed this school believe that receiving instruction in regularly scheduled courses from a single teacher is not necessarily the best spirit in which to advance creative work. Those who are in a learning stage benefit most by associating with working artists and developing with them variations on the artistic process (through actually drawing, painting, and sculpting). If the 'student' so prefers, he can choose one artist on the faculty and work exclusively with him. But it is the school's belief that more is to be gained by exposure to the different subjects of all four artists—to what modern artists paint about, as well as how they paint. It will be possible to work with a single artist only in evening sessions, since the afternoon sessions are the responsibility of the faculty as a whole.

CURRICULUM: There are no formal courses. Each afternoon and evening session will be conducted by one of the four artists as a spontaneous investigation into the subjects of the modern artist—what his subjects are, how they are arrived at, methods of inspiration and transformation, moral attitudes, possibilities for further explorations, what is being done now and what might be done, and so on. The afternoon sessions are from 1:30 to 4:30, and the evening sessions from 7:30 to 10:30. There is no instruction on Fridays, when the school will be at the disposal of the students for independent work. The school is closed on Saturdays, Sundays, and certain holidays.

STUDENTS: Those attending the classes will not be treated as 'students' in the conventional manner, but as collaborators with the artists in the investigation of the artistic process, its modern conditions, possibilities, and extreme nature, through discussions and practise.

REQUIREMENTS: There are no technical requirements; beginners and those who paint for themselves are welcome; the school is for anyone who wishes to reach beyond conventional modes of expression.

REGULATIONS: Smoking will be regulated according to the fire laws; anyone who does not fit in the school will be asked to withdraw (with refund of unused tuition).

TERMS: (each of ten weeks)

11 October - 17 December, 1948
3 January - 11 March, 1949
21 March - 27 May, 1949

FEES: (payable in advance by term or year)	Term	Year
One evening a week	45.	125.
Two evenings a week	80.	225.
Four evenings a week	150.	400.
Five afternoons a week	150.	400.

In regard to any further particulars, please write or telephone the Secretary of the school.

The announcement for The Subjects of the Artist: a new art school, 1948–49.

teachers. However, he was such a presence at the school that many of the students thought he was. Then, too, according to David Hare, the teachers didn't feel they knew with absolute certainty what they themselves were doing in their own work. They weren't that sure of their own abilities. Newman would tell the students, "I can't draw at all," and, unlike a truly professional teacher such as Hans Hofmann, he never drew or painted on a student's work to correct it. Newman was content to talk about art in a general, theoretical way and to be as encouraging as he could.

The teachers at this very unusual art school believed that an artist's subjects were inside her or him, waiting to be released in the act of painting. They rejected anything a student did that looked like it was coming from a literal subject—a still-life object, a figure, or a landscape situation—and they rejected anything that approximated work already done by others. It should "grab me," Hare thought. "I don't want it to look like something I've ever seen before in my life." He especially liked one student, who would work at the school and also bring paintings from home to show his teachers—but who said "The hell with you" if the instructors didn't like the work.[3] The Subjects of the Artists School supplied a spacious workplace and a wide range of materials with which the teachers urged their students to experiment. Huge sheets of brown paper were frequently used because they discouraged preciosity. "Barney and Mark [Rothko] worked hard for me," one student at the school, Mary Abbott, remembered.

> They changed me completely. Cubism had been my teacher. Now I had to destroy the object, get rid of horizon, and not use any literary subject either. The point was to get you so you weren't putting down marks deliberately, but also not arbitrarily either. So you really felt it. Then it began to be real. First you had to learn to take a chance—a line, a brushstroke, or some dabs—and then keep pushing it so you'd know it was real and you weren't translating an object.[4]

Another student, Yvonne Thomas, said, "Mark and especially Motherwell completely turned me around," helping her search for her "subject," her feeling behind the shapes she was making and the colors she used. "The subject was very real," she recalled, "but no [specific] object was accepted as the base for the picture. Only subjective feeling."[5] The

A painting by Yvonne Thomas, executed at The Subjects of the Artist: a new art school.

teacher of the new American way of painting had plenty of empathy, but no time-honored solutions to give the student.

Although Abstract Expressionism was still a movement in formation at this point, it had already lost a major figure: Arshile Gorky. This young patriarch and, for many, the role model for the new American artist, who once said, "subjectivity is separated from objectivity by the smile and the tear," died prematurely at the age of forty-four early in 1948. The fact that the The Subjects of the Artists School opened its doors only months after his death was a coincidence that seems somehow inevitable in retrospect. Gorky had already been *the* great teacher of the Abstract Expressionist way of seeing and working. He was the unsurpassed master of visual literacy. Painters as diverse as Elaine and Willem de Kooning, John Ferren, Conrad Marca-Relli, Lee Krasner, and Raphael Soyer—even sculptors Isamu Noguchi, Raoul Hague, and Reuben Nakian—learned from him. His instruction was not given in any formal setting, but, instead, *ad hoc* on the city sidewalks, in the coffee shops,

Arshile Gorky. (Photo by Gjon Mili, **Life** *Magazine © Time Warner Inc.)*

and ethnic restaurants, as well as during visits to studios, galleries, and museums. Though Gorky's charismatic personal style, a mixture of theatrical flamboyance and inexplicable sadness, wasn't imitated by the New York School artists who came under his thrall, the fact that he *had* style, effective style, worked subtly on his peers and on the next generation of artists. They knew they must develop their own.

So interwoven was fact with fiction in Gorky's life, and so mythic a figure had he become by 1950, that his memorial exhibition, held at the Kootz Gallery from March 28 to April 24, 1950, was followed up within a year by a major retrospective at the Whitney Museum of American Art. This was the first such show for an Abstract Expressionist, just as the extensive biographically oriented monograph by Ethel Schwabacher

that came out a few years later was the first full-length book on one. Many in the New York art world knew Gorky by sight but were not familiar with his work; many others had heard one or more of the various legends that had sprung up about him. The Kootz memorial show stimulated an intense desire to know more. In 1950 Clement Greenberg finally "caught up" with Gorky and decided that he was the best deceased American painter. More important was the dawning recognition of Gorky's generative role in the development of the new American painting. This was confirmed later in the year at the 1950 Venice Biennale when Pollock, de Kooning, and Gorky were chosen as the representatives of the most advanced painting in America.

It was no accident that Gorky had become a legendary figure in the New York art world; the legends were partly self-generated. He told three or four different versions of his birth and early life in Armenia, but all of them stressed the beauty of the countryside around Lake Van, the nobility and martyrdom of his people, and the enchanted way fable mixed with fact in everyday life in that extraordinary place where tragedy was, and still remains, the norm. All of his different versions were based on some degree of truth, it turns out, and all of them were fabulous. He was a spellbinding talker who spoke in an "ironic, purring voice," according to one friend; another emphasized the violent and passionate nature of his conversation. Stuart Davis, who had once been very close to him, said Gorky expressed himself "in a complex personal jive that was extremely remote from accepted English usage. It was no mere matter of a simple foreign accent, although that was present, but an earthquake-like effect on sentence structure and a savagely perverse use of words to mean something they didn't."[6]

All of Gorky's friends were impressed by his total understanding of pictorial plasticity, the formal dynamics of the complex movements and countermovements that go on in a painting. That is why his kind of visual literacy was so central to Abstract Expressionism. In the thirties Gorky explained how pictures worked to artists and art historians, to union members, and to politicians alike. "He loved to take a picture apart," related abstract painter Rosaline Bengelsdorf Browne. "He loved Ingres, a very realistic painter on the surface, but when Gorky analyzed what he did in the pictures, it became very abstract and had the same basic pictorial language that Cubism had, that abstract art on the highest level had."[7] Sculptor Raoul Hague remembered that whenever Gorky

and Elaine and Bill de Kooning went through museums, "Gorky told them what was what."

> And no intellectual could approach him, really get into him. That's why the intellectuals never liked him. They couldn't keep up with him. But they couldn't see that Gorky himself was a kind of art, the kind of art he was painting. He loved to explain, to show you [and] he knew quality. So, in museums he took everyone by storm. Fogg Art Museum graduates, the Harvard art graduates, used to come and they were privileged to have Gorky take them to the Metropolitan Museum.[8]

De Kooning told Harold Rosenberg that Gorky was "a Geiger counter of art. In a room in a museum, he always ran to the right painting, and in the painting he always picked the really interesting thing."[9] "He was oracular," artist-critic Jacob Kainen said, "a principle greater than himself spoke through him."[10]

Gorky cut such a melodramatic figure—thanks in part to his great height, which he emphasized by dressing in a black ankle-length coat—and his manner was so authoritative, though never uncordial, that few would question him about inconsistencies in his biography any more than they would dare to challenge his opinions on art. Gorky studied paintings passionately, incessantly. Friends would often find him totally rapt before a painting at the Metropolitan or the Modern, almost as if he were worshiping at a shrine. A piece of carpet in a Vermeer, a Celtic manuscript, sections of armor, a Byzantine sculptural fragment—and always, the paintings by Ingres and Picasso—these were his habitual stops as he made his pilgrimages through these museums. While he focused on the art object, he blocked out the whole rest of the world. Jacob Kainen, who was an acolyte of Gorky's in the thirties, recalled one episode where Gorky "took apart" Poussin's *Triumph of Bacchus* for Kainen's edification when it was on view in a private New York gallery:

> [Gorky] traced the spiral movement spinning off from the wheel of the chariot, followed the verticals, horizontals and diagonals and related all the spaces, shapes, colors and their cunning echoes. This sort of analysis was a revelation to me; it included color sequences and shifts, back and forward movements, obviously there were underlying shuttlings I hadn't grasped.[11]

But when he disliked the work, his manner became outrageously theatrical. In a room where Gainsborough's simpering *Duchess of Devonshire* was being admired by two women, Kainen recalled that "Gorky looked sideways at me, then moved close to the painting, scrutinizing it carefully up and down." The ladies moved back to watch him in awe. In a few minutes Gorky returned to Kainen's side and fixing his baleful eye on the canvas, announced: "How horrible!"

On the street Gorky's eye would delight in mud-spattered walls, cracks in the sidewalk, and the designs left from torn posters and the ravages of weather. He would follow an imaginary shape-making line from a mark on the street at his feet, across traffic, up park trees, along the cornice of a building and up into the clouds, where it might become an Armenian stork or a crouching woman. All the things of the world registered on a plane located at a focal point a few feet in front of his eyes. Whatever their actual contours, they were distorted on that plane, providing new abstract shapes for him to play with in his mind's eye. A virtuoso of identifying hidden images—on car trips he drove his companions to distraction by tirelessly pointing out images in the clouds—Gorky wouldn't tolerate any in his work. "I never put a face on an image," he often said.

Gorky rarely smiled, perhaps because his teeth were so widely separated, but more likely because he found little in his world amusing. His haunted eyes were framed by swathes of darkness—shadowing eyebrows, a mane of black hair, and a full, thick mustache. His high seriousness was genuine; it had been fully earned in his Armenian experiences, and nothing had happened to change it after his arrival in this country in 1920. He lived and worked in Watertown, Boston, and Providence for the first few years here, surrounded by dreary miles of factory buildings, uninteresting frame houses, and unsympathetic people. He hated it all and dreamed of returning to his beautiful homeland around Lake Van. He tried to practice art and to study it, but nothing he saw of American art was up to his standards, set in the ancient and medieval world of his youth. He moved to New York because he knew it was the center of American art, and was only slightly less disappointed by what he saw there. He went to the Grand Central School of Art to study, and they made him a teacher. (He'd been drawing since he was three, and his line never faltered.)

Gorky had immense knowledge—both of older art and of the most

recent developments—from a lifetime of haunting museums, churches, and galleries. He scrimped to acquire art books, going without electricity in 1935, for instance, because he had spent seventy-five dollars for a rare edition of a book on Pieter Breughel. He'd buy brushes and paint when he didn't have enough to eat, keeping his immaculate studio off Union Square fully stocked with art supplies at all times. They were his *sine qua non.* Nor was he sparing in his use of materials; day after day, when he'd lavishly applied thick swaths of rich pigment to a canvas, building it up into an undulating topography, he'd end the session by scraping the whole surface off and onto the floor. Nothing mattered but the work. Gorky's studio was an oasis for himself and for the other artists struggling to survive the grinding, spirit-eroding Depression years. No wonder it made de Kooning dizzy to enter Gorky's world.

Through the painful years of the twenties and thirties, Gorky did daily battle with the greatest artists he knew: first Ingres and Cézanne, then Picasso and De Chirico, finally Miró and Matta among the Surrealists. By 1941 he began to break through into his own personal form-world— habitual gestures dominated by a curve and a sharp point—and his own visual content, both of which were based in early memories of his Armenian life. Gorky described his process of creating hybridized abstractions out of memory images to his sister Vartoosh:

> Visualize painting as the mobile positioning and partitioning of component parts of materiality. The dimensionality of our three houses coalesce with red orchards and blue gardens. Houses built by man's labor and apricot trees by nature's formula and the artist making them all his own by controlling their motion as a conductor leads his orchestra. The rectangular walls with butterchurns and clay baking tools and Armenian rugs pasted on them stretch and twist in seeking contact with wheatfields and cloth trees and Armenian crane; and garden stones, all floating within one another and swept up by the universe's ceaseless momentum just as life-nourishing blood when flowing through the body nudges the artery walls on its journey. . . . All gently wrapped in the Armenian bouquet of Khorkom, the entire world in miniature and in cosmic greatness, blood-spurting tragedy and sorrow and joy. . . .[12]

"He was exploding," de Kooning said, describing Gorky's fevered painting. "He had a way of painting fast, floating painting, very fast." [13] "Watch

the excitement of the brush," Gorky told his friend Raoul Hague as he painted. "You've got to attack, you've got to attack," he responded when a painter friend, Max Schnitzler, said he was "nuts" for painting so wildly with such expensive paint. He painted full-tilt, on his feet, all faculties maximally charged, just the way he lived. De Kooning, who was desperately trying to keep up with him artistically in the early years, described him this way: "He was the general. Like we would be walking, and all of a sudden, he would cross the street. So I would tell him, 'I wish you wouldn't do that Arshile, because you do that the right way and skip the car but I run into it.' "[14]

Gorky was a man of powerful contrasts. Tears would run down his face as he listened to the plaintive, melismatic songs of Armenia. But when this "big strong, Armenian Caucasian mountain man" as Stuart Davis described him, felt the need of some exercise he would take on the ruffians lying in wait for him outside his studio door. He would stride into their hail of pelted trash shouting ethnic epithets at them, and then with his enormous hands would proceed to bash together all the angry heads he could grab. Adolph Gottlieb stressed Gorky's dualities in his catalogue introduction to Gorky's 1950 memorial exhibition at the Kootz Gallery. Having known him since the thirties, Gottlieb wrote that "he seemed to combine a ferocious appearance with a gentle manner, through which flashed a savage wit." He noted that there is "a curious undertone of gentleness and brutality that emanates from the canvases."[15]

Gorky's memorial show included many of the greatest and largest paintings of his final years: *Betrothal I, Agony, Calendars, The Plow and the Song, The Orators,* and *Diary of a Seducer.* Like *Last Painting* itself, many of the canvases of the last two years of his life were more aggressively and brusquely painted than the ones of the early forties, as though he sensed he didn't have enough time left to make them perfect. All of Gorky's work is marked by a formal dualism in the linear interplay of curving elements. The forms he invented were absolutely ambiguous: flat and rounded, concave and convex, positive and negative, at one and the same time. The reading of any given shape depends on the readings of adjacent shapes made as one's eye moves through the paintings. Gorky's shape can be as soft and vulnerable as a woman's breast, yet it often terminates in, or is viciously pieced by, needle-sharp points. One feels that his work is simultaneously concerned with sensuality and pain.

Gorky's curve-point combination gave him the possibility of never-ending plasticity, a form-world of incessant inventiveness. Doubled, Gorky's shape is a heart; open-ended, it is flamelike; closed and elongated, it becomes the boomerang shape of "modern" design in the forties. Completed, doubled, and nestled end to end, it is the yin-yang symbol of totality. The never-ending, push-pull, give-and-take of this symbol epitomizes Gorky's perfectly balanced positive and negative spaces. (Interestingly, Abstract Expressionism as a whole was often called "yin-yang art" in Cedar bar parlance by those who wanted to put it down.) No holes, no protrusions, but also no real flatness. Gorky's suggestive space is an endless continuum of active forces at play. As Meyer Schapiro said: "Gorky discovered an atmosphere suited for the objects of modern fantasy, primitive, visceral and grotesque..."[16] As our eyes wander in and out of the soft places in a typical mature Gorky of the kind in his 1950 show—*Agony,* for instance, at The Museum of Modern Art—we imaginatively palpate the painting with our hands. Our flesh is torn by the sharp points as it slips inside of dark tunnels and emerges from tumescent tubes. We probe his space the way a rubber-gloved surgeon might feel our viscera. Gorky's lines are sometimes like steel wires harshly slicing space as though it were cotton candy; at other times they are as fragile as glass fibers or angel hair.

Reviewing the memorial exhibition, *Times* art critic Howard Devree said that Gorky had wit as well as bitterness, satire, and lyricism.[17] Devree described Gorky's great painting, *Diary of a Seducer,* 1945, as "a ghostly convocation of shapes . . . in a grotto-like space," thereby capturing some of the vaguely menacing quality of the painting. Art critic Harold Rosenberg later termed *Diary of a Seducer* "infinitely subjective" because he read it autobiographically. He saw the painting as a record of the immigrant who succeeds through his charm and of the artist as seducer who wins love through his art. The more general reading is preferable, since Gorky, far from being a womanizer—though more than the normal complement of women threw themselves at him—cannot even be said to have been lucky in love. Both his marriages failed. The first, to Marney George in 1935, lasted only a very short time. His second marriage, to Agnes Magruder in 1941, produced two children, Maro in 1943 and Natasha in 1945. This marriage lasted until shortly before his suicide, to which the breakup was undoubtedly a contributing factor.

Diary of a Seducer is an elegiac study in grays lighted here and there by muted touches of yellow and red as if by candles and embers. It is a dreamscape, a floating world of reverie, where forms shift in and out of focus, up to, through, and back behind the picture plane, in a slow dance. A horizon in the distance is suggested by five horizontals in a broken line across the painting just above the midpoint. Taut, thin lines weave through the picture space, encircling color areas to form shapes, then sliding off to curve a plane up out of the mist, though without lending it substance. Like the prolonged series of different notes sung to one syllable in a melancholy Armenian song, Gorky's continuous though modulated line breathes life into the dead materials of paint and canvas. No story is told, but a sense of a flow of action and a passage of time is somehow conveyed.

Diary of a Seducer *by Arshile Gorky.*

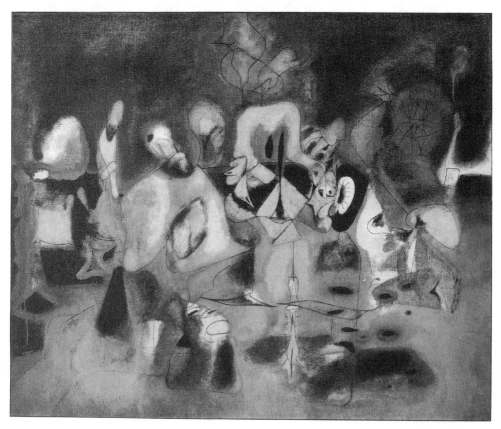

Various readings of *Diary of a Seducer*'s meaning have been entered into the lists, but no winners have yet been declared. Gorky's highly specific drawn forms tease the viewer into this kind of exercise. Artist-critic Elaine de Kooning found a series of connections between *Diary* and Jacques Louis David's *Mars Disarmed by Venus,* citing the similar massing of forms across the horizon in each. But this is a common compositional device throughout Gorky's work which is more likely to stem from Paolo Uccello's *Battle of San Romano,* a huge photographic reproduction of which was always hanging prominently on his studio wall.[18] The strange spectral nocturnal light in the Uccello provides another link to *Diary of a Seducer.* Then, too, a similar distribution of forms occurs in another work, Jean-Auguste-Dominique Ingres' splendid grisaille *Odalisque,* a painting Gorky was known to adore in the Metropolitan Museum. The silvery-gray tonality of this highly seductive *Odalisque* provides a firm connection with Gorky's largely tonal painting.

Another seminal painting that must also be seen as a source for *Diary of a Seducer* was Picasso's grisaille *Guernica.* Resettled in its home away from home at The Museum of Modern Art after exhibition at the New York World's Fair in 1939 and a nationwide tour, this painting was an ever present source of inspiration for Gorky, de Kooning, Pollock, Motherwell, and many other New York School artists in the forties and fifties. For many Americans, *Guernica* was a powerful symbol of the destructive force of war, and Gorky, having endured the atrocities of the Turks during World War I, must have been intensely moved by Picasso's response to the bombing of this innocent Spanish town. The epic size of the painting, and the fact that its message is conveyed completely by gray, black, and white newsprint-like tones, affected all the New York artists. But for Gorky, who had been close to such tragic scenes, the screams for help, the cries of despair over dead babies, the lamentations in this painting undoubtedly had personal relevance. His own experiences were of the blackened bodies of cholera victims and the swollen bellies of his mother and other starving people on the death marches, rather than of violently brutalized or massacred victims, but all were forms of violence, to be sure.

In a less painfully subjective mode, Gorky's biographer, Ethel Schwabacher, saw *Diary of a Seducer* as suggesting the theme of a poet singing to cheer his solitude—an interesting reading, since we know Gorky liked to sing Armenian songs to himself as he painted. In his happiest

early memories of Armenia, his homeland was a magical place filled with art and exciting legends. His childhood was centered around his mother, the beautiful Lady Shushanik who was descended from one of the most ancient and noble families in the land, the family responsible for establishing the church complex in their town. As an adult Gorky enshrined her in two portraits with himself at her side like a worshiping acolyte. In a marvelously revealing remembrance, Gorky linked these childhood joys with the linear tracery of mature paintings like *Diary of a Seducer*:

> I tell stories to myself while I paint, often nothing to do with the painting. My stories are often from my childhood [which] my mother told me while I pressed my face into her long apron with my eyes closed. She had a long white apron like the one in her portrait, and another embroidered one. Her stories and the embroidery on her apron got confused in my mind with my eyes closed. All my life her stories and her embroidery keep unraveling pictures in my memory.[19]

The great tragedy of Gorky's young life, one that haunted him always, was, of course, his beloved mother's death from starvation in his arms.

It seemed to people like Schwabacher, who knew him well, that love and death were always linked in Gorky's mind. This makes it more understandable that a painting erotically titled *Diary of a Seducer* should seem to be filled with smoke and devastation. In fact *Charred Beloved I & II,* which were painted following the disastrous 1946 fire in his studio, seem far less mournful. In its smokiness, its sensuality, and its sense of desolation, *Diary of a Seducer* can be said to predict not only the fire, but also his own self-destruction after his wife left him— for another artist. He had no way of knowing in 1945 that his life would change so much and so tragically in the next three years.

The major alterations came about in Gorky's life after he met André Breton in the winter of 1944 at a party given in the poet's honor by the writer Margaret La Farge Osborne. Shortly afterward, the pioneering American Surrealist dealer Julien Levy took Gorky into his gallery. Breton wrote the introduction to the catalogue for Gorky's first show with Levy, saying that for him Gorky was "the first painter to whom the secret has been completely revealed!"[20] Breton devoted the concluding chapter in the new edition of *Surrealism and Painting,* published in 1945,

to Gorky. Largely as a result of all this attention, 1945 was the first year in Gorky's life that he had no financial worries. But the intense presence of such high-power Surrealists in his life was a mixed blessing. Margaret Osborne located the source of Gorky's final troubles in his move later in the year to Sherman, Connecticut—the home of his new dealer and of a number of other Surrealists—because it took him out of the studio-gallery-museum context in which he felt so important and so secure. The move was made for practical reasons as the Union Square studio, his home and work space since 1932, was no longer suitable for him with a wife and two growing daughters. Osborne wrote:

> When he moved to Sherman, he was plunged into a closed world, one which, in important ways, was foreign to him. He had none of the language of the worldly, none of their cynicism. He was meant to plane it alone, and now belonged to a club. His gifts as a teacher were of no use there; off his own base he lost the power to assert himself. For the first time he struggled with small accomplishments, learned to drive a car, and drove it into a ditch; learned to make cocktails, and made them far too strong. He was simple, where his companions were complicated, and complicated in ways they had little patience with. [He was] defenseless in surroundings of such sophistication, of such fast knowledge, and with . . . the playful Surrealistic cult of Sadism, dangerous to the vulnerable in the hands of the thoughtless or malicious. For this he had no weapons; his weapons were on the ground he had left.[21]

His profound artistic sophistication notwithstanding, Gorky was a simple peasant on the most basic human level. He became convinced his wife was being unfaithful to him, and no one could persuade him otherwise. He told his neighbor, Saul Schary, "I made a terrible mistake getting in with these Surrealist people. They're terrible people. The husbands sleep with each other's wives and they're terrible people. I never should have let Agnes get mixed up with them."[22]

Even though the title of *Diary of Seducer* was suggested by one of his Surrealist friends, Max Ernst, Gorky may also have been aware of Søren Kierkegaard's chapter "The Seducer's Diary," in *Either/Or* in which the narrator, gripped with anxiety over the love affair he is discovering in a man's secret papers, describes being "carried along into that kingdom of mist, into that dreamland where one is frightened by one's shadow at

every moment." [23] The vastly deep, yet shallow, stagelike space of *Diary of a Seducer* is like the ambiguity Kierkegaard's diarist describes:

> Behind the world in which we live, far in the background lies another world, and the two have about the same relation to each other as do the stage proper and the stage one sometimes sees behind it in the theater. Through a hanging of fine gauze one sees, as it were, a world of gauze, lighter, more ethereal, with a quality different from that of the actual world. Many people who appear physically in the actual world are not at home in it but are at home in that other world. [24]

The diarist himself "possessed the poetic through the ambiguity in which his life elapsed." [25] Kierkegaard's narrator was far too intellectual to be a seducer in the ordinary carnal sense; instead he used "passionate energy" to hold his loved one at the "the pinnacle of passion" by breaking off the relationship at its apex at "the high point where he was sure she would offer everything." [26] The fact that Kierkegaard had created a perfectly distilled metaphor of the relationship between artist and artwork would certainly not have been lost on Gorky. Every aspect of Gorky's work, from its meaning in the largest sense down to the most specific details, was ambiguous, his every form an either/or situation.

Willem de Kooning acknowledged Gorky as his "senior," but Jackson Pollock did not, although he apparently never even saw Gorky's work in any depth before the 1950 memorial show at Kootz. Pollock was a man acutely sensitive to rivals, and he recognized Gorky as one from the start. Pollock was showing in the most prestigious Surrealist gallery in the mid-forties—Peggy Guggenheim's Art of This Century—but the guru of the movement, André Breton, passed the mantle of "Leading American Surrealist" to Gorky in the catalogue for his 1945 show at the Julien Levy Gallery. Then, too, watching Gorky holding forth on art with such facility and authority to a group of admiring listeners at a museum or in a cafeteria would not please a man like Pollock, who always wanted to be the center of attention himself. At parties, the situation would be even worse. When Gorky had a little wine, he would become light-hearted and would put on records of Armenian music and begin to dance. His friends, pleased to see him enjoying himself, would stand politely along the walls, sipping their highballs, to watch his beautiful solo. Such a situation must have been intolerable to Pollock, who could

only keep attention focused on himself by outrageous conduct—like urinating in the fireplace, roughhousing, or grabbing the nearest woman. "As a matter of fact," de Kooning recalled,

> Pollock was a very belligerent man. I was at a party once and he started insulting Gorky and Pollock was drunk. He was going to do this and he was going to do that, and he said to Gorky, "You're a lousy painter." Gorky didn't bat an eyelash. He took a long knife which he always kept in his pocket. He used it as a pencil sharpener to make piles of pencils with long lead because that's the way he drew. Like he used to say, he used pencils in drawing "like a surgeon's tool." Beautiful lead and then he had these enormous hands . . . very beautiful hands. And he would have this pencil and he could make terrific drawings, beautiful drawings, very sharp point. So it became a habit for him to take that big knife out and sharpen a pencil whenever somebody wanted to make trouble. People knew they shouldn't fool around with him. You know what I mean. And Pollock didn't either. Gorky just answered him, "Well, we're different artists."[27]

While it is true that Pollock's work lacked the gentleness of which Gorky was capable, they both used line lyrically. Gorky's line was as labyrinthine as Pollock's, sometimes moving without stopping through the picture space at great speed, but also, as we have seen, slowing down to create forms out of the plastic matter of that space. Pollock tended to paint on a larger scale than Gorky, though Gorky's six-by-eight-foot *Summation,* 1947, in The Museum of Modern Art, rivals the size of Pollock's paintings. Gorky's normally rich color makes Pollock look like a black-and-white painter by comparison. One basic thing they shared, however, was a sense of the painting as a living, responsive organism with which they each had a deeply intimate relationship.

Gorky's posthumous influence on artists in the fifties came mainly through de Kooning's development of a complex but relatively imitable style out of a fusion of his own superbly versatile paint handling with Gorky's curvilinear form-world. So quickly and thoroughly did Franz Kline and Jack Tworkov create their own personal idioms out of this stylistic amalgam that they were fully up to the speed of the other Abstract Expressionists by 1950. Later on, a host of younger imitators created what was derisively called the "Tenth Street Style" out of a

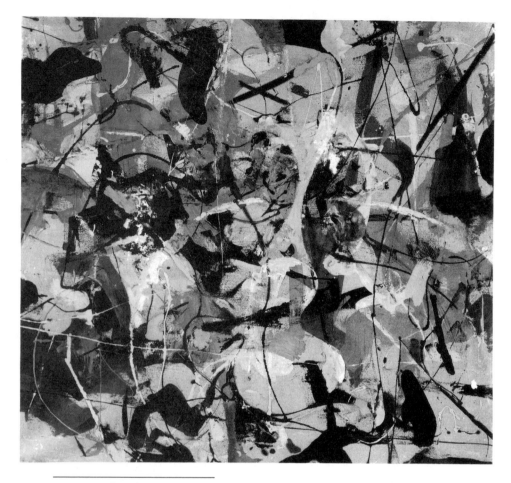

Number 36 *by James Brooks.*

shared Gorky-de Kooning-Pollock esthetic. Pollock's style was not as readily imitable as de Kooning's translation of Gorky's was, because it depended so much on his "dripped" paint technique; to use the same method was simply to produce "Pollocks." But his reliance on chance effects, particularly the accidental, stained-in and splashed-on indicators of spontaneity, became fused with the Gorky-de Kooning paint handling in their followers' pictures. Though the open-ended gestural freedom of Pollock's work influenced everyone, it had the most direct effect on James Brooks. But the curvilinear form-world of the Gorky-de Kooning axis also left its mark on Brooks's canvases.

James Brooks's 1950 painting *Number 36* is a classic example of how this three-strand influence operated at its best. It contains numerous

passages of Pollock-like dripped and poured paint, but one is less aware of them than the Gorky-like biomorphic shapes they cross, define, and are sometimes obliterated by. Though these shapes were originally arrived at as spontaneously as the drips and spatters, they are definite in their perimeters and their movements. They arrived on the canvas in one of two ways: either they stained through from the other side where he had been working or they were improvised directly. On April 23, 1950, Brooks described his working process to his fellow artists at a Studio 35 Roundtable discussion:

> My work is improvisation to start with. My purpose is to get as much unknown on the canvas as I can. Then I can start digesting or changing. The first thing is to get a great many unfamiliar things on the surface. The working through on another side is an unfamiliar attack. There are shapes suggested that start improvising themselves, which I then start developing.[28]

Brooks's method of subsequent shaping, however, is decidedly de Kooning-like; it involves cutting forms over other forms, blotting, scraping, or rubbing them away, and then pouring or painting other forms on top. But the result of this complex, interactive process is a painting that would never be mistaken for one by any of the other three painters —it is pure Brooks.

The seminocturnal light in Brooks's paintings gives them a very distinctive, identifiable look. It puts one in mind of the moment at dusk when the bright greens of nature suddenly thin to dark, shadowy charcoal grays. The forms float as if they are under the sea or free-falling slowly through dark, debris-littered outer space. Though Brooks is an inventive colorist who went on to explore many other parts of the spectrum, the blue-green-black-white-gray color chord in *Number 36* is sounded in numerous other paintings over the years. The nocturnal or undersea quality of the light is practically a constant in his work from this time on, and even though the scale of the units filling his paintings increases dramatically over the years, the form-world of the 1950 paintings is his for life.

The paintings Brooks showed at the Peridot Gallery from March 27 to April 22, 1950, were fluid, curvilinear abstractions full of rhythmic, free-flowing brushwork and accented by drips and splashes of paint. Though

biomorphic forms far outnumbered straight-edged ones, they were held in check by horizontal and vertical reminders of stability, even in the tondos, or circular paintings. Brooks's world was a transient one of emergence and convergence in constant flux, yet it had a calm, measured quality. His work is subtly emotional without seeming frantic; it doesn't have Pollock's violence even when the lines are trajectories flashing through the canvas space.

James Brooks the man was very much like his paintings: open, civilized, quietly surprising, and, in 1950, possessing soft-edged, somewhat quizzical Robert Taylor good looks. Born in 1906 in St. Louis, he studied at Southern Methodist University in Dallas before coming to the Art Students League in New York. He was quite successful at WPA public mural work, but never incurred the kind of jealousies that were felt toward the "big names" on the project. Brooks was the kind of man other men instinctively like, and the kind of painter other artists respect, with an ego neither swollen nor threatening. Without any doubt he was one of the top muralists at work in public spaces during the thirties. His enormous mural in the Marine Air Terminal at La Guardia Airport, which was recently restored to view after being covered with paint for many years, is one of the finest of this genre.[29] As one of the few major New York artists to be drafted in World War II, he missed the early Surrealizing phase of Abstract Expressionism. When he returned, he felt the need to retrench, and he spent a couple of years learning about Cubism before he felt solidly grounded enough in Modernist painting to launch out on his own.

Brooks accidentally discovered his staining technique in Maine during the summer of 1948. He had been experimenting with collage on bemis cloth, a very porous linen, gluing paper onto the surface of relatively Cubistic abstractions. The shapes of the black-colored glue stains that came through on the reverse side of the absorbent cloth supports for these collages began to fascinate him and he started to apply paint to that side, eventually abandoning the material on the front. It was like being surprised with a gift. He found himself suddenly in possession of a "subject" which he hadn't consciously painted. After a get-acquainted period where a dialogue developed between him and the painting, he began to juggle it into to a state of resolution. "At some undetermined point," he once wrote, "the subject becomes the object existing independently as a painting."[30] He further underlined the essential passivity of his role when he explained: "My interest is in this encouragement of

the forms that are intent on surfacing, and my function is to act not as a maker but as a discoverer."[31] Jackson Pollock's example was of great support to Brooks in his "journey of discovery." Brooks believed that Pollock's unconscious came through strongly in his paintings, "much more so than most of us, and it helped us to break through so we didn't think so consciously of how pictures should be made or how space had to be constructed."[32]

Brooks had gotten to know Jackson Pollock's artist brother, Sanford (Sande) McCoy, in the thirties when Sande was an assistant on the Marine Air Terminal mural. Then in 1946 Brooks took over half of Jackson's Eighth Street studio when Pollock and his wife, Lee Krasner, moved to The Springs on Long Island to live. Brooks saw Pollock whenever he and Lee made return visits to New York. Brooks recalled that:

> At 8th Street, due to their staying in a tiny room, we got pretty well acquainted, although Jackson had a hard time talking, he was so shy. He was in conflict and with a few drinks he couldn't take things and would get pretty wild, but now there was no Sande to talk him out of it. I can't handle a drunk and avoided him when he was drinking, so I got the reputation of being afraid of him. As it happened, Jackson was afraid of other people when he *wasn't* drunk, as if he's been put down or hurt. He was open to so many things, you know, and to be open hurts a great deal.[33]

In 1949 Brooks and his wife, the painter Charlotte Park, began spending the three summer months on Long Island's Montauk Point, where they saw a great deal of Krasner and Pollock. Pollock had stopped drinking the year before when he went under the care of a local GP, and miraculously, for the first and only sustained period in his life, the treatment worked. He stayed on the wagon until late fall 1950, shortly after the doctor died.

In addition to just having good times together with their wives, walking along the shore, and creating temporary assemblages out of beach detritus, Brooks and Pollock spent a great deal of time talking about painting. As Brooks recalled:

> Jackson could talk about painting quite beautifully. It was good to talk about your work with him because he attacked it in a structural way— not bringing in other meaning that painting has that you can't talk

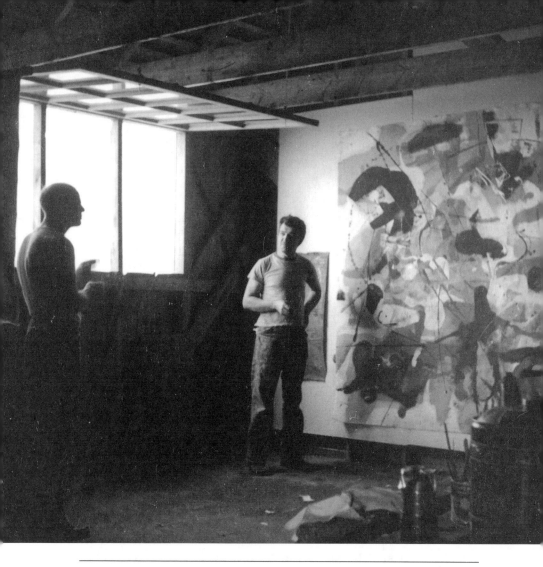

Jackson Pollock in James Brooks's Montauk studio in 1950, discussing Brooks's painting **Number 42** *tacked to the wall. (Photo by Hans Namuth © 1991)*

about too much. Other times he would go into a very interesting monologue about the things in paintings you had done that provoked him in a psychological way—the images—the strange formations you were bringing out or repressing.[34]

Pollock's example of being "in" his painting, of allowing his unconscious as much free rein as possible, reinforced Brooks in his effort to forget what he'd learned from Cubism about how to construct a picture, and instead, to let it emerge, as he put it, to "work right into another

world." Reviewers of Brooks's first solo exhibition of these new abstractions in 1950 saw that the paintings expressed states of mind through form alone. One discussed the movements of "shapes [which] flow, collide and melt into each other at top speed"[35] while another saw that "forms wander into and across each other, and lines describe movements, sometimes elliptical, like rockets across the evening sky, sometimes circular...."[36] It is interesting in retrospect to see how many times images of velocity occur in critical writings in the early fifties.

In 1950 it was still radical to believe that abstract shapes alone, unaided by representation of any kind, had the power to convey feelings. In fact, at this time, the end of March 1950, The Museum of Modern Art, the Whitney Museum of American Art, and the Institute of Contemporary Art in Boston felt so strongly that the new American abstraction wasn't being given a fair hearing that they issued a joint statement in its support. The statement proved to be quite controversial because these institutions affirmed their belief in modern art as a continuing vital force and emphasized their duty to present it to the public. Some of the powerful newspaper and magazine critics of the day heartily disagreed. The statement's signers, Barr, Ritchie, and d'Harnoncourt of the Modern, Goodrich and More of the Whitney, Plaut and Wight of Boston's ICA, claimed that the so-called unintelligibility of modern abstract art was the inevitable result of exploring new territory, but they also felt that the size of the gap between the new art and the public was exaggerated. They stated their belief that modern art has humanistic value and plays a spiritual and social role in the world, underlining this by recalling both the Nazi and the Soviet opposition to Modernism. Like Weldon Kees's first piece for *The Nation* discussed earlier, the museums' joint statement was directed at Michigan Republican congressman George Dondero, whose speeches vilifying modern artists, art critics, and museums as subversive tools of the Communist Party made him the Joe McCarthy of the art world.

Discussing the joint museum statement in her *New York Times* column on April 2, 1950, Aline Louchheim pointed out how ridiculous it was to expect the same old images and spatial concepts to express the new understanding of the unconscious, which had come to assume importance alongside conscious, deliberate acts. She also mentioned the new concept of the universe, including the space-time continuum,

as being beyond our senses, and therefore best expressed in an abstract symbolic language. The relation of Brooks's new image world to the time/space ideas of Einstein was distantly and inadvertently suggested by one reviewer of his March-April show who wrote: "Painted in extremely thin washes of color, Brooks scrapes his surface until a lean, bare and blotted appearance is obtained, as though his paintings were palimpsests of absorbent paper across which time has trailed its soft fingers."[37] Because his paint was stained into the canvas weave, either down into it or emerging up to the surface from the other side, Brooks was able to literally physicalize rather than illustrate or create the illusion of an indefinite spatial continuum. By contrast, Pollock's paint clearly lies on the canvas surface, although one can imagine the white ground disappearing.

Pollock's open-ended esthetic was the key to a long life's work for Brooks, who was still able to create honest, deeply felt abstractions in the stain idiom he evolved until a few years before his death in 1992. Artists in Brooks's wake, who never grasped the crucial psychological dimension of Abstract Expressionism, took his stain technique and produced largely decorative abstractions in the ensuing years in a movement that came to be known as "color field painting." But back in 1950 Brooks's work, as if in perfect tune with the emotional complexities of the time, physicalized the unconscious in forms that seemed to occupy a sub-atomic world of trajectories and force lines amid softly splitting and disintegrating matter.

It could be argued that, except for his influence on Brooks, Jackson Pollock had a more direct effect on sculptors than on painters, since so much of the new "expressionist" sculpture involved freewheeling techniques of applying metal to metal—including spraying, soldering, pouring and dripping it on—which were nearly as aleatoric, or chance-ridden, as Pollock's way of painting. Ibram Lassaw, a neighbor in The Springs on Long Island, dripped molten metal over three-dimensional, openwork, semi-Cubistic armatures of welded metal. The resultant effect, while fragile and jittery, has frequently been compared to Pollock's linear traceries. Other sculptors not so close to Pollock, such as Theodore Roszak and Seymour Lipton, also used a variety of brazing and molten-metal techniques in direct metalworking to achieve expressionistically jagged, clotted surfaces.

But it was Herbert Ferber, a close friend of Motherwell, Rothko, and

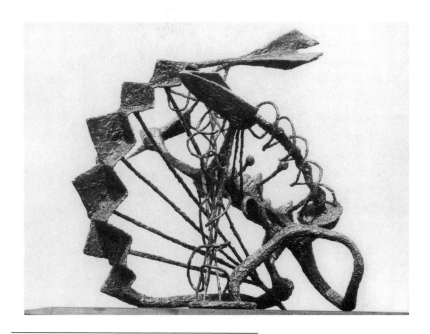

The Action Is the Pattern *by Herbert Ferber.*

Gottlieb at mid-century, who found an open ended, gestural way of working that was probably the closest parallel to Pollock's kind of painting, aside from David Smith's. Ferber often said, "There's no such thing as action sculpture,"[38] but he made a work in 1949 titled *The Action Is the Pattern* which is full of aleatoric passages that appear to record the artist's gesture. Carving stone or casting bronze is fully premeditated, but melting lead foil onto copper sheeting and brass rods that he welded together in open, space-incorporating structures allowed Ferber a much more flexible, responsive way to work. One reviewer called the sculptures Ferber exhibited at the Betty Parsons Gallery from March 6 to March 25, 1950, "tortured," "savage," "agitated," and "at times expressive of poetic inner feelings."[39] Working in an additive way, as this same critic, Belle Krasne, pointed out, Ferber was able to "use space as a material, playing void against solid, making what is *not* there as important as what *is* there." The open linear rhythms he sets up in *The Action Is the Pattern* and others like it in this exhibition is very close to the look of Jackson Pollock's linear matrixes. In fact, Ferber titled another work in the show *Portrait of J.P.* in honor of the painter who was a master at using space as a material. The same reviewer described this piece as "graceful," though she admitted that seemed like a strange adjective to use. But, she wondered, "how else can one describe the

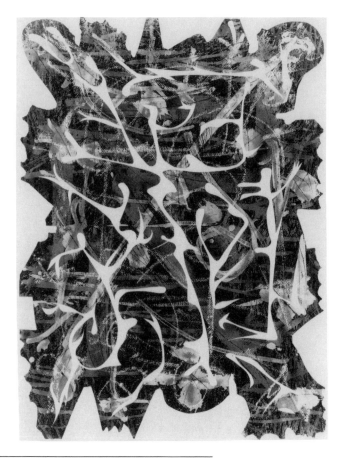

Orderly Crowd – Family *by Alfonso Ossorio.*

lunge, the taut stretch of that arched metal, trapped like an animal's skeleton between two upright barbed wire supports."

Pollock and his wife were living in New York City during these winter months in a house at Nine MacDougal Alley lent to them by artist Alfonso Ossorio and his friend Ted Dragon while Ossorio was in the Philippines painting a church mural. Ossorio had only recently gotten to know the Pollocks after purchasing one of Jackson's 1948 paintings. He recently spoke of the effect Pollock's spontaneity and openness to the subconscious had on him at mid-century: "I realized that Pollock was carrying on exactly in the tradition that I was most interested in, and in a way had bypassed the Renaissance and had gone back to a much earlier tradition of art in terms of dealing with forms and shapes directed by ideas rather than appearance."[40] The work Ossorio did in the Philippines in 1950 outside of the church commission—the "Victorias" draw-

ings, as they are called—seems to be comprised of equal parts of Pollock and of "primitive" art native to that area. The horror-vacui, the obsessive layering of images, the white "spirit-drawing," the uncontrolled look of both Pollock's and Ossorio's work at this time lends it a shamanistic aura. Ossorio's *Orderly Crowd—Famille,* 1950, is among these spontaneous mixed-media drawings with its irregular perimeter of jagged edges. The later "Victorias" drawings become even more intensely obsessive, both imagistically and in the jewellike quality of the paint application. Ossorio's move into encrusted assemblage was a natural one to make from this point.[41]

In a long joint letter to Ossorio when the Pollocks returned to The Springs in late March, they encapsulated their winter season "in town." (Lee is the "I" voice.)

We attended several openings, an educational reception at the museum, an insane dinner party given by [hosts] whom we didn't know, and who weren't there. They hadn't gotten back from South America —heard a part lecture at the Club and looked at endless paintings— Gorky show—good Buffie [Johnson] & Pousett d'art [Richard Pousette-Dart]—alright I guess—Ferber—I didn't like [presumably Pollock did]—Jim Brooks—alright Mary Callery [an openwork metal sculptor of highly abstracted figures]—no—Black & White Show at Kootz— Picasso's romantic picture in color was interesting—Brancusi's Fish and Pollock's painting shine at the museum's [MOMA's] recent acquisitions—The Times & Tribune don't agree with me on Pollock [*Number IA, 1948*]—That about sums up our New York trip.[42]

By the very nature of their endeavor artists are loners. They fiercely defend their rights as independents, and yet they secretly find comfort in the company of like minds. With the traditions of Thoreau and Whitman behind them, and the thoughts of Kierkegaard, Nietzsche, modern anarchists, and existentialists running through their heads, the New York artists were the most militant individualists in American art history. Yet, by April of 1950, they not only sensed that they were part of a group, but went so far as to sit down together around a table at Studio 35 to define their shared position. This roundtable discussion is generally regarded as one of the pivotal events in the history of Abstract Expressionism, and it took place in a historically important place, Thirty-five East Eighth Street, the former home of The Subjects of the Artists School. A few of the instructors at nearby New York University had kept the Friday night speakers series going as part of the continuing education program at NYU. Robert Motherwell taught privately in his own loft, but he stayed involved with events at Studio 35.[1] As the youngest member of the Abstract Expressionist group, and therefore perhaps most in need of colleagues, he saw himself as the group's chief spokesman. In addition to writing catalogue introductions like the one for Kootz's *Black or White* show and delivering lectures around the country about the New York artists, he was compiling the material for the survey of contemporary art he would publish next year, *Modern Artists in America*. A large section of that book would be devoted to this three-day meeting of the minds, April 21–23, at Studio 35, which he helped moderate.

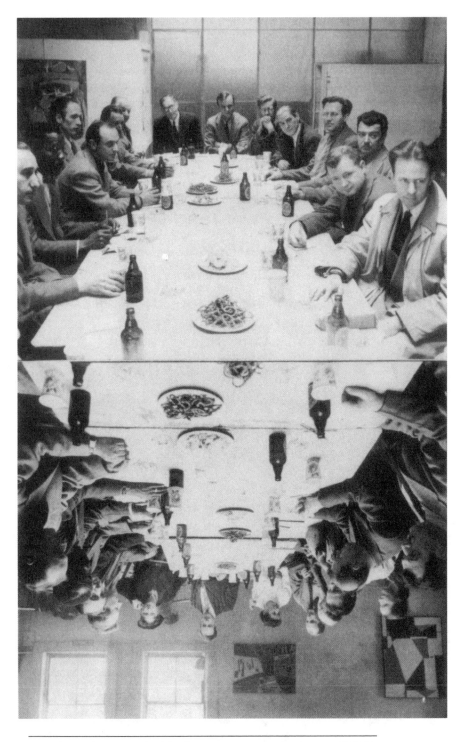

The three-day roundtable discussion at Studio 35, April 1950.

Ironically, at this moment of unity, April, the two most withdrawn and fanatically independent loners in the new Abstract Expressionist movement held one-man exhibitions of their recent work: Clyfford Still and Richard Pousette-Dart. Predictably, the cantankerous nonjoiner, Clyfford Still, stayed completely away from the Studio 35 sessions. But, it is interesting that for all his opposition to the idea of being seen as a member of a group, the other fierce loner, Richard Pousette-Dart, took part in all three days of the talks. He even brought up the question of what common denominator or binding factor joined them all and went so far as to ask if they mightn't each "paint or sculpt upon an agreed subject, theme, idea, or problem"[2] and exhibit the results. Needless to say, no one took him up on his proposal.

Over beer and pretzels, with MOMA curator Alfred Barr, Motherwell, and sculptor Richard Lippold alternating as moderators, the main points covered over the three days did, in effect, address the issue of what made them different from academic abstractionists. Although dozens of artists were invited, only twenty-five attended one or more of the ses-

Ritual *by Norman Lewis.*

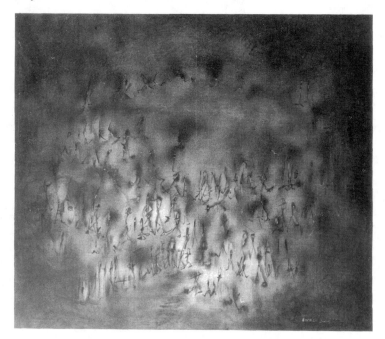

sions. They were William Baziotes, Janice Biala, Louise Bourgeois, James Brooks, Willem de Kooning, Jimmy Ernst, Herbert Ferber, Adolph Gottlieb, Peter Grippe, David Hare, Hans Hofmann, Weldon Kees, Ibram Lassaw, Norman Lewis, Richard Lippold, Seymour Lipton, Robert Motherwell, Barnett Newman, Richard Pousette-Dart, Ad Reinhardt, Ralph Rosenborg, David Smith, Theodoros Stamos, Hedda Sterne, and Bradley Walker Tomlin. Of these three women and twenty-two men, eight were sculptors. Only one Black artist was present, Norman Lewis, despite the fact that one of the teachers sponsoring Studio 35, Hale Woodruff, was Black. Lewis had just closed his March 22–April 15th Willard Gallery exhibition of atmospheric abstractions with vague landscape overtones. His world was poetic and filled with reverie. Like such other Black abstract painters as Hale Woodruff, Romare Bearden, and Thomas Sills, Norman Lewis's "abstract expression" was a gentle, lyrical one, lacking the violence of de Kooning or the force of Clyfford Still.

This was the first time these New York artists had ever sat down together to codify what their work was all about. There were many problems to be talked out in this esthetic version of group therapy. Approximately one quarter of the participants were interested in defining their commonality. Adolph Gottlieb established this theme as important to their discussion at the outset when he said:

> It seems to me that we are approaching an academy version of abstract painting. I think that has some bearing on our meeting here, in that I think, despite any individual differences, there is a basis for getting together on mutual respect and the feeling that painters here are not academic, and we should make some distinctions.

The central questions addressed during the first day's session were how does the artist begin a work, and how does he finish it. Baziotes explained beginning this way: "Whereas certain people start with a recollection or an experience and paint that experience, to some of us the act of doing it becomes the experience. . . . The artist feels like a gambler. He does something on the canvas and takes a chance in the hope that something important will be revealed." The others, too, gave highly characteristic responses. Motherwell, ever the astute analyst, said: "We are involved with 'process' and what is a 'finished' object is not so certain." He added:

I find that I ask of the painting process one of two separate experiences. I call one the "mode of discovery and invention," the other the "mode of joy and variation." The former represents my deepest painting problem, the bitterest struggle I have ever undertaken: to reject everything I do now feel and believe. The other experience is when I want to paint for the sheer joy of painting. These moments are few. The strain of dealing with the unknown, the absolute is gone. When I need joy, I find it only in making variations on what I have already discovered, what I know to be mine. The other mode is a voyaging into the night, one knows not where, on an unknown vessel, an absolute struggle with the elements of the real.

Ebullient Hans Hofmann, whose work rarely seems tortured or dour, said, "My work should reflect my moods and the great enjoyment which I had when I did the work." Newman, with marvelously sharp indirection, answered: "The artist's intention is what gives a specific thing form." Concerning the completion of a painting or sculpture, the majority of the respondents said they thought the work was finished either when they couldn't add anything else or take anything else out. Typically, de Kooning said, "I refrain from 'finishing' it." With wit and practicality, Adolph Gottlieb capped the discussion of when a work is finished by saying, "I usually ask my wife."

Much of the second day's discussion involved the question of titling abstract works of art; very little was resolved. Norman Lewis felt strongly that titles were the conduit through which the artist communicated with the public. Pousette-Dart, who kept his raincoat on during the sessions as though he were always about to leave, nevertheless consistently contributed his thoughts to each topic, though his words often seemed to contradict his actions as an artist. In response to the issue of naming works, he said he thought it would be a "tremendous thing" if they could all agree to use numbers as titles, and yet his own titles are conspicuously loaded with import: *Path of the White Bird, One World, Illumination Gothic.* On the subject of whether or not artists should sign their works, there was much more agreement. The consensus was that de Kooning was right when he said, "There's no such thing as being anonymous"—the artists *were* their work.

The third session involved a complex esthetic discussion of what each artist meant by beauty and whether it had any place in their work. Finally

they got down to practical questions like whether or not they thought of themselves as professionals, which some did and others didn't, and whether they should give their direction or movement a name. Alfred Barr, the museum official, pushed for this, but most of the participants probably agreed with de Kooning when he said, "It is disastrous to name ourselves."

Even though most of the artists were not willing to discuss the issue of communication with the public, they actually made what subsequently became the strongest move the Abstract Expressionist group would ever make toward reaching the public, as the sessions ended. Adolph Gottlieb, who had been doodling and jotting down his thoughts about the upcoming show of contemporary American art at the Metropolitan Museum, suggested that they send a letter to the Met protesting its jury selection process and announcing their decision to boycott the show. The artists liked his idea and agreed to support his efforts. In doing so, the New York painters saw themselves as a group, an avant-garde group, and proclaimed that fact. Even Clyfford Still signed the letter. He may have put it characteristically self-servingly, but nevertheless clearly, when he said years later:

> Although we shared certain basic attitudes, a basic vocabulary, there was no cabal, no gang, no real movement. We were all quite different. These were strong people. They had their hands on a strong thing. I think I may have been the only one who fully realized how strong this thing was. When you have a tiger by the tail, you don't deal with it lightly.[3]

While not close friends, Clyfford Still and Richard Pousette-Dart were gallery mates and they respected each other. Pousette-Dart's March 27 to April 15, 1950, exhibition at Betty Parsons immediately preceded Clyfford Still's April show. Pousette-Dart liked Still because he was, he said, "a maverick who didn't play the art game," but Pousette-Dart's own bellicose bitterness lacks Still's grand style. Slight of build, with small round eyes that always seem wary in their quiescent state (between blazings of anger), Pousette-Dart is not a man who seems happy to be in this world. Perhaps that's why his subject matter is so consistently otherworldly, as titles like *Time Is the Mind of Space, Spirit Head,* and *Burning Stars* indicate. His rhetoric, like Still's, is quite flamboyant, with

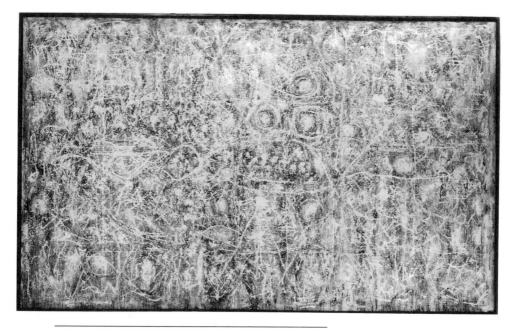

Path of the White Bird *by Richard Pousette-Dart.*

religious references and words like "spiritual," "transcendent," "celestial," "mystical" and "radiant" sprinkled liberally throughout all of his utterances.

Pousette-Dart's 1950 exhibition included intricately linear, abstract paintings and sculptures. The paintings were symmetrical and the light in them was ghostly and radiant; the sculptures had a fantastic, dream-like quality. *Path of the White Bird,* 1950–51, though not in the exhibition, is typical of his work at this time with its enmeshed traceries of white lines in which underlying colors seem embedded like jewels. Every minute particle of the surface is actively pigmented; no air can penetrate the dense linear maze. His obsessively additive process resulted in paintings thick with finely textured pigment, and sculptures that seemed to grow and spread like the shelters and traps found in the natural world, from spiderwebs to stalactite-encrusted caves. He always approached the work directly

with whatever I happen to feel at the moment—felt remembrances of form experience ... derived from places I have been, people, faces, figures, forms, things I have seen, emotions I have felt. An artist makes lines and forms to satisfy feelings within himself that are inexpressible in any other way, the highest things he knows within himself. He writes

his own transcendental language. Art reaches into the unconscious but
is never unconscious. It's a dynamic balance between the conscious
and the unconscious.[4]

Pousette-Dart's name has to be entered in the lists of the bitterly
contested joust about who painted the first really big canvases among
the Abstract Expressionists. If one discounts backdrops and true murals
painted *in situ,* if Jackson Pollock's 1943 *Mural* for Peggy Guggenheim's
foyer is not considered an easel painting even though it was painted in
his studio, and even if Clyfford Still's painting *1944-N* was actually
painted in 1944 rather than the small version of it[5]—then Pousette-
Dart's 90-by-120-inch painting, *Symphony Number 1, The Transcenden-
tal,* which is dated 1941–42 by the artist, would have to be the earliest
truly enormous easel painting in the Abstract Expressionist style. But in
1950, before fame began leading to fortune, and such quibbles became
life-and-death issues, amicable relationships between Pousette-Dart,
Still, Pollock, and the others were not yet being destroyed by arguments
over who did what when.

Pousette-Dart's social position in the New York art world at mid-
century was more equivocal than Still's, but neither man was "one of
the boys." Despite a disclaimer that "I was fiercely by myself and doing
my own stuff . . . I guess I was even belligerent about my aloneness,"[6]
Pousette-Dart has admitted that he saw his fellow artists at openings and
parties through 1950, his last year in Manhattan. He occasionally drank
coffee with Rothko, Newman, or Reinhardt at Horn & Hardart's and was
invited to several dinners at the Rothkos'. He recalls David Smith being
so desperate for money that he attempted to sell him one of his impor-
tant sculptures for seventy-five dollars, but Pousette-Dart was equally
broke. He also remembers Barnett Newman kindly helping him hang
his April show at Betty Parsons. Though he appreciated Newman's assis-
tance, he didn't like the fact that Newman had so much influence in the
art world, and he, like many others, compared Newman's own January
show at Parsons with the "Emperor's new clothes."

The social interaction of the New York artists was a great deal more
complex than the picture one may have of de Kooning, Kline, and the
gang hanging out, beers in hand, at the Cedar Tavern. "People have the
wrong idea about the art world then," Robert Motherwell said. "It wasn't
a monolithic avant-garde. There were about eighteen friends, two or

three involved with each other here, two or three there. Until the Artists Club began [at the end of 1949], there was very little commerce among this collection of artists,"[7] except for the Friday evening sessions at The Subjects of the Artists School. Motherwell recalled that "there were so many cliques fighting with one another that we ran the Friday evenings like a graduate seminar where you couldn't attack the speaker or talk off the point."[8]

In the years around 1950, Robert Motherwell was probably closer to more of the different factions comprising this small avant-garde than was anyone else, though his lifestyle was less bohemian than that of most of the artists, as the following anecdote reveals:

> Living up near Hunter with a job and a family, I didn't have much time to hang out in bars. One night I went to the Cedar Tavern and joined de Kooning and some of the others in their booth. You know how you get to that stage after you've had a number of drinks and you want to buy everyone a round. Well, I wanted to do that and everyone said no, they'd pay for themselves, but I really felt like doing it so I insisted. De Kooning finally said, "Let him pay. He's rich. He's got a job." De Kooning wasn't doing badly then. He'd gotten more money for a painting that year than any of us ever had. [*Excavation,* 1950, won the $2,000 purchase prize at the Art Institute of Chicago.] I had just gotten my bank statement saying that I had about $230 to my name which I showed them saying I was sure he had a lot more money than I. De Kooning said, "Well, let him pay anyway. He smells rich."

Motherwell's close circle of friends at this time included Baziotes, Newman, Gottlieb, Rothko, Herbert Ferber, Bradley Walker Tomlin, and, as of mid-1950, David Smith, even though most of them showed with Betty Parsons while he was with Sam Kootz. Rothko had come into his life in the summer of 1946 when, according to Motherwell, Rothko rented a greenhouse near him in The Springs on Long Island. "He was isolated with no car and I would drive him to the stores. I guess my thoughtfulness must have moved him so he included me with his closest friends—Barney, Adolph, and Herbert Ferber. Adolph introduced Tomlin into the group. It was like an extended family. I like to think of Rothko as my own discovery. I loved his reality and I still think he's the most underrated of the group. As [James] Joyce said, 'A work is only as

authentic as the depth of being out of which it comes,' which is the opposite of virtuosity." Motherwell described the group this way:

Ferber served as a kind of in-house shrink for all of us. Always very reassuring, orderly, and calming. Newman was a friend in a domestic way. He'd send over cold medicine if you were sick, and bring something for the new baby. It was very family-like. Dinners at each other's places.

Earlier in the forties, when Motherwell had Peggy Guggenheim for his dealer, her husband, Max Ernst, and his European Surrealist cohorts formed another interlocking circle, one that Motherwell described as extremely important to him:

After the winter of 1941–42 which I spent in Mexico with Matta [Echaurren] I was full of excitement about Surrealist attitudes and Marxist politics. I talked with Gorky until four o'clock in the morning one night about Surrealist techniques and political matters. Gorky's response was to say, "My politics are to be in favor of whoever's in power." Later we grew to dislike each other. He probably thought me arrogant to be telling him about the possibilities in Surrealism.[9]

Gorky's friends leered at me when I went to [Julien] Levy's. But Matta was the deepest influence on my life. Not his paintings, but his generosity and his accuracy. He was the Lord of the Manor coming down to praise the local blacksmith's well-made shoe. We were both upperclass so he could easily connect with me. It's the international breeding that connects. He was a wine connoisseur, among the many things that made people unable to take him seriously. He still regards me as his best American friend. When [Arthur] Danto wrote about me recently he had a phrase in the piece about my grace among the roughnecks of Greenwich Village. I had to learn about baseball because of all the Irish bars in which I had beers. It took me a while to realize that others were picking up on the refinement as my real character.

Peggy Guggenheim gave lavish parties where liquor flowed the way coffee normally did at other artists' gatherings, and where outrageous behavior was expected. Her parties weren't considered successful unless a fight broke out, a marriage broke up, or a friendship broke down.

Rumor had it that the last male still on his feet at the end of the night kept the hostess company till dawn. A sophisticate like Motherwell could take all this in stride, and even Pollock's characteristically wild behavior when he was drinking could have seemed perfectly normal in Guggenheim's elegant Sutton Place town house. Undoubtedly that is where he began his practice of urinating in the fireplace at parties, a habit of which everyone soon tired. Pollock's twenty-foot 1943 *Mural* in Guggenheim's foyer perhaps even functioned as a kind of indicator of the high jinks in store for her guests with its frieze of violently gesticulating figurelike forms crowded together in a shallow, impacted space. Some of her artists, however, must have felt uncomfortably out of place in Guggenheim's posh surroundings. Clyfford Still, who was represented by her gallery, surely crossed the threshold on only the rarest occasions, and one cannot readily imagine rumpled, unsmiling Rothko, wearing a stained sweater-vest and eyeglasses so smudged they were barely transparent, chatting amiably with some couturier-gowned contessa from Italy.[10]

Instead, in the years before Art of This Century closed in 1947, one would have been more likely to find Rothko with his friends Newman and Gottlieb sitting quietly around the dinner table at painter Buffie Johnson's town house listening to her talk about Buddhism, Jung, and female goddess worship. Johnson remembers entertaining them every other week or so in the early forties, and the discussions ranged widely over topics in philosophy, psychology, anthropology, and Oriental religions.[11] A painter who'd been exhibiting since the late thirties, Johnson had already begun the research into prehistorical great goddess worship which would ultimately result in the publication of *Lady of the Beasts* in 1988. Since she was already something of an expert on ancient myths and religions, subjects that interested most of the New York artists in the early forties, she was undoubtedly an easy-to-tap fount of information. She recalls the artists' being extremely interested in her findings, listening attentively, and plying her with questions, while their wives were absorbed in talk about their respective occupations.

Like Buffie Johnson, the painter Hedda Sterne and her husband, Saul Steinberg, also conducted a very informal Upper East side salon in those years. Their guest lists often overlapped[12] since Newman and Rothko were also frequent visitors here, as were David Hare and some of the Surrealists. Clyfford Still even put in appearances at the Steinbergs',

whom he liked all his life. (In fact, Steinberg was the only artist Still invited to the luncheon in Still's honor at the Metropolitan Museum on the occasion of his retrospective exhibition shortly before his death in 1980.) Both women's parties included important figures in the literary world—Johnson because of her marriage to critic Gerald Sykes; Sterne because of Saul Steinberg's connection with the *New Yorker* writers. (Steinberg's covers and cartoons frequently appeared in its pages, but he built an equally strong reputation in the New York gallery world.) One instance of the visual and literary interaction was *New Yorker* writer Joe Mitchell's reaction to seeing Barnett Newman's January exhibition: he was so impressed by it that he told Hedda and her friends excitedly that he'd "never had such an esthetic experience." Newman, for his part, undoubtedly entertained the writers when he announced at one of Sterne's dinners that he was going to move to a particularly small island in the Caribbean. "They need a prophet," he said. "Any country that has television sets and no electricity needs a prophet." [13]

A story Hedda Sterne tells about Newman also concerns the interaction of writers and artists, in this case Harold Rosenberg, who wrote for *The New Yorker* for many years and who was a frequent guest at her dinner parties. The incident also points to what should now be obvious as a significant aspect of the Abstract Expressionists' social behavior— alcohol consumption. It seems that Newman and Rosenberg had been talking and drinking literally all night, undoubtedly arguing about politics, since Newman was against any "isms" except anarchism, and Rosenberg still had faith in some of the others. It was 7 A.M. and they were still arguing as they stood in front of an apartment house in which one of them lived. Unfortunately their voices wakened someone sleeping behind an open window above them, and an irate woman threw water down on them. Later that day, Newman ran into Rosenberg and said, "I know we were talking all last night, but I swear I don't remember what we talked about." Rosenberg came back with: "Are you kidding? Don't you remember that you said . . . ?" and proceeded to launch into his side of the argument again. Suddenly the fight resumed, the drinking, too, and the cycle was about to repeat itself. The next morning, around the same time, they found themselves noisily arguing under the same window, and once again the woman upstairs doused their ideological fires.

Hedda Sterne said that Rosenberg was a truly phenomenal drinker whose gift for consumption could not be surpassed. She is convinced

that he was largely responsible for turning de Kooning into an alcoholic;
the painter made valiant attempts not to let Rosenberg drink him under
the table. He lost in more ways than one. The problem of excessive
drinking touched nearly all the Abstract Expressionists at one time or
another, and because their consumption of alcohol is firmly linked with
them in the public's mind, the subject must be taken seriously. In the
forties Mark Rothko did his drinking in Jerry's Bar on Sixth Avenue, and
he never became a Cedar Tavern regular, so many people did not find
out how heavy a drinker he was until the end of his life. As we have
seen, Barnett Newman could be similarly affected and Baziotes's routine
included daily stops in the bars. His students at Brooklyn College re-
member that Baziotes often seemed to need to be "tanked up" before
he faced them in class. David Smith became a very heavy drinker and,
like Pollock, died as a result of combining alcohol and driving. Mother-
well had a serious drinking problem for many years, and the sculptor
Tony Smith, who was not one of the Abstract Expressionists but a close
friend of many of them, was an alcoholic.

A story that poet Stanley Kunitz told about Franz Kline is emblematic
of the period.

One night, fifty-seven I believe it was, after dinner there is a knock at
the door, about ten or eleven o'clock. We open the door and there is
Franz toting a case of beer, and a big fellow looming over him also
carrying a case of beer. Franz says, "Here. Here's Charles Olson." As if
to say, here, he's yours. Olson's a poet and we come from the same
city, Worcester, and we're contemporaries, but we'd never met. The
two of them were loaded and Franz was in rare form, and we're sitting
around this little room, which was the room we slept in, too. Both of
them are copious beer drinkers and Franz is going off on a riff that
seems endless. This monologue which went on for hours and hours
until dawn was consumed with one story that had to do with the
roofing of the house in Pennsylvania and a baseball team and a dog,
each of which had something to do with the other, and all the stories
ran into each other. He'd hardly finish one when he'd start another
one, and you never knew whether he was still talking about the dog
or about the roof, but it was the same endless story and it was hilar-
ious! And he thought so the most. He says, "You want to talk about
poetry," but he never let us talk. He had the floor all this time. Mean-

while, Charles, who had opened his mouth at first when he said "Hello" and how glad he was to meet me, never had a chance to speak again. The night wore on and wore on and around towards dawn Franz was still spouting forth these anecdotes of his childhood. They were getting down to the end of that beer and Charles had to go to the bathroom. He got up and suddenly his eyes glazed over and he fell flat on his face, on the floor, right down just like that, and Franz, who was in the middle of a sentence, didn't pause for a word. He finished the story, got up from his chair, and went over to Charles lying face down on the floor, put his foot on his neck and said, "And so another redskin bites the dust." [14]

Hedda Sterne, who knew both worlds, having spent her years as a young artist in Paris amid the Surrealists, says that there is a major difference between the way most Europeans and Americans drink, that the French, for example, drink because they grew up having wine with their meals and drinking is therefore fixed in their daily patterns of behavior, whereas those Americans who drink do so to get drunk. Her ideas were seconded by Donald Goodwin in his book *Alcohol and the Writer*. Goodwin's findings would seem to hold equally true for many modern American artists, particularly the Abstract Expressionists. Goodwin gives three explanations for why so many writers drink: 1. "The hours are good" when you're answering to no one about how you spend your time. 2. "It is expected," because you're supposed to be tragic, lonely, passionate, dissipated, and doomed, and drinking is a fine way to accomplish all that. Goodwin quotes the writer John Cheever on this point: "If you are an artist, self-destruction is quite expected of you. The thrill of staring into the abyss is exciting. . . ." And 3. The need for inspiration. Here Goodwin quotes Nietzsche, who wrote in *Twilight of the Gods* that "For art to exist, for any sort of aesthetic activity to exist, a certain physiological precondition is indispensable: intoxication." [15] Both Motherwell and Baziotes were fascinated with Baudelaire's similar ideas about intoxication, and Baziotes quotes the poet on the subject in his notes:

One must always be intoxicated. That's the main thing: it's the only issue. In order to feel the horrible burden of Time which breaks your shoulders and bows you to the earth, you must become intoxicated

without respite. But with what? With wine, with poetry or with virtue, as you please? [16]

William James once wrote that "one of the charms of drunkenness unquestionably lies in the deepening sense of reality and truth which is gained therein." [17]

Another more obvious charm is the socialization that cocktail parties or "nights out" in a tavern permitted. Drink pushes the "on" button. The politician Huey Long (played by Broderick Crawford in *All the King's Men,* a 1950 movie) was so turned "on" after his first drink that he was miraculously transformed into a spellbinding orator. And the social code of the time actually encouraged drinking. In fact, the list of movies and plays in 1950 in which drinking played an important or central part was so extensive that a writer for *The New York Times* noted the popularity of "stage tipplers" in a Sunday, April 2 column. [18] He cited *I Know My Love,* Uncle Louis in *The Happy Time,* the drunken sailors in *Mister Roberts,* Charlie Chaplin's *City Lights,* the champagne drinking in *Gentlemen Prefer Blondes,* and, of course, Eliot's *The Cocktail Party.* He might also have mentioned *Tight Little Island,* the English play about a shipwrecked cargo of whiskey on a dry British isle, and Budd Schulberg's *The Disenchanted,* a thinly disguised portrait of F. Scott Fitzgerald's last alcoholic days as a Hollywood screenwriter. This was one of the best-selling books of 1950. Such excess was tragic, but highball drinking (cigarette in hand) was very much the norm in the postwar years. One can hardly imagine a movie where the stars were not so posed. Even innocence himself, Jimmy Stewart, regularly meets his pooka friend Harvey, the invisible rabbit, for martinis in a bar.

Paradoxically, instead of releasing the flow of ideas and images, alcohol can stem it for some who suffer from overly stimulated imaginations. Their minds race, their synaptic activity is in high gear, and they need something to push the "off" button. Willem de Kooning and Jackson Pollock can both be seen anew in this light. Overwhelmed by having to decide moment by moment, stroke by stroke, between this line and that, this color or that, this shape or that, de Kooning was rarely able to finish a picture in the early years. Each small part of the canvas held innumerable alternatives; each image came with an endless ancestry of related images; each picture could be, could have been, countless others. This hysteria of indecision reached its acme in *Woman I,* which he started in

1950 and abandoned as unfinishable before it was resurrected and "completed" in 1952. By that time de Kooning had begun to have some measure of success, and for him, as for all the others, with success came more alcohol consumption. By the time he had become a functional alcoholic, he no longer had such problems finishing a painting.

Pollock, whose prodigious drinking made all the other artists seem like sherry sippers at a tea, may simply have had even more stimuli to drown. Trying to paint the myriad images that flooded his mind by dragging a brush through viscid pigment was unbearably frustrating. The method couldn't keep up with his "madness." Once he changed to a swift method—spilling, dripping, flinging the liquefied paint onto the canvas—he could let the web of intricate imagery take over. The paint spoke for itself, for himself. Even though the resultant images were wildly entangled, literal outpourings of his jumbled thoughts and feelings, he experienced "an easy give-and-take" with the canvas while he made them. As viewers, we float on an almost euphoric plane of liberated consciousness when beholding them—as if we are birds soaring over an endless sea of briar thickets on which we never have to land. While method and "madness" were fused (between 1948 and the end of 1950) he didn't need alcohol to control the profusions inside his head anymore, but when he later resumed the drawing of semi-figurative images, he also went back to the bottle.

Depression and drinking are two definitely linked conditions for many solitary creative people, but often these conditions are accompanied by insomnia, hypochondria, anxiety, and a host of phobias. (Not surprisingly, incessant smoking is another common oral activity connected to this elemental pair of "D"s.) Mark Rothko was the classic epitomization of the depressive side of the drinking-artist syndrome, but Baziotes, Motherwell, David Smith, and Philip Guston had also been frequent victims of this reaction. Profound gloominess would often overtake Rothko in mid-sentence at a dinner party, and without a word he would get up and walk (in silence) into another room or simply go home. Late in life he frequently drank himself into a stupor, like the Consul in Malcolm Lowry's *Under the Volcano,* published at the end of the forties. Lowry once said, "The real cause of alcoholism is the complete baffling sterility of existence as *sold* to you." This immense sense of spiritual isolation is an emotion we know Rothko felt. In this state one is completely self-absorbed; one's work is oneself, it is the only

solution to the dilemma of existence, it is the only moral deed on which one can depend, and it consumes the artist totally.

Clyfford Still, the artist Rothko undoubtedly was closest to in spirit, felt exactly the same way, but he handled the situation in a diametrically opposite form: he got angry. Instead of turning his frustration inward, on himself, he focused it outward, lashing out at everything he found wrong with a world that didn't understand him. As in everything else, because he always seems to have played against type, Still, neither a depressive nor a drinker, was virtually a teetotaler. Ethel Baziotes recalls an episode when she and her husband were having drinks with Still at the Plaza Hotel. Each had a scotch, but when a second round was suggested, Still declined, saying, "This stuff has licked better men than me." Constantly insisting that he wanted "to make it perfectly clear," Still was driven to determine every aspect of his life, and alcohol represented a threat to his absolute control.

When Clyfford Still moved to Manhattan in 1950 he looked very much the way he had looked for the previous five or six years and would look for the next three decades before his death in 1980. He was tall and quite thin, with a neat, trim beard and mustache, and his hair was gray. His face was lined in that good ol' country way that signifies years of squinting in the sun on the farm. He was obsessively neat in appearance and in his living and working situations. He wore a shirt and tie even while playing baseball, and wore spats well into the forties. A Scottish tam or a beret was often set firmly on his head, and a scarf always seemed to be in place around his neck. Unlike the other artists, Still was never photographed with a glass in his hand. In fact, the only thing he ever seems to hold is something with which to make art.

Instead of needing artificial stimulants, Clyfford Still was intoxicated by Baudelaire's last option—virtue. Witness the following excerpt from Still's diary:

Quiet. Broken by the stretching of four canvases. A great free joy surges through me when I work. Only, the conceptions are born too quickly. And with these tense slashes and a few thrusts the beautiful white fields receive their color and the work is finished in a few minutes. Like Belmonte weaving the pattern of his being by twisting the powerful bulls around him, I seem to achieve a comparable ecstasy in bringing forth the flaming life through these large responsive areas of canvas. And as the blues or reds or blacks leap and quiver in their

tenuous ambience or rise in austere thrusts to carry their power infi-
nitely beyond the bounds of the limiting field, I move with them and
find a resurrection from the moribund oppressions that held me only
hours ago. Only they are complete too soon, and I must quickly move
on to another to keep the spirit alive and unburdened by the labor my
Puritan reflexes tell me must be the cost of any joy.[19]

Without the Freudian overtones, the words Still uses to describe his
emotions as he paints are the ones most often used to describe his
work. In one of his earliest critical mentions[20] the "swift" and "dashing"
nature of his brushwork was singled out; by 1947, *Art Digest* critic
Alonzo Lansford was saying that Still's "jagged patterns . . . evoke curious
and foreboding feelings of mysticism which are intriguing and a little
frightening."[21]

Again and again one finds writers using adjectives such as flamelike,

1950 – A No. 2 *by Clyfford Still.*

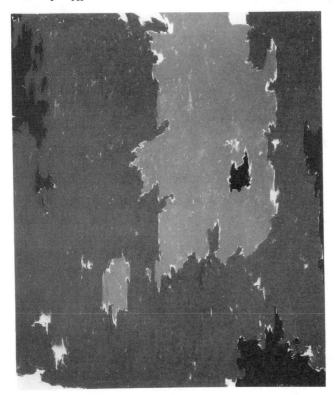

slashing, churning and spurting, ragged, rent and torn, molten, raw, and most often, violent, especially with the pictures in his April 17–May 6, 1950, exhibition at the Betty Parsons Gallery. In these paintings of 1948–50 he had finally and completely forged his image world and he would never veer away from it for the rest of his life. He had broken free of the constricted, turgid, and gloomy neo-Gothicism of the earlier work. Gone were the smooth silhouettes of even the most foreboding shapes, replaced by extreme agitation along all the edges of his lambent interlocking forms.

1950-E, in the Metropolitan Museum of Art, is a typical and particularly fine example of the pivotal work Still was doing at mid-century. Every square inch is alive. All the silhouettes are irregularly activated to create maximum interaction between figure and ground. Only slate-blue, black, and white, plus small amounts of dark red and yellow, figure in this painting, but in a given canvas Still rarely used more than four or five colors, customarily separating them so that usually no more than two colors abut. Thus the formal action isn't optically coloristic at all; it is purely a light/dark, matte/glossy, figure/ground interaction. In *1950-E* yellows flicker along the white edges as if to open up ragged channels through solid matter into a lighted space beyond. The drama takes place primarily between the deep variegated blue area and the looming black form that seems to rise up and overwhelm the blue like a thunderhead. In fact, the feeling is very like one of roiling storm scenes by Salvator Rosa or Jacob van Ruisdael, and the harsh, flickering light reminds one of El Greco. The painting is activated all over, yet unified into a single expressive whole by that agitation. If it weren't for the speed and the sharp points by which color cuts into color, one would be put in mind of debris-laden molten lava spewing sparks and steaming ashes as it moves inexorably over the earth's surface. Critics used such words as "assault" and "confrontation" to describe Still's work, and that is how Still saw it too:

> When I expose a painting I would have it say, "Here am I; this is my presence, my feeling, myself. Here I stand implacable, proud, alive, naked, unafraid. If one does not like it he should turn away because I am looking at him. I am asking for nothing. I am simply asserting that the totality of my being can stand stripped of its cultural camouflage and look out on the factional people who pass before me and see

them without rancor, desire or fear." Certainly I will not be the pawn of any man's judgement.[22]

Still arrived in New York in 1950 fully prepared for the kind of exposure his work would have. His rhetoric was honed to a knife edge. He had lived in New York for various periods during the forties and was cognizant of what was going on in the studios of the most advanced painters. Artist friends such as Rothko had been invited to teach at his bailiwick, the California School of Fine Arts (CSFA) in San Francisco during the heyday of his reign there in the late forties. Still's forbidding reputation had also been spread by his CSFA students, who remember the powerful visual impact he made in 1946 when he first appeared at the school in a long black overcoat. They all confirm his messianic style and radical austerity.[23] John Grillo, studying at the CSFA on the GI Bill, described Still's studio at the school as "the God damnedest cell you ever want to see." Jon Schueler, another of his students, said that Still demanded "absolutes of himself in everything." Schueler was struck by his "extreme purity" and by the "terrifying demands" he made on himself and therefore on everybody else. Hassel Smith, who taught at the same school, was convinced that Still thought of himself as a new messiah, speaking feverishly about painting's potential ability to "blow the world apart" and about the artist as a guerrilla fighter in a deadly serious war. As a result, Still's students loved him, and everyone else kept his or her distance.

Rothko may have felt as though he should or could have been the Savonarola of Abstract Expressionism, but Still really *was*. In his eloquent and often vitriolic sermons to students, friends, and captive audiences large and small, Still violently attacked the vices he saw running rampant in the art world. He was uncompromisingly severe in his condemnation of artistic corruption and he called for the regeneration of spiritual and moral values and a devotion to artistic asceticism. He meant it when he wrote:

The work itself, whether thought of as image of idea, as revelation, or as a manifest of meaning, could not have existed without a profound concern to achieve a purpose beyond vanity, ambition, or remembrance, for a man's term of life. Yet, while one looks at this work, a warning should be given, lest one forget, among the multitude of

issues, the relation I bear to those with "eyes." Although the reference is in a different context and for another purpose, a metaphor is pertinent as William Blake set it down:

> THE Vision of Christ that thou dost see
> Is my vision's Greatest Enemy:
> Thine is the friend of All Mankind
> Mine speaks in parables to the Blind:
> Thine loves the same world that mine hates
> Thy Heaven doors are my Hell Gates.

Therefore, let no man under-value the implications of this work or its power for life;—or for death, if it is misused.[24]

It is safe to say that no artist has ever written in such a seriously evangelical manner about his work. Was he simply crazy, as many people who have read his statements think? Perhaps. Such an idea has been expressed more than once in print, even in an exhibition catalogue.[25] But the people who knew him well don't seem to think so, even after he broke off his relationships with them, as he inevitably did with most friends. Baziotes, who liked Still, called him "the minister," and Ad Reinhardt, who didn't (perhaps because they had so much in common), said, "Still was terrific when he was assaulting everybody, when he was angry." De Kooning thought he was a fanatic, but Franz Kline typically defended Still by saying "but he's a painter," when Elisabeth Zogbaum, Kline's friend, remarked on Still's poor manners even though Kline probably agreed with her. "He made no effort at even the most common civilities," she recalls. "He couldn't be bothered. I guess he thought he was above it all."[26] To put it mildly, Still wasn't one for small talk. He would carry on in the same hypercritical and preacherly manner at any social gathering.

But Still knew that he should return social favors at least once in a while. One time in 1950 or 1951, when he lived in Greenwich Village, he threw a party, as he explained, "in order to pay back all the people who'd had me over for dinner." The party fare consisted of a hunk of cheese on the kitchen table—a wooden block into which Still had stuck some knives. Dinner at the Stills' on Twenty-third Street a few years later remained a two-couple affair for lack of space, and the food was eaten off orange crates.[27] As late as 1970 when critic Katharine Kuh visited his

Maryland studio with *Vogue* photographer Anthony Snowden to do a profile piece on him for the magazine, all the Stills had to offer the weary crew after a long day of unrolling paintings to be photographed was a plateful of soggy graham crackers and some tea. They were forced to undergo this repast standing up in a small area of the kitchen, which was crammed with rolled-up paintings like every other room in the Stills' huge American Gothic house.[28] Even the guest bedroom was full of canvases. Metropolitan Museum curator Lowry Sims recalls that she spent the night at his house while she was working on his 1979 retrospective and she had to crawl over the canvases to get into bed.

There were only two things Still did that seemed "normal," and even they had a fanatical edge. He adored cars, big, fancy cars. The painter Ed Dugmore, a Still student whose touch never lost its reticence despite Still's powerful influence, remembers a Silver Bullet Jaguar with wooden side panels which Still "loved like a baby" and polished obsessively. When he first moved to New York he would invite Dugmore to go out with him to visit the car in Brooklyn, where its parking garage cost more than Dugmore's studio rent. Still always had huge gas-guzzling cars with luxurious leather interiors even though he was parsimonious in the extreme about everything else. Dugmore also became involved with Still's other "American" obsession—baseball. They went to the ballpark together or watched the games on TV in bars, Still not drinking. Unlike almost every other artist who rooted either for the Dodgers or, like Dugmore, the Giants, Still was a Yankee fan. Uncompromising absolutist that he was, Still especially loved pitcher's games, thrilling over a shutout. He even played sandlot baseball on Astor Place with some of "the guys" from the Artists' Club, and he and Dugmore threw a baseball back and forth in Central Park when weather permitted. Dugmore recalls that Still's pitches were so fierce he had to really concentrate on catching them to avoid injury.

Still married twice and had two children, but he kept everything about them secret, even from his students, the people with whom he usually spent most of his nonteaching, nonstudio time. John Grillo remembered being quite surprised when he found out that Still was "just as caught up in the complexities of daily life as anyone else, with a wife and kids and a girlfriend on the side."[29] Still's second wife, Patricia, survived him, as did his two children, Diana and Sandra. The children endured an exceedingly overprotected and overcontrolled childhood with their

Clyfford Still with Ed Dugmore in Central Park for an afternoon of ballplaying in the early 1950s. (Photo by Eadie Dugmore)

stern father. What they read, how they played—almost all their non-school activity was determined by Still.

How and why did Clyfford Still become such an extremist? His beginnings were quiet enough. He was born in Grandin, a small North Dakota farming town, in 1904, and a year later his father, an accountant, moved the family to Spokane, Washington. When he was six, they moved again, this time to a homestead in Alberta, Canada, though they retained the house in Spokane, living there during the winters while Clyfford attended school. It seems he was always interested in art and learned art history from books and magazines. Using the local preacher's library, he found such books as *Masters Everyone Should Know* in which reproductions of his favorite painters—Velázquez, Rembrandt, and Turner—were outnumbered by those of the English Pre-Raphaelites he detested. He loved reading Greek dramas, also Carlyle, Ruskin, and H. L. Mencken, and he studied music by subscribing to *Etude* magazine and memorizing the piano works of Beethoven, Schubert, and Chopin. Years later he said he had always been interested in "the kind of vastness and depth of

a Beethoven sonata or a Sophocles drama—the possibilities of human-
ity, of aspiration and joy and tragedy they represent."[30] He also found
his way to Nietzsche, Tolstoy, and Blake, who remained important
sources of inspiration throughout his life. All three were the kinds of
fervently independent thinkers and relative social outcasts that he, not
coincidentally, became.

The turning point in Still's life seems to have been his first trip to New
York at the age of twenty-one. He was disappointed by seeing the paint-
ings he had become so familiar with in reproductions, and by the Art
Students League, where the curriculum included "all the exercises . . . I
had already explored for myself some years before and had rejected . . .
as a waste of time."[31] His enrollment at the League lasted approximately
forty-five minutes by his own count. After that he painted on his own
and soon came to the conclusion that "very few of [the great artists]
merited the admiration they received and those few most often achieved
true worth after they had defied their means and mores." The art world,
he decided by the age of twenty-five, was full of "aesthetic puerilities
and cultural pretensions," and critics were "as completely ignorant of
the whole of painting which they befouled and presumed to direct, as
they were inept in the art of writing." In later years he rejected every-
thing post-Cézanne, and looking back at the thirties, he saw the situation
this way:

> The manifestos and gestures of the Cubists, the Fauves, the Dadaists,
> Surrealists, Futurists or Expressionists were only evidence that the
> Black Mass was but a pathetic homage to that which it often presumed
> to mock. And the Bauhaus herded them briskly into a cool, universal
> Buchenwald. All the devices were at hand, and all the devices had
> failed to emancipate.[32]

The thesis he submitted in 1935 (at the age of thirty-one) for his
master's degree at Washington State College in Pullman, Washington,
was entitled *Cézanne: A Study in Evolution*.[33] It is an intimate revelation
of what must have been his own state of mind as he evolved into the
new messiah of painting, since practically everything he wrote about
Cézanne was true of himself, either then or later. Still seems to have
identified completely with Cézanne and his struggle. He stresses Cé-
zanne's violent temper and uncouth behavior, excusing it by saying he

thereby shrewdly concealed his inferiority as a provincial lacking in social graces. Still wrote:

> But recognizing his inability to meet the world on its own terms he wisely withdrew to the refuge of his work. He married and begot a son. Always he painted. . . . Convinced the world was not ready for him, and having no need to make money, he retired to his estate in the south. There, avoiding and avoided by painters and townspeople alike, he pursued the lonely and isolated way.[34]

This is precisely what Still himself did when he moved to a small town outside Baltimore, Maryland, in 1959, but he'd always been at least a partial recluse even while he lived in Greenwich Village. He would periodically tell people he was "going out west for a while" and then he would hole up in his studio for a few weeks of uninterrupted work. Herman Cherry, who had a studio in the same building as Still at Forty-eight Cooper Square, rarely saw him. Some years later, at a panel discussion at The Club, when Thomas Hess was reporting at length that Still had told him this, and Still had told him that about his work, Cherry said he found it hard to believe that Still had talked so intimately to anyone. "I had a loft in the same building as Still for years, and the only thing he ever said to me was 'Good morning.' I never answered him back because I didn't want to invade his privacy."

Still's description of Cézanne's lifework foretells his own: "He started his career with a reckless elemental vigor and the most complex subject matter." He closed it, "persistently searching, unappreciated, hypersensitive, with an unbending will."[35] When discussing Cézanne's paintings Still stresses the "ragged detached edges," "heavy planes," "massive structures," and "rhythmically synchronized rugged volumes"—all of which characterize his own work.[36] Still regarded the total impression made by a work of art as more important than the "emotive fragments. The particular or superficial became subordinated to the whole."[37] Still quotes Coleridge's definition of the means to all great art as: "The subjugation of matter to spirit so as to be transformed into a symbol in and through which the spirit reveals itself."[38] This is a concept of art with which he identified as much as he thought Cézanne did. Still devoted a major section of his dissertation to a lengthy quotation from Cézanne in Joachim Gasquet's book *What Cézanne Said to Me.* In quite

fascinating ways, the passage that Still chose reflects the Abstract Expressionist esthetic as we have already seen it. Cézanne tells Gasquet that he can't allow a single crevice in the painting which would let the emotion, the light, the truth, escape. Thus he advances the whole of the canvas at one time and then:

> My canvas joins hands. It is full. But if I feel the least distraction, the least weakness, above all, if I interpret too much one day—if today I am carried away by a theory which is contrary to that of the day before, if I think while painting, if I intervene—why then everything is gone. The artist should quiet within himself all the voices of preconceived opinion. He should forget, forget, be silent, make of himself a perfect echo.[39]

Still stands virtually alone in his complete rejection of modern European painting after Cézanne. No traces of Matisse, Picasso, Mondrian, Miró, or any other Europeans can be found in his work.[40] The English painters J. M. W. Turner and William Blake were, in fact, two of the very few artists Still ever talked about positively to his students. This English bias seems natural given his Scotch-English genealogy, but it is nevertheless a maverick position. Blake's influence was probably stronger in Still's earlier work, where it is fused with darkest Cézanne in symbolically portentous imagery. Blake's swirling, trailing, streaming lines, his closed but greatly elongated silhouettes, and his apocalyptic flames lighting nighttime skies can readily be found in Still's paintings of the late thirties and early forties. "Agonized, tortured, foreboding," one reviewer said of his work. "They are a hieratic vision of hell on high."[41]

Still's pictorial expression of the sublime in painting later shifted into a grander, less lurid mode. Contact with Rothko and Newman may have played a role here, but Turner is central to his mature, awesome, and ecstatic concept of sublimity. William Gaw, one of Still's fellow CSFA instructors in 1945–46, remembers that Still had numerous reproductions of Turner's paintings around his studio, but no such clues to Still's artistic genealogy were apparent in subsequent years. When Gaw asked Still about them, Still replied that "most of these nonobjective guys do the same thing, it gives me a certain feeling."[42] If you look at Turner's paintings as abstractions, turn them on their sides or upside down, suddenly you see a strong, dark/light compositional structure that re-

sembles Still's. More to the point, you see that the violent turbulence of nature at its most elemental and destructive—its most sublime—which Turner tied to the real world of ships at sea and trains in a storm, is emancipated by Still's abstraction into a universal dynamism of natural forces.

Still had fused these streams of influence into a unified vision by the end of the forties, and when he exhibited that "vision" in 1950 at the Betty Parsons Gallery at least one critical response was appropriate: the *Art News* reviewer said he "paints a world that is powerful and dense, where life and death themselves merge." For Still, as for Blake, the conflict between good and evil was irreconcilable. Given this as fact, both men believed that constructive work, the creative acts of free people, offered the only hope for humanity. Such work represented a new, an alternative religious vision in human society. A man's work was everything.[43] Any impediment to it, any nonprescribed use of it, any weakening of one's total responsibility for it, was tantamount to following the devil's path to perdition. "We are now committed to an unqualified act," Still stated in the catalogue of the *15 Americans* exhibition at The Museum of Modern Art in 1952, "not illustrating outworn myths or contemporary alibis. One must accept total responsibility for what one executes. And the measure of his greatness will be in the depth of his insight and his courage in realizing his own vision."[44]

Blake controlled the printing of his engravings so that his vision is always intact, his work "unqualified," word and image immutably fused. Turner wanted all of his works to go to the National Gallery, which was to build a special wing or gallery for them because he thought of them as his "children" and he wanted to keep them together. But Turner's will was betrayed by his executors and his intentions thwarted. Still undoubtedly had the tragedy of Turner's legacy in mind when he made extremely limited stipulations in his own will concerning the fate of his paintings after his death.[45] He gave two museums excellent representations of his work while he lived—the Berkeley Museum and the Albright-Knox Art Gallery in Buffalo. But all the rest of the nearly two thousand paintings left when he died[46] are to go only to a municipal (not private, and therefore a financially disinterested) museum that will agree to supply a separate building, curator, restorer, and staff for his work and never to sell it or let it leave the premises. He often told how he had traveled three hundred miles as a young man to hear a Rachma-

ninoff concert, so he felt it was the least one could ask of people who wanted exposure to his life-altering work that they travel to see it. Still so fanatically controlled the conditions under which his paintings were seen and would be seen after his death because he fervently believed that his vision *could* change the world.

Knowing how nearly impossible it would be to attain this dream (all these works remain in storage today to their physical detriment and our esthetic loss), Still was obsessed with the Metropolitan Museum retrospective of 1979–80, which he saw as his last chance to control the way his artistic vision reached the world. According to Katharine Kuh, he had been diagnosed as having stomach cancer while the show was being organized and had been told he should have an immediate operation. He declined, saying, "I will not be operated on until this show is over."

"It meant so much to him," Kuh said. "He wanted that show in the Met more than anything in the world." [47]

Still controlled every aspect of the exhibition—which paintings were chosen, where they would be hung, and how they would be discussed in the catalogue; he even prevailed upon his friend Katharine Kuh to write the introduction while he wrote the rest of the text himself. By the time the exhibition was over, it was too late for the operation. Two weeks before he died, Still visited Katharine Kuh while he was in New York to see his doctor. "He was in the most terrible pain," she recalled, "but his behavior was unbelievable. He was so wonderful. He sat in this room and talked to me. I could see he was in terrible pain. He looked so badly, my heart went out to him. He was still angry, he still said the same things. He talked only about art; he didn't talk about his problems at all. And when he left he walked me to the elevator and at the elevator he was still this tall, erect . . . and he was dead white. I could see he was in agony, and he said, 'So, this is it, my friend Kathy,' and he shook my hand. Still once said, 'Where I grew up, when there were snowstorms, you either stood up and lived or laid down and died. You make your peace with certain forces.' " [48]

After the close of the sessions at Studio 35, Adolph Gottlieb immediately went into action drafting the letter boycotting the Metropolitan Museum's planned exhibition of "American Painting Today—1950." He called upon his friends Weldon Kees, Robert Motherwell, Ad Reinhardt, Barnett Newman, and Bradley Walker Tomlin for advice. Since Rothko, his former manifesto-writing accomplice, had already left on his trip to Europe, Gottlieb had to get his comments by telegram. Financial considerations—the high cost of cables—may have contributed to the admirable brevity of the letter's final version. Once the very terse wording was decided upon, a process which took nearly a month, the letter was mimeographed and sent to the twenty-eight signatories: fourteen painters who had supported the initial proposal for the letter at Studio 35, plus Mark Rothko, Clyfford Still, Jackson Pollock, and Fritz Bultman, who hadn't attended the sessions; and seven of the sculptors who had, plus Day Schnabel, Mary Callery, and Theodore Roszak.

Once signed, on May 20 the letter was placed in the expert hands of Barnett Newman to bring to the attention of the public. When Motherwell asked him later, "How in God's name did we ever get on the front page of *The New York Times?*," Newman gave him the answer with a smile: "You don't know, but years ago I ran for mayor of New York. During that time I learned how to get to the city editor's desk. So I just phoned it."[1] The next day, dressed to the nines and looking far more like a prosperous lawyer than a painter, Newman handed the following "exclusive" across the city desk:

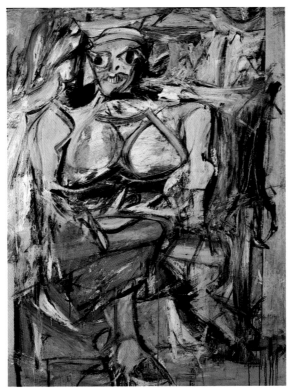

Woman I *by Willem de Kooning*

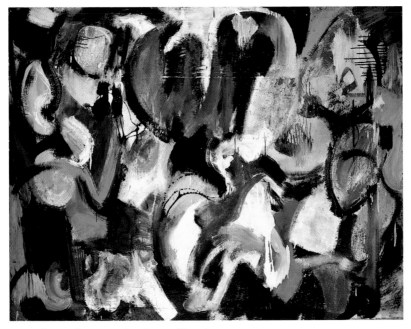

Months and Moons *by Grace Hartigan*

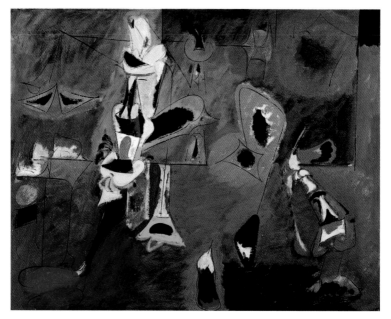

Agony *by Arshile Gorky*

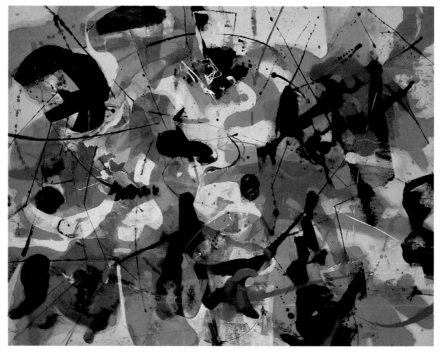

Number 42 *by James Brooks*

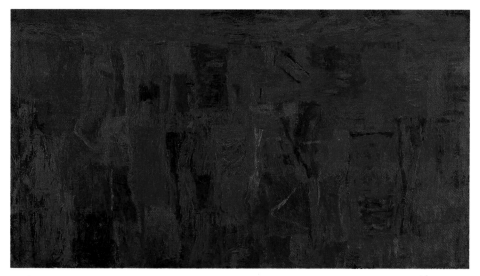

Red Painting *by Philip Guston*

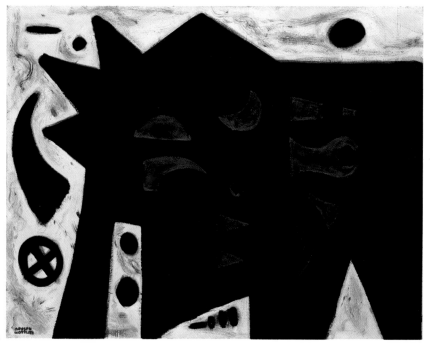

Castle *by Adolph Gottlieb*

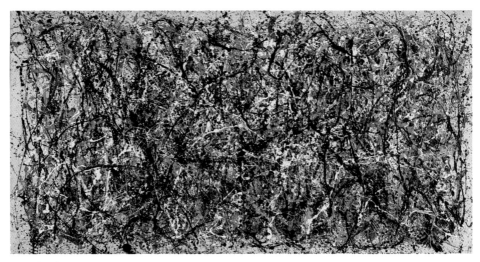

One (Number 31, 1950) *by Jackson Pollock*

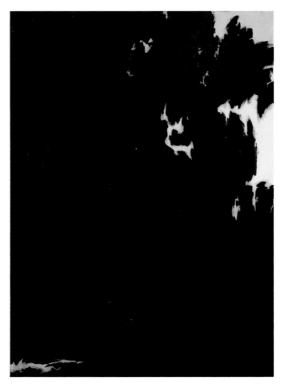

1950 – E (PH-372) *by Clyfford Still*

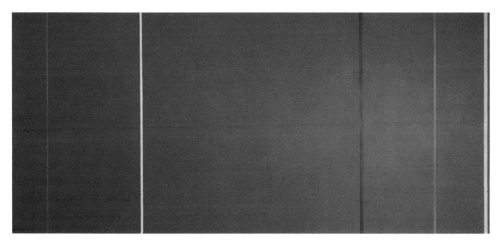

Vir Heroicus Sublimis *by Barnett Newman*

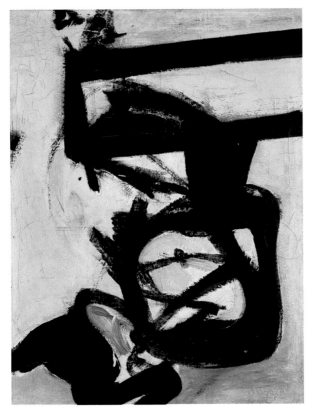

Nijinsky *by Franz Kline*

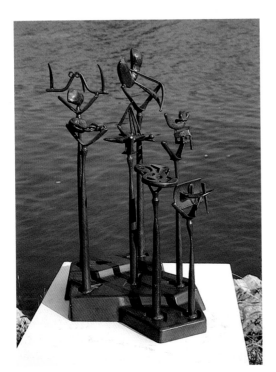

Sacrifice *by David Smith*

Gothic Frieze *by Lee Krasner*

Yellow Still Life *by Robert Motherwell*

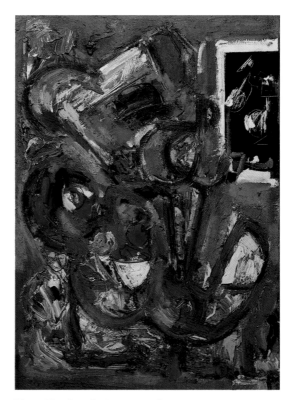

Blue Rhythm *by Hans Hofmann*

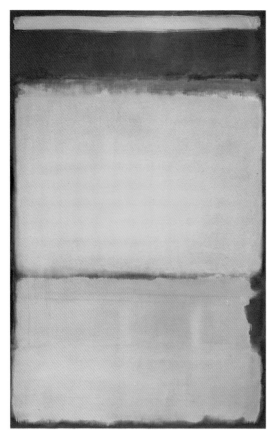

Number 10 *by Mark Rothko*

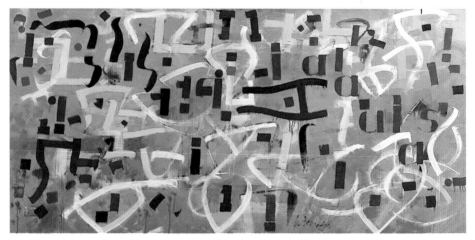

Number 9: In Praise of Gertrude Stein *by Bradley Walker Tomlin*

May 20, 1950

Open Letter to Roland L. Redmond
President of the Metropolitan Museum of Art

Dear Sir:

The undersigned painters reject the monster national exhibition to be held at the Metropolitan Museum of Art next December, and will not submit work to its jury.

The organization of the exhibition and the choice of jurors by Francis Henry Taylor and Robert Beverly Hale, the Metropolitan's Director and the Associate Curator of American Art, does[sic] not warrant any hope that a just proportion of advanced art will be included.

We draw to the attention of those gentlemen the historical fact that, for roughly a hundred years, only advanced art has made any consequential contribution to civilization.

Mr. Taylor on more than one occasion has publicly declared his contempt for modern painting; Mr. Hale, in accepting a jury notoriously hostile to advanced art, takes his place beside Mr. Taylor.

We believe that all the advanced artists of America will join us in our stand.

Jimmy Ernst	Ad Reinhardt
Adolph Gottlieb	Jackson Pollock
Robert Motherwell	Mark Rothko
William Baziotes	Bradley Walker Tomlin
Hans Hofmann	Willem de Kooning
Barnett Newman	Hedda Sterne
Clyfford Still	James Brooks
Richard Pousette-Dart	Weldon Kees
Theodoros Stamos	Fritz Bultman

The following sculptors support this stand.

Herbert Ferber	Seymour Lipton
David Smith	Peter Grippe
Ibram Lassaw	Theodore Roszak
Mary Callery	David Hare
Day Schnabel	Louise Bourgeois

Fortune smiled and there were no major news flashes to fill the front page of Monday's paper—only an earthquake in Peru, sixty more explosions in a New Jersey phosphorous fire, a 15 per cent increase in automobile liability costs in New York, Germany's Konrad Adenauer speaking out in favor of a united Europe, and Britain's Labour Party promising a "moderate" policy. There was room for two columns of text under this headline—"18 Advanced Painters Boycott Metropolitan; Charge 'Hostility to Advanced Art' "—with the story continuing on page 15. In addition to quoting from the letter and listing the signatories, the unsigned article related Newman's explanation that the advanced artists were critical of all the highly conservative juries—regional, national, and award-giving—that the Met had set up. It ended by saying that Met Museum President Redmond was in Europe and both Hale and Taylor refused to comment on the letter until they saw it.

And so the problems of a group of relatively unknown artists were suddenly front-page news. Protests of museum policies had been made by artists before, sometimes even by large groups of artists, as the American Abstract Artists had done in the thirties, but this was the first time artists' protests had made such an impact. Then, just as success breeds more success, the story on the front page of the *Times* stimulated *Life* magazine to run an article on the situation, and this meant that a picture of the artists had to be taken. The group photograph itself created a movement in the mind of the public at large, and through this photo the history of American art was forever changed.

The caption for the group photo in *Life* was "The Irascibles," and it came from a specific reference. Undoubtedly irked by not having been allowed to break the story, *New York Herald Tribune* art critic Emily Genauer took the side of the museum against the artists in an unsigned[2] May 23 editorial titled "The Irascible Eighteen." In her piece, Genauer warned the artists that their "irascibility" could only harm their cause since museum directors are "apt to become so irritated with unjustified criticism . . . [as to] render them immune not only to constant sniping but also to new ideas." She claimed their accusation that the museum was "notoriously hostile" to advanced art was unfounded, since works by some of the signers had been included in recent exhibitions and had even been purchased by the museum and would soon be included in the summer exhibition of its American collection.

Genauer was answered on May 25 by Gottlieb, again with the help,

primarily, of Newman and Reinhardt. The letter was written over the signatures of the same twenty-eight artists, but it was never published. The artists pointed out that the exhibitions Genauer referred to were not organized by the Met, which, in fact, posted notice to that effect disclaiming all responsibility for the selections in one of these shows, "Artists for Victory." As to the few paintings by the protestors owned by the Met, Gottlieb's letter stated that it was "incredible that this [the few advanced paintings among the many academic works purchased] ought to be regarded as real recognition; it only shows that the prestige of advanced art is sufficient that a few examples of it will be tolerated by the Metropolitan." Weldon Kees, albeit far from impartial on the subject, backed Gottlieb up when he pointed out in his June 3 column in *The Nation* that the Met's "cushy Hearn fund, bequeathed to it generations ago for purchasing work by living American artists, has been left in the vaults, most of it, and what little has been touched has been spent for paintings that might as well have been chosen by the Elkhart Bide-A-Wee."[3]

Kees began his column with a review of Bradley Walker Tomlin's exhibition at the Betty Parsons Gallery. On view from May 8 to May 27, this was Tomlin's first show in six years and his first at that gallery. Personal tragedy had come together with a profound change in his art, and the new gallery, a hotbed of "advanced" painting, was appropriate for his new imagery. All the reviewers noted the change, but Kees made it the main point of his piece. Calling Tomlin "the most recent convert to a style of painting for which we still have no satisfactory name . . . and which is marked by a free, imaginative, and highly personal Non-Objectivism," Kees noted that Tomlin had given up working "impeccably and gracefully in the Cubist tradition" and was now covering his canvases "with swirling calligraphy and dripping paint." Tomlin's emotions were much more evident in the new images, Kees said, which became "symbols of tension and discord." Indeed, beneath the suave urbanity of Tomlin's gently sardonic social manner, behind his slender elegance and his immaculately groomed appearance, lay a soul in turmoil, wrestling with his materials like Jacob with the Angel.

Three of Tomlin's finest paintings—truly his masterpieces—were in the Parsons exhibition: the very large, squarish *Number 20* of 1949 in subdued, Braque-like grays, tans, and greens; the vertical *Number 7* in stately, somber hues; and the unusually long, horizontal canvas,

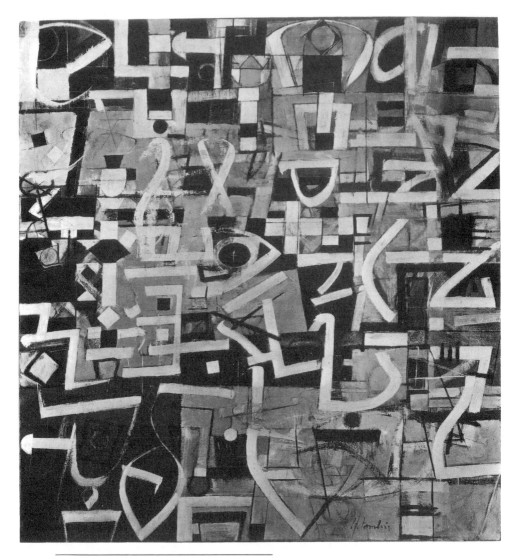

Number 20 *by Bradley Walker Tomlin.*

Number 9: In Praise of Gertrude Stein, 1950. It is almost as though all the forces that brought Abstract Expressionism into existence coincided to produce one shining example in which its many aspects might join at this particular moment. In all three paintings black-and-white is in equal partnership with color, as happened so often in the work of this period by Pollock, de Kooning, Gottlieb, and Motherwell. The residue of the spontaneous handmade mark—drips, smudges, ragged edges—is present alongside the palimpsests of the marks he made earlier and changed. A sense of compartmentalization recalls Gottlieb's Pictographs

even here where the grid is very loose, and a melancholy, even nocturnal, light pervades the canvases, a light that shares something with Brooks and Baziotes. Tomlin's paintings are large and they are charged all over their surfaces with energy in the "classic" Abstract Expressionist manner. His way of working is closer to de Kooning's procedure of execution and erasure than to Pollock's additive method, but the results resemble Gottlieb's paintings more than those of anyone else. The Swiss artist Paul Klee's small but highly evocative pictographic abstractions influenced both Gottlieb and Tomlin. However, the Americans' scale is enormous by comparison, and their attack is powerful, while Klee's approach is reticent.

Ribbonlike shapes—ovals, ellipses, arrows, crosses, as well as letters (L, E, S, T, I, and A in particular)—dance across the surface of Tomlin's paintings in a calligraphic labyrinth. As in Gottlieb's work and in some late forties de Koonings, one is surprised by their incomprehensibility. Islamic, Oriental, and other ornate script can be read, but these shapes cannot. Tomlin's repetitive forms resemble sheet music—notes for a song which cannot be sung. Poetry, too, was a central inspiration to Tomlin, as his crowning achievement of 1950, *Number 9: In Praise of Gertrude Stein,* indicates. One yearns to read the cryptic, agitated script scrawled with such seeming urgency across the painted surface. Instead of being stymied by the impossibility of doing so, one returns over and over to the musically interwoven forms on imaginary staves which seem almost to create sounds. Where a line seems to end in a period-like dot, the eye stops; where it flows off the edge, one senses continuation. Rhythmically bouncing along the painting's lower edge are three open-ended ellipses recalling Stein's repetitive phrase—"A rose is a rose is a rose."

Tomlin had in fact been a guest in Gertrude Stein's Paris salon during the twenties. (He met Georges Braque there, a painter who was surely one of his idols. One can readily see Braque's influence on Tomlin's Cubist paintings of the early forties.) Gertrude Stein's characteristic manner of repeating words until their meaning shifts or disappears, her near-hypnotic, incantatory vocal style, and her "allover" or non-hierarchical blanketing of imagery exactly parallels the pictorialism of Tomlin's mature work. And there are fascinating similarities between her way of working and the Abstract Expressionists' modified automatism. The American Mabel Dodge, with whom Gertrude Stein and her friend

Alice Toklas were staying in the south of France during the autumn of 1912, described Stein's working habits this way:

> Gertrude always worked at night. After everyone was asleep she used to sit . . . writing automatically in a long weak handwriting—four or five lines to the page—letting it ooze up from deep inside her, down on to the paper with the least possible physical effort; she would cover a few pages so and leave them there and go to bed, and in the morning Alice would gather them up the first thing and take them off and type them. Then she and Gertrude would always be so surprised and delighted at what she had written, for it had been done so unconsciously she'd have no idea what she'd said the night before.[4]

Her passivity, her determination to let the images flow unimpeded from her pen and then her refusal to alter even one word later was her way of being completely honest, of expressing herself exactly as she was, warts and all. Stein's writing was "intended as an exact description of inner and outer reality."[5] While not all the New York artists were so completely passive, their acceptance of accidental effects, drips, pentimenti, smudges, etcetera, their spontaneous and unpremeditated way of working in a near-trancelike state, being "in" the painting, or one with it, are all akin to her working style. A flowing, allover, rhythmic labyrinthine image results for both poet and painter.

Tomlin came to this new way of working late in the forties—when he was himself in his late forties. Having been born in 1899, he was among the eldest members of the New York School once he made his "conversion" to the new American way of painting. His earlier way of living and working came to an abrupt end in 1945 with the death of Frank London, his dear friend and studio companion of more than twenty years. Adolph Gottlieb (for whom poetry was crucial, as we have seen) stepped into the breach left by London, but he was only the first of a series of supportive influences on Tomlin between 1945 and his untimely death in 1953; Motherwell, Guston, Pollock, and Brooks were among the others. Having made his acquaintance earlier, Tomlin invited Gottlieb to his studio for lunch not long after London's death. Gottlieb remembered that

> Tomlin seemed quite sad, lonely and at loose ends. He indicated great interest in my work and told me he felt the need to break with what

he had been doing and get on a new track. My impression was that the cubist type of still life he had been painting for years bored him and the new direction he saw in my pictographs made him feel his own work was dated and old hat. He seemed very curious about all the newer painters, wanted to meet them and was enthusiastic about the new directions in which painting was going.[6]

One painting of Gottlieb's in particular, *Sounds at Night,* 1948, affected Tomlin very strongly. Gottlieb said that Tomlin suggested the title for the painting when he saw it in the studio because it "struck him as a visual equivalent of sound." The painting was included in Gottlieb's January 1950 show at Kootz, but in the meantime Tomlin's style had become dominated by white linear shapes the width of a flat brush on a dark ground, similar to those in *Sounds at Night.* Clement Greenberg noticed the similarity between the two men's work as early as 1948, but the close proximity of their shows in 1950 caused confusion in some critics' minds about who did what first. Gottlieb had a direct effect on Tomlin's homage to Gertrude Stein as well, as the following anecdote indicates:

Sometime in 1951 I believe [1950, in fact], when Tomlin was sharing a studio with Motherwell at Astor Place, I dropped in to see them. Tomlin was working on the large canvas that the Museum of Modern Art now owns [*Number 9: In Praise of Gertrude Stein*]. It was tacked to the wall. Tomlin said he'd been working hard on this painting, and still had considerable work to do on it. He particularly wanted to make some changes in the lower left corner. I told him emphatically that in my opinion it was his best painting, that it was right the way it was and he should leave it alone. I did not think he was convinced and feared he would over work and spoil it. However when I later saw the canvas exhibited, I realized he had left it exactly as I had said to.[7]

When a painting was finished was a concern of the Abstract Expressionists, as we have seen, but in Tomlin's case his very great technical skills as a painter could cause him to over-finish a canvas. The wildness of *Number 9 . . . ,* its raw, barely controlled, almost frenzied élan, is precisely what makes it so great a painting. He rarely matched its fervor and, in fact, the painting he left unfinished on his easel when he died suddenly of a heart attack in 1953 has a quite similar spiritedness. In that last painting, *Number 15,* as in the MOMA canvas, one is not merely

presented with the end product of a series of decisions, but one is given the opportunity to view the process of its making, the starts and jumps, the suggestions left unfulfilled, the assertions made and then abandoned in favor of others. In this way—more extreme in *Number 15*—his work came closest to that of Pollock, his idol in 1953. Tomlin had just returned from visiting the Pollocks when he was stricken; he had been in the beginning stages of purchasing land near them in The Springs so he could see more of Jackson.

"Tomlin used to have crushes on people," Motherwell once said.[8] "He liked me, because he regarded me as a gentleman, too; but he loved me, as he did Philip Guston and Jackson Pollock, because of a wholehearted and perhaps reckless commitment on our parts . . . to painting, and the acceptance of the consequences it brings about in one's life. The three of us [were] filled with a self-torment and an anxiety that was alien to Tomlin, but to which he must have deeply responded to have loved us so much in turn. He simply ignored our wives."[9] In the winter of 1949–50 Motherwell shared his huge Astor Place studio/school[10] with Tomlin. Though Motherwell tended to use his studio at night, and Tomlin preferred painting in daylight, they sometimes painted side by side, even perhaps sharing the same palette, or so it seems when one compares the color in certain of their works from this period. The studio was above a bookstore which they both haunted. Tomlin gave Motherwell a book of English criticism of T. S. Eliot's poetry for Christmas and received in exchange Joyce Cary's *The Horse's Mouth.*

One highlight of their time together, Motherwell recalled, was Tomlin's very encouraging remark that it was "beautiful to see a Motherwell coming into existence." He also remembered the day that Tomlin kept him from destroying *The Voyage,* 1949, and *Granada,* the first large-size work in his *Elegy to the Spanish Republic* series:

> It happened in a moment when I was literally suicidal and was ready to destroy not only the paintings but myself. An artist has an inner radar and can detect whether one is polite or is sort of enthusiastic or really means it from the gut, and his reaction [to the paintings] was really from the gut. And in that sense maybe I owe my life to him. . . .[11]

Motherwell benefited from Tomlin's presence in his life, but Tomlin got something he needed from this relationship as well. Judging by the

importance of Frank London to him in the early years, and Gottlieb more recently, Tomlin seemed to have been very much in need of a strong guiding hand. In Motherwell's words:

> I think it was essential to him. I don't mean in any sexual connotation, but it's almost as though he were the kind of woman who was ideal when there was a strong husband and very much at sea without a strong man present. The man had to have a certain charisma of one kind or another. . . . It had to be both the man and his artistic position simultaneously working.[12]

Tomlin's personal life may explain his uniquely dependent position in the New York School. Love and art came to be fused in Tomlin's mind early on in somewhat similar ways: a strong, encouraging mother to whom he stayed closely tied all her life;[13] teachers who made him their pet once they saw how well he drew; prizes, commissions, and scholarships in high school and college, and a successful early career in magazine illustration. On the other hand, Tomlin set forth a painfully revealing glimpse into the negative aspects of an artist's psychological situation in a story fragment he wrote when he was probably in his early thirties. It concerns a ten-year-old boy named Humphrey who is caught painting in the room of his fifteen-year-old sister Alice—forbidden territory for him and his paint box. While he stands sheepishly biting his lip or chewing the handle of his paintbrush she harangues him for everything from making a mess and letting the light in on Mother's carpet to not blowing his nose. "You're worse than your brother Robert," she shrieks. "At least he gets filthy playing baseball, not fussing around like a sissy playing with a paint box."

> The tense look on the boy's face gave way to a kind of inner recoil. His lip trembled slightly and he sniffed. He turned to the window to hide the emotional strain which had suddenly become acute. His breath came sharply in small regular jerks.
>
> Alice never failed to recognize Humphrey's faculty of sudden withdrawal when he was wounded. . . . [She] loved Humphrey and did not like to hurt him. In spite of the fact that she could recognize Humphrey's moods and reactions, she could never anticipate them and as a result frequently tortured the little boy without meaning to wound

him. . . . Nevertheless it was only to Alice that Humphrey turned instinctively for understanding. She knelt down now and her arm slipped around Humphrey's waist. The boy's breathing changed to a violent intake of air which was expelled in a series of quick gasps. Then the defense mechanism collapsed and he turned from the window and threw his arms around his sister's neck. He sobbed convulsively.[14]

Many of the images in Tomlin's story, as childish and elemental as they may seem, actually bear consideration in the light of the messy Abstract Expressionist way of painting and the criticism it engendered, particularly in the popular press. Equating Jackson Pollock's actions to that of a criminal by calling him "Jack the Dripper" may lie at the extremity of disapproval for "bad" behavior on the part of the artist, but there is no doubt that the public and the genteel artistic tradition of the past were both opposed to this new, rough and ready way of handling of paint. American taste had always favored neatness in pictures—in the nineteenth century, the Hudson River School's microscopically rendered detail had been the acme of neatness—and of popularity—and even in Europe the image one had of the artist was that of a dandy, dressed in an immaculate frock coat and beret, daubing paint on a preframed canvas without getting a spot of it on the Oriental carpet beneath his feet or the silk coverlet on his chaise. Tomlin had had such a studio in Paris in the twenties, but it is obvious from his story fragment that he yearned to make a mess, to blast out of the constraints of "good behavior" through his art, and he did so after 1945 when he fell in with the Abstract Expressionists. In fact, the notion of the "well-made picture," of painting as some kind of *haute cuisine,* was exactly what the Abstract Expressionists were out to destroy.

The touch of guilt for having committed a forbidden act, the shiver of mixed pleasure and fear for having done so which Tomlin so openly described, is also a part of the creative experience. De Kooning told a friend that many times he wakes up and is extremely depressed. "But then I hear the sounds of children outside in the street and I go to the window. I see them going to school with all their books, and I'm immediately cheered up. I think, 'Thank God, I don't have to go to school.'" There is a sexual component to messing in the viscid material of paint as well—de Kooning's line that "flesh is the reason oil paint

was invented" rings true. Then, too, Pollock's drip began a series of connections in more than a few writers' minds between the painting act and male ejaculation. But there is also a scatological overtone. The notion of the artist laden with guilt, dirtying his clothes or body with paint as though he were playing with excrement, is an idea alluded to by art critic Eugene Goossen. For Clyfford Still, Goossen said, "paint is a scatological element smeared cosmetically over the canvas."[15]

The image of the artist as bohemian or ruffian was not characteristic of Tomlin personally. Motherwell once said that Bradley Walker Tomlin looked like "the son of an Anglican Bishop or a British general, he had an air—so that it would have surprised none of us if indeed he had been, though I realize now that he was his own construct, from his military mustache to the Brooks Brothers scarf."[16] In fact Tomlin's older brother became an Episcopal minister, and the artist once criticized him for having had his photograph taken in street clothes rather than in his clerical robes. Tomlin's father had been an invalid, and he himself was physically frail all his life. At college in Syracuse he managed to get another student to take the required physical training test in his place so he would be eligible to graduate.

Elegant, sensitive, handsome, and witty are the descriptive adjectives that are used most often about Tomlin. His friend Frank London was elegant and cultured in the Southern style, despite the fact that, according to Tomlin, he often petulantly claimed he despised Southern ways. London was very dapper and eccentric; he wore small wire-rim glasses, had a mustache, and smiled with his lips shut and nearly pursed. A pinky ring and a walking stick were ever present accoutrements. Tomlin apparently met London when he was about nineteen or twenty and London at least twice that age. They shared studios in Paris and New York, both in Woodstock and in London's town house on Manhattan's East Side. Unlike Tomlin, London was married, and he had a son named Marsden, probably named after another friend, the painter Marsden Hartley. London introduced Tomlin to the joys of flea-marketing, which they did together daily in Paris and London. They haunted antique shops and had a great reputation among their friends as ingenious interior decorators because of all their "finds." The only times they were not together during their twenty-five-year relationship were when Tomlin lived alone in Woodstock or shared a studio there with someone else, and for a two-year period in the mid-thirties when Tomlin moved across

from London's Forty-eighth Street town house to a studio of his own. A painter, Gwen Davies, whom Tomlin had known from Woodstock, had a studio in that building, and though there was some talk of a possible marriage, entertained and encouraged by their friends, it never came about. Tomlin moved back into the studio in the Londons' town house, and he and Davies remained friends. She found him a place near hers after London died.

Despite being quite different from the macho-male art establishment of mid-century Manhattan, Tomlin managed to find a niche there. He was a regular habitué of the Cedar Tavern in the early fifties, even though he might sit alone at his table rather than join the raucous activity in the booths or at the bar. In terms of his art, rather than his life, the fact is that the Abstract Expressionist movement was so powerful it was able to sweep some artists along with it who might never have been able to create such emotional abstraction on their own. By this time it was "in the air" and the effects were being felt all over New York.

Yet when *Life* selected "19 Young Americans" as "the country's best artists under 36" to feature in their March 20, 1950, issue, it failed to recognize the new spirit in art. Calling *Life*'s article a "journalistic egg" Weldon Kees wrote:

> What is significant and vital in recent art activity in this country—the emergence of a radical, original, and pervasive movement animated by Abstract, Fauve, Expressionist, and Surrealistic influences, which has its most extreme expression in the work of such enormously influential men for young artists as Hans Hofmann, Jackson Pollock, Arshile Gorky, Willem de Kooning, and Richard Pousette-Dart—is here completely bypassed. It is as if one wrote an account of recent pictorial journalism without mentioning *Life* and its contemporaries.[17]

Two of the artists *Life* selected were distinguishable from what Kees saw as "a cast of art-school medal-winners and housebroken scholarship perennials whose feet are firmly planted in the past." Kees didn't single them out, but Theodoros Stamos and Hedda Sterne were working abstractly and shared something of the new spirit in New York art. They are the only "younger" artists chosen by *Life* who would reappear in its pages later on among "The Irascibles."

Almost as if he intended to show *Life* the kinds of artists they ought to

have selected, art dealer Sam Kootz mounted an exhibition of "Talent 1950" at his gallery in May consisting of twenty-three unknown or little known New York painters, most of whom were under thirty years of age. The selections in this show had been made by art critic Clement Greenberg and art historian Meyer Schapiro on a Sunday tour through cold-water flats cum artists' studios in Greenwich Village some weeks before. In his article on the exhibition in the May *Art News,* Thomas Hess said that Greenberg had been "one of the first to champion the now increasingly recognized group of 'extremist' U. S. abstractionists," and that Schapiro was an equally distinguished authority on medieval and modern art. The results he added, were one of the most successful and provocative exhibitions of younger artists he'd ever seen.

The best work in Kootz's show was informed with the vigor we associate with Abstract Expressionism, and was created with its semi-automatic process of give-and-take with the canvas. Many of the painters included would go on to establish major reputations during the fifties, among them Grace Hartigan, Elaine de Kooning, Al Leslie, Joe Stefanelli, Leatrice Rose, Hyde Solomon, Esteban Vicente, and most importantly, Franz Kline. Esteban Vicente, a senior artist from Spain who had been

Brown Paper Collage *by Esteban Vicente.*

living in New York since 1937, had only recently begun to employ automatist procedures in the creation of his imagery. He came to them through collage, but they loosened his structure sufficiently to liberate his painted line and his color in ways that would sustain him for the rest of his life. He would exhibit the results of his new way of working the following November at the Peridot Gallery. Franz Kline would be making a major stir with his new black-and-white abstractions at the Egan Gallery just before then, but Greenberg had inexplicably selected a portrait for the Kootz show rather than one of the new paintings, and the work didn't make much of an impact.[18]

Like many of the others in the Kootz New Talent show, Grace Hartigan had been completely enveloped by the new wave of painterly abstraction by 1950. Within a couple of years she would abandon abstraction, and all of her imagery would be drawn from photographic sources, but her paint handling has always retained its expressionist fervor. Influenced primarily by her friends Pollock and de Kooning, she felt so much like "one of the boys" that she actually used the name George Hartigan until 1954.[19] It is a measure of the esthetic utility of the Abstract Expressionist approach that Hartigan, like Tomlin, was able to make utterly personal statements in the idiom at this relatively early stage in its evolution. Hartigan's 1950 painting *Months and Moons* has the large, bold, rhythmically curvilinear forms, and the rich color that would characterize her work for life. The forms take their cue from a color advertisement for pancakes which the artist glued in the lower left "to keep the picture going."[20] The golden pancakes shift into crescent and whole moons, the moons become silvery gray and bespotted with brownish-blood reds. The allusions to women's cyclical biological ties to the moon are not accidental, though the painting itself is full of pictorial incident that happened by chance—drips and spatters, poured contours and smudges of wet paint into wet.

Wild and beautiful Grace Hartigan was twenty-eight in 1950. She had been married twice and had a son by then, but her commitment to the new American way of painting was so complete that she actually broke up a relationship with one man because he didn't like Jackson Pollock's work. She was married to her second husband, artist Harry Jackson, at Lee and Jackson Pollock's house in The Springs in 1949. Her close friends Helen Frankenthaler and Joan Mitchell shared her enthusiasm for Pollock and were in the process of developing their own forms of

The King Is Dead *by Grace Hartigan.*

Grace Hartigan in Essex and Hester streets studio, around 1950.
(Photo by Walter Silver)

Abstract Expressionism largely from his example. But in 1948 Pollock had encouraged Hartigan to seek out Willem de Kooning, which she did, and her long friendship with him proved to be an even stronger and more lasting influence on her work. It is fully evident in *Months and Moons*.

Abstract Expressionism was essentially a painting movement, and perhaps therefore it is fitting that the most "pictorial" of the advanced sculptors of the day—David Smith—should have come to be seen as the movement's leading sculptor. The work for which Smith is best known tends to be flat and frontal rather than conceived "in the round," and it is linear rather than bulky, like traditional sculpture, which is

David Smith welding in his Bolton Landing studio. (Photo by John Stewart)

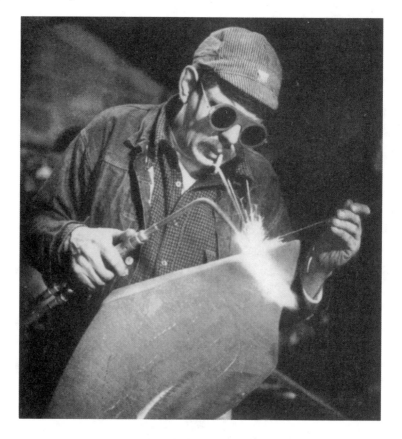

conceived in terms of masses and volumes. Historically, sculpture has been a slow medium; it takes time to carve, to cast, or to build up on the armature—the three basic, premodern ways of making sculpture. David Smith was a fast-moving, improvisational, gestural-seeming sculptor whose work reflects the speed and excitement of mid-twentieth century life. Steel, and the welding techniques which make it possible to join steel elements in midair, liberated Smith to create sculptures which have the immediacy of the new American paintings.

Speaking in terms of the work, rather than of friendships, David Smith was closer to Jackson Pollock than to any of the other Abstract Expressionists. In their work of the early forties, both artists bring the structures and formal devices of Cubism to bear on broken facets of reality and on fragmented psychological imagery suggestive of Surrealism. The emotional and imagistic violence of both men's work is extremely close at this point and shares a clotted, turgid desperation, though they hardly knew each other. Their common grounding lies in Picasso's prewar expressionism, the tortured portraits of Dora Maar, and the tragic eloquence of *Guernica*. Pollock and Smith each made a great leap forth at mid-century into the "classic" linear imagery we have come to recognize as one of the hallmarks of Abstract Expressionism. Technical factors caused both artists to make this leap: Pollock, by switching in 1947 from applying paint with a brush to the swifter methods of dripping and pouring liquid paint onto the canvas, and Smith by concentrating, after 1949, on steel as his medium instead of using combinations of metals (iron, steel, bronze), and on welding rather than on other fabrication methods such as soldering, brazing, casting, or forging. All of Smith's greatest sculptures are welded steel: *Helmholtzian Landscape*, 1946, *Royal Bird*, 1948, *The Letter, 24 Greek Ys, Star Cage,* and *Sacrifice,* all of 1950, and *Australia* and *Hudson River Landscape* of 1951, in addition to certain works in the later *Voltri* and *Cubi* series. "Possibly steel is so beautiful," Smith felt," because of all the movement associated with it, its strength and functions. . . . Yet it is also brutal: the rapist, the murderer, and death-dealing giants are also its offspring."[21]

Released by their own innovations in their respective mediums, the two artists matured simultaneously as well. Smith's flying arcs and aerodynamically swift fragments are the exact sculptural equivalent of Pollock's webs and loops of pigment. Both have the quality of signature images; Smith's were exhibited for the first time in May 1950 at the

Marian Willard Gallery, halfway between Pollock's November 1949 and December 1950 Parsons Gallery exhibitions of his famous "drip" paintings. Both artists peaked at mid-century and then retreated from the implications of their achievements in abstraction to a more comfortably familiar semi-figurative style in the early fifties. Pollock died before he could find his way into a new and satisfactory abstraction; Smith lived to see its fruition in his almost "futuristic" stainless steel *Cubi* series of the sixties.

David Smith and Jackson Pollock were both violent people. Motherwell has said that he thought Americans were inherently violent, but among the New York artists, no one came remotely close in this respect to Pollock and Smith, and no one so freely expressed this violence physically, both in their work and in their lives. (Both died in high-speed automobile accidents.) While Pollock's behavior was predictably tied to his consumption of alcohol, Smith's was more generally erratic. His raw psychic nerves could be triggered by little things his family and friends had no way to anticipate. Superficially, Smith's deep but surprisingly sweet voice and his expansive, big-soft-teddy-bear style were entirely winning, but the anger seething beneath this lovable exterior was always ready to erupt, and had been since he was a child. In addition to such dangerous but still relatively normal boyish activities as jumping back and forth between moving freight cars on parallel tracks in the Paulding, Ohio, railroad yards, he used to set off dynamite in the fields around his hometown, and he once loaded and fired the Civil War cannon in the town square.

Smith was born on March 9, 1906, in Decatur, Indiana, a town his great-grandfather had helped to found, but the family moved to Paulding when he was fifteen. His father was an official with the telephone company, and like many Americans of his generation, he worked on various inventions in his spare time. Smith recalled:

> When I was a kid, everyone in town was an inventor. There must have been fifteen makes of automobiles in Decatur, Indiana; two blocks from where I lived there were guys building automobiles in an old barn. Invention was the fertile thing then . . .[22]

The tinkerer-inventor tradition provides a solid base for modern American sculpture. Alexander Calder's inventiveness with wire, his mobiles,

and motorized sculptures are as firmly set in this tradition as Smith's incorporation of machine parts and other mechanical contrivances and "found" objects in his sculptures.

David Smith's mother was a teacher and a very active member of the Methodist Church. She promoted puritan values at every opportunity, and Smith rebelled against her oppressive conventionality whenever he could. Late in life, two of the things he said that "sculpture is" were "praise from a grandmother for a mud pie lion" (created when he had been tied to a tree to keep him from running off to the refuge of his grandmother's house) and "the found book of nude marble women hidden by a schoolteaching Methodist mother."[23] Smith told Frank O'Hara in a filmed interview that all his sculptures were girls. "I don't make boy sculptures," he added.[24] But from his earliest days of fashioning female images in the mid-thirties, Smith tended to mutilate, dismember, or otherwise destroy the integrity of the female form in a completely non-Classical, brutally expressionist manner. Taking a major clue from Alberto Giacometti's *Woman with Her Throat Cut* of 1932, which was included in the 1936 MOMA exhibition *Fantastic Art, Dada and Surrealism,* he seems to have intuitively understood the sadistic misogyny that lay at the heart of Surrealism. More often than not in Smith's early work, the female is recumbent, not like a seductive odalisque, but rather as a victim. Human brutality was one of Smith's main themes. In the race for survival some fall; there are the oppressors and the oppressed. "Specters" haunted him and his work, specters of greed and rapacity causing death and destruction, vicious animals, and predatory birds. Usually the victim is female.

And the sad truth is that David Smith abused women, both verbally and physically. Not all the time—he could be wonderfully charming and a great companion when he chose to be—but both of his wives left him because of his brutality. Dorothy Dehner, a painter who met Smith when he came to New York in 1926[25] and married him a year later, said that she had no idea about this side of him during their courtship. One week into their marriage, however, he exploded into violence.[26] His mother had sent them a complete meal (in those days practically all the mail was overnight so you could do that)—a roasting chicken ready to cook with all the fixings. Dehner set the table with silver candlesticks someone had given them as a wedding present, laid out the food, poured him the glass of milk he always liked to have with meals, and called him

to the table for the feast. Though Freud would say chance was not involved, given Smith's hatred of his mother's conventionality, he accidentally knocked into the table as he sat down and the milk spilled over into the food. Dorothy Dehner barely uttered "Oh, David . . ." before he swept the entire dinner up in the tablecloth and threw it against the wall. He ran out the door leaving his wife frantic with worry. Sometime later he was brought back to the house by two burly men who had fished him out of the ice-floe-filled Hudson River into which he had leaped. His clothes were frozen to his skin. She got him undressed and put him to bed with a hot drink. When she asked him to promise that he'd never do anything like that again, he replied, "I won't promise anything to anybody."

It was a few years before something like that happened again, but then episodes of domestic violence occurred with increasing frequency throughout the thirties and forties. "But that was the only time that he ever took his anger out on himself," Dehner said, "except unconsciously. He used to burn himself a lot," she remembers, "and then he would come running to me saying, 'Dorothy Dehner, Dorothy Dehner, fix my finger.' " But he never burned himself seriously or had other kinds of major accidents while working despite the heavy materials and machinery he used. When he acquired his first welding rig in the mid-thirties he set it up in their Brooklyn apartment, and while he welded, his wife, sprinkling can in hand, ran here and there putting out the fires in the loose drawings tacked to the surrounding walls.

In 1934, Smith found a place in the Terminal Iron Works on the Brooklyn waterfront where he was allowed to set up his equipment and could finally weld without danger. He loved working with two Irishmen in that shop, men named Blackburn and Buckhorn, and he reveled in being one of the boys, drinking with them at Red Mike's, the local "men only" saloon. Smith's language was ever after liberally sprinkled with four-letter epithets. He recalled that Red Mike's was a place where "we ate lunch, got our mail, and accepted it as a general community house. It was the social hall for blocks around. Any method or technique I needed, I could learn it from one of the habitues, and often got donated material besides."[27] He loved the idea of being a workman like any other, and all his life he was very proud of his union membership.

Life in Brooklyn during the Depression was very full. In addition to the eight-to-four workingmen's hours he kept, he continued to draw

and paint at home. (All his life he kept two studios for these separate but linked activities.) Dehner and he spent the better part of 1931 in the Virgin Islands in a kind of exotic Gauguin exile, making art out of beach detritus, and most of 1935 on a trip to Paris, Greece, and Russia. After purchasing a farm at Bolton Landing in the Adirondacks, they spent the warm months there every year, giving up their apartment and selling its furnishings each spring, only to acquire some secondhand replacements the following fall to furnish another flat. The Brooklyn evenings at home were often spent with their good painter friends Lucille Corcos, Edgar Levy, and Esther and Adolph Gottlieb, who lived nearby. They sketched one another, and at one point made an etching jointly, doing so on a plate pulled on Gottlieb's press. Senior artists like Arshile Gorky, the Russian expatriate John Graham, and the master of American Cubism Stuart Davis often joined them during the evenings. The Graham-Gorky-Davis axis had developed such a distinctive style of painting in the thirties using black outlines and bands in the manner of Picasso that they were caustically referred to as "the stripe painters." Smith's paintings of those years were influenced by Stuart Davis, but his earliest sculptures are derived either from the welded work of Picasso, Julio Gonzales, Jacques Lipchitz, or the "nightmare" assemblages of Giacometti and the Surrealists. It is not until 1950, when he fully committed himself to welded steel and an open, linear, graphic kind of sculpture, that the influence of Stuart Davis's black-band pictorial framework could be seen in Smith's sculptural work.

In 1940 Smith and Dehner moved permanently to the farm in Bolton Landing. Life there, it seems, was quite idyllic in a pioneer sort of way. In a charmingly faux-primitive picture of 1942, *David and Dorothy in the Garden of Eden,* from her "Life on the Farm" series, Dehner depicted the two of them standing naked in front of the barn, one of his arms around her waist, the other resting on a shovel, amid an orchard of apple trees and grape vines. Dehner recalled:

He was a lovable guy, a delightful companion, and we had lots of fun. We'd go mushrooming, we'd go fishing, we'd go up in the woods and find all kinds of things. I used to smoke the hams so I'd go up for hickory bark. David and I would pull off the hickory bark. I loved it. I'd scratch at the garden for half an hour, then I'd be back at the drawing table or my painting. I did piles of work that he [eventually] lost for me.

They raised their own fruit, vegetables, and livestock, made their own wine and much of their clothing, and generally lived off the land. Their evenings were spent reading by lamplight the piles of books sent on to them without charge from the library in Albany. James Joyce was a special favorite, but Smith was extremely well-read in all the modern classics. There was time left for a productive art life, as Dehner has indicated. In the years around 1940 Smith worked on his antiwar series, *Medals for Dishonor,* which were cast bronze reliefs, but he was also developing new, nonfigurative approaches to three-dimensional sculptures: mythological birds and beasts as well as highly abstract and symbolic landscapes, still lifes, and interiors.

During the war years David Smith took a job welding tanks at the American Locomotive plant in Schenectady. He had to spend the better part of every week away from the farm, and that ate into his sculpting time. Perhaps he resented Dorothy Dehner's hours in the studio while he was working—at least his subsequent behavior concerning her work suggests something of that sort. Because of increasingly frequent episodes of physical brutality, she left him for approximately the latter half of 1945. Smith analyzed himself in a letter to a friend, written while he was recovering from injuries suffered in an automobile accident shortly after she had left him:

> I am bound by a personal outlook, which for me gets solved by work —which I fight to do. I have a dilatory nature—there is so much to be read—so many women to lay—so much liquor to drink—fish to catch, etc.—but I get the most satisfaction out of my work . . . the more I work the more it flows. Sometimes while I'm working on one piece I get a conception for a wholly new and different one . . . but suggested in the thought process which somehow took place during the manual work of the other. . . . My ego flourishes on the quantity of this stream plan. . . .[28]

David Smith was a huge man with huge appetites—Bunyanesque, many felt. Motherwell remembered his giant working boots in every room of the house and the Clark Gable assurance he radiated. Motherwell met Smith for the first time in the spring of 1950 when, at the request of Marian Willard, Smith's dealer, he agreed to write a short foreword to the catalogue of Smith's upcoming exhibition at her gallery. Motherwell recalled their meeting:

I drove in from East Hampton in a jeep to meet him in an old fishhouse on 42nd street for lunch at 12:30. I wasn't sure what he looked like, but I saw a large back of a man in a tweed jacket and thought it must be him. He said, "I'm having Irish with a Guinness chaser. Want some?" And we spent the next 12 hours drinking before I drove back to East Hampton. We became really close friends when I married Helen [Frankenthaler]. He used to say ours was the only proper marriage in the art world. We were so close he had a key to my house with a room of his own. We'd know he was there when he came in unannounced because the house would shake. Rothko and he were the two artists I most deeply loved for entirely different reasons. Rothko was my mystical friend; David was my American friend. I could talk to him about shotguns or sports or baseball. David's and my esthetics were practically identical. His Spanish Elegy sculpture was taken from my paintings of that name. He was always trying to get me to make some sculpture and I would say that I wasn't a sculptor. He insisted that it was an easy thing for me to do. "You just make some chalk marks on a sheet of steel and I'll do the rest," he said. He had conned me into it and I was intending to go up to Bolton Landing and finally make an attempt at it a few weeks before he died.[29]

Another important thing Motherwell and Smith had in common was their love of James Joyce. Smith saw his own stream of visual ideas that spawned ever more imagery as similar to Joyce's stream of consciousness. Surely Smith also identified with the "secondtonone myther rector and maximost bridgesmaker" hero of *Finnegans Wake,* who is described at one point by Joyce as "escapemaster-in-chief from all sorts of houdingplaces" who "towers, an eddistoon amid the lampless, casting swannbeams on the deep; threatens thunder upon malefactors and sends whispers up fraufrau's froufrous." Like Smith, this myth-making bridge builder also enjoys the simple things in life: "business, reading newspaper, smoking cigar, arranging tumblers on table, eating meals, pleasure, etcetera, etcetera, pleasure, eating meals, arranging tumblers on table, smoking cigar, reading newspaper, business; minerals, wash and brush up, local views, juju toffee, comic and birthday cards; those were the days and he was their hero."[30]

Smith, who loved largess in much the same way James Joyce did, often said he needed a truckloadful of materials before he could get started working on a sculpture and that he never stopped to decide what

was good and bad among what he had made. But in the early years he counted the rods and sheets of steel in his studio with care, and he assessed his accomplishment with equal exactitude. In 1950 he had the support of a Guggenheim Fellowship, and for the first time in his life he was able to work at an optimal pace. At the beginning of 1951 he applied for a second grant listing his accomplishments as a result of the support he had thus far received, saying that 1950 had been "the most fluent and productive period of my career."[31] Among the items listed under "Accomplishment I" besides thirty drawings of "sculptural concepts for continued work" was the following:

> Completion in this time of thirteen works, all in metal, several six feet in height, one being a four-figure group [probably *Sacrifice*], the others larger and with more conceptual depth than previous work, makes it almost a certainty that I will complete the eighteen or more works as planned in the twelve-month period.

In his report he claims that as far as he knows he is "the first American to work sculpture directly in steel and like materials." Even though his work bears little resemblance to that of Alexander Calder's wire works, whether "stabile" or "mobile," Calder's predate Smith's "direct sculptures." In addition, Calder worked openly—drawing in space—which may be why Smith never liked his works referred to in that way. But the content of Smith's sculpture, whether it is expressionistically violent or relatively controlled by a grid, is distinctly different from Calder's and therefore he can be said to have been the first to make direct sculpture in an emotionally charged manner. Calder's shapes are so tightly tied to the biomorphic form-world of Miró that he throws David Smith's independence into high relief.

Smith's use of letter forms and other cryptic glyphlike units in his work at this time is truly innovative. *The Letter,* 1950, included in his April 18–May 13, 1950, Willard Gallery exhibition, is one of the most austere and radical of the sculptures in this vein. It is an openwork, vertically oriented rectangle, crossed by horizontal lines, each of which is adorned by a string of letterlike shapes and pictographs, most of them "found" machine parts from the local hardware store. At top left is the greeting, at bottom right, the signature, both at angles to the rigid rectilinear grid of this flat, thin sculpture. Letters of the alphabet had, of

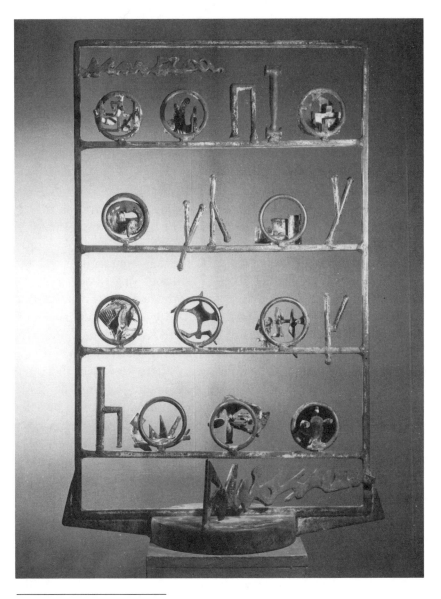

The Letter *by David Smith.*

course, been used by the Cubists, but in a very different fashion. In a Cubist still life the letters "BAL" or "JOU" are punning clues referring to aspects of life in Paris at that time; in David Smith's sculpture the letter forms *are* the content, as he stated in his grant report:

Before letters—consequently words—existed, the artist-sculptor made symbols of objects. The objects depicted were identity memories

that came purely from the artist's mind. The pragmatists later made
words, and to this day, turn these symbols against the artist by de-
manding the "what does it mean" explanation when the formation all
along was of artist origin and represented a statement requiring only
visual response and association.[32]

He explained to the Fellowship committee that he was essentially refer-
ring to ancient Near Eastern cuneiform writing, which he had discov-
ered as a child in his beloved grandmother's Bible, but he related it to
Chinese writing in its origins and even to Polynesian symbol records,
which he claimed to have studied. If his listeners were familiar with the
way the Assyrians depicted mountains as three flying wedges pointing
upward at an angle, and God as crossed, long-stem wedges symbolizing
totality, or if they had read Ezra Pound's 1936 publication of Ernest
Fenollosa's *The Chinese Written Character as a Medium for Poetry*,[33]
they would have had no trouble understanding what Smith was talking
about. Fenollosa grasped that Chinese characters were vivid shorthand
thought-pictures based on the operations of nature—an animal's move-
ment, falling snowflakes, seeing—without any basis in sound. Dawn, for
instance, is a square sun above a horizon line.[34] Since one automatically
sees the poetic image as one reads the characters, the poet's role is
primarily that of ordering them in temporal sequence. This is essentially
what Smith was doing in his glyph and letter sculptures. "I have sought
object identity by symbols, demanding the return to symbol origin be-
fore these purities were befouled by words," he wrote. "I have used
repetition, and rearrangement, for visual acceptance only."[35]

The Letter, 1950, marks many changes in David Smith's life. Artistically,
it represents the first acknowledgement of the literally pictorial nature
of his sculpture. With only a few exceptions, the rest of his nonfigural
work will bear a strong relationship to the configuration and the flat,
two-dimensional orientation of this piece. Smith had started out as a
painter, and despite his skills in metalworking developed during the
thirties and forties, he always painted and drew simultaneously with
making sculpture. He continued to maintain that when he worked with
steel the picture plane was still behind his imagery somewhere. (And
one might recall here how simple he thought it would be to translate
Motherwell's paintings into sculptures.) In *The Letter,* he states it plainly:
resolutely frontal and flat, only his signature breaks into the third dimen-

sion. "Outside of Brancusi," he wrote (whose abstract supports Smith was not loath to adopt for his own), "the greatest sculptures [of this century] were made by painters."[36]

In fact, the vast majority of the world's sculpture throughout history has been frontal, from Siva in his flaming circle to a Greek pediment or a Mayan stele. Only since the Renaissance, and only in Western art, has the thrust been toward figure sculpture conceived completely in the round. But then, since Picasso, sculpture was no longer even obliged to be figural; it could be based in still life, and by implication, landscape, architecture, or any other natural or mechanical image, even a letter. The Cubist concept of collage (or assemblage, its sculptural equivalent) was based on unpredictable juxtapositions of form and content which violated the consistency common to earlier representational art.

In biographical terms, *The Letter* makes specific reference to the woman with whom he was having an affair at the end of the forties—Jean Freas, a student at Sarah Lawrence College, where he had begun teaching in 1948. According to Freas, the sculpture was meant to woo her back to him after a quarrel, and the salutation reads "Dear Jeano." (Ironically, the letter forms welded into this piece and others of this period were discovered by Smith's wife, Dorothy Dehner, in the hardware store and brought to his attention.) But, like the letters in Bradley Walker Tomlin's paintings that don't make words, Smith's letter to his new ladylove cannot be read. One can only assume that the "Y"s are stick figures—male when inverted,[37] female when open at the top—and that there are sexual implications in the conjunction of male-bird-cannon images and circles with their female connotations. (Much of Smith's early work had involved female forms being penetrated by just such phallic images.) Possibly the presence of a fetus form in the first circle on the second register also had some specific meaning, though he had used it in a few early works.

In 1950 Jean Freas represented new possibilities for Smith, who even signed his letters to her "Freeman." Twenty-three years younger than he, and infatuated as only a student can be, she offered him a tempting alternative to life with Dorothy Dehner, a woman older than he, who had originally been *his* mentor and with whom he'd been living in constant close contact for nearly twenty-five years. He had become increasingly abusive to his wife, criticizing her for everything from not being a blonde to doing the laundry herself instead of sending it out.

"Just out of the blue he'd go up to me and bang me on the arm, leaving an enormous bruise, or he'd throw me to the floor and kick me," she said. "He broke my ribs three times. I was what they call a battered wife." Fortunately she met a psychiatrist who was able to help her deal with this increasingly intolerable situation. Dr. Bernard Glick and his wife, through a series of coincidences, became very friendly with the Smiths, and the doctor spent many hours alone with David in his studio. Apparently the artist felt that he could show and tell the doctor anything —his most intimate secrets, his pornographic drawings, and the collages he made out of "girlie" magazine pictures which he would alter by drawing over them, turning the girls into boys and the men into women. Smith and Dehner had a particularly nasty scene in the spring of 1950 while in New York for his show. Afterward Dehner was so upset that when she happened to pass Dr. Glick's office while out walking, she went up to see him. He comforted her, talking with her for hours, she recalled, "and then he said a terrible thing to me. He said, 'You know you have to leave him or he will kill you. Now do you think you can?' I said, 'I don't think I can.' "

Back on the farm with Smith in the summer and fall of 1950 Dehner began to think of putting a lock on her studio door. The danger of Smith's interest in guns also dawned on her. He kept three different gauge rifles in the truck at all times to be prepared for any kind of wild game, plus handguns. Worried about the visual access to her studio through her large window, she found herself crawling into the fireplace to see if she would be out of range there. "Imagine the stupidity!" she says now. Things finally came to a crisis point on Thanksgiving Day, 1950. After the traditional holiday dinner at a friend's house in Bolton Landing, where Smith became very drunk, he beat his wife severely. Luckily for her he was so nearly comatose that she was able to escape; naked, she grabbed her coat and boots in the kitchen and jumped into the truck parked outside, its keys still in the ignition. She sought refuge at a friend's house, and the next day she dragged herself to the doctor's office. When he asked her what had happened, she tried to cover up as usual, but the doctor knew better.

Robert Motherwell once said that artists are monsters—unpredictable, volatile, hurtful—particularly to those they care for the most. Picasso could be inordinately cruel to those close to him without the quality of his artistic endeavor suffering in the slightest. In most of David Smith's relationships, he was a kindly, caring man, and very much loved

despite these horrendous exceptions to his good behavior. So powerful is the emotional ambiguity Smith generated that nearly forty years after she left him Dorothy Dehner could say, "He was a dear and I'll always love him." Although she remained in contact with him until his death, after the Thanksgiving 1950 violence their marriage was over.

Freed of the restrictions that living with David Smith had placed on her creative life, she was able to explore printmaking with Stanley Hayter, a long-cherished dream, and to begin sculptural work. Both media continue to hold her interest, and after years of working on small pieces she spent much of the 1980s making monumental outdoor sculptures in steel. She had been painting abstractly in a Cubist-Surrealist mode for twenty years, but shortly before she left David Smith she had begun drawing abstractions inspired in part by the intricate illustrations of various life forms in the 1904 German tome by Ernst Haeckel, *Kunst-form der Natur.* These new drawings made exquisitely sophisticated use of the white of the paper as positive shapes and may have stemmed from the outline drawings on tissue paper with which Haeckel overlaid his

Star Cage *by Dorothy Dehner.*

colored illustrations to identify the various species. David Smith immediately recognized the sculptural potential in one of these fascinating abstractions of 1949, *Star Cage,* but claimed he was "too jealous" to work in collaboration with Dehner on a sculpture from it, as she suggested.[38] Instead he proceeded to make his own version in steel, *Star Cage,* 1950, which is very close in overall appearance.

In spite of all the tragic domestic turbulence, 1950 was still an especially productive year for David Smith. His show at Willard was well received, and he even sold a piece.[39] Motherwell's catalogue introduction stressed the emotional charge carried by the new work. He wrote: "David Smith is less detached; outside reality blows through him," adding that "the present work seems to me to be emotive and anguished, less 'pure.' "[40] In this vein, one critic noted how effectively Smith linked the "forms of prehistoric life with the phenomena of contemporary living."[41] Another said his work differed from other sculpture in metal because of the "transcendent vigor which is its heartbeat," noting that it was "rugged rather than effete and open to the movement of light and air rather than anchored in solid mass."[42]

Nineteen fifty was to be surpassed only by 1951. That year, Smith loosened up the tight grid and enclosing frame of previous works like *The Letter,* letting the lines of steel swing and loop freely in space. However, the sculptures remain completely frontal, like pictures without a frame. *Hudson River Landscape,* 1951, was, he stated, a "synthesis" or "after image" of dozens of drawings made on the train between Albany and Poughkeepsie while he was teaching at Sarah Lawrence, but it was also a product of chance:

> . . . later when I shook a quart bottle of India ink it flew over my hand, it looked like my landscape. I placed my hand on paper—from the image left I traveled with the landscape to other landscapes and their objects—with additions, deductions, directives which flashed past too fast to tabulate but elements of which are in the sculpture. [It] possesses nothing unknown to you. I want you to travel, by perception, the path I traveled in creating it.[43]

Indeed, one has the sensation of zipping along the swooping curves of *Hudson River Landscape* only to be jogged abruptly into right angles at the center, of crossing the width of the piece on jagged debris and

David Smith's Bolton Landing studio exterior with **Australia**. *(Photo by David Smith © 1992 Candida and Rebecca Smith/VAGA, New York)*

bumping down uneven steps, of peering through a "rib cage" and into irregular organic ovals that seem like cross sections of intestine, and of marching in step along the top of the sculpture with stick figures moving in from both sides to meet at a kind of exclamation point marking the piece's central axis. It is a collage of somatic sensations because it is a mix of the organic and the geometric, the hard and the soft, the jagged and the smooth, a collage that makes as much reference to the human body as it does to the slanted banks of the Hudson River and the industrial detritus that lines its shores.

The marvelously dynamic *Australia,* 1951, on the other hand, is titled for a place he never saw or planned to see, an exotic land of vast open spaces crossed by animals that leap and bound, and aborigines who view the world through X ray eyes. The sculpture he made has a unique wildness, perhaps as a result, and is probably his single finest work. The fact that its body is balanced at the center on angled legs with "head" and "tail" cantilevered far out on either end in exactly the same way that a kangaroo balances itself between leaps seems to have escaped most critics. Reviewing his 1950 exhibition, Tom Hess had commented on Smith's ability to explain his forms no matter how abstract they seemed "not in terms of who is doing what and to whom, but in phrases like 'faces in trees'; 'the old ambition of flowers in steel'; 'only the eagles can live here.' "[44] Because of this tendency to be depictive or representational, Smith's most successful work was done in configurations like *Australia* that were not based on the human body, but rather on conceptual tables, platforms, or altars, animals and birds in motion, buildings, chariots, landscapes, or letters. All of the post-1950 wagon-wheel-supported *Voltri* sculptures, the offering-like *Agricola*s, and the gateway or post-and-lintel *Cubi*s belong in this nonfigural category.

Smith gave *Australia* to his daughters, Rebecca and Candida, born in 1954 and 1955 to Jean Freas, as he did most of the work of the last years. "Daddy makes sculptures for two little girls" was scrawled on his workbench. His friend Herman Cherry said that "the thing he most feared was loneliness, and in the later years, it became more acute."[45] He was working well, producing at a breakneck speed, though rarely selling anything, and he had the companionship of his models, frequently students from the women's colleges in which he taught, but he desperately lacked the fellowship of like minds. Bolton Landing was not a convenient place for his friends to visit. When anyone did, it was a very special occasion for him. Once, around 1959, Dorothy Dehner unwittingly provided one of these occasions, though it turned out to be terribly painful for her. When she had left Smith that Thanksgiving in 1950, her departure had been so precipitous that she took only a bunch of drawings with her and none of her paintings. She became involved with making sculpture and prints during her first years alone in New York, but at the end of the fifties, remarried and with a good-sized studio again, she wrote to Smith and told him she wanted to come up to get her paintings and all the rest of the work she had left there. She relates that he wrote

back saying, "Yes. Please come. Its been cold here but its OK now. The roads are in good condition. No mud. I've kept your work in very good shape. I put it in the cellar [which was warm and dry]. P.S. Jeannie left [Jean Freas, his second wife, who left him in 1958 after six years of marriage]. Good to see you again." When she arrived at the farm, Dehner recalled:

> He came out and he hugged me and he kissed me. It was as if I had just gone down shopping 'cause he always used to come out and have a hug, you know. "I'll bring your drawings to you. I've got the bundles." So he came out and he put in four bundles. But they were small bundles, there were only four or five pictures in each of them. So I said, "Where are the rest?" He said, "Oh. They're in the barn. I'm making a feast for us, I have to look after the roast." And so I backed up the station wagon to the barn and I looked in and couldn't see anything. Then I went to the northwest corner because I thought I saw a corner of a canvas. There was no roof over that and the chinks between the boards were wide because the barn was over 200 years old and hadn't been used for years and years and hadn't ever been painted. And there wasn't anything on the canvas. All the paint was gone. The years of snow and freezing and rain and heat and everything. All my paintings and drawings that he'd stacked there were ruined. I felt as if I'd had such a major operation that all of my organs were out of me. I felt like a ghost. I wasn't a me anymore. I put them in the station wagon and I put a tarp over them and he knew. When I drove down to the house and he came out he said, "Well, the feast is all ready" and I was afraid to say anything. I was afraid for my life. I didn't know what any remark might bring out, so I went in and there was the feast and we talked and talked . . . about anything else, until it was safe for me to leave.

Apparently few of his friends knew about Smith's violent side, though they might have guessed. Motherwell was very fond of him, as was Helen Frankenthaler. She and Motherwell were accompanied by Cleve Gray, editor of *David Smith on David Smith,* a posthumously published collection of his writings, on their last visit to Bolton Landing before Smith was killed on May 23, 1965. Smith's truck veered off the road after a cocktail party in Bennington, Vermont, before he was due to give a talk at the college. It rolled over, crushing his skull. Gray, a relatively new

friend of his, describes how the week before Smith had rushed out of his house to greet them:

> He was a Titan, big scale, powerful presence—one felt he could and did hurl thunderbolts—but underneath we had already learned there was gentleness and vulnerability. His presence loomed, six feet four of robust flesh, a clean white shirt open on his hefty chest, his straight, dark hair carefully brushed, his face a bit flushed; he had been working over the kitchen stove.[46]

After a sumptuous repast of fresh sole in herbs and wine, smoked turkey, and Chinese asparagus fresh from the garden—everything prepared entirely with his own hands, served on a massive refectory table and accompanied by the appropriate wines—Smith lit one of the numerous cigars he smoked in a day and took his friends to the studio to see his new work. Gray described the scores of these last black-on-white paintings and drawings:

> Nudes crouching lying, standing, contorted or at ease, fat or thin, ranging from the classical and realistic to the expressionist and abstract but all defined by a highly charged, bounding line that was tense, excited, impetuous, violent and destructive. They were like attacks upon womanhood. . . . David was proud of his production, delighted with the fact that there were so many female nudes surrounding him; he joked like a schoolboy.[47]

The sadistic edge to his humor was typical; he was not a cheerful man, but rather a driven, unhappy one, like so many of the Abstract Expressionists. A poignant passage written in his private notebook around the time of the breakup of his first marriage in 1950 conveys something of what he must have been feeling in those last years when he was again living alone:

> The heights come seldom—the steadiness is always chewing the gut —seldom without a raw spot—the times of true height are so rare, some seemingly high spots being suspected later as illusion . . . the future—the factory or the classroom, both undesirable yet possible at present, but in twenty years neither will be open . . . and nothing has

been as great or as wonderful as I envisioned. . . . It would be nice not to be so lonesome sometimes—months pass without even the acquaintance of a mind, acquaintances are pure waste—why do I measure my life by works—the other time seems waste— Can the life measured by work be illusion? . . . and so much work to be done—it comes too fast to get it down in solids—too little time, too little money. Why can't it stay as a vision—for who else do I make it? . . . If I walk fifteen miles through mountains I'm exhausted enough to want to rest, and the mind won't—enjoying nature is only occasional and not complete enough—but more so than artificial stimulations of jazz and bop and beer which race along without the mind and leave me feeling cheated—I hate to go to bed—to stay alive longer—I've slipped up on time—it all didn't get in—the warpage is in me.[48]

Davdid Smith may have had a surfeit of rural isolation in which there was nothing to do but produce sculpture, but most other New York artists sought exactly that freedom, particularly during the summer. The older generation went to Maine or Massachusetts coast towns like Blue Hill or Gloucester, which had a long tradition of summertime artist invasions, but those younger in age and spirit tended to gravitate either inland toward Woodstock or out to the tips of Long Island and Cape Cod. Woodstock in upstate New York's Catskills had been an active artists' colony all during the century. It was close enough to Manhattan to be a year-round home for many New York artists, among them Tomlin and Guston, until the end of the forties, when they began to spend the winters in Manhattan. East Hampton and The Springs, where Motherwell, the Pollocks, and the Brookses had settled, were rough and relatively undeveloped then compared to the elite resort of Southampton. One could still "live off the land," as the Pollocks partly did, growing their own vegetables and fruit, going clamming and fishing with the "locals." Provincetown, on the tip of Cape Cod, Massachusetts, was the farthest from New York geographically, but the closest in spirit. Referred to by one wit as "Greenwich Village with clam sauce," it had the narrow streets, the cafés, the close social proximity of urban life, with alternatives on every side—virtually deserted bay and ocean beaches, ponds, dunes, and deep backwoods where one could be as isolated as one wished. By 1950 the local Portuguese fishermen were no longer keeping the artists supplied with free fish from their daily catches, but Province-

town was still a cheap and easygoing place to spend the summer making art. Hans Hofmann was the leading art teacher of the colony, his classes packed with budding second-generation Abstract Expressionists. Other painters, such as Adolph Gottlieb, went to Provincetown for the sailing, swimming, and socializing, as well as to paint. Tomlin visited Gottlieb there a few times at the end of the forties when Gottlieb's influence on him was in full force. Edwin Dickinson, Myron Stout, and Fritz Bultman lived on the Lower Cape year-round; Pollock and Krasner, Newman, Baziotes, and Kees, Giorgio Cavallon, George McNeil, Tony Smith, and David Smith all passed through at various times. In addition to Hofmann, Robert Motherwell, Jack Tworkov, Franz Kline, and Mark Rothko all eventually bought property and established permanent summer residences in "P-town."

During the summer of 1950 Motherwell, Pollock, Krasner, and Brooks were painting at peak excitement in their East Hampton studios, producing many of the paintings on which their future reputations would rest. Tomlin and Guston were doing the same in Woodstock. Kline, Newman, and de Kooning spent the summer in New York, although Kline had a short teaching stint at a Catskill Mountain resort in August where he could escape the summer heat. Large black-and-white abstractions had taken over his studio walls during the previous year, and when the dealer Charles Egan saw them that summer, he gave Kline a fall date for a show at his gallery. Newman moved into a larger studio and immediately started working on the eighteen-foot red painting for which he is probably most famous, *Vir Heroicus Sublimis.* De Kooning finished the largest painting of his career, *Excavation,* which he had been working on since January, and sent it off to the Venice Biennale for exhibition. He then launched himself back in the figurative stream with *Woman I,* perhaps the most controversial painting since Picasso's *Demoiselles d'Avignon.*

In those years, the Manhattan galleries shut down from June through August, eliminating the focus of much of the artists' social life aside from The Club. In 1950, the summer fare at the museums was boring as usual, especially the Metropolitan Museum's much-touted survey of American Art from its collection. The Met's curator had, as everyone expected, failed to fill in the many gaps in their holdings of modern and contemporary art with work by the more advanced artists. The big news in the New York art world this summer was the Venice Biennale, where Henri

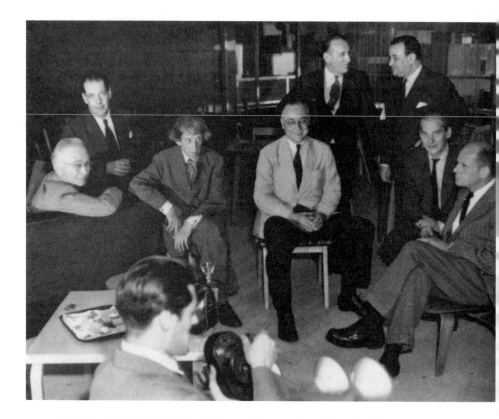

Reception in the penthouse of The Museum of Modern Art, New York, June 27, 1950, for American Artists in the Venice Biennale; left to right, Edward Steichen, Rene d'Harnoncourt, John Marin, Andrew Carnduff Ritchie, Lee Gatch, Alfred M. Frankfurter, Willem de Kooning, and Jackson Pollock. It was around this time and about this kind of official recognition that de Kooning made his famous statement "Jackson Pollock broke the ice." (Photo by Jack Calderwood)

Matisse won the grand prize. For the twenty-fifth anniversary of this oldest international exposition of contemporary art, the American Pavilion mounted its most unusual exhibition to date: a huge John Marin retrospective to represent the older generation, and a group of six small one-person exhibitions of works by six younger artists to represent contemporary trends. Three of these "junior" artists, chosen by the editor of *Art News,* Alfred M. Frankfurter, were relatively conservative: Hyman Bloom, Lee Gatch, and Rico Lebrun; but the other three, selected by MOMA curator Alfred Barr, were quite radical: Arshile Gorky, Willem de Kooning, and Jackson Pollock.

These latter three vanguard artists were not familiar to the European audience, which had had only slight exposure to recent American expressionist abstraction. Despite that, the Europeans took the work in stride.[1] Accustomed to Surrealism, they didn't have too much trouble with Gorky, and those who had come to terms with organicized Cubism via Duchamp were prepared for de Kooning's form-world, if not for his violence. The strongest negative as well as positive responses came in reaction to Pollock's powerful fusion of painterly form and function. Typically, the English critic Douglas Cooper felt that the younger painters imitated well-known Europeans (not specifying whom) "with a singular lack of conviction and competence." Pollock, however, Cooper deemed "a striking exception," and "undeniably an American phenomenon," though he still found the work "meaningless."[2] The great Italian painter Giorgio Morandi spoke for most sophisticated Europeans when he responded to Gorky's work as being "a little French," and said, in front of the de Koonings: "These Americans are very interesting. . . . They dive into the water before they learn to swim." But when he turned to face the Pollocks, he gasped, "Ah, ah . . . this is new. Vitality, energy— new!"[3]

The Italian critic Bruno Alfieri wrote an article on Pollock's work for the June issue of *L' Arte Moderna* in which he insisted that Pollock's pictures represented absolutely nothing but chaos.[4] Alfieri wrote: "It's easy to detect the following things in all of his paintings:

—chaos
—absolute lack of harmony
—complete lack of structural organization
—total absence of technique, however rudimentary
—once again, chaos. . . .

Pollock has broken all barriers between his picture and himself; his picture is the most immediate and spontaneous painting.[5]

However, Alfieri ended the piece by saying that "compared to Pollock, Picasso, poor Pablo Picasso . . . becomes a quiet conformist, a painter of the past." Pollock was naturally thrilled with that part of the piece, deducing its meaning from the Italian when he received a copy during a family reunion in The Springs later that summer. (He was so proud of the linkage of his name with Picasso's in an important Italian art maga-

zine, and of seeing his own 1947 statement from *Possibilities* reprinted in the same issue, that family members complained he was more interested in it than he was in them.) When *Time* excerpted Alfieri's piece on November 20, 1950, and Pollock was finally able to see a translation of the part about chaos (minus the comparison with Picasso, but plus the mistaken idea that he had accompanied his works to Venice), he was furious. He fired back a telegram which was later published:

NO CHAOS DAMN IT. DAMNED BUSY PAINTING AS YOU CAN SEE BY MY SHOW COMING UP NOV. 28. NEVER BEEN TO EUROPE. THINK YOU LEFT OUT MOST EXCITING PART OF MR. ALFIERI'S PIECE. [Surely the favorable comparison with Picasso.][6]

Neither Pollock's nor de Kooning's finances enabled them to attend the Biennale; if they had, there would probably have been a much greater storm of publicity surrounding their contribution. Summers in Europe were still too expensive for most New York artists. In the spring and summer of 1950 Mark Rothko was in Europe, but it was thanks to a small inheritance that he could forgo the usual summertime alternatives of staying in the city and working, or escaping to the country. He had written to Barnett Newman from Paris on April 17 saying that he realized this must be the day Newman was installing Clyfford Still's show at Parsons and sending "my thanks and my hopes that Clyff will get something he wants out of the show or at least not be bruised too deeply."[7] He went on to say that Paris was even more alien and unapproachable than he had imagined. He particularly disliked the city's "decay" and its "pastiche of textures," though he found the evenings at the cafés a lot like the Waldorf Cafeteria. By the end of June he was writing from Rome to find out the latest news on the responses to Still's and Tomlin's shows and the "Irascibles" letter, and to impart news of the expected arrival of his and Mel's first child. (Rothko later told Annalee Newman that he was convinced Mel had become pregnant the first night on the boat to Europe, she had been so relaxed.) He said they were planning to let practical considerations wait until they got home, but by mid-July he announced that he was planning to look for a job on his return.

In a letter of August 8 Rothko commiserated with Newman's "illness and distress" as a result of the tribulations of setting up a new studio— always an extreme ordeal for Newman. The new studio on Wall Street

near the East River was considerably larger than the tiny space Newman had rented on Nineteenth Street. No longer would Annalee have to help him walk a painting out the door and back in again in order to turn it around. Newman had been eager to work large ever since seeing Jackson Pollock's eight-by-sixteen-foot canvas, *Number 1A, 1948* in Pollock's show the previous winter. Newman said later that

> In 1949–50 I began, in terms of the inner necessity of my work, to move in terms of size. Independently Pollock was making the large paintings. I was making the large paintings, and I . . . looking back on it now it was very logical that it was an internal necessity. Pollock, moving the way he did, had to move in terms of the wide expanse, just as I was moving the way I did. I had to move in terms of the same wide expanse to see if I could get something that was, you might say, symphonic. . . .[8]

As he customarily did, Newman worked out the proportions of the canvas which would later be titled *Vir Heroicus Sublimis* well in advance of ordering the stretcher, and those proportions determined much of what would ultimately be the painted image, even though when he actually came to confront the blank canvas he would do so with as little in mind for it as possible. The dimensions of *Vir Heroicus Sublimis* are those of Pollock's *Number IA* with an additional two feet of width. The two eight-foot squares into which Pollock's canvas was easily divisible was too stable a format for Newman. Symmetry had served him well in the past to break the perspectival box of Renaissance space in paintings like *Onement I* and *Be I,* but in order to generate the kind of "symphonic" expanse he now felt he needed, the symmetry would have to be hidden. He was thrilled when he arrived at the eighteen-foot width for this first extra-large-scale painting, since 18 was his favorite number. In addition to symbolizing life *(Chai),* 18 is *Shemoneh Esreh,* the most important ancient prayer still used in daily temple services, and it is a crucial number in the Talmud.[9]

Once the prepared canvas was ready for paint, Newman apparently *felt* his way into placing vertical "zips" that outlined a perfect eight-foot square in the center of the expanse. This square was then at least half-intuitively concealed by "lighting" its left edge with white and "shadowing" its right edge in blue. Two more eccentrically placed "zips" cut

through the remaining flanking areas of luminous red until the last weeks before his spring 1951 show at Parsons. At that point he added a fifth element, the yellowish-tan stripe next to the right edge of the canvas. This stripe and the white "zip" are the tonal high points of the painting, and since they are highly asymmetrical, the central square almost disappears. The power of the central square is intuited, its hidden symmetry only serving to make the viewer's relationship to the painting a "felt" emotion rather than an overtly dictated one. Standing at the middle of the painting, one feels flanked by the verticals in a protective way, without feeling trapped by them. One senses one's own importance there, but one remains free to turn and pass in front of the "zips" and become simply one vertical unit among others in real and painted space.

The Latin title of this painting, *Vir Heroicus Sublimis,* refers in a general way to "man" as an erect, upright creature, a special being in a world full of lesser—crawling, hopping, flying, and creeping—things. "Man" is a heroically sentient, and therefore sublime, being. But it also has a specific source in contemporaneous American history. On June 25, 1950, North Korean forces had crossed the border into South Korea, declaring war and meeting little resistance as they swept south toward Seoul, the South Korean capital. The city fell three days later, and on June 30 President Truman committed U.S. forces to a United Nations peace-keeping effort under the command of General Douglas MacArthur in a mission to restore South Korea's borders. After drastic and devastating invasions and counterinvasions, the center of conflict settled down along the 38th parallel (the present-day border) by January 1951, but MacArthur then wanted to mount an invasion of North Korea and, if necessary, to take on China, the USSR, and the whole Communist world. MacArthur expressed these views in a letter to Congress, and Truman responded by firing him on April 10, 1951. When Newman heard the news of MacArthur's dismissal on his studio radio, he flung his fist in the air "like a tribune of the people commanding the revolution to begin" and shouted *"Vir Heroicus Sublimis!"* [10] Then he finished the painting which now bears that name.

The situation in Korea was probably one of the few things other than his work that Willem de Kooning was talking about during the summer of 1950. In June he was still desperately trying to finish *Excavation,* and for the rest of the summer he was just as desperately trying to start

Woman I. Born in 1904, de Kooning was only a year older than Newman, but by 1950 he had a major reputation, while Newman was still known only to a small nucleus of New Yorkers. De Kooning had enjoyed tremendous respect among his fellow artists as a masterly painter for many years before he received the official seal of art world approval in 1948: The Museum of Modern Art purchased the largest painting out of his first one-man exhibition at the Egan Gallery, a show that had been widely acclaimed in the press.

In 1950 there would have been few who disagreed with the choice of de Kooning and Pollock to represent the latest radical developments in American art at the Biennale. None of their peers was as well known or accepted by the art establishment. In fact, the two were rivals because they had no others. Pollock had "broken the ice," as de Kooning put it, meaning not only that he had broken through in the popular press but also in the elite circles of art-conscious museum trustees and benefactors whose support is essential. But the conventional wisdom about Pollock was that he was a wild man, an artist who "couldn't draw"; de Kooning's obvious skills as a draftsman brought the new art respectability. Who could say, "Why, my five-year-old can do better than that!" when faced with an exquisite early de Kooning pencil drawing of a woman that could hold its own alongside Ingres's best efforts? Already in 1948 Pollock and de Kooning had crystallized the central defining image of the New York School—allover, highly energized, and impulsive painterly abstraction—and now they were painting the masterpieces of that movement. Moreover, they had the crucial support of *Art News,* the best art magazine at the time, and of the three leading art critics of the day—Clement Greenberg, Thomas Hess, and Harold Rosenberg.

Without any doubt, de Kooning was the best-trained artist in the New York School, having received a complete course of traditional artistic instruction in his native country. Willem de Kooning ("the king," in Dutch) had been born April 24, 1904, in Rotterdam, Europe's largest port, to a café-bar-proprietor mother and a spirits-distributor father, who divorced when he was five. Accustomed to getting her way, his mother battled for and won custody of Willem and his sister. Cornelia Nobel de Kooning's talented son was apprenticed at the age of twelve to the commercial art and decorating firm of Jan and Jaap Gidding; they in turn urged him to attend the full eight-year evening course at the Rotterdam Academy of Fine Arts and Techniques, which he did. There

he was thoroughly grounded in lettering, which he often used later to begin a painting and which introduced him to "cutting in" forms and to positive/negative shaping. His training in perspective resulted in his near-obsession with it during the thirties and forties, even in some of his most abstract works. He also studied proportion, which he learned to manipulate supremely in order to confound viewers' expectations through jumps in scale, and, of course, drawing from the figure; in fact it can be said that he has yet to be surpassed as a draftsman in this country. He mastered a wide range of painting techniques—the arsenal at his command is still being expanded through experimentation—as well as a bag of illusionist's tricks. He also learned to think of a painter's occupation as a job like that of any other worker, not as an exalted, dilettante's way to pass the time. He always dressed like a workman and was proud of any painting he did well, including housepainting and illustration. He made a living as a housepainter when he first came to this country and says even now, "I was a good one—not a smearer."[11] Although he no longer has what he calls "the Don Quixote energy" he once had, he still works in his studio seven hours a day, seven days a week, keeping interruptions to a minimum by refusing to answer the telephone or to make appointments except under extreme duress.

One of young de Kooning's next employers, Bernard Romein, introduced him to the work of Piet Mondrian, not an obvious but nevertheless a profound influence on his art ever since,[12] and to Walt Whitman's poetry and Frank Lloyd Wright's architecture. Reverberations of Wright echo through the studio he designed for himself in The Springs after his move there in the 1960s. Walt Whitman's effect on him was probably subtler, but his interest in American writers has been steady and is often reflected in his art. The nocturnal ambience of de Kooning's *Light in August,* 1948, for example, reflects Faulkner's setting of Joe Christmas's climactic scenes in the novel of that title. One is tempted to interpret the painting's ambivalence as to whether it is a black-on-white or a white-on-black image as a possible echo of Christmas's uncertainty about his own racial heritage. But de Kooning isn't likely to have thought so literally. He read a great deal, but he also liked to be read to; his wife and friends often accommodated him in this.[13] "I like to be among writers as well as artists," he once said. "I don't think writers are necessarily more intelligent or better speakers than artists, but I find their conversation very stimulating. Sometimes I could say of myself that I

painted with a good ear, because their talk, the words they used, made a picture in my mind." [14]

Besides Wright and Whitman, western movies, Louis Armstrong, and other jazz musicians, de Kooning was drawn to America by the dream of making a lot of money at commercial art and by the photographs he'd seen of long-legged American "flappers." It took six attempts, but he finally jumped ship and came ashore in 1926 at the age of twenty-two. In the mid-fifties he reentered the country legally, but in 1950, still worried about deportation, he told a *Knickerbocker* interviewer that she'd better leave out what he'd told her of how he arrived in this country, allowing her only to print that "the journey was filled with adventures, but I guess the muses were with me." [15] Recently he told the story more fully:

The U.S.—I had a lot of trouble getting there. Every time I hid out on a ship, they found me, or the boat wasn't going anywhere. Then my friend, he worked in the boat kitchen, he got me on board and I slept near the machinery. We got to Boston and we had enough money to buy a ticket on a passenger boat, with music and dancing, and early one morning I just walked off the ship and I couldn't believe it—I was free on the streets of New York.

We went to New Jersey, and at the train station I saw this guy pouring coffee into a long line of cups. He didn't lift up. He just poured fast to fill it up fast, no matter what spilled out and I said, 'Boy, that's America!' [16]

From the earliest pictures of de Kooning in this country on the ferry from Hoboken (his home for his first year here) to the most recent professional photos, he has always appeared devastatingly handsome. He is not a tall man, but he is compact and well proportioned. In photos taken by Hans Namuth in the summer of 1953 when he was staying at Leo Castelli's house in East Hampton, he looks movie-star gorgeous, especially when a slight smile crosses his lips. With age his brilliant blue eyes paled slightly and his golden hair silvered, but if anything these changes only made him more attractive. When Elaine Fried, his future wife, first saw him, this is how he struck her:

I met Bill in a bar in 1936. I thought he had seamen's eyes that seemed as if they were staring at very wide spaces all day. He had an inhuman

look—vacant, limpid, angelic. I visited his studio several days later with a friend. It was the cleanest place I ever saw in my life. It had painted grey floors, white walls, one table, one bed, four chairs, one easel, one fantastically good phonograph that cost $800 when he was only making twenty-two dollars a week, and one painting—a man— on the easel. The whole effect was: that this man was great.[17]

The austerity of his lifestyle, reminiscent of Mondrian's, would be typical of all of de Kooning's living/studio spaces. In the Depression days, when a good meal was a special occasion, he used to say that if you kept your place neat and clean, someone was bound to ask you to dinner. A 1950 photograph of his studio shows everything neatly tucked in its place, including a bag of potatoes, and the only visible item that is not essential to survival is an announcement card for Mark Rothko's January show. His current studio is so dramatically clean and modern it looks as though it had been designed by the hybrid offspring of Frank Lloyd Wright and a ship's engineer. De Kooning had this to say about his friend Rothko's studio on East Sixty-ninth Street: "I couldn't figure out why he didn't clean the skylight. You know I'm a clean bug. I want everything light and bright. And his skylight was so dirty, but I didn't tell him that and I thought if I had that place I would clean that skylight."[18] (Of course Rothko undoubtedly allowed the skylight to remain layered with soot purposely to screen out light.)

De Kooning was one of the first artists to transform factory lofts into studios. Preparing for marriage to Elaine Fried in 1943 he took an unprecedented (and never repeated) period of six months off from painting to change a high-ceilinged top-floor loft on West Twenty-second Street into a perfect space for two artists in love. His friend, poet Edwin Denby, described the loft:

When he took it, it had long stood empty. He patched the walls, straightened the pipes, installed kitchen and bath, made painting racks, closets, and tables; the floor he covered with heavy linoleum, painting it grey and the walls and ceiling white. In the middle of the place, he built a room, open on top, with walls a bit over six feet high. The bed and bureau fitted into it; a window looked out into the studio. The small bedroom white outside and pink inside seemed to float or be moored in the loft. All of it was Elaine's wedding present.... While

they lived there, Saturday afternoons he stopped whatever he was doing and washed the place down.[19]

This practice of cleanliness was the most typically Dutch thing he brought from his homeland other than his accent, and neither was ever lost. His deep, yet slightly nasal voice comes in bursts, and his clipped, staccato delivery tends to shorten and simplify the English language: "dot" is that, "der" is there, "wit" is with, "ting" is thing. One of his favorite words is "ridiculous," pronounced "ri-dik-ilus" with emphasis on the "dik."

Despite how recently he had acquired a command of English, de Kooning had many intellectual and literary friends with whom he and Elaine attended cultural events and held endless discussions in the thirties and forties. One of these friends was Edwin Denby, who lived next door. William MacKay, Denby's biographer, described the poet as "a man who had smoked opium with Cocteau, exchanged pleasantries with Meyerhold, met Diaghilev, talked with Freud about self-analysis ('impossible for non-Freuds'), and been bored by the conversation of James Joyce."[20] This arch-cosmopolitan had only recently returned from Europe, where he had enjoyed a successful career as a dancer and theatrical provocateur; now he intended to support himself by becoming a dance critic. Elaine Fried was Denby's favorite companion to attend dance performances with, both because of her beauty and her intelligence; he, in turn, helped and encouraged her to become a writer on art. Willem de Kooning's observations were also a great help to Denby, particularly in his essay on photographs of Nijinsky dancing. De Kooning advised Denby to stress Nijinsky's plasticity, his instinct for countermovement, which heightened the intelligibility of the relationships between body parts—concerns that were de Kooning's own at the time. De Kooning's set and costume designs for the Ballets Russes in 1940 came about as a result of this friendship as well.

Denby's—and by extension the de Koonings'—circle of friends in New York included Virgil Thomson, Aaron Copland, Lincoln Kirstein, and Jane and Paul Bowles. Denby shared his studio with the German photographer-film-maker Rudolph Burckhardt, whom he'd met overseas. The group tended to meet at midnight for coffee at the local Stewart's cafeteria. Denby recalled the great intensity of the conversations between his friends and de Kooning, everyone repairing to de Koo-

ning's loft when the cafeteria closed. De Kooning had a way of imagining himself in the situations under discussion, or in their opposites, and he did both with complete conviction. Denby remembered that de Kooning

> kept heading for the image in which a spontaneous action had the force of the general ideas involved. And there he found the energy of contradictory actions. The laugh wasn't ridiculousness, but the fun of being committed to the contrary. He was just as interested in the contrary energy. Self-protection bored him.[21]

It seems that de Kooning was more a both/and than an either/or man even in the thirties. His earliest post-immigration work seems to have included both radical abstractions and classical figure studies. The abstractions are a species of still life in which unnameable objects occupy unchartable space. Their color is strong, their lines lyrical, and their mood is strangely disquieting. Mondrian and Miró—pure Constructivism and poetic Surrealism—coexist peacefully in these gently elegiac canvases, which don't end up looking like either kind of painting.[22]

De Kooning's figures of the thirties, usually men, are ghostly, poignant apparitions in pink and gray emerging from fields of dusty ocher. Reminiscent of Picasso's acrobats,[23] these moody presences, with missing hands, half-faces, double shoulders, and legs fragmented into abstract shards, seem simultaneously to belong to the history of great classical figure painting and to subvert it. According to Elaine de Kooning, most of the portraits had Edwin Denby's eyes. Denby often sat for de Kooning, sometimes reading his poetry aloud as he did so. But de Kooning painted his own face very often as well, and Rudy Burckhardt and Max Margulis also sat for him. A writer who became a vocal coach, Margulis was very involved with jazz in the thirties and forties, and de Kooning was often his companion at the clubs where it was played. (Meanwhile Denby was accompanying Paul Bowles on his nightly "research" forays into Harlem hot spots for the score Bowles was writing for *Denmark Vesey,* a Charles Henri Ford opera about the Black leader of a slave revolt.)

De Kooning's strange figure paintings are haunted by a kind of prolonged sadness that seems to have larger implications than simply being a reflection of the Depression era. This may stem from their seeming

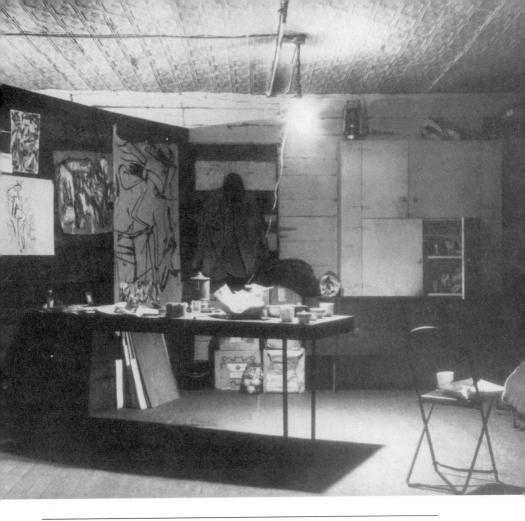

Willem de Kooning's studio in January 1950 when he began work on **Excavation.** *Note the announcement card for Mark Rothko's Parsons Gallery exhibition tacked to the wall next to the table and the plaster-stiffened clothing dummy hanging at the rear, which he used as a substitute for a model for many early figure paintings. (Photo by Harry Bowden)*

entrapped by still air, caught in a pervasive timelessness. De Kooning's use of manikins either from window displays[24] or of his own devising undoubtedly augmented this effect. He told an interviewer years later how he constructed one of these stand ins:

I took my trousers, my work clothes. I made a mixture out of glue and water, dipped the pants in and dried them in front of the heater, and then of course I had to get out of them. I took them off—the pants

looked so pathetic. I was so moved, I saw myself standing there. I felt
so sorry for myself. Then I found a pair of shoes—from an excavation
—they were covered with concrete, and put them under it. It looked
so tragic that I was overcome with self-pity. Then I put on a jacket and
gloves. I made a little plaster head. I made drawings from it, and had
it for years in my studio. I finally threw it away. There's a point when
you say enough is enough.[25]

Denby recalled de Kooning's problems uniting the figure with the
ground, making a shoulder work (he even dedicated a poem to de
Kooning titled "The Shoulder"[26]) or creating a frontal seated figure
without employing foreshortening (foreshortening made him feel quite
ill, he said[27]). "I can hear his light tense voice saying, as we walked at
night, 'I'm beating my brains out, I'm stuck with my picture.' Next time
I asked him about it, 'I think I'm getting it, I've an idea I'm trying out,'
he said. Once or twice after weeks of that, he kicked or slashed the
canvas to bits; usually he stowed a canvas on the rack saying he couldn't
finish it."[28] Elaine said, "I would weep when I saw him starting to scrape
off a work that looked great. One day I came home and saw he'd done
a perfectly magnificent 'Woman' painting. He agreed it was pretty good,
but said, 'It has to be moved over two inches.' So he started to paint it
again, bit by bit—and, of course, he lost the whole thing. Another time,
he got so mad he jumped up and down on a painting and threw it in
the garbage can."[29] Friends like Denby and Burckhardt rescued much
of the early work that remains before de Kooning could decide to push
it further or change it.[30] One is reminded of Cézanne's frenzies, his
obsessive, desperate need to get his *petit sensation* down on canvas
exactly as he felt it.

After Elaine came into his life, paintings of women began to replace
those of men. Her sister Marjorie also sat for de Kooning, and both
women had large, luminous eyes, a feature which became characteristic
of most of the subsequent *Woman* paintings.[31] Male subjects are infre-
quent after 1943, when Elaine and Bill were married, and remain so in
his work today. In the beginning the women were beautiful sex god-
desses. Some wore crowns, all bared beautiful, bulbous breasts; some
preened, a few were goggle-eyed, others simply gazed into hazy space.
Later in the forties they became frightening, but at first they were basi-
cally whole, like the men, with only a few missing or hidden parts. Later

they were reassembled out of the pieces into which their former configurations had been torn, with all their rough and jagged edges remaining to tell the tale. The early women seemed to have relatives in the paintings of Ingres; later the strife-ravaged women of Picasso appeared to be their kin, particularly Picasso's brutally war-torn visages of Dora Maar from the end of the thirties.

Pink Angels, c. 1945, painted at the midpoint of the decade, is also at the turning point of a dramatic shift in de Kooning's style, technique, and attitude. It is the perfect embodiment of both the tensile strength and the vulnerability of the flesh at a time when the world was most intensely aware of those aspects of humanity. The pink forms seem to spin in space, and yet still hold onto some kind of organic integrity. It is as if de Kooning had entered the bedroom of a Titian goddess, an Ingres countess, or Picasso's *Girl Before a Mirror,* had partially disintegrated the figure, and sent her off into the future at great speed. This may be more than coincidence if we recall that on August 6, 1945, the atomic bomb was dropped on Hiroshima and de Kooning said about that catastrophic event: "It made angels out of everybody."[32]

Collage thinking—the de/re/constructive process of creation through fragmentation and reassembly—determined de Kooning's painting from this point on. No longer did he have to gear himself up into frenzies of frustration trying to get a shoulder or a bent knee to "work." He would make full-scale paper drawings, which he then cut into sections and rejoined in abrupt ways that are not physiologically correct, but which are so esthetically satisfying that one doesn't care. Besides, the surprises can be downright thrilling, and the potential for provocative ambiguity is limitless. Nowhere is this more exciting than in the predominately black abstractions of 1948 in which white outlines backlight black forms to create a tremulous nocturnal ambience. *Black Friday*'s funereal overtones, the celestial trajectories of *Dark Pond,* and the restless nudging of crowded black silhouettes in MOMA's *Painting*—all generate a nervousness that seems appropriate to the nuclear age the world had so recently entered. In 1949 whites came back with a vengeance, and in great paintings like *Attic* and *Asheville* every square inch of the surface seems charged with as much energy as an atomic particle. His de/re/construction process is so relentless that practically no pictorial unit can be detached or isolated from interaction with all the other units. The only question left to answer is, When to stop? Often in the

later forties this became an insoluble question. When this happened, de Kooning would go for long walks at night suffering every doubt and fear of artistic impotence that any serious painter has ever suffered, and more. (He made the acquaintance of Rothko in the middle of one such night on a park bench in Washington Square when Rothko was having a similar attack.) Years later he remembered that "those anxiety attacks scared the hell out of me. I felt my heart skipping beats. Then this doctor friend told me to take a little brandy in the morning. It worked good, it stopped the attacks, but I became a drunk. I can't touch it anymore."[33]

De Kooning's friend Franz Kline used to say that painting a picture is like hand-stuffing a mattress. You keep putting more and more material in until you realize it's bulging out in all sorts of places and start taking a little out here, a little there. Then you see hollows, and you've got to put more back in. Suddenly, out of the corner of your eye, you see that it seems to be flat, and you quickly tiptoe away. Looking at *Excavation* one almost has the feeling that for once de Kooning took Kline's advice. He "tiptoed away" on June 15, 1950, and immediately shipped *Excavation* overseas to the Biennale. Along with *Asheville* and *Attic*,[34] smaller-sized paintings of the previous year, it represents the culmination of nearly two decades of de Kooning's abstraction. Yellowish-white predominates, with nests of red, flashes of blue, and blushes of pink interspersed among sharp-angled fragments of matter that seem neither flesh nor bone, but nevertheless organic. This whitish pigment (which was originally less yellow) is surely not the stuff of trees or flowers, still life objects, buildings, or mountains. If anything it is flesh-made-stone in the manner of Cézanne's bathers, who never seem as human as the sculptures he depicted in other works. But whereas Cézanne's figures retained their integrity as figures, de Kooning's organic forms in *Excavation* are just that—forms not figures.

What is it a painting of, if anything? De Kooning told curator Katharine Kuh that when he started the picture he had been thinking about the image of a line of women knee-deep in watery mud from the Italian film *Bitter Rice*.[35] There is definitely a sense of a ground line running across the bottom of the picture which suggests a plane on which figures might stand. But he may have been thinking of Cézanne's bathers, too, or any number of other large-scale, multiple-figure compositions in the history of art. On the other hand, he may not have been thinking of past art at all—the possibilities are endless. When Martha Bourdrez, a writer for

The Knickerbocker, came to interview him in the spring of 1950 while he was working on *Excavation,* he was humming a Dutch tune. Referring to the canvas on his easel, he said, "This morning I suddenly liked it and I remembered that song about Piet Hein, you know, something about *'Klimmen in het want,'* (Climbing in the raft [sic]). The Dutch are tough people, are not they?"[36] Upon correcting the author's mistranslation of the word "want," one discovers a clue to one of the painting's possible meanings. Piet Hein was the famous sixteenth century Dutch admiral who captured the Spanish "Silver Fleet" of galleons loaded with silver. The song de Kooning was humming—known to every Dutch child—is about Piet Hein having a short (little) name but having performed an enormous deed. "Want" is the Dutch term for a ship's rigging. Perhaps de Kooning felt enmeshed in the structure of this canvas like a sailor in the openwork mesh of the rigging. It seems that way

Excavation *by Willem de Kooning.*

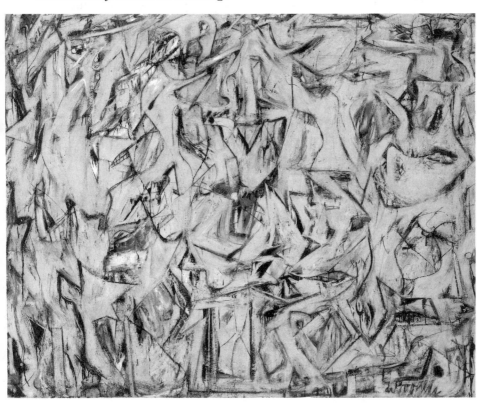

from de Kooning's later description of the process of painting *Excavation* in an interview for *The New York Times:*

> "I think I started here," he observed, pointing to the upper left-hand corner. "I said, 'Well, I'll make a stab at it here.' I wasn't thinking about any method or manner that had realities. So you do a little bit, and you feel comfortable with it. Then you say, 'I'll make it open here and closed here,' and that way you go around and around, a little bit at a time . . . you can keep going on with what's connected to it. Because if you keep a section you're comfortable with, you can build out from it, little by little. Maybe if it doesn't go too well, you put it aside and come back the next day to start up again."[37]

The closed shapes that occur in *Excavation* and other abstractions from this time seem to have an object sense, as though they could be read as something specific. But as soon as you try to do so, their meaning shifts—a "candle" becomes a penis, a "matchbook" becomes a cathedral, a "breast" becomes a torso or an arm. In the same way, the whole picture shifts in and out of multiple identities. The only thing you can be sure of when you are dealing with a work by de Kooning is that you can't be sure of anything. What does the title *Excavation* refer to, after all? Certainly not to a group of women in a rice paddy, though that reading is visually plausible, nor to sailors climbing a ship's rigging. Does it refer to one particular excavation out of the many being done in Manhattan at this boom time in apartment house construction? Perhaps. Just such a large building was replacing Fourteen–Eighteen Washington Square West, to the dismay of many Greenwich Village residents, and the south side of Washington Square was rapidly falling to the wrecking ball. From a quiet street of quaint houses that had been occupied by famous turn-of-the-century writers and artists, it was being transformed into one side of the quadrangular center of New York University's modern campus. The NYU Law School was under construction there in 1949–50. Protests were made, but to no avail in those pre-landmark designation days. Another huge excavation was being dug that year at Fifth Avenue and Fourteenth Street as the building in which Thomas Edison designed the electrification of New York City was torn down to make way for Lane's Department Store.

Excavation looks too full of forms to have any connection with a giant

gaping hole in the ground; but when it is turned upside down, such a concept becomes possible, particularly in light of the shoring-up verticals which then run along the top. (De Kooning did turn his abstract paintings while he worked on them.) Although de Kooning's *Excavation* does not in any way resemble either, there were two paintings he was likely to have known with the same subject: George Bellows's 1913 painting, *Pennsylvania Station Excavation,* in the Brooklyn Museum, and Peter Blume's *Excavation,* 1948. This latter Surrealistic painting had been included with a work by de Kooning in a *Vogue* spread on fifty-three contemporary artists the previous winter, when de Kooning began his *Excavation.* Finally, the title may simply be a metaphor for the mental process people constantly go through in the modern world, the process of digging through the accumulated detritus of centuries of information with every waking thought.[38]

Excavation is classic de Kooning in its endless digging of one form into another, one shape out of another. It is comprised of interpenetrating units that form a massive, single image, since no one shape stands out from the impact made by the totality. Responding to paintings such as this by de Kooning and others at this time, art critic Leo Steinberg wrote about modern art's "dissolution of the solid" in his essay "The Eye Is Part of the Mind," saying that substance had been "activated into a continuing event." Space in contemporary art like like de Kooning's was, in Steinberg's opinion, no longer a passive receptacle, but rather "an organic growth interacting with matter."[39] In an oddly poetic statement de Kooning wrote at the end of the year, which was presented in the February 1951 MOMA symposium "What Abstract Art Means to Me," the artist described his concept of space.

The argument often used that science is really abstract, and that painting could be like music, and for this reason, that you cannot paint a man leaning against a lamp-post, is utterly ridiculous. That space of science—the space of the physicists—I am truly bored with by now. Their lenses are so thick that seen through them, the space gets more and more melancholy. There seems to be no end to the misery of the scientists' space. All that it contains is billions and billions of hunks of matter, hot or cold, floating around in darkness according to a great design of aimlessness. The stars *I* think about, if I could fly, I could reach in a few old-fashioned days. But physicists' stars I use as buttons,

buttoning up curtains of emptiness. If I stretch my arms next to the rest of myself and wonder where my fingers are—that is all the space I need as a painter.

Notwithstanding de Kooning's gut objections to the space of science, his work does seem to have a great deal in common with contemporaneous scientific concepts.[40] As Leo Steinberg wrote: "The scientist's sense of pervasive physical activity in space, his intuition of immaterial functions, his awareness of the constant mutability of forms, of their indefinable location, their mutual interpenetration, their renewal and decay—all these have found a visual echo in contemporary art."[41]

De Kooning had been struggling with the problem of integrating figural and other mutable forms with their environment his whole life. For him it was the primary problem of painting. Arshile Gorky, de Kooning's mentor, had of course worked in a similarly interactive manner, if less aggressively, and had passed his totally ambiguous, plastic vision on to his Dutch friend. De Kooning, in turn, taught others to see with a painter's eyes. Edwin Denby was one grateful recipient of this vision. A passage in a poem titled "Groups and Series" shows that de Kooning taught Denby to see interlocked positive and negative shapes in the world around him. It reads almost like a description of *Excavation:*

> In your eye's mirror, in the field it takes,
> see next each shape the hole the shadow makes,
> a hole that blurs, blots further like a flood
> fed from the black that colors clotting blood.
> Through the eye's lentils thread this piece of death
> until the hybrid lung draw easier breath,
> contrary functioning superimposed
> holds all our many senses safe enclosed.[42]

Yet Denby reacted unexpectedly upon seeing *Excavation* in a European context years after writing this poem:

In 1950 . . . I had been abroad and out of touch for several years when I heard that pictures of [de Kooning's], painted since I left, hung at the Venice Biennale. I was eager to see them. But, after reaching Venice, a week and more passed before I got to the Biennale park. I had been

walking through the exhibitions in a stupefied state for two hours when I entered a large room hung with de Koonings, Gorkys and Pollocks. I stood glancing around with a smile, ready to have them take me back to the New York that was home, expecting Bill and I would go down to the corner for a coffee. Not at all. The pictures looked at me with no recognition whatever, not even Bill's. I had no private access to them. Standing there as a stranger, I saw the lively weight the color had, the force and sudden grace the excitement had, I realized that the buoyancy around me was that of heroism in painting.[43]

The model "action painter," de Kooning is endlessly putting in, taking out, locking, unlocking, penetrating, walling off, opening and closing forms, until the viewer is exhausted pulling them out of the void only to have them drop back into it with the next flicker of the eye. His subjects are often both indoors and outdoors, figures and landscapes, at the same time. He is a sort of action thinker, seeing every issue from both sides, every concept from at least two perspectives. A perfect case in point occurs in a statement he wrote in 1950 titled "The Renaissance and Order" for a lecture (read for him by Motherwell) at the Friday night series at Studio 35:

Insofar as we understand the universe—if it can be understood—our doings must have some desire for order in them; but from the point of view of the universe, they must be very grotesque. As a matter of fact, the idea of "order" reminds me of something Jack Tworkov was telling me that he remembered of his childhood [in Poland].

There was the village idiot. His name was Plank and he measured everything. He measured roads, toads, and his own feet; fences, his nose and windows, trees, saws and caterpillars. Everything was there already to be measured by him. Because he was an idiot, it was difficult to think in terms of how happy he was. Jack says he walked around with a very satisfied expression on his face. He had no nostalgia, neither a memory nor a sense of time. All that he noticed about himself was that his length changed![44]

Over the many years of his career, de Kooning's forms have become relatively larger in scale and, with that, his compositions are less densely packed than they were in 1950, the high point of his personal *horror*

vacui. Though his figure paintings have usually been highly abstract and his abstractions often had either figural or organic overtones, de Kooning has never been willing to give up either way of painting entirely. He never "returned to the figure" because he never left it; he didn't "turn to abstraction" because some of the very first works he painted in this country were pure abstractions. It is obvious, given this dual allegiance, that 1950 was *the* absolute moment for de Kooning: the culmination of his allover abstractions in *Excavation* and of his figurative works in the start of the *Woman* series with *Woman I,* the work which to this day remains his single most famous painting.

Looking back on it, De Kooning said that he started painting the Women because he felt stuck after *Excavation,* which is hardly surprising, given what a monumental effort it had been. He had pushed abstraction as far as he could for the time being. Choosing a subject that had been painted throughout art history eliminated problems of composition and relationships for him. He put the figure in the center since there was no reason not to, and put in the eyes, nose, and mouth of normal physiognomy. But when he got to the body, all the ways the nude female had been depicted before him—all the idols, the saints, the bathers, and the whores—flashed across his mind screen. On top of that were all the ways women were being displayed in commercial advertising and film, and all the ways he'd noticed women sitting, standing, resting their heads on their hands, crossing their legs. A thousand glimpses registered anew. (Denby had written years before, "In a split second a girl is forever pretty."[45]) Making the Woman's anatomy specifically one way and not another "flustered" him. A decade later he told an interviewer, "The Woman became compulsive in the sense of not being able to get hold of it—it really is very funny to get stuck with a woman's knees, for instance. It almost petered out. I never could complete it." He added:

> Content is a glimpse of something, an encounter like a flash. When I was painting those figures, I was thinking about Gertrude Stein, as if they were ladies of Gertrude Stein—as if one of them would say, 'How do you like me?' Then I could sustain this thing all the time because it could change all the time; she could almost get upside down, or not be there, or come back again, she could be any size. Because this content could take care of almost anything that could happen.[46]

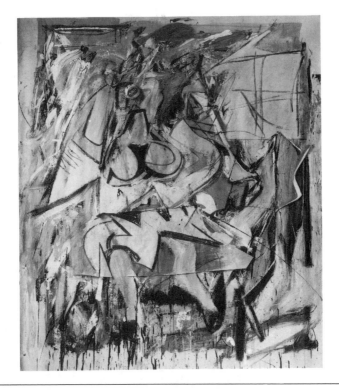

Willem de Kooning's Woman I *at two stages between 1950 and 1952. Note the way some of the overlaid drawings in the earlier state were painted into the later stage. (Photos by Rudolph Burckhardt)*

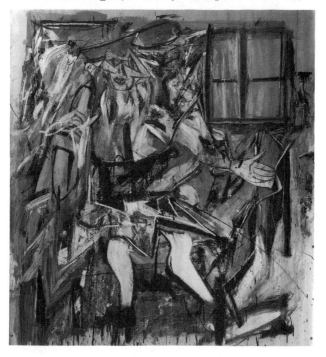

Years later de Kooning found that he was still frightened by the women he began painting in the summer of 1950. And ever since then, people have reacted similarly to these formidable images of woman-kind. Gertrude Stein, whose writings indirectly influenced de Kooning's *Woman* paintings, was—in photographs and in Picasso's portrait of her —a formidable physical presence herself, and may have been a direct source of inspiration. By person and by reputation, Stein reigned among the writers in de Kooning's circle of friends. Edwin Denby's cadences even seem to echo her prose style, and she was probably taken more seriously by Virgil Thomson and the rest of the Denby group than by any other segment of the American cultural elite. All of the females in the *Women* series are massive, with gargantuan breasts and thighs press-ing against their clothing—none are timid or dainty. (According to Mabel Dodge, Stein would often lift her skirts in hot weather to air, and at the same time to show off, her magnificent thighs.) And it was also the image of Stein with Alice B. Toklas—two strong women standing together—which was probably in his mind. *Woman I,* in fact, began as a huge drawing diptych of two standing women.

But another woman writer also had a powerful effect on de Kooning's imagination—Jane Bowles, whom he had come to know through Edwin Denby. In the years of their acquaintance, Bowles was working on *Two Serious Ladies,* which was finally published in 1943.[47] Bowles's highly unconventional heroines, Miss Goering and Mrs. Copperfield, are both formidable in their own right and fiercely independent, but they are also somewhat dotty. The equal, but minimally interactive, treatment they receive in the novel is very much the way de Kooning handles two women in his drawings.[48]

Both Bowles's and Stein's heroines blend into one another in de Kooning's thinking. In an interview with E. de Wilde for the Dutch version of the catalogue of his 1968 MOMA retrospective he made this plain when he took out a book of reproductions of Bernini's work and said:

The Ecstasy of Saint Theresa . . . You see that face! Fantastic, hmm? and corny. Any part of that statue could be something else. The clothes could be leaves . . . but then he puts that face on top and that's "it," as if she's coming. And that foot at the bottom—fantastic. He has the "it," and "oomph" . . . D'ya know the book "Two Serious Ladies" by Jane

Bowles? Well those ladies are my "Women." In a humorous or philo-sophical sense they're nut-ting. Or those Saint Theresas of Gertrude Stein in her play "Four Saints in Three Acts." Now those are really Theresas. . . .[49]

The Saint Therese Gertrude Stein's words portray is, like de Koo-ning's *Woman I,* "half in doors and half out of doors," she is seated, but she is also "not seated at once," and "once seated." She is "not sur-rounded" and yet she is "visited by very many as well as the others really visited before she was seated. There are a great many persons and places close together." She is "not young and younger." She is in a garden, "the garden inside and outside of the wall," but she is also in a storm in the Spanish town of Avila where "the snow is warm but the river is not." And, "Saint Therese could be photographed having been dressed like a lady and then they taking out her head changed it to a nun and a nun a saint and a saint so. Saint Therese seated and not surrounded might be very well inclined to be settled." Many other things do and simultaneously don't happen to Saint Theresa. All of this might have been going through de Kooning's mind as he worked on the painting, including being repeatedly asked "how much of it is finished," and being pressed for clarity in the matter of "how many windows and doors are in it?" and other distinc-tions and differences. Gertrude Stein's litanous way of writing lends itself to being remembered in fragments that are all but impossible to eradicate from your mind once they are firmly embedded there.

Woman I seems to sit on a green embankment with her feet in bright blue water.[50] De Kooning remembers that as a child in Rotterdam he was always near the water. He also recalls being struck by seeing women wading in the canals, their skirts lifted above their knees. Even more personally compelling is a story only half remembered about an inci-dent that happened to him when he was about three. It seems that he had been thrown into a sewer by some bullying boys (presumably an open, constructed channel of some sort), and was rescued from drown-ing by an old woman. Elaine de Kooning, relating this incident in a 1983 interview, went on to say, "So that ferocious woman he painted didn't come from living with me. It began when he was three years old." So often was Elaine cited as the subject of de Kooning's *Woman* series that

she had become extremely tired of the situation and had already made other attempts to get herself "out of the picture," such as the following one:

> Hans Namuth, the photographer, was doing artists that summer [1953], and I said, "Hans, take one of me. I want to get rid of this nasty rumor that I'm the subject for this painting." He snapped me standing in front of it, and it's fantastic how we fit together, like mother and daughter.[51]

Elaine de Kooning's smile was sweet compared to *Woman I*'s devilish grin, but she remains one source for the picture despite her protests. Her husband insisted that before he met her his paintings were "all quiet and serene. Then they became turbulent."[52] Although we know that de Kooning could suddenly become quite vicious toward people close to him, including his wife, Elaine was no weakling. Like most of the other women of the Abstract Expressionist group, she was smart, tough, and able to take care of herself. Many adopted what might most accurately be described as a "gun moll" attitude, replete with wisecracks, swear words, and sexual innuendo. Whether drinking, free-living, or arguing about art, these women were literally matches for their men.

According to Rudy Burckhardt, Elaine "treated him badly" in the early years of their relationship with Bill de Kooning. She did order him around. In a room with friends she would imperiously demand, "Bill, a light for my cigarette." Burckhardt believes that they were madly in love then but the reason they got married was that Bill was losing too much painting time having to accompany her home to Brooklyn in the wee hours of the morning because she refused to stay overnight. Reminiscing about the early days of their marriage, Elaine said, "We painted in the same room. Bill would say, 'Gee, I'm hungry,' and I'd say, 'Boy, me too,' and we'd go out to the Automat for something to eat. One day Bill said, 'What we two need is a good wife.' "[53] But by the end of the forties the balance was shifting. Elaine had begun writing for *Art News* in 1949 under the sponsorship of de Kooning's ever-staunch supporter Tom Hess (with whom it was rumored she was having an affair), and she was on her way to becoming the "Queen of the Art World" in the fifties. Not only was she doing well as a painter—she had been selected for the Kootz "New Talent" show in May 1950, and her early expressionistic

"sports" paintings were large, forceful, and well received—but her position at *Art News* made her an art world power.

Her husband, of course, already was one. By 1950 de Kooning was surrounded by perceptive, talented, and beautiful women artists. Some even threw themselves at him. One young painter, who became very well known later in the fifties, came straight to his door around this time and told him she wanted him to make love to her. As she tells it now, she demanded nothing, no strings, no commitments, just admiration and its reward. Perhaps she felt that a little of his magic would rub off on her—and maybe it did. Many women artist friends had studios in his immediate vicinity, adding to the strains within the de Kooning marriage. Young, stunningly beautiful Mary Abbott lived near his Fourth Avenue studio while she was studying at The Subjects of the Artists School. De Kooning would kindly bring kerosene up to her stove for her. He found former Black Mountain student Pat Passlof a studio around the corner and began giving her painting lessons. When she was driven out by a fire, he helped her fix up another studio; eventually he introduced her to his old friend Milton Resnick, whom she later married. Whatever the reality or rumor, by the summer of 1950 when Rudy Burckhardt photographed Elaine and Bill in front of the initial full-scale drawings for *Woman I,* the tension between them was palpable. Burckhardt points out in retrospective amazement that their emotional split is perfectly expressed in a line that runs down the center of his photograph dividing them. In the picture, Elaine looks as though she is seething, and, as the photographer notes, de Kooning has a "worried look" that he didn't have in previous pictures.[54]

Elaine de Kooning always believed that her husband's mother, Cornelia, was the main source for his images of women, and for the turbulence with which he depicted them. As she tells it, life with his mother had been a constant emotional roller coaster ride:

Listen, that was no pink, nice old lady. She could walk through a brick wall. Franz Kline and Jackson Pollock had identical mothers—short, stout ladies. You can see them on the prows of ships, breaking gigantic ice floes. Nothing turns them back. . . . That lady was formidable. She ran a bar and a restaurant frequented by sailors. Bill says she was a hysteric. If he laughed at her, or she got angry, she would grab a knife and raise it as though she was going to kill herself, yelling, "Cora cannot stand this a moment longer!"[55]

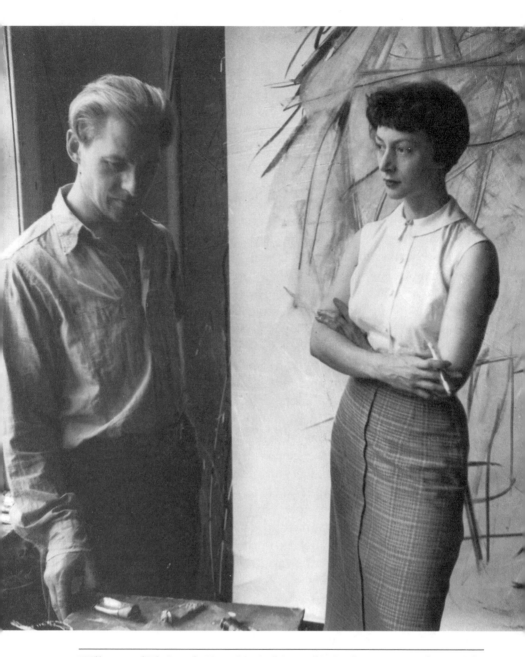

Willem and Elaine de Kooning in his studio in the summer of 1950. The initial drawing of Woman I *as a two-standing-figure composition is tacked to the wall behind them. (Photo by Rudolph Burckhardt)*

De Kooning says the women he painted scare him now "not so much to look at, as to think how she came out of me, how it happened."[56] But with so many conflicting kinds of women in his mind—lover, mother, and savior; admirer, humiliator, enemy, and friend; colleague, mentor, and rival—is it really surprising?

The *Woman* series of the early fifties was shown as a group in 1953 at the Janis Gallery amid a mighty storm of controversy about his so-called return to the figure, as well as about his treatment of those figures. A 1955 painting, *Woman as Landscape,* marked de Kooning's shift at mid-decade into abstractions with either figural or landscape overtones. They are characterized by a bewilderingly wide range of colors, paint-application techniques, and shapes. Young painters fell over themselves to imitate his style, initiating the so-called Tenth Street School, named for the area where they all lived, worked, and were starting to show in co-op galleries. *Easter Monday, Gotham News, Time of the Fire,* and *Police Gazette* are among the best-known works of this mid-decade period of burgeoning fame and fortune. His rivalry with Pollock peaked, and his friendship with Kline deepened. The increased scale of the internal units in his work toward the end of the fifties undoubtedly reflected Kline's reciprocal influence. In the sixties, de Kooning's move to Long Island was accompanied by a general lightening of his palette. Rosy pinks and yellows, silvery grays and pale blues predominate instead of the reds, browns, deep blues, and greens of the fifties. Women again became a frequent subject, but now they were often luscious and unthreatening, more like the innocent shepherdesses of Boucher than the jagged *femmes fatales* of Picasso. During the seventies, most of the paintings were untitled and seemed to be equally inspired by the figure and by landscape, set either indoors or out. Red, yellow, and blue, set off by black, white, and gray, came to dominate his palette during these years in a subtle, surprising return to his Constructivist roots. In the next decade the Mondrian influence grew even stronger, not only in terms of color but also compositionally, as de Kooning simplified his paintings down to a few elements, often aligned along horizontal and vertical axes. He also began making bronze figural sculpture at the end of the sixties, which he has developed into a richly inventive, fully Expressionist art form.

After Elaine left him in 1954, he lived with Joan Ward, with whom he fathered a child, Lisa, born in 1956, just after his official separation from

Elaine. Joan Ward's twin sister, Nancy, was seeing Franz Kline at the time, and this mid-fifties period was also when Pollock was having an affair with Ruth Kligman that ended with his death. Toward the end of the fifties de Kooning also had a prolonged affair with Kligman, after which he went back to Joan Ward.[57] Ward continues to live in a house near his studio in The Springs, as does Lisa, even though Elaine de Kooning moved back into his life in the mid-seventies to take care of him. Even as early as the end of the fifties, de Kooning's drinking problem had become so serious that he began suffering blackout spells. Only a small amount of alcohol made him drunk to the point of illness. Elaine convinced him to join Alcoholics Anonymous, but it was already too late to stop his memory loss. By the time of Elaine's death in the spring of 1989, he had deteriorated to the point that he was unaware, even at her funeral, that she was dead. The fact that he remained able not only to paint but to do so with no apparent diminishing of his powers serves to validate the extent of the role played by the motor and intuitive or subconscious mental processes in Abstract Expressionist painting.

There was rivalry between Pollock and de Kooning over women, but their art and their relative reputations as artists were even greater sources of friction. Their competitiveness was not always friendly. Two actual fights between them have been reported, but remain uncertain. The scuffle among Pollock, de Kooning, Kline, and a few others at "The Red House" in Bridgehampton in 1954, which resulted in a broken ankle for Pollock, was apparently just boyish horseplay, not a serious brawl; it seems Pollock caught his foot on something and fell. The episode at the Cedar Tavern in which de Kooning is said to have punched Pollock, when Pollock refused to return the blow, saying, "I don't hit artists," has been related often by Lee Krasner, who wasn't present, and it may not be accurate.

De Kooning and Pollock also had rival followings. De Kooning's solidly entrenched reputation among his fellow artists led to his having a large number of admiring friends and acolytes. Pollock's outrageous behavior when "under the influence" was imitable, but the other artists couldn't readily transform his way of painting into their own personal styles as they could de Kooning's. Just as Gorky's style had been open to de Kooning's manipulations, de Kooning's way of working offered seemingly limitless possibilities to his peers and members of the next generation. Kline himself had gone through a "de Kooning phase" be-

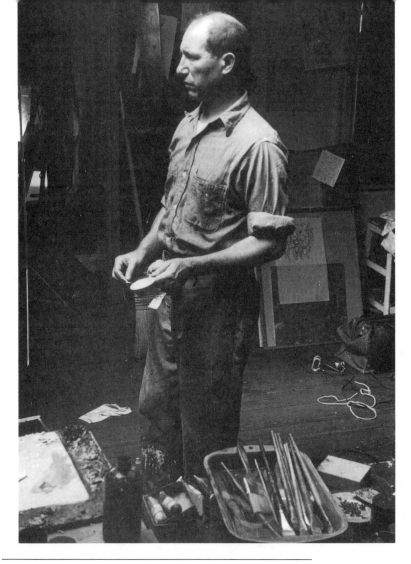

Jack Tworkov in 1950. (Photo by Rudolph Burckhardt)

tween 1947 and 1949, finally jettisoning the use of smaller units and smaller scale as well as the use of color to find his own place in Abstract Expressionism.

Jack Tworkov, whose studio abutted de Kooning's loft at Eighty-five Fourth Avenue, and who was also in the Egan Gallery, was literally stylistically as close to de Kooning in 1950 as anyone could be and still retain a clearly identifiable esthetic position.[58] Born in 1900, Tworkov was de Kooning's senior, but until 1952 he was one of de Kooning's many followers. He too was an immigrant from Poland.[59] In contrast to the Dutchman's aggressively quick, if often elliptical, articulation of his thoughts, gentle Tworkov, who had aspired to be a poet in his youth,

was always soft-spoken and careful when expressing himself. They met in the mid-thirties when Tworkov was a successful, though quite modern, figurative painter and de Kooning was struggling to come to terms with Picasso and Cubism, Mondrian and Purism, John Graham and Arshile Gorky, all at once, in highly strange abstractions. De Kooning's figurative work of the late thirties and early forties made a strong impression on Tworkov, but in the years after 1948, when they had adjoining lofts and a daily exchange of ideas and opinions, Tworkov's work was revolutionized by de Kooning's. *The Sirens,* 1950–52, is the

Sirens *by Jack Tworkov.*

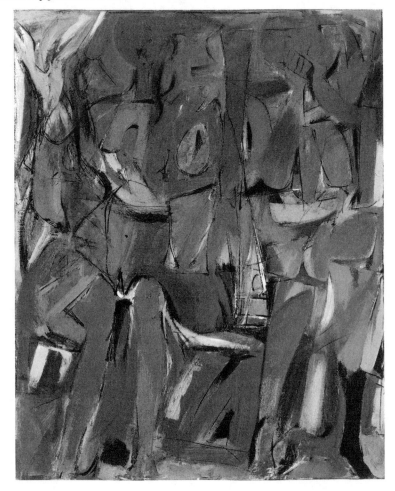

pivotal canvas in which Tworkov's figures are fragmented into organic shards in the manner of de Kooning's *Woman I*, which was being painted next door. It seems tidy by comparison, but it led Tworkov to his *House of the Sun* paintings of 1952–53 in which he found a gridded, pictorial framework completely his own that could support a lifetime of painterly abstraction.

De Kooning held sway at The Club: Pollock was the star of the Cedar Tavern, at least until his last years, when he was often banned from the place and would stand outside with his bloated face pressed beseechingly against the tiny glass window in the front door, begging for permission to reenter. Pollock said he "didn't need clubs," but perhaps, as Harold Rosenberg pointed out, it was that for the most part "Pollock didn't like doing things with coffee." De Kooning recalled that "Pollock was suspicious of intellectual talk. He couldn't do it—at least not while he was sober. But he was smart enough—oh boy—because when he was half-loaded, that in-between period, he was good, very good, very provocative. But he had contempt for people who talked—people who

The Cedar Street Tavern at 8th Street and University Place. (Photo copyright by Fred W. McDarrah)

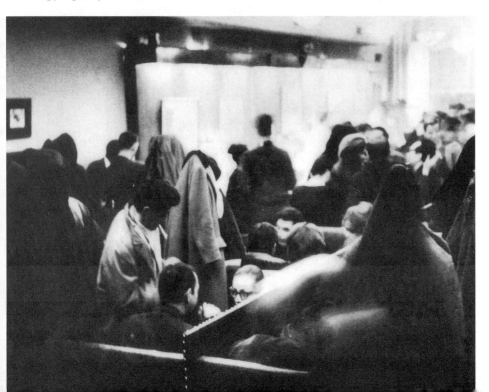

taught."[60] Pollock was a swaggering "Set 'em up Joe" kind of barroom cowboy according to Elaine de Kooning. "Jackson would break the rules and Bill and Franz . . . admired it," she added. "I think all the male artists did."[61] De Kooning said of Pollock:

> I was jealous of him—his talent. But he was a remarkable person. He'd do things that were so terrific. After a while we only used the Club on Friday and Saturday nights. The rest of the time we'd all go to the Cedar Bar as we were drinking more then. So when Pollock was in town he'd come to the Cedar too. He had this way of sizing up new people very quickly. We'd be sitting at a table and some young fellow would come in. Pollock wouldn't even look at him, he's just nod his head—like a cowboy—as if to say, "Fuck-off." That was his favorite expression—"Fuck-off." It was really funny, he wouldn't even look at him. He had that cowboy style. It's an American quality with artists and writers. They feel that they have to be very manly. . . . He'd go berserk —like a child—a small boy. We'd run, fight, jump on each other. Such joy, such desperate joy.[62]

One of Pollock's favorite challenges to a newcomer was to ask him, "What are you doing to bring notoriety to your name?" Women would be playfully mauled before or while being asked, "Wanna fuck?" His habit of calling women "whores" when he was drunk was so ingrained that it took a great effort of will to remember not to address Elaine de Kooning and other women painters he respected that way. Willem de Kooning recalled:

> Jackson—yah, he would put on that tough guy act, you know? But he wasn't such a pain in the ass he really needed those tranquilizers doctors gave him. Sure, he called me "Nothing but a French painter," thought I was doodling off maybe. *But*—Jackson took on the responsibility of being a *painter*.[63]

Meaning that he belonged to a brotherhood of painters, and painters were a breed apart from the rest of humankind. Even today among the survivors of the fifties generation, the designation "painter" means someone a cut above mere mortal. A painter has special needs, he or she can make unusual demands (usually of those who love them), and

can perform extraordinary deeds. When, on more than a few occasions, Pollock told de Kooning, "You know more, but I feel more," he went even a step further. With that observation, he unknowingly tapped into the long tradition of "polar couples" in art history—Leonardo and Michelangelo, Ingres and Delacroix, Braque and Picasso.

Pollock was very jealous of de Kooning's preferential treatment in Thomas Hess's book *Abstract Painting: Background and American Phase* when it appeared in 1951. Not only did Hess give de Kooning almost twice as much discussion space, he put him first and Pollock last. Pollock was so upset at this affront that he threw the book to the floor at de Kooning's feet at a meeting of The Club. "Why'd you do that?" de Kooning asked. "It's a good book." "It's a rotten book," Jackson replied. "He treats you better than me." [64] Pollock's opinion of de Kooning's work kept changing. According to painter Nick Carone, who was a friend to both, Pollock "had been all for Bill's earlier things—that narrative stream of consciousness, Joycean approach." [65] Then, he habitually referred to de Kooning's *Women* paintings as "that shit," and yet in 1951, a year after the *Woman* series was begun, Pollock was using his drip method to draw recognizable imagery himself. The artist Nick Marsicano relates another story about a contretemps between Pollock and de Kooning a few years later. Marsicano claims that after seeing the new work in 1955 at the Martha Jackson Gallery Pollock said to de Kooning, "I don't like your show. You painted it too fast." And de Kooning responded, "Who the hell are you to speak? You paint like a chain smoker." [66] At this point, the middle of the fifties, when de Kooning's following among the younger artists was beginning to outstrip his own, Pollock came down hard on de Kooning's new abstractions. Nick Carone recalls:

As they were sitting at the bar, Jackson said, "About that fucking picture at the Guggenheim, Bill—it's not up to your standard. What are you trying to do?" [He is undoubtedly referring to *Composition,* 1955.] Bill got very angry, but Jackson phoned me, all upset, told me it was because Bill didn't understand. He said, "Bill is my *friend.* I believe artists should have a brotherhood." And that's what he wanted, brotherly love, and he would attack for that. Then he went on, "He thinks probably I'm jealous or something, but I really have great admiration for him." [67]

For all their rivalry, de Kooning and Pollock were friends, particularly in the company of Franz Kline. De Kooning and Kline were very close and had been since the mid-forties. They would usually take care of Pollock when all three were "on the town." This trio was closer and lasted longer than the Gottlieb-Rothko-Newman triumvirate of the forties, or any of the other artistic groupings, because their friendship was based in a sibling kind of love that expressed itself largely in nonverbal ways, such as horseplay. And Pollock could turn to Kline for companionship when de Kooning was not in the mood to be friendly. De Kooning was feared for the ferocity with which he could turn on people when he was drinking heavily, but Kline was usually mild-mannered and gentlemanly, even when drinking. However, Robert Motherwell remembers one night at a party in his Upper East Side town house when de Kooning and Kline were baiting Pollock viciously, calling him a has-been:

> He had every right to get drunk or to slug them, but in fact he just took it. Obviously he had made up his mind to keep his cool, and after a while he left. The party went on until I don't know when, but I couldn't believe Kline. It was the only time I ever saw him like that; it wasn't only kidding but profoundly aggressive. I don't know whether it was de Kooning egging him on. . . .[68]

All three were behaving uncharacteristically, probably because of the context. Motherwell's more upscale living situation tended to bring out the worst in them, though this time, inexplicably, not in Pollock. The aftermath of this party is described by the poet Robert Creeley, who was then one of de Kooning's staunch admirers:

> It used to be said of William Carlos Williams that the literal fact of his being there gave us one *clean* man we could utterly depend on, that nothing could buy his integrity. We had the same feeling and respect for de Kooning, who, in those days, we'd see most every night in the Cedar Bar, usually in company with Franz Kline, another of our absolute heroes. De Kooning, characteristically, was good to us, but he didn't let us off the hook—as, for example, the night Kline got stomped and lost a tooth on his way back downtown from a party at Motherwell's in our company. De Kooning's question, very simply: "And where were you guys?"[69]

De Kooning might well have been jealous of Pollock's fame, though his desire for privacy would have prevented him from wanting such notoriety for himself. He doesn't seem to have competed with Pollock artistically, however—although Pollock competed with him—except possibly in 1950 with the painting of *Excavation,* which challenged Pollock's large picture size. But large scale was in the air then, as we have seen. In later years many words would be expended over who made the first "big picture" in the New York School, but it does seem to come down to a contest between Pousette-Dart's *Symphony No. 1* and Pollock's *Mural* for Peggy Guggenheim's foyer. They were bigger than anything else around. De Kooning's *Excavation* must be seen as intentionally competitive with Pollock's recent very large black-and-white "drip" paintings. De Kooning knew that Pollock's major contribution to the 1950 Venice Biennale was to be *Number 1A, 1948,* a five-and-a-half by eight-and-a-half-foot canvas. At more than six-and-a-half by eight feet, *Excavation* is de Kooning's largest painting ever, and it was completed for that same exhibition.[70] Unlike Pollock or Newman, de Kooning was never comfortable working larger than the open spread of his arms, and years later, when he saw the painting at the Chicago Art Institute, he told curator Katharine Kuh that he still wasn't sure it had to be so big.

Painting large, and painting on the wall or the floor instead of on an easel, caused the Abstract Expressionists to be more physically active when they worked than artists had tended to be in the past. During the summer of 1950, photography played a particularly important role in demonstrating the dynamism of the new American art and in establishing the myth of the artist as an "action painter." But the intervention of photography in the public image of the artist was a gradual process, and it is worth tracing here. During the summer of 1950, when Rudy Burckhardt began photographing de Kooning in the studio working on *Woman I,* he did so mainly because he was a friend and he thought it would be interesting to record a work in progress—as it had been to follow Picasso's changes to *Guernica.* He had no idea that the painting would take so long—it wasn't declared "finished" until nearly two years later—[71] nor was the story of its making published in *Art News* until 1953.

Since Burckhardt was focusing more on the developments in the painting than on the painter, his photographs are classic images of an

artist in the studio, arm raised to draw, or brow furrowed in thought. Picasso, Matisse, and other world-famous artists had been photographed similarly in the past. Traditionally the artist is shown calmly in place before the easel, actually or ostensibly adding a daub to its surface. (In earlier times the painting on the easel was often finished, even varnished, and an elaborate frame was already in place around it. The artist, garbed in smock and beret, paintbrush and mahlstick in hand, was simulating his normal activity.) The idea of seeing the artist's actual working process became more interesting as art moved away from depicting an external reality in favor of an internal one. Van Gogh was the pivotal figure in this large cultural shift to intimacy. Our interest became less technical and more voyeuristic. We wanted to sense the passion of the painting act. In the late 1940s *Art News* began a series of articles "So-and-so Paints a Picture," which partially satisfied this need, and Burckhardt's pictures of de Kooning at work were intended for such use.

A major change from this traditionally static approach, however, occurred in 1946 when *A Visit with Matisse* was filmed. This moving picture included slow-motion sequences of Matisse making drawings of a flower and the head of his grandson. Interestingly, this section revealed how intuitively or automatically Matisse worked, much to his own chagrin:

> There was a passage showing me drawing in slow motion. Before my pencil ever touched the paper, my hand made a strange journey of its own. I never realized before that I did this. I suddenly felt as if I were shown naked—that everyone could see this—it made me deeply ashamed. You must understand this was not hesitation. I was unconsciously establishing the relationship between the subject I was about to draw and the size of my paper. I had not yet begun to sing.[72]

The next breakthrough took place in early 1950 with the pictures taken by Gjon Mili for *Life* magazine of Picasso drawing in space with a flashlight. Here, thanks to modern photographic techniques, the centaur Picasso outlined ephemerally in light over a period of time could be seen as a single image in its entirety. It was fixed forever in the printed photographic image, which appeared to hover in space. Because they let us see him in action, Mili's still pictures seemed to give us access to the artist's mind.[73]

Hans Namuth's photographs of Pollock painting in the summer of

1950 represent a quantum leap forward in this genre. He used elements of both of these precedents to transform the artist into a mythic figure capable of creating great works of art before our very eyes. The pictures Pollock worked on that summer while the camera was focused on him were *One: Number 31, 1950* and *Autumn Rhythm,* unarguably two of his masterpieces. Though Namuth's pictures were taken only weeks after Burckhardt photographed de Kooning, they represent a very different phenomenon. They seem more like film stills than traditional photographs, and in fact they were followed immediately by a seven-minute black-and-white moving picture, and then early in the fall by one in color with sound.

Hans Namuth had met Pollock only shortly before taking his pictures, yet Pollock displays an enormous sense of trust by his lack of self-consciousness in front of the camera. Namuth introduced himself to Pollock at the July 1 opening of a group show at East Hampton's Guild Hall, "Ten East Hampton Abstractionists," in which both Pollock and his wife, Lee Krasner, had paintings. They made a date for the following weekend, when Namuth, who had a summer place in nearby Water Mill, would be back from the city. Instead of being ready to start a painting when Namuth arrived, Pollock announced apologetically that he had already finished it. But upon going into the studio to look at the painting —very likely *One: Number 31, 1950*—he realized that he had more work to do on it and began to paint. Namuth recalls:

> His movements, slow at first, gradually became faster and more dance-like as he flung black, white and rust-colored paint onto the canvas. He completely forgot that Lee and I were there; he did not seem to hear the click of the camera shutter.... Later Lee told me that until that moment, she had been the only person who ever watched him paint.[74]

Perhaps because he thought he had finished painting for the day and had changed out of work clothes, Pollock is pictured painting in a clean T-shirt and slacks and wearing shiny, unspotted loafers. He is lean and lithe, his brow grooved in concentration. A cigarette dangles unheeded from his lower lip. "It was great drama," Namuth recalled later, "the flame of explosion when the paint hit the canvas; the dancelike movement; the eyes tormented before knowing where to strike next; the

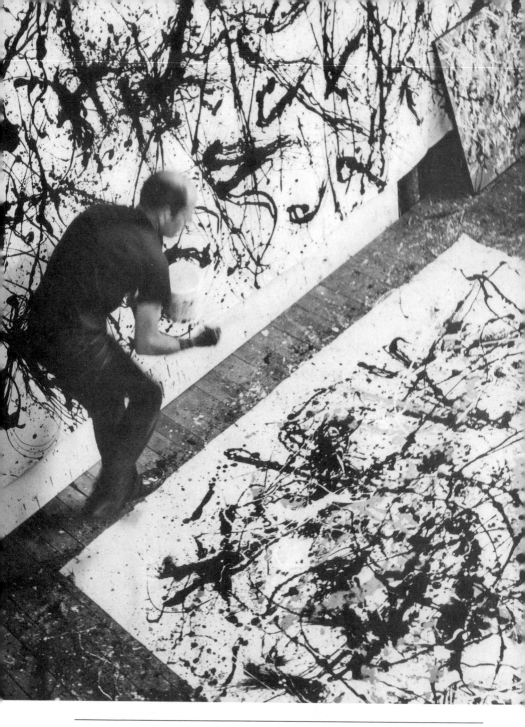

Pollock painting Autumn Rhythm *in the late summer of 1950. Note the presence of* Number 32, 1950 *on his left and of the small canvas titled* Autumn Landscape *on the floor ahead of him. (Photo by Hans Namuth © 1990)*

tension; then the explosion again . . . my hands were trembling."[75] He and Namuth exchanged almost no words during that first day or on the many subsequent sessions that summer. The photographer felt that Pollock's inability to express his feelings in words caused him to express them in paint. "It was during the act of painting itself that Pollock engaged in the act of communicating," he said.

As seen in Namuth's pictures, Jackson Pollock's power of concentration is so intense that it seems animalistic, like a cat stalking its prey with all its senses, every cell on full alert. He and his picture are one —so much so that it is impossible to look at the poured paintings with which he is generally identified without seeing Pollock leaning over, lunging and looping lines of liquid paint onto the canvas. One looks at absolute abstractions, but acutely feels the existence of the artist. The situation is a perfect embodiment of Flaubert's notion that an artist should be in his work like God in nature: present everywhere but visible nowhere.

In this regard Pollock's reply, "I am nature," when Hans Hofmann criticized him for not working from nature, seems remarkably if unconsciously astute. The poet and art critic Parker Tyler explored this idea in a perceptive article in March 1950 titled "Jackson Pollock: The Infinite Labyrinth." He pointed out that by abandoning the finite brush stroke for the "revolving continuity" of poured paint Pollock created multiple, overlapping, and therefore insoluble labyrinths that

> are not to be threaded by a single track as Theseus threaded his, but to be observed from the outside, all at once, as a mere spectacle of intertwined paths, in exactly the same way that we look at the heavens with their invisible labyrinths of movement provided in cosmic time by the revolutions of the stars and the infinity of universes.[76]

Tyler said that unlike traditional representations in which the observed world is shown, Pollock presents the viewer with an "absolute space," inhabited by curving lines with no point of entry or exit, "for every movement is automatically a liberation—simultaneously entrance and exit." His way of painting "charges the distance between his agency and his work with as much *chance* as possible," he wrote. He doesn't say it, but "chance" isn't really very chancy in a Pollock: nature takes its course in his work through basic laws of physics and chemistry concerning

gravity, viscosity, and motion mechanics. At first reading, Tyler's ending seems overwrought, but, as we shall see, when viewed in the light of Pollock's own thoughts about his work and about religion, it is not surprising that Pollock liked what Tyler wrote:

> Pollock's paint flies through space like the elongating bodies of comets and, striking the blind alley of the flat canvas, bursts into frozen visibilities. What are his dense and spangled works but the viscera of an endless non-being of the universe? Something which cannot be recognized as any part of the universe is made to represent the universe in totality of being. So we reach the truly final paradox of these paintings: being in non-being.[77]

Pollock wrote very little about his own work, but in 1950—probably toward the fall—he produced a short, oddly organized and punctuated statement about his work. Everything in the following verbatim account seems surprisingly eloquent and insightful:

> *No Sketches*
> acceptance of
> *what I do.*
>
> _____
>
> Experience of our age in terms
> of painting—not an illustration of—
> (but *the equivalent.*)
> Concentrated
> fluid
> Technic is the result of a need _____
> new needs demand new technics _____
> total control _____ denial of
> the accident _____
> States of order _____
> organic intensity _____
> energy and motion
> made visible _____
> memories arrested in space,
> human needs and motives _____
> acceptance _____

<div align="right">Jackson Pollock [78]</div>

What Pollock is outlining here is not only his way of working but the philosophical premises behind it. The painting is created on the spot, not from a priori plans. In a fatalistic Oriental way he simply *accepts* what comes out. The atomic age in which he lives, a time of great uncontrollable forces at work, and yet a time of enormous personal responsibility for one's actions, is not symbolized or illustrated in his work—but re-*experienced*, first by the artist, then by the person viewing the painting. This life experience is condensed for the viewer, through the *fluid*ity of the paint. In order to achieve this he needed a new *technique*—letting the paint stream off a tool instead of pushing it deliberately around, with, on—and a new artist's material (readily pourable paint). He has enormous *control* over his new means and methods, and therefore nothing happens that he doesn't want to happen. The results have a definite sense of *order,* given the physical limitations of both means and method. Only so much paint per dip can be accurately placed so far away from the can. A certain specific gesture, made with a specific force, will leave a certain kind of mark, etc. The paintings are unavoidably *organic* (rather than geometrical), again given the nature of the means and method, but powerfully so, not casually, seductively, nor playfully. He is literally making *energy* and *movement visible* in a static painting space. What events or feelings fueled his unconscious mind as he worked we will never know. We have to simply *accept* them as he did, and let ourselves be swept up in his image world as he let himself be swept away by them while he created it.

In 1947, the year he started doing the poured or drip paintings, Pollock had written the following statement for the sole issue of *Possibilities,* that most seminal of art world "little magazines." It now begins to mean a great deal more to us despite its familiarity:

> When I am *in* my painting, I'm not aware of what I'm doing. It is only after a sort of "get acquainted" period that I see what I have been about. I have no fears about making changes, destroying the image, etc., because the painting has a life of its own. I try to let it come through. It is only when I lose contact with the painting that the result is a mess. Otherwise there is pure harmony, an easy give and take, and the painting comes out well.[79]

When Pollock is *in* his painting, he is in what some psychologists now call "the zone," an arousal state with a heightened level of energy and

concentration, much like an athlete's. In this state of mind the athlete and the artist experience a kind of near-mystical euphoria. They can "see the seams on the baseball" flying toward them, as Ted Williams once reported. The ball seems to go so slowly they have "all the time in the world" to hit it, but they don't even have to think about doing so— their bat hits it automatically. They feel they can do no wrong, make no false moves, as if their body is functioning on "automatic pilot." Lawrence Shainberg, in a *New York Times* article called "Finding the Zone," gives a classic example of what happens "in the zone":

> When attacked by his master for being too willful, Eugen Herrigel, author of *Zen in the Art of Archery,* said: "How can the shot be loosed if 'I' do not do it?"
> " 'It' shoots."
> "And who or what is this it?"
> "Once you have understood that you will have no further need of me." [80]

Significantly, this book was in Pollock's possession along with the *Bhagavad Gita,* Lao-Tzu's *The Way of Life,* and Witter Bynner's *The Way of Life According to Lao-Tzu, Maha Yoga or the Upanishadic Lore in Light of the Teaching of Bhagavan Sri Ramana,* and *Yoga Explained* by F. Yeats-Brown, as well as books by Thomas Merton, Paul Tillich, Suzanne Langer, Simone Weil, and Lin Yutang on various aspects of religion and philosophy. It is difficult to imagine someone as poorly schooled as Pollock, who was often left back, and never did manage to graduate from high school, reading such books. [81] Yet friends report that he struggled through many of them, and that his conversation was sprinkled with psychological jargon and references to Oriental philosophy. Since Pollock functioned on a need-to-know basis in everything else, it is unlikely to be a mere coincidence that his own state of mind when he was painting "in the zone" so exactly followed Oriental practices.

Pollock often said he painted from the unconscious. His interest in Freud's and Jung's ideas about the unconscious came not only from the Surrealists he knew but also from the psychiatrists who were treating him for alcoholism over the years. Much of his early analysis, particularly by his Jungian analysts, had to do with interpreting his drawings instead of his dreams, since he was not very verbal. Later Pollock became a sort

of Zen artist able to tap into the unconscious while working on his "paint stream abstractions." The Japanese philosopher D. T. Suzuki wrote that when "we reflect, deliberate and conceptualize, the original unconsciousness is lost and a thought interferes."

Man is a thinking reed but his great works are done when he is not calculating and thinking. "Childlikeness" has to be restored with long years of training in the art of self-forgetfulness. When this is attained, man thinks yet he does not think. He thinks like the showers coming down from the sky; he thinks like the waves rolling on the ocean; he thinks like the green foliage shooting forth in the relaxing spring breeze. Indeed, he is the showers, the ocean, the stars, the foliage.[82]

He *is* nature.

Before 1947, when Pollock began trusting himself to flowing paint, his mind was caught in a turbulent stream of unconscious urgings that was moving too fast for his paintbrush. Once rid of the brush and the thick, brush-dragging pigment that comes out of tubes, Pollock was able to follow any inspiration without technical effort. Zen artists use flowing black ink instead of thin paint, but, like Pollock, work rapidly, with absolute sureness, making strokes which they are neither capable nor needful of correcting. Master Zen artists, Eugen Herrigel explains, learn that if they want to unleash the full force of spiritual awareness they must perform like a dancer.

If you do this your movements will spring from the center, from the seat of right breathing. Instead of reeling off the ceremony like something learned by heart, it will then be as if you were creating it under the inspiration of the moment, so that dance and dancer are one and the same. By performing the ceremony like a religious dance, your spiritual awareness will develop its full force.[83]

Thus it is not surprising that in Namuth's pictures Pollock looks like a shaman in the throes of a ritual. The paint appears on the canvas as if by magic. One rarely sees the paint itself being flung because it is indistinguishable from what is already there—just the blurred movement of the artist's hand as he waves his wand over the charged field of the painting. In a photo in which Lee Krasner is seated on a stool to his left, you can

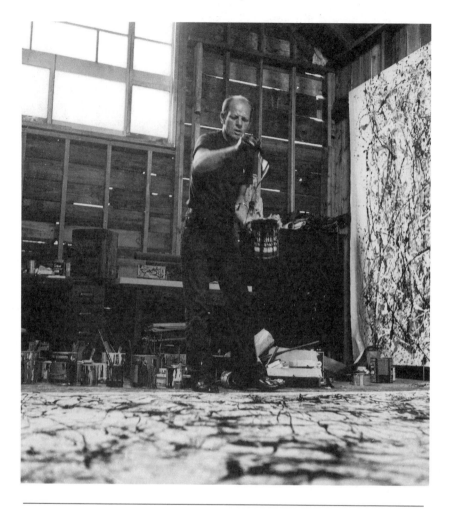

Jackson Pollock painting **Autumn Rhythm.** *Note the careful placement to the paint stream pouring off the hardened brush in his hand. He is standing at the bottom edge of the painting where his paint cans were located. Note too the spaces between the rough barn siding. (Photo by Hans Namuth © 1990)*

actually see the line of paint flying through the air in front of her. His wife watched him in awe: "His assuredness . . . was frightening to me. The confidence, and the way he would do it was unbelievable at that time. For me it is working in the air and knowing where it will land. It is really quite uncanny. Even the Indian sand painters were working in the sand, not the air."[84] Gripped by impulses that seem electrical, driven by inner, unconscious forces, and concentrating with a superhuman

intensity of focus, Pollock finally realizes the dream of Western artists since Gauguin—to be a primitive in touch with the other world, in touch with God.

Pollock wasn't a religious man in the usual sense, but he was a searcher, a seeker after truths higher than could be provided by life on earth. His family was ardently antireligious, but he did not share their views. When he married Lee Krasner in 1945, he insisted on a church wedding, though he never attended church otherwise.

(Paul) Jackson Pollock was born in Cody, Wyoming, on January 28, 1912, the fifth and last son of Roy (Mc Coy) Pollock and Stella McClure. He came into the world after a long and traumatic labor due largely to his twelve-and-a-quarter-pound size. Strangled by the umbilical cord and "black as a stove"—his entrance to life was itself something of a "miracle." Less than a year later the family made the first of the nine moves they would make in the next fourteen years as one life-supporting venture after another failed. His parents eventually separated, and mother and sons finally settled down in Los Angeles. There Jackson attended the Manual Trades High School; future artists Phil Goldstein (Philip Guston), Reuben Kadish, and Manuel Tolegian were fellow students. Their favorite teacher was Frederick John de St. Vrain Schwankovsky (Schwanny to them), who introduced them to yoga and Eastern philosophy on an extracurricular basis. He even brought Jiddu Krishnamurti, the proclaimed reincarnation of Buddha, to talk to them privately. Krishnamurti was on a world tour at the time, and had established a camp north of the city in the Ojai valley. Shortly afterward, he repudiated the claim to godhood and went into semiseclusion, retaining only a marginal connection with the Theosophical movement. Around that time Pollock "dropped religion for the present" but this youthful "conversion" to Eastern philosophy seems to have had a permanent effect on him. He certainly never stopped thinking about it. His second dealer, Betty Parsons, remembered him this way:

> He was a questioning man. He would ask endless questions. He wanted to know what I thought about the world, about life. He thought I was such a jaded creature because I'd travelled; he wanted to know what the world was like—Europe, Asia. He was also extremely intrigued with the inner world—what is it all about? He had a sense of mystery. His religiousness was in those terms—a sense of the rhythm

of the universe, of the big order—like the Oriental philosophies. He sensed rhythm rather than order, like the Orientals rather than the Westerners. He had Indian friends [Mr. and Mrs. N. Vashti],[85] with whom he talked at length and who influenced him greatly.[86]

Pollock was constantly searching for answers to the myriad questions he had about the world, but also to discover what answers others had found. The architect-cum-sculptor Tony Smith, who knew Pollock since the early forties, felt strongly that Pollock saw art as a form of therapy mixed with religion:

> Once, sitting at Louse Point and listening to the water, he said, "I'm in analysis, you know. Fred [the artist, Gerome Kamrowski] doesn't believe in analysis. He says that art springs from neurosis; that the neurosis should be left intact." I didn't know anything about analysis, but I imagined that art sprang from something quite primitive. I thought it might be something like yelling, and then hearing the echo. He seemed relieved, but the incident is typical of the way in which he checked things out. He was conscious of different attitudes and approaches to things. He mused aloud about esoteric religious ideas, Oriental philosophy, things I knew nothing about. I once made a casual reference to Western man. He straightened right up and said, "What's the matter with Eastern man?"[87]

The three great paintings of the summer of 1950—*One: Number 31, 1950, Number 32, 1950, Autumn Rhythm: No. 30, 1950*[88]—were all included in Pollock's Parsons exhibition at the end of the year and will be discussed in the December chapter in the context of his artistic development. Some observations about them in light of Namuth's on-the-spot photographs are in order here, though. First, and most importantly, they all have a definite orientation as to top and bottom which was established at the outset: what is the bottom now in each painting was so all along, and it was where the artist stood most of the time as he worked. Though he moved around the canvas and added pigment from both sides and from the top, two out of three photographs of him at work show him at the bottom edge. Only one-third of the time does he appear to work from all the other three sides combined. He may actually have worked even more often from the bottom edge than the photographs tell us, since that is the side of the studio with the window, and

no photographer enjoys shooting into the light. According to the photographs, the bottom edge of the canvas is where the paint and painting tools are located.[89] Each time Pollock wanted a new color, he had to go there. It is likely that most of the time that he reentered the painting

Jackson Pollock painting Autumn Rhythm, *standing in front of* One (Number 31, 1950). *He seems to dematerialize in a shaft of light as he paints. (Photo by Hans Namuth © 1990)*

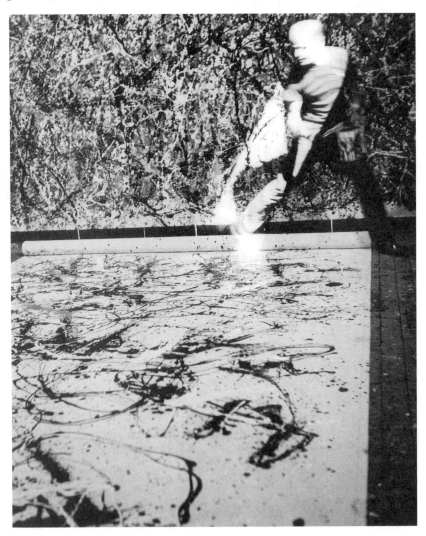

with the new color in hand, he did so from that bottom edge. As the stick or hardened brush was taken out of the can, some of the liquid paint was bound to fall off the tool as Pollock began his gesture. As a result, the bottom edge is much denser with pigment than the rest. (This is not as true with *Number 32, 1950,* which is very thinly painted and for which a basting syringe may have been the tool of choice.)

In conjunction with the physical commitment to the orientation was the fact that as standing humans we are used to seeing the world as a place where the densest physicality occurs at our feet. As we move out and upward into space, everything moves away from us in a curving continuum of closer to farther, sharper to less clear, easier to reach to less easy, and so on. Knowing that, artists can work against our natural orientation in the world to flatten the picture space, as they so frequently do in modern paintings, or they can use it—as Pollock did—to anchor the viewer to something solid when no other clues are given. Had he chosen to place the edge next to the paint cans at the top of his image instead, he would have given us a very topsy-turvy world in which things seemed to be falling down out of the picture.

Thus, although he didn't work with the horizon line in his mind's eye in the way of someone who paints on an upright, vertical canvas, Pollock did operate from the premise of normal human spatial orientation rather than equally from all sides. True allover pictures by Pollock, or anyone else for that matter, which don't have a weighted side, tend to seem decorative, like fabric designs that could go on forever, because we are given no clues to our orientation in relation to them. This is one of the reasons why these three pictures from the summer of 1950 are great in a traditional sense; by contrast, many of that year's smaller works —paintings in which he could easily work from all sides—are less compelling or satisfying. One other interesting fact comes to light in the photos of *Autumn Rhythm.* Some of Namuth's early pictures of Pollock at work on this painting show a small, squarish canvas resting against *Number 32, 1950.* Called *Autumn Landscape,* but probably painted the previous spring, it shares with *Autumn Rhythm* a right-angled corner form in the upper center and a general sense of the top as an area where forms seem to be bursting forth. Though we know Pollock didn't work from studies, he did habitually work surrounded by recently painted canvases (mainly for lack of storage space in the case of big pictures), but here it seems possible that the smaller picture was delib-

erately used as an inspiration for the larger canvas. It is small enough to have been easily stored.

In the photos one can see light pouring through the siding on the walls of Pollock's studio. Clearly it was only usable in warm weather. He didn't have enough money to insulate and heat it until years later, and by then he had deteriorated physically and emotionally to the point of not being productive. The beginning of the end came at the conclusion of Namuth's photography and filming sessions almost as though Pollock knew—as Duchamp knew after creating *The Large Glass*—that he had created his masterworks already, and all there was left to do now was to repeat them. Using the poured line after that to draw recognizable images was Pollock's way of not "painting Pollocks" but still being true to himself. Some of these quasi-figurative works are marvelous, but their semi-abstract status was not very warmly received, just as de Kooning's "return to the figure" was not easily accepted by his friends. Even Pollock's staunch supporter Clement Greenberg abandoned him in favor first of Clyfford Still and then of Barnett Newman. After 1951, when Pollock did try to "paint Pollocks," they tended to become clotted and overworked.

Interestingly, the last work Pollock painted for Namuth's camera was, like Marcel Duchamp's masterpiece, on glass. Because of this, *Number 29, 1950* represents yet another truth about Pollock's work that the camera revealed. Only one critic ever grasped what Namuth's camera confirmed: that Pollock's endeavor has sculptural aspects. Elaine de Kooning, perceptive as ever, though still only a novice at writing art criticism, had noted in a March 1949 *Art News* review of his recent show at the Betty Parsons Gallery that Pollock's "complex luminous networks . . . give an impression of being frozen in position. His flying lines are spattered on in intense, unmixed colors to create wiry, sculptural constructions, which stand immobile and apart, uninvolved with the backgrounds." Formalist critics in the years since have fallen over themselves trying to prove how optical, and therefore post-Cubist and non-sculptural, Pollock's work is. To do so they emphasize how his line does not make shapes, does not incorporate "negative" space or otherwise engage the picture plane that is represented by the white canvas surface, i.e., the background. But Elaine was married to Willem de Kooning, the master of pictorial ambiguity, of figure/ground interaction, and she was a painter herself. She knew what a painter does, and that by not doing it

Pollock was creating a kind of sculpture on the surface of his canvas. In fact, the relief quality of his surfaces is quite fascinating and deserves more attention. It does not show up well in reproduction, but when you see the actual works, or see Namuth's movie and watch Pollock build up paint, sand, broken bits of glass, wire, and screening on the surface, you quickly become aware of their physicality. Your eye watches from below because Namuth and his camera were beneath the big sheet of glass that rested on a trestle Pollock built for it at the photographer's suggestion.

Poet and critic Frank O'Hara was fascinated with the painting that resulted. "What an amazing identity *Number 29* must have!" he said. "Like that of a human being." [90] O'Hara saw Pollock's work as pointing to a new "imponderable esthetic" for artists of the future. One of these, Allan Kaprow, the initiator of "Happenings," believes that Pollock represented the last step in a gradual movement forward out of deep Renaissance space, through the Cubist picture plane and into the real space of life. "The 'picture' has moved so far out," Kaprow explains, "that the canvas is no longer a reference point. . . . Pollock's near destruction of this tradition may well be a return to the point where art was more actively involved in ritual, magic and life than we have known in our recent past." [91]

Hans Namuth filmed his first movie of Pollock that summer in black-and-white, using his wife's home-movie camera and the available light in the studio. He showed it to professional film editor Paul Falkenberg, who thought it well worth doing over again in color and helped him raise the money to produce it. Since there was no electricity in the studio for lights, they had to work outdoors. It was sunny but sharply cold that last day of shooting at the end of November 1950,[92] but the money was running out, as was the light, so there was a desperation to finish. The crisis feeling in the air broke when they suddenly realized the painting was complete. "We are done!" they shouted, throwing their arms around each other. "It's great, it's marvelous!" and in the blind euphoria of the moment and the rush to warmth indoors, Pollock went straight to the cabinet beneath the sink, pulled out a quart of bourbon and poured tumblerfuls for both. "This is the first drink I've had in two years," he said. "Dammit, we need it!" [93]

Lee Krasner turned white, knowing that Pollock's first drink was a portent of disaster. Alfonso Ossorio and Ted Dragon, Penny and Jeffrey

Potter, Josephine and John Little, Peter Blake and Namuth's wife, Car-
men, had gathered at the Pollocks' for a post-filming, post-Thanksgiving
roast beef dinner to which they all contributed.[94] Normally Pollock
would have made the pies, and perhaps the bread, which he enjoyed
doing, but this day the photography session took precedence over
everything else. After another glassful of bourbon Pollock began "play-
ing" with some cowbells on a leather strap, trying to swat Namuth with
them. But the cool and polished Namuth was not one for raucous
horseplay. Unaccustomed to handling Pollock in this state, Namuth said
things that only further irritated him. Finally, Pollock overturned the
massive refectory table laden with the feast and stalked out, crunching
through the broken glass and china. According to Buffie Johnson, Pol-
lock ended up at the house of a mutual friend—Happy Macy—later that
night, where another dinner party was in progress. He had already kept
one of her guests, Dr. Violet de Lazlo, his former Jungian analyst, on the
phone for two courses, and now he cornered her in a nearby room for
a "consultation." Dr. Lazlo had been the only one able to keep him
sober for long periods in the forties before he found Dr. Heller—the
East Hampton GP who got him "on the wagon"—but this time even she
couldn't reverse the downward course on which Pollock had just
launched himself.

No one knew as well as Lee Krasner what a tremendous loss this
would be. She had already seen him through years of destructive drink-
ing that had turned the Rimbaud quotation she once scrawled on her
studio wall into a prophecy. The lines which she felt "express an honesty
which is blinding" came from Rimbaud's *A Season in Hell.*

> To whom shall I hire myself out? What beast must I adore?
> What holy image is attacked:
> What hearts shall I break?
> What lie must I maintain? In what blood tread?[95]

But in the early years of the living hell of life with Jackson when he was
drinking, at least some psychological help was available and, more im-
portantly, there was a future to look toward, a future of critical success,
financial reward, and great esthetic impact. Unfortunately, by the end of
1950 that future had already taken place. Just about all that was going to
happen for Pollock in his lifetime had happened, and it didn't add up to

very much. Though his esthetic impact had been strongly felt, directly in the work of James Brooks and indirectly in the coming generation of "stain painters," he had no followers. Indeed, he couldn't have any, because for them to drip paint would be to "paint Pollocks." Critical "success" in the popular press meant being called "chaotic" and, later, being labeled "Jack the Dripper," both of which hurt him deeply. Serious critical support was about to shift to de Kooning, and so were the collectors. While Jackson and Lee weren't starving, the wherewithal for anything above the bare necessities simply did not exist. (That dinner feast Pollock overturned had been a communal effort for reasons of necessity.) Even though there were some sales from the 1949 show, the prices were low (in the hundreds, for the most part), and the 1950 exhibition would do far worse, as Greenberg predicted, even though it would include three of Pollock's largest and greatest paintings.

When Lee Krasner had sought Pollock out late in 1941, she did so as one professional artist who wanted to meet another. Pollock was one of the few artists whose work was unfamiliar to her among those John Graham had selected besides herself for an exhibition at the McMillen Gallery. The Picassoid still life of Krasner's that Graham had chosen was as tough and successful as anything being done in that vein in America at that time, but it looked tame and familiar compared to Pollock's overwhelmingly brutal inclusion, *Birth*. When she walked in the door of Pollock's Eighth Street studio and saw his work for the first time, she felt she was seeing into the future, and she was stunned. "My God, there it is," she thought.

> I couldn't have felt that if I hadn't been trying for the same goal myself. You just wouldn't recognize it. What he had done was much more important than just line. He had found the way to merge abstraction with Surrealism. . . . You have an individual who appears on the horizon and opens the door wide. We all live on it for a long time to come, until the next individual arrives and opens another door . . .[96]

Krasner had been studying art since her girlhood in Brooklyn where she was born on October 27, 1908. Having submitted herself to a thorough grounding in traditional art at the National Academy of Design, she then found the perfect modern antidote to it in the classroom of Hans Hofmann. By the end of the forties she had a studio of her own,

she was employed on the WPA, and she moved in a circle of sophisti-
cated artists. While not pretty, she had a spectacular figure, and her
relationships with men were serious and intense. She had left Hof-
mann's school feeling that he was too rigid in his separation of drawing
and painting, too tied to reality, and too formal. Hating Surrealism,
Hofmann was stubbornly resistant to submerged psychological content
in art. Krasner was ripe for what was in essence an abstract form of
expressionism where line and color fused in images that came welling
up out of the unconscious. Or at least she was able to recognize it when
she found it in Pollock, if not quite ready to try it herself. She was
reluctant to give up the safety of her Hofmann-instilled hold on the real
world of objects and nature, and to shift to her inner emotional world
instead. With post-women's movement defensiveness she recalled later
that:

> After I met Pollock it took a long time for me to absorb the kind of
> work he was doing, just as with Cubism earlier. But we equalized in
> some sense. In fact, once we asked ourselves hypothetically what
> would have happened if it had been me who came through first. But I
> wasn't earning a living in those days, and we had to concentrate on
> what would bring in some money. If I had to be a teacher as so many
> of the artists' wives who supported their husbands were, I wouldn't
> have painted at all. I maintain I never gave up. I kept a corner for
> myself. And I always painted.[97]

Though she was a strong artist in her own right, she shares with those
other artists' wives (Esther Gottlieb, Annalee Newman, Musa Guston, the
two Mrs. Rothkos, and Elaine de Kooning), whether Jewish themselves
or the wives of Jewish artists, the symptoms of a kind of Jewish wife
syndrome: take-charge capability, unquestioning support, high ambition
for the man, and an absolute willingness to make even major sacrifices
in his behalf, such as giving up motherhood and putting her husband's
career first. Some see this behavior as a result of the old-fashioned, Old
World way many of them were brought up. The Jewish daughter was
trained to defer to the male, whether father or brother or son. Whatever
the origins of this behavior pattern, it reemerges in women deferring to
the male as the better of the two, the superhero who can make it for
both of them—with her help. Barney told Annalee he would make her

a millionairess, and he did, but it didn't happen until after his death. And that was the way it went, for Lee and Annalee at least, if it went at all.

Meanwhile, in addition to doing everything she could to help Pollock with his career, Lee Krasner had her art, and she struggled mightily with it. She didn't accomplish much between 1942 and 1945 while she shared the Eighth Street studio with Pollock, though for him those were tremendously productive years despite the drinking. When she finally began working from her inner self in the middle of the forties, she produced what she called "Little Images," tightly coiled spirals, intricate webs of linear densities, small slabs of color and noncolor filling modest canvases edge to edge. Some seem close to Mondrian at his most obsessively "all-over" (the "plus and minus" paintings), some recall the "spirit writing" of Mark Tobey, others are more like the tight grids of the Uruguayan painter Joaquin Torres-García. The expansiveness and aggressiveness of attack she admired in Pollock, and in his sources of inspiration, Mexican art and Picasso, seemed unavailable to her. She couldn't let force lines swing far, and her directional flows were tightly controlled by the framing edge. Her images didn't explode, they imploded.

Art critic Barbara Rose, who made a study of Krasner's work, feels that despite her originality and her independence, Krasner's upbringing (in an Orthodox Jewish family) and her solidly traditional schooling worked against her drive toward total emotional expression. "As long as Pollock was alive," she wrote, "Krasner could not afford to enter the world of trancelike 'otherness' in which he operated when he painted. *Her* feet, at least, had to be securely planted on the ground." Rose reported that Krasner had a dream that expressed her fears in this regard:

> Jackson and I were standing on top of the world. The earth was a sphere with a pole right through the center. I was holding the pole with my right hand, and I was holding Jackson's hand with my left hand. Suddenly I let go of the pole, but I kept holding onto Jackson, and we both went floating off into outer space. We were not earthbound.[98]

Not long after their marriage in 1945, Pollock and Krasner moved to The Springs to live year-round. They both loved being in close touch

with nature, and felt the same things about the land, the sky, and the moon. "He did a series around the moon," Krasner remembered. "He had a mysterious involvement with it, a Jungian thing. I had my own way of using that material." She recalled later:

> With Jackson there was quiet—solitude. Just to sit and look at the landscape. An inner quietness. After dinner, to sit on the back porch and look at the light. No need for talking. For any kind of communication.
> If we found we couldn't sleep at dawn, we might drive the little car and park it and go walking in the woods, for hours. That was the big thing to do. Or—let's go swimming at night.[99]

The first year they lived in The Springs Pollock painted in the upstairs bedroom because the barn was too full of junk to be usable. He had a show coming up the next fall. Krasner worked on mosaics near the stove in the kitchen. Once they moved the barn away from the house, where it obstructed their view of the marshes, and got the barn in shape as a usable space, Pollock made that his studio. Like the bedroom, which Lee then took over, it was unheated, so neither could work when the weather was cold. Even though her studio was large enough to facilitate work on fairly big pictures, the "Little Images" Krasner now began creating were quite small in size as well as scale. But working from interior material still frightened her; it wasn't until the mid-fifties, when she began psychoanalysis, that her work became consistently and fully Abstract Expressionist.

Perhaps buoyed by her success in the East Hampton art world—she had taken second prize in the summer 1950 Guild Hall exhibition, "Ten East Hampton Abstractionists," while Pollock had taken third—she suddenly began to try to loosen the tight rein she always had on her image world. She greatly expanded her scale by filling huge canvases with elongated stick figures in rhythmic groupings, roughly brushed in white against a black ground. They recalled Pollock's *Mural,* but in a more lyrical mode. The attempt was abortive, unfortunately, and all we know of these paintings comes from seeing unfinished corners of them in Hans Namuth's photographs of Krasner in her studio that summer. She subsequently destroyed them all. On the basis of some of the smaller gestural abstractions that followed, Pollock finally convinced his dealer, Betty Parsons, to give his wife a solo exhibition in the fall of 1951. *Gothic*

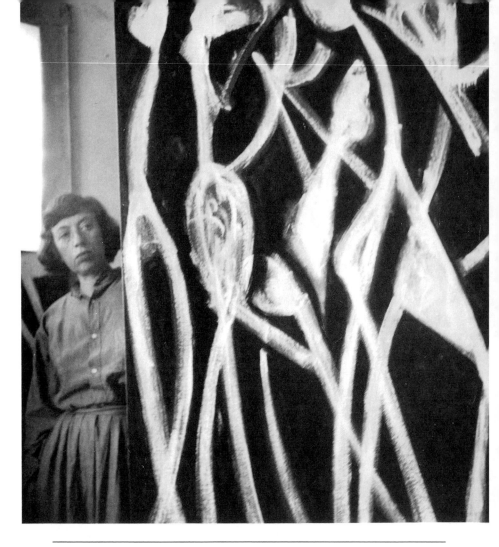

Lee Krasner standing behind one of the huge gestural paintings she painted in 1950 and subsequently destroyed. (Photo by Hans Namuth © 1990)

Frieze, 1950, at three by four feet, was probably among those medium-sized, loosely painted, jagged compositions that swayed Parsons. It is brooding and rhythmic in a way that reminds one of Pollock without seeming derivative, so thoroughly grounded is it in Hofmann's fusion of Cubism and Expressionism. *Gothic Frieze* proved that it was possible for her to approach her husband's emotional level in paint without losing her identity. However, to Parsons's dismay, Krasner underwent another crisis of confidence just prior to her show and retreated to the safety of Mondrian for inspiration. The works, which received generally negative response, were thickly painted colored rectangles of varying sizes ar-

ranged asymmetrically on the canvas. It wasn't until seven years later, after Pollock's death, that she was able to fully realize the promise of those free abstractions of 1950. The liberating mechanism for her to make this breakthrough was the decision to destroy old works—tearing up the drawings, cutting or ripping the canvases into shards—and to recycle them into new ones. Pollock had enjoyed one critic's statement that his poured paintings lacked a beginning or an end; Krasner here literally made her beginnings her end, simultaneously opening and closing the cycles of her life. Both Krasner and Pollock would have been acutely aware of the mystical Eastern death and rebirth cycle this action replicates.

One senses that in the destruction of old work Krasner was finally giving vent to the rage she must have felt for years about her secondary place in the art world. Critic friends from the thirties such as Clement Greenberg and Harold Rosenberg had completely ignored her in print. Pollock's dealers wanted no part of her. Long after Pollock's death, museum curators continued their habit of not giving her work any serious attention. As for friends, when Barnett Newman's call to Pollock came in May 1950 from Adolph Gottlieb's Brooklyn studio where they and a number of other artist friends were composing the protest letter to the Met, Newman never thought to ask Lee for her signature as well. She was furious. After all, she was the more politically active of the couple, and their friends knew she was an artist. But she said nothing. As a result, if Sam Kootz had been taken up on his offer to mount a sort of *salon des refusés* of "The Irascibles' " work in his gallery, she wouldn't have been included. Nor was she invited to the *Life* photo session with Pollock for the picture that put the New York School on the map. In those days, the hold advanced American male artists had on the art establishment was so tenuous—as the Met's hostility to their work demonstrated—that no one was going to risk loosing its grip by having a woman take a man's place. The feeling was that "the men" had to "make it" first—then the others would follow.

As orchestrated by Newman and Gottlieb, the Met protest letter definitely involved grandstanding. Numbers weren't important; names were. Pollock's was essential. De Kooning, Gottlieb, Rothko, Newman, Tomlin, Motherwell, Baziotes, Still, and Brooks were the other names known to anyone who knew anything about the art world then. Hedda Sterne's name was linked to that of her famous husband, Saul Steinberg, but it

was also useful, in itself, since she was a woman with a wide reputation who had been singled out for attention by *Life* earlier that year. The same was true of Jimmy Ernst and Theodoros Stamos, and the Met had made Stamos's work one of the precious few gap-filling purchases they had promised. Krasner's former teacher, Hans Hofmann, who had been well established in the U.S. since the thirties, was also an important signatory to have, since he represented an older generation, one with School of Paris clout. He also operated the only viable art school where one could study the new, advanced way of painting. Krasner hadn't shown a great deal, and her name was not yet known to many outside the art world.

Fortunately, Krasner was a survivor. Three years before her death in 1984, she had the pleasure of seeing an exhibition mounted that was titled "Krasner-Pollock: A Working Relationship," in which their paintings and their contributions to each other's endeavors were more or less equalized. That this was a post-women's movement phenomenon, and that the best of Pollock and the best of Krasner are in no wise equal, was probably not lost on her any more than it was on the exhibition's viewers. But that is less important than the fact that an effort had been made to redress the skewed balance of their accomplishments. This show was followed in 1983 by a retrospective at The Museum of Modern Art in which her lifework was finally given a comprehensive overview.

Although Pollock's resumption of drinking wreaked havoc with her personal life, Krasner must have come to realize in the early fifties that she was an independent person with an artistic life worth pursuing, for that is what she did. After the temporary retreat of her Parsons show, she became stronger and stronger every year. Inspired anew by Matisse after his 1951 MOMA retrospective, she reworked some of the rhythmic paintings of 1950–51. *Blue and Black,* 1951–53, and *Ochre Rhythm,* c. 1951, frame the two sides of her nature: a dynamic energy that seems to want to burst out of the picture space in the latter, and in the other, a formal grandeur that hauntingly connects Matisse with both Mondrian and Islamic calligraphy.

Her first big breakthrough came in 1953–54. She began by collaging torn remnants of black-and-white drawings, and quickly moved on to incorporate pieces of discarded paintings as well, often mounting them on other canvases or on board. The process eliminated the need for deliberate drawing—her "lines" were roughly torn edges, her "shapes"

were created automatically. It also freed her from an innate tendency to tighten her pictorial constructions. She could move things around and change them with abandon. Doing so, and then gluing them down, required that she work on a horizontal surface, which liberated her from the ingrained habits of years of working at an easel. Her scale kept increasing, as did her openness to accidental effects. (She sometimes even utilized fragments of Pollock's discarded pictures.) Matisse was winning out over Mondrian in the battle for her artistic soul, though her colorism remained intensely personal and offbeat. Orange, ocher, pink, and brown predominated over yellow or blue. Like Matisse, she also knew how important black and white were to make the color sing in a picture. Pollock gave her much support at this time, and one of his own paintings, *Easter and the Totem,* 1953, even shows evidence, both in its structure and its color, of her influence on him.

It is significant that she began to sign her full name to her paintings by 1955, instead of just initialing them.[100] Her Stable Gallery exhibition that year was a complete artistic success. Nature forms had begun to predominate, and then, by the beginning of 1956, she was fully into gesturally free paint handling, no longer afraid to let her unconscious mind take control of the brush. She was tearing into forms painted on the canvas as though she were manipulating collage elements, scratching them out violently, slashing the paint on the canvas and letting it fall and run at will. She even felt independent enough to embark on her first trip to Europe in July 1956—without Pollock. This was the first time in their fourteen years together that Pollock was on his own. He died in a car accident while she was in Paris. It took her a long time to come to terms with the guilt she felt about this, but finally she was able to say, "I had to realize that things would have happened in the same way even if I had been sitting right here in my living room."[101]

Krasner's last painting before sailing—the freest and most psychologically compelling work she had done thus far—was titled *Prophecy,* and that is precisely what it seems to have been, a prophecy of the future, of a lifetime of greater and greater artistic freedom for her. After her husband's death, violent feelings immediately poured out in a series of semi-figurative paintings overflowing with flayed, gouged, smashed, and broken forms. Krasner's paintings of 1956–59 seem so full to bursting with emotion that they are more like exorcisms than expressions of feeling. Working in Pollock's barn, now lined with white walls and in-

sulated, she began to paint on his scale. By the end of the decade she
was making fifteen- and seventeen-foot paintings full of wild gestures,
painted at apparently high velocity. Titles like *Uncaged, The Gate,
Charred Landscape, What Beast Must I Adore?,* and *Polar Stampede* give
a good indication of her mental state at the time. The turbulence and
almost demonic energy of these paintings finally begins to wear itself
out by the end of the sixties, and in the years that remained to her she
returned to a lyrical, controlled mode that harked back in spirit to the
days before Pollock came into her life. If he hadn't done so, chances are
she would never have been inspired to let her passions break through
the powerful bounds of a tightly constructed form-world. Then too, if
she hadn't let Pollock into her life, chances are he would never have
found the peace and the guiding, protective support he needed to work
at his peak. Whatever might be said about the relative worth of their
individual contributions to art, there is no doubt that the entirety of
their common contribution is far greater than the sum of its two sepa-
rate parts.

In the early fall of 1950 the New York artists returned from their summer workplaces even more excited than usual about the upcoming season. Publication of their protest letter in *The Times,* the representation of their kind of art at the Venice Biennale, and a general sense of taking their place on the international stage of art made them look forward more confidently than before to the immediate future. Still hanging over their heads, just as it did over everyone else's, was the threat of nuclear war, and one of the tensest years in the Cold War era. Aware of this though they were, their chief battle was with and for their art. Most of them would have felt that William Faulkner's eloquent statement upon accepting the Nobel Prize for Literature on December 10, 1950, echoed their own thoughts. Faulkner said:

> Our tragedy today is a general and universal physical fear so long sustained by now that we can even bear it. There are no longer problems of the spirit. There is only the question: When will I be blown up? Because of this, the young man or woman writing today has forgotten the problems of the human heart in conflict with itself which alone can make good writing.[1]

Well back in the fall of 1945, just days after the atomic bombs fell on Hiroshima and Nagasaki, the possibility of global annihilation had already begun to seem real. Paul Boyer, author of *by the Bomb's Early Light,* a 1985 study of American thought and culture at the beginning of

the atomic age, wrote, "This awareness and the bone-deep fear it engendered are the fundamental psychological realities underlying the broader intellectual and cultural responses of this period."[2] In January 1950 President Truman had authorized production of hydrogen bombs, and the possibility of our completely destroying the world became even closer to realization.

The summer of 1950 had seen the Cold War heat up on another front: the establishment of the Congress for Cultural Freedom. This ideological segment enlisted in the fight against Communism, but with the pen instead of the sword. On June 26, in advance of the week-long initiatory meeting of the CCF in West Berlin, *The New York Times* announced that the new organization "will challenge the alleged freedoms of Soviet-dominated Eastern Europe and attempt to unmask the Soviet Union's and Soviet-sponsored 'peace' demonstrations as purely political maneuvers."[3] The CCF message was that intellectuals of the Western world should join forces against Communism, a repressive system which was rapidly and literally gaining ground the world over.[4]

Artists, perennially segregated from intellectuals in the common expression "artists and intellectuals," tended to be vaguely aware of these events, but not especially involved. Though many writers lent their pens to Cold War weaponry, the painters withheld their brushes. Even the more politically inclined members of the New York School probably felt as disengaged by 1950 as Robert Motherwell, who dates his time of political passion in the thirties. Artists like Kline, de Kooning, and Pollock, from whose lips political sentiments rarely, if ever, issued, probably didn't even read *Partisan Review* or *The Nation* except for the art columns; but most of the other artists often took their political and intellectual cues from those signposts of contemporary thought.

Responding to a perception of general interest in the reanimation of religious values in order to assure the survival of society in such perilous times, some of the spring 1950 issues of *Partisan Review* had been devoted to a symposium on "Religion and the Intellectuals." The general gloom of the series was lightened in a few places as, for example, when James Agee asked the question "How can anyone who has swallowed the doctrines relating to penis-envy, or the withering away of the State, strain at the doctrine of Transubstantiation?"[5] W. H. Auden was one of the few who spoke to the artist readership when he stated that the artist

does not have to believe what he says, only entertain it as a possibility: e.g., if he writes a poem about the Crucifixion, there is no means of knowing from the poem whether he believes in it as a Christian must believe or is using it as a convenient myth for organizing the emotions his poem expresses, for in poetry dogma and myth are identical.[6]

No more perfect example of the truth of Auden's statement can be found than in the art projects commissioned for religious contexts that were executed by the Abstract Expressionists in and after 1950. In a clever move to promote his artists, art dealer Sam Kootz had paired Motherwell, Gottlieb, Hofmann, Baziotes, and sculptor David Hare with five architects, and had exhibited the results of their collaborations, the models, and representative sections of the paintings at his gallery in October. Thinking on a grand, mural-size scale seemed to be very good for the painters, Hofmann especially. His seven-by-four-foot "detail" of the *Chimbotte Mural* was far bolder than any of the paintings he would be exhibiting in his one-man show at the gallery later in the month. Truly Abstract Expressionist in spirit, this painting is full of painterly élan and bravura technical effects. Its highly charged emotionalsim shows Hofmann at his most expansive. Passages of drybrushing intersperse areas of scumbling and thick impasto. Many of the sides of his multifarious artistic personality are fused into a single successful image which presages his future work.

Motherwell and Gottlieb were both commissioned to create works for synagogues as a result of the Kootz show even though their projects in that show were secular. During the next three years Gottlieb designed ark curtains for two synagogues and a stained-glass wall for a third without succumbing to the cliché images of Judaism—the menorah, a burning bush, and the Star of David. Motherwell, not being Jewish, was less anxious to avoid the standard symbols, but he, too, created some very free-form abstract designs for his synagogue commissions. In later years, when Rothko and Newman created religious artworks, they also used the dogma more as a "convenient myth for organizing emotions" than as subject matter.

In Provincetown during the summer of 1950 Hans Hofmann and Fritz Bultman wrote a joint statement titled "Protest Against Ostrich Politics in the Arts."

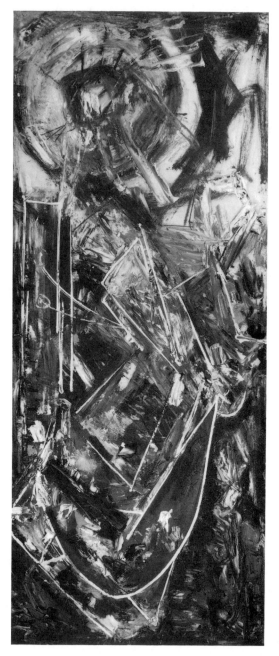

Chimbotte Mural *by*
Hans Hofmann.

The estate of the arts should never be narrowed to a national basis
—particularly by the artists.

The greatness of Paris is to offer an invitation of participation to the
spirit. If the United States has assumed, as in the last few years, the

same free and open attitude, this warrants great promise in the arts. Paris's humanism has given the opportunity for free development of such artists as the Spaniards—Picasso, Gris, Miro; the Swiss—Klee, Corbusier, Giacometti; the Russians—Kandinsky, Chagall; the Rumanian—Brancusi; the Irishman—Joyce; the Americans—Stein, Man Ray, Carles;[7] the Pole—Lipchitz; and many others.

Still today many of them are living masters of Paris. We earnestly hope that artistic creation in America will develop the same fruitful ground to equal such a great example.[8]

This statement, humanist and internationalist in spirit, was more of a gentle warning than a manifesto. It was issued on the occasion of an exhibition organized largely by Bultman and Hans Hofmann's wife "Miz" (pronounced "Meets") at the Provincetown Art Association in August which they titled "Post-Abstract Painting 1950—France—America."[9] The co-curators defined post-abstract painting as a style that went beyond formal relationships as well as national boundaries. They wrote in the accompanying brochure that the new "post-abstract painting communicates plastically, sensually, and psychologically through the inherent quality of paint. It goes directly from the painter to the observer, without reference to a naturalistic world, creating an image of its own in a mysterious existence."

This show probably was, as its organizers claimed, the first artist-organized international exhibition of advanced contemporary art held in America since the Armory show in 1913, and it was undoubtedly the most radical of any international exhibition mounted since that event. It was certainly far superior to the Pittsburgh International, which had been reinstituted this summer for the first time since 1939. Critics greeted the 1950 Pennsylvania show with the disdain one would have expected if its curators had deliberately set out to invite the most mediocre, least radical art then in existence. Henry McBride, though far from the most progressive critic of the day, decided that it displayed an art world that hadn't advanced at all in the last dozen years. He found the show "quiet and unalarming," saying that "we are quite used to everything in it." Neither the Americans nor the Europeans selected for the Pittsburgh exhibition seemed to him to open any door to the future. Instead, it appeared to him, as he "whizzed by" the pictures in a wheelchair due to an "indisposition," that "everybody in the art world . . . is

standing pat on the discoveries of forty years ago. No one has had a new thought."[10]

The "new thought" was, of course, the new American way of painting, but it rarely appeared in these professionally selected institutional shows. As an example, curator James Johnson Sweeney defined "American Painting—1950" quite conservatively for the Virginia Museum in Richmond on the occasion of their new biennial of U.S. art. His personal biases led him to balance abstractions by Mondrian followers like Fritz Glarner and I. Rice Pereira with more emotional figurative paintings by Stephen Greene, Jacob Lawrence, and Hyman Bloom. He did not include any of the Abstract Expressionists.

The only 1950 show to address directly the issue of similarities and differences between advanced painting on both sides of the Atlantic was Sidney Janis's October 23–November 11 exhibition, "Young Painters in U.S. & France." A panel discussion on "Parallel Trends in Vanguard Art in the U.S. and France" was held at the gallery the day before the show closed. In this carefully selected exhibition, Americans were linked with the French, artist by artist in pairs. Gorky, for example, was matched with Matta, his friend in the early forties. This was an instructive combination, since Gorky had learned something from Matta about automatism, but unfortunately Matta failed to grasp the rich complexity of Gorky's spatial ambiguity. Matta never managed to extricate himself from the deep, consistently charted space of the Renaissance. The pairing of Kline's open and dynamic *Nijinsky* with a tight, slick, neatly bordered abstraction by Soulages prompted one young fan of Kline's to say to him, "There you are, Franz, in a Brooks Brothers suit." The other pairings—of de Kooning with Dubuffet, Pollock with Lanskoy, and Rothko with de Stael—all reinforced a general impression that the New York painters were less interested in the *haute cuisine* of the painting process, less afraid of the framing edge, and more inclined to be emotional than their European counterparts. Sadly, none of the exhibiting artists took part in the concluding panel, which was comprised only of critics and artists of other persuasions.[11]

Hans Hofmann was the artist who might have been most interesting to see in the context of Janis's exhibition—though one would be hard put to find an apt French counterpart for him, since he was truly of both worlds. Born in Germany on March 21, 1880, a year before Picasso, Hofmann had been in Paris with the great Spaniard in the crucial ten

years between 1904 and 1914. He moved to the U.S. in the early thirties, he showed with Motherwell, Still, and Baziotes at Peggy Guggenheim's avant-garde gallery in the early forties, and was an adept practitioner of the impulsive Abstract Expressionist way of handling paint by 1950. His work was marked by unrestrained gesture, brilliantly rich color, the incorporation of accident, and a boldness and vigor that seemed eminently American in its gusty exuberance and energy. Even though he was seventy in 1950, a full generation older than even the eldest Abstract Expressionist, he painted like a young man. Experiencing America from the age of fifty on seemed to have given him a whole new lease on life.

Despite all this, Hofmann's European roots held firm. In 1949 he had been honored with a major exhibition at the Galerie Maeght in Paris, one that Picasso himself attended, making a rare public appearance to congratulate the now-American artist he'd known so long ago. In the photograph of the two in front of a recent Hofmann painting, Picasso seems to look at the camera with an odd air of gentle resignation, while the considerably taller and more robust Hofmann seems to fairly burst with energy, as though he were about to take his hands out of his pockets, roll up his sleeves, and set to work. That year the French art magazine *Derrière le Miroir* devoted an issue to Hofmann that contained "An Appreciation" by Tennessee Williams (who was probably suggested for it by Fritz Bultman). Williams praised Hofmann's "spiritual intuition" in the context of the painting space which demands obedience to the laws of physics. In fact, Hofmann's "first law of vision" was that in analyzing sight rationally "we must differentiate between the act of physical seeing and the act which makes seeing a spiritual experience."[12]

It is interesting that Tennessee Williams chose to reflect on the painter's scientific side since Hofmann's career beginnings were in that area right after high school. He was the son of a well-to-do government official in central Bavaria who had married the daughter of a wealthy farmer and winemaker. As a young, musically talented boy with "Goethe-like beauty," according to his friend Lillian Kiesler, Hofmann's golden voice charmed the elite of Germany all the way up to the Kaiser when he soloed with a boy's choir. "He was a myth, a legend in Germany," she relates.[13] At sixteen, his voice now changed, and his school life over, he left his father's Munich home. Unable to support himself on dreams of being an artist, he went to work in the engineering department of the Bavarian Public Works. There he invented an electro-

magnetic comptometer (something like a calculator), the patent for which had to be signed by his mother because he was under age. When his father sent him the earnings on his invention via a messenger, who reportedly showered the gold coins onto his desk, he quickly put them to use in his study of art and in setting up housekeeping with sixteen-year-old Maria ("Miz") Wolfegg.[14] He lived the normal life of the art student, except that he continued to invent things on the side. An 1898 shipwreck inspired him to create a submarine radar device to warn ships of underwater dangers. A sensitizable light bulb which could glow after being turned off without electricity and a portable food freezer for use on military maneuvers were two of his other inventions. He failed to follow through on these, however, by completing the patenting processes, having become primarily preoccupied with art. But this scientific involvement could be said to extend to his art as he strove to understand and explain the mechanics, physics, and metaphysics of modern art. He always saw science as creative, and creativity in art as having a scientific basis.

Munich had been attracting art students from many countries in Europe and the Americas for decades by the time Hofmann began attending some of its many art schools. The Munich Academy had undergone many interesting changes of direction important to developments in nineteenth century art, and there were a number of famous independent art schools to choose from as well. French Impressionism was just beginning to lighten the dark, Old Master-brown realism that flourished in Munich, and Hofmann's early paintings reflect this shift. Like everyone else in that city in the 1890s, it seems, Hofmann studied with Anton Azbe, a Yugoslavian painter known for his small stature and his large capacity for wine, his lightning-speed corrections of the students' work, his spirituality, and his generosity. Wassily Kandinsky, a Russian painter who was fourteen years older than Hofmann, but who had also just begun his art studies with Azbe, later wrote that Azbe taught many of his exceedingly numerous students at no charge, asking in return only that they "work as hard as possible."[15] It certainly seems likely that this lonely and mysterious but kindly teacher was an inspiration for Hofmann's lifelong commitment to art instruction, particularly of a very individualized sort. Azbe also repeatedly emphasized three things that Hofmann would later stress as well: the application of pure, unmixed color directly to the canvas, working with broad, sweeping lines, and the use of a spherical concept of rendering form in space.[16] These were

radical ideas around 1900, predating and in many ways anticipating Cubism, Expressionism, and other experimental attitudes toward making art in the twentieth century. Even Kandinsky's and Hofmann's preferences for the palette knife over the brush (Kandinsky in the early work, Hofmann in the later paintings) began with Azbe's encouragement to "paint freely." Despite their congruent student years, Hofmann doesn't seem to have made the acquaintance of Kandinsky at this time.

Schwabing, the quaint and affordable bohemian suburb of Munich where Hofmann and his wife lived, was full of painters, poets, musicians, and dancers. Famous writers such as Thomas Mann, Frank Wedekind, and Rainer Maria Rilke (whose poetry would inspire more than one Hofmann painting) walked its streets daily, but it seemed that everyone there was an artist in one way or another. Even Hofmann's non-artist wife, Miz, developed her decorating panache, her horticultural and culinary mastery, and an all-around esthetic sense in this highly cultured environment. By the end of the century, Munich had become a major focal point of the arts and crafts movement and was witnessing the breakdown of the distinctions between "high" and "low" art. One of the effective ideas the Hofmanns put into practice for the rest of their lives was to paint their tables and chairs, doors, windows, and floors bright reds, blues, greens, and yellows. Doing so transformed their living environment into a work of art.

Of all the great paintings available for study in Munich's museums, Hofmann fastened on Titian's *Christ Crowned with Thorns* in the Alte Pinakothek. It became his touchstone for life. The fact that it was painted by an artist in his nineties filled him with personal hope which sustained him through an overextended pedagological life. (He wasn't able to support himself on the sale of his paintings without the earnings from his art school until 1958, when he was seventy-eight years old.) Perhaps even more important, however, is the painting's dynamic interplay of powerful forms moving energetically in and out of the shallow space of the steps on which Christ falls beneath his tormentor's blows. These rhythmic spatial thrusts and counterthrusts cannot have gone unnoticed by the man who defined painting in terms of "push and pull" and whose paintings never failed to demonstrate that concept:

> The Mystery of plastic creation is based on the dualism of the two dimensional and the three dimensional. Appearance is two dimensional. Reality is three dimensional. The essence of the picture plane

is its two dimensionality [which] must be preserved . . . [but when] it reaches its final transformation in the completed picture, [it] must achieve a three dimensional effect, distinct from illusion, by means of the creative process.

Two dimensional expression can be creative only by the co-existence of positive and negative space. . . . Space is not a static, inert thing. Space is alive; space is dynamic; space is imbued with movement expressed by forces and counterforces; space vibrates and resounds with color, light and form in the rhythm of life. Movement is the expression of life.

Push and pull are expanding and contracting forces which are activated by carriers in visual motion. Planes are the most important carriers, lines and points less so. To create the phenomenon of *push and pull* on a flat surface, one has to understand that by nature the picture plane reacts automatically in the opposite direction to the stimulus received. . . . *Push* answers with *pull* and *pull* with *push*.[17]

A fortuitous introduction to a wealthy Munich collector, Phillip Freudenberg, led to sufficient financial support for Hans and Miz to live in Paris from 1904 to 1914, and to spend their summers vacationing in Germany. In Paris he quickly became aware of Cézanne, and this enabled him to see the role of color in the activation of pictorial space:

Cézanne understood color as a force of *push and pull*. In his pictures he created an enormous sense of volume, breathing, pulsating, expanding, contracting, through the use of color. Only very great painting becomes so plastically sensitive. . . .[18]

Cézanne was all intuition, but the late pointillist painter Georges Seurat was scientific, and thus his appeal for Hofmann was also strong. In fact, Hofmann became part owner of Seurat's great final work, *Le Cirque,* from which he undoubtedly learned a good deal, not only about color but also about the emotional effect of lines and forms.

On their very first day in Paris, Hans and Miz stepped into the center of the avant-garde art world when they happened to stop at the Café du Dome for a coffee on their way to lodgings in Montparnasse. At this café, Hofmann subsequently met most of the roster of artists he would cite in praise of Paris's internationalism nearly fifty years later: Picasso, Braque, Delaunay, Matisse, and Gris, Munch, Pascin, Carles, and many of his own

countrymen. Hofmann was a marginal figure in the loose group of artists around Picasso and Braque, "intellectual" followers of Cubism who were embroiled in endless discussions of current theories[19] like the "fourth dimension" and Henri Bergson's concept of time, scientific developments by Einstein and Planck, the new "higher" mathematics and geometries (i.e., non-Euclidian and n-dimensional), and metaphysical speculations. Of the smaller epicenters of the Cubist group—the *Section d'Or* and the so-called Puteaux group, named for the Parisian suburb where some of them had their studios, Hofmann was closest to the Robert and Sonia Delaunay circle of Orphists.[20] Hans and Robert collaborated on designs for Sonia's textiles while Miz worked by her side painting ties and scarves.

Each Cubist developed differently, Cubism providing, as John Berger has pointed out, an "esthetic valence" rather than a style to imitate. Hofmann's propensity for science, however, led him to theorize more than to practice what he was hearing preached. Almost all of his early work was lost during the two world wars, but indications are that he was not by any means prolific during those years. Lillian Kiesler has suggested that his very low painting output while teaching was due more to psychological blocks than to lack of opportunity. The outbreak of war in 1914 caught him in Germany, where he opened an art school the following year. The ideas he accumulated in Paris were codified and collated with previous concepts while he taught during the next fifteen years, but he remained committed to them for life. They are readily apparent in the following excerpt from a 1930 article he wrote during his first summer in the U.S.:

All true productivity realizes itself simultaneously upon an artistic and scientific basis. With the acceptance of the Theory of Relativity by Einstein the fourth dimension has come into the realm of natural science. The first and second dimension include the world of appearance, the third holds reality within it, the fourth dimension is the realm of the spirit and imagination, of feeling and sensibility.

All cultural interests are, in their final analysis, filled with the urge to give content and substance to life. All profound content in life originates from the highest phenomenon of the soul; from intuition, and thereby is found the fourth dimension. Art is the expression of this dimension, realized through the other dimensions.[21]

After he moved to the U.S. permanently in 1931 and began teaching at the Art Students League in New York, Hofmann stopped using the term "fourth dimension" but he continued to talk about the role of empathy and spirit in art.[22]

> The process of creation is based upon two metaphysical factors: (1) upon the power to experience through the faculty of empathy, and (2) upon the spiritual interpretation of the expression-medium as a result of such powers. Concept and execution condition each other equally.[23]

As we have seen in Fritz Bultman's case, young people in America were drawn to Europe to study with Hofmann despite the language barrier. Hofmann's thick accent, the liberal admixture of French and German into his unorthodox English usage, and his unconscious habit of asking *"Nicht wahr?"*—Is it not so? (which he apparently pronounced "nikker")—after every assertion, was compounded by partial deafness since childhood, which had developed to the point where he didn't really listen to anyone. (His brother had deafened him by poking a fork in his ear as a child, according to Lillian Kiesler. This brother later killed himself after the death of their father. The sister Hans adored became permanently insane at the outset of World War I. Her illness was the reason he was caught in Germany when war broke out.) At the League, and later in Hofmann's schools in New York and Provincetown, the class monitor would often reexplain what Hofmann had said about a student's work after the critique was over.[24] When Lee Krasner studied with him, she relied on monitor George McNeil to do this for her. This service was performed earlier in the thirties by Lillian Kiesler and her friend the painter Alice Hodges, both of whom helped Hofmann inside the school and befriended him outside it.

Thus it is probably because of expediency that Hofmann developed his method of teaching by showing—making corrections directly on the students' drawings or diagramming alternate possibilities in the margins, tearing drawings up to rearrange the compositions, and attaching pieces of colored paper to the canvas surfaces with thumbtacks to try out different planar movements. Some students, like Krasner, were outraged by this, but most seemed to take it in stride. Hofmann was a wild man when he painted, so such abruptness was natural to him. Lillian Kiesler posed for him often and was one of the few people other than his wife allowed in his studio while he was painting. She relates:

He was so emotional when he worked, in some ways I thought maybe he'd lose his mind. He was almost out of control—though he wasn't. He had that side—ferocious—as though he could tear down the Berlin Wall. I just couldn't believe the way he was slapping and dashing— as though he was going to destroy the canvas.[25]

For this reason he preferred to paint on wood instead of canvas for many years.

Hofmann never let his students know what his work was like, fearing to influence them to "paint Hofmanns." But in 1944 he agreed to an exhibition at Peggy Guggenheim's gallery. This and many other career-oriented changes in his life, including the shift to canvas and to larger-scale pictures, were the outcome of his wife, Miz, having come back into his life at this time. They had married in 1929, after thirty years of cohabitation, because he was going to America. She remained in Munich, running his school as best she could with other teachers until 1939, when Hofmann was finally persuaded by Fritz Bultman and other people who were aware of the grave dangers looming there to get her out of Nazi Germany. She was miraculously able to book passage on virtually the last boat to leave for America. By this time, after eight years of living independently, Miz had been effectively replaced by a number of women only too happy to keep this still vigorously handsome, tall, blond, blue-eyed master artist company, to help him with the school, to pose for him, run errands, and generally function as quasi-wives. Besides Lillian Kiesler and her friend Alice Hodges, Hofmann was closest to rich, aristocratic Helen Donnelly and to artist Mercedes Carles Matter, the daughter of Arthur B. Carles, the American Fauvist Hofmann had met in Paris, whose colorism he had long admired.[26] Hans and his wife continued to live apart for five years after Miz's arrival here. It was not until she nursed him through a serious hernia operation in 1944 that they again shared living quarters.

When Miz took charge of Hofmann's career she catalogued the work in the studio, assigning dates as accurately as she could to paintings for which he only vaguely remembered the order of execution. She made contacts in the art world that were helpful to his career, entertained these people with great energy and charm, and made all the decisions concerning framing, exhibition, and prices. She is credited by their friends with Hofmann's ultimate shift to abstraction in the forties, and for his use of canvas in order to work on a larger scale than wooden

panels allowed. She undoubtedly helped select the works for Hofmann's very important first exhibition at Peggy Guggenheim's gallery, Art of This Century, in 1944. Some of his most radical previous work—small dripped and splattered organic abstractions on panels of 1939–44 such as *Spring,* 1940, *The Wind,* 1942, *Fantasia,* 1943, and *Effervescence,* 1944, which were deemed experimental—were left out of the show. They prophesy the bursting, freewheeling excitement of Hofmann's late work. Miro[27] and Kandinsky were probably the main sources of inspiration for this side of his endeavor, since he was working, as the titles indicate, from a feeling for nature rather than out of his subconscious. He was opposed to Surrealism's stress on sexuality and the unconscious, which was epitomized for him by Salvador Dali, and he may not have wanted to seem to be in any way connected with that style even though the gallery promoted it. Putting his best foot forward with works solidly based in the Cubist-Fauve tradition instead must have seemed wise to Miz as well as Hans at the time, but in retrospect it was unfortunate. Hofmann would have been credited with the initial Abstract Expressionist use of the drip technique if these wonderful little experimental paintings had been included.[28] No one but Miz and perhaps a few of his closest friends even knew they existed. Neither Lee Krasner, his former student, nor her husband, Jackson Pollock, would have seen them, since Hofmann was extremely reticent about showing his work to others.

Picasso's work of the twenties and thirties was the primary sustaining influence for Hofmann in the 1940s, just as it was for the young American painters. But it was the savage side of Picasso that brought out the best in all of them. Many of Hofmann's strongest paintings of the mid-forties (like *Idolatress,* 1944, and *Bacchannale,* 1946) have a great deal in common with Jackson Pollock's of 1942–43 when Picasso's influence on him was also at its height. The younger American's ferocity and daring in these years surely had a strong effect on Hofmann even though the older artist couldn't tolerate the young man's disregard for traditional techniques and studio practices.

Hofmann's color habits were probably learned early, in Munich and in Fauvist Paris, for they belong to that European expressionist "tradition" of clashing reds and greens. Nine times out of ten the conflict between red and green—hot and cold, fire and earth—is the activating force in his work. Only occasionally does a color like blue or yellow take over a canvas. When this happens, in *Blue Rhythm,* 1950, for in-

stance, one feels excited by something brashly daring and new even though the composition retains the solidity of a Cubist still life. The paint has been applied liberally with a staggering range of effects. One finds clots and globs as well as dripped and inscribed lines. Clearly, a wide array of tools were put into use for the picture. While he tended to use pure colors straight from the tube, he sometimes mixed them on the painting or on the palette as well. The results were almost never muddy even when the resultant colors were not easily identifiable. In this painting he also put various colors on the edge of a palette knife and swirled them onto the surface together. The sheer coloristic and painterly energy in his later work is virtually unmatched among American Abstract Expressionists. It is so full of joyful good spirits that one becomes convinced he never suffered a bad day in his life.

In the years 1945–47 Hofmann painted a number of vigorous color abstractions with titles such as *Transfiguration, Ecstasy, Immolation,* and *Resurrection* that may have had something to do with his recent illness and recovery. The world had to wait another decade, however, for Hofmann to fulfill completely the promise of the vitality in this work and in his earlier "experimental" paintings. Most of the works from 1950 are not buoyant. They represent a temporary retreat from the freedom of the mid-forties on two separate fronts: to the safety of thinly painted Cubist still lifes and to more traditional representation in the form of thick, gruffly impastoed heads and figures. Despite his broad-ranging technical skills, at seventy years of age and with a heavy teaching load thanks to the great postwar influx of students on the GI Bill, he apparently chose to play it safe with subjects he could handle without strain.

This time in his life represented the high point of Hofmann's popularity as a teacher. There were many one-man art schools in New York, Provincetown, and elsewhere, but Hofmann's was the most important and the most progressive. In Provincetown the Cubist Karl Knaths, also a German, was the other significant Modernist working in the thirties and forties, but he did not teach. The writer Anton Myrer combined the two German-American painters for the artist-teacher character in his first novel, *Evil Under the Sun.* Published in 1951, after considerable editorial assistance from Myrer's friend Weldon Kees in the summer of 1950, the book was based on what Myrer saw of artistic life in Provincetown the two previous summers he had spent there with his wife, the artist Judith Rothschild. She, Kees, and Fritz Bultman had remained close to Hof-

Hans Hofmann photographed painting in 1950 for an **Art News** *profile. (Photo by Rudolph Burckhardt)*

mann, their former teacher. They knew—and Myrer conveyed in his character—what an enormous emotional toll the teaching part of Hofmann's life was taking on the art-making part, particularly at this time. When one self-important (and highly self-destructive) student in the novel, the Irishman Mike Doyle, comes to see his teacher one night in desperation about his work, "Hofmann" has to put his own painting aside at a painfully critical moment to help him. Myrer's fictional teacher advises Doyle with Hofmannlike grace, urging the young artist to work very hard in his search for his own reality.[29]

Myrer's art students never get to see their master paint any more than

Hofmann's students did. Had they done so they would probably have been amazed at his wildness. Even when working from a painstakingly composed still life—as he did for Elaine de Kooning's article in the February 1950 issue of *Art News*[30] with Hans Burckhart's camera clicking away all around him—Hofmann's way of working was fast and furious. "At the time of making a picture, I want not to know what I'm doing," he told Elaine. "A picture should be made with feeling." Citing his "prodigious nervous energy" the author wrote that "working with astonishing speed, never sitting down, constantly in motion between his palette and his easel, applying his paint with broad, lunging gestures, Hofmann often finishes a painting in a few hours." Though he was dressed in blue overalls and workshirt for the camera, Hofmann usually painted with no clothes on, as if even they would be an impediment to his movements. "A picture must be finished in one sweep," he told Elaine, explaining that he never "patched up" a troublesome area but went over the entire composition anew. She believed that this process accounted for the "violent immediacy" of his pictures. At the end of every day, like fellow European Willem de Kooning, he cleaned up all his brushes with soap and water and even scraped off his entire palette, usually a pane of glass. He told Elaine he might use "a hundred tubes for one picture, or one tube for a hundred pictures; lots of medium or none at all," given the extreme differences in paint thickness he permitted himself. Sometimes, as he did while painting *Fruit Bowl: Transubstantiation No. 1* for this article, he limited his palette to a few colors (in this case red, white, blue, and yellow), but usually he filled his palette with hues. In this work much of the paint was soaked into gauze and rubbed onto the canvas once the "architecture" of the picture was established in thinly brushed blue lines (the way Cézanne often began a painting). Brushes of all sizes might be used as well as sponges and gauze for rubbing, sticks and other gouging tools, and he often employed spatulas furiously to scrape and swirl and swipe the soft pigment around. Paint spattered all around him as he worked, dotting every surface.

Reviewers of Hofmann's October 24–November 13 show at the Kootz Gallery noted the vigor of his work. "A firecracker sparkle in their explosive reds and blobs of mixed color," wrote one critic. "Deep pigment is troweled, furrowed and smeared to produce an inside-a-crystal world of rich amorphous color," said another. The *brio* with which *Blue*

Rhythm appears to have been painted is typical. Urgent, densely inter-meshed passages of red and green roil the blue, giving it a kind of urgency and physicality, and these hues are intensified by the contrast with the black and white of the rectangle in the upper right. However, the mix of styles and techniques, sizes, and subject matter in his show disturbed the critics. "Mercurial as ever," wrote one, while another said the new work defied classification since each canvas creates an indepen-dent reality of its own. A thickly impastoed expressionist head with barely recognizable features could be unsettling next to a highly abstract still life of a glass and a bowl of fruit on a table, its pigment lightly rubbed into the canvas, most of which had been left bare.

Hofmann's major flaw was probably that he had the kind of stylistic breadth that could fool a casual viewer into mistaking his exhibition for a group show. When in the mid-fifties he finally gave up recognizable subject matter entirely, he substituted the contradictory play of hard-edged forms against loosely painted ones for the former dialogue be-tween the real world of objects and the painted reality. Mondrian-style rectangles took the place of fruit baskets and figures. But, even in the last eight years of his life when he loosed the full arsenal of his painterly gifts, he still continued to paint very differently from one canvas to the next. Rectangles cover one surface completely while in another only one or two float in a sea of pale, melding hues amid sprays of multicol-ored spatter. "If I ever find a style, I'll stop painting," he once told his dealer, Sam Kootz. He did have a recognizable style, of course. One never mistakes his paintings for anyone else's. He simply wasn't caught in the trap of a single image or one way of working.

In many ways Hans Hofmann and Franz Kline represent the two extremes on the polyglot spectrum of Abstract Expressionism. Thirty years Kline's senior, and a cultivated, knowledgeable teacher, Hofmann was surrounded by a coterie of friends and students all his adult life. Up until middle age, Kline was a loner, a part-time barroom cartoonist, and only a sometime participant in the doings of the New York art world. As a young man Hofmann was thoroughly at home with the important developments in modern European art, while traditional, conservative young Kline never fully demonstrated control of any of them. Hofmann's forte was his handling of color, a masterful fusion of French elegance, German *angst,* and American headlong rebelliousness. Kline was the master of stark black-and-white, his color always a difficult issue. Hof-

mann's experimental abstractions of 1939–44 are most likely the very first explosively loose, fully Abstract Expressionist paintings made in New York. Kline, on the other hand, was the last major New York artist of the pioneering generation to take up the new way of painting in America.

Like Andy Warhol, who was almost too late to catch the Pop art boat which he later captained,[31] Franz Kline made so essential a contribution to Abstract Expressionism that the movement doesn't exist in the public mind without him. Together, Kline's thrusting black bands, de Kooning's whiplash gestures, and Pollock's flying skeins of pigment have come to signify the New York School. The identification of Abstract Expressionism with painterly violence, with tremendous speed and energy, with raw emotionalism, occurs instantly and unquestionably in Kline's work.

The spare, stark black-and-white canvases with which Kline made his artistic debut in 1950 were instantly legible and unforgettable: *Leda*, a rough-edged black square sprung in the air above a floating horizontal group of diagonals; *Hoboken*, a giant, circular bubble caught between the ragged pincers of an irregular black star; *High Street*, horizontal tracks supported by buttresses of converging diagonals; *Chief*, a gigantic black "thing" bearing down on you; and *Nijinsky*, fabulous Nijinsky, an abstracted flying leap, caught by the painter in midair, a tangle of springing curves gathered in a horizontal rush that bounds out of the canvas on the right like the dancer sailing through the window in *Le Spectre de la Rose*.[32] The other paintings are no less memorable. Reviewers felt their impact, one speaking of how the forms "shoot out at you," another citing their "asymmetrical scaffoldings and tensely, precariously balanced squares or circles." The reviewer went on to echo the reaction of an astonished art world when he wrote: "Assuredly these paintings hit the eye and arrest the attention, as any explosive spectacle will."[33] Once he was there, Kline was more completely and consistently there than anyone else, never wavering in his commitment to either half of the term Abstract Expressionism.

With the acceptance of the black-and-white canvases in his first one-man exhibition, Franz Kline finally found himself at the center of an art world among like-minded fellow artists. Early in life, when others had crossed the country or the sea to be in New York, he had gone to England; while his future friends shared the camaraderie of joining

forces on the WPA, in the Artists Union, and in the all-night cafeterias of Depression era and wartime New York,[34] he had scrounged a desperate and lonely existence drawing caricatures for bar patrons and decorating tavern walls, turning out potboilers of any sort at the request of his patrons, and hawking his wares on the fences of Washington Square. He painted landscapes and portraits, boat scenes and cityscapes, bare studio interiors, locomotives and sad clowns. Twice he won prizes in National Academy shows, and he dreamed of membership in the Salmagundi Club, such an arch-conservative bastion of tradition that it made even the Academy seem progressive. It is safe to say that not a single other Abstract Expressionist thought along these lines during those years.

Despite an ebullient social style which gained him vast numbers of friends and admirers in the fifties, Kline had an indissoluble knot of sadness fixed in the center of his being. Perhaps it was caused by being orphaned by his father's suicide at the age of seven, his mother unable to support four children alone. The tragedy of his wife's mental illness might have been an equally causative factor. Then, too, it is possible, as one of his friends believes, that he always suspected something might not be right with his heart after having had rheumatic fever as a child. Even at his most depressed moments, however, at the deep end of a long night of drinking, he never expressed a fear of dying. He did identify with the tragic figures in art and history—Nijinsky in particular —and Nijinsky died in 1950 just before Kline made his own leap into the limelight.

Nijinsky epitomized the dancer as a tragic figure inexorably trapped and controlled by his art. His two female counterparts were the heroines of *Giselle,* which was performed in New York in 1950 by the Sadler's Wells ballet company, and of *The Red Shoes,* a 1947–48 film which had become a cult classic by 1950. Kline titled one of the 1950 paintings *Giselle,* and he painted Nijinsky as a poignantly sad Petrouchka many times. He tended to give his self-portraits the same mournful cast he gave the dancer. Kline's last—and best—portrait of Nijinsky as Petrouchka was painted in 1950, but he also painted one of his greatest abstractions of that year with the dancer as subject. In this abstract *Nijinsky,* Kline captures the sense of forces rushing through space in defiance of gravity, but the energy seems to be expended in anguish rather than joy. The torn edges of the ensnarled black lines help to create this feeling, and the forcefulness of the two tilted horizontal

bands moving into the picture from upper right seem like powerful magnets that are locking everything inescapably into place.

When he smiled, Kline was handsome in a Ronald Colman kind of way. But when his face was in repose, the deep creases that scored dark lines from cheek to chin on both sides of his face gave him a noticeably doleful look, which he often exaggerated in his self-portraits. A very pronounced widow's peak parted his brow, its upward curves mirroring the downward curves of his dark mustache. He was not tall but his shoulders were athletically broad from a lifetime of sports. One night when he, Pollock, and Guston were arguing the merits of various cartoonists in the Cedar bar, discussing their relative abilities to capture their subjects with a minimum of lines, Pollock was challenged to draw Kline. He concentrated for a while, and then grabbed a napkin and rapidly drew a V—the widow's peak, but also the overview of Kline, who tapered quickly down from his wide shoulders to his toes. When Guston drew Kline, he emphasized his friend's top-heavy frame with a triangle tapered down to two tiny feet, his wide shoulders crowned by two smaller triangles, points touching, for his nose and hair. By 1955, the date of Guston's drawing, Kline would probably have appreciated the elegance and urbanity with which Guston characterized him, but back in 1941, when he had drawn his own caricature, he depicted a rumpled, city room wise guy in a snap-brimmed fedora, pipe between his teeth, his sketchbook at the ready like some hack newspaper artist.

Kline was a great quick-sketch artist, and it was ultimately his skills in this area that became the mainstay of his large-scale abstract paintings. His early paintings have a quality of distance and poignancy—and sometimes, obvious sentimentality—which is very different from the intense personal immediacy of his drawings of the period. Perhaps it was the years of caricatural sketching in the bars, which trained him so well in observation and mimicry that he could convulse his fellow artists when, as part of an ongoing story, he would suddenly act out with astounding accuracy someone's gestures, facial tics, and vocal mannerisms. In the thirties and forties, in addition to being a free-lance cartoonist and a journeyman muralist in Village restaurants and bars, Kline made and repaired picture frames,[35] built walls and stage sets, and did just about any job he could to support himself and his British wife. Still they were evicted from one pathetic apartment or loft after another for nonpayment of rent.

Kline's wife, Elizabeth Vincent Parsons, was the product of a different world, and never seems to have contributed to the support of the household. The daughter of an English colonel, she had studied dance with Enrico Cecchetti of the Russian Ballet, Diaghilev's former ballet master and Nijinsky's teacher. Her dance career lasted only a few years during the mid-twenties. When Kline met her twelve years later, the woman who had been presented at court in 1925 was now reduced to modeling in his illustration class at the Heatherley School of Fine Art in London. He asked her to pose privately for him, but having no money, he charmed her into accepting her first Coca-Cola in lieu of payment. Perhaps she danced for him privately too, and she did pose for him during the early forties, but apparently, unlike most of the other artists' wives, she did no outside work to add to their meager income. Left alone at home for long periods of time, she seems to have become more and more emotionally withdrawn. The many sad or brooding drawings Kline made of a motionless, darkened figure resting in a rocking chair or seated at the kitchen table with her head down on her arms give mute testimony to her steady, inexorable retreat from the world.

In 1945 they moved into a chauffeur's apartment over a garage on an estate in Brooklyn, but Kline's daily absences while working in a studio on West Fourth Street left her too much time for dark thoughts, and she became convinced the house was haunted. The following year he could no longer care for her at home and she was committed to the state mental hospital in Central Islip, Long Island. She was released in Kline's care a few times over the next fourteen years of hospitalization, and on his visits he took her out for coffee, lunch, or a drink nearby. He would bring her *New Yorker* magazines, which she loved, but it was clear to those who occasionally accompanied him on such trips that she was not able to maintain normal, rational conversation for a sustained period of time. When she was finally released in 1960, she chose to live out on Long Island near the hospital in case she needed care rather than to live with or near Kline, even though he purchased the house on Thirteenth Street directly behind his Fourteenth Street studio for her to live in.[36]

The whole tragic affair was recorded in innumerable drawings and paintings of Elizabeth in her chair, and, later on, of the rocker itself, empty and forlorn—an image that became one of the major sources for his abstractions. Some of the early pictures show Elizabeth in the studio on the other side of his big French easel, while in others she seems to

be trapped within a barlike grid. The painting he termed his first abstraction, *The Dancer,* 1946, shows an immobilized standing figure caught within horizontal and vertical bands, and *Dancer at Islip,* painted three years later, further abstracts the dancer while making the cage into an unbreachable prison.

A number of his earliest fully abstract works painted at the end of the forties were composed of rockerlike shapes; some were even titled *Elizabeth.* Mature abstractions like *The Bridge,* 1955, *Turin* and *West Brand* of 1960, and *Mahoning I,* 1961, may, however, be considered part of the same formal family. Just as the rocking chair was a poignant stand-in for his wife, his easel was a lonely substitute for himself. It was also a frequent early subject that was carried over formally into the abstractions of the fifties. *Head for Saturn, Red Painting, Black and White No. 2, Zinc Door, Shaft, Slate Cross* are all paintings with easellike configurations. Both image families seem haunted by a sense of absence, as indeed does Kline's other, practically ubiquitous image—the open

Wotan *by Franz Kline.*

(empty) square.[37] Not an impersonal geometric shape, Kline's square is a stand-in for the human head or body, perhaps even, like the rocker, for the wife lost to him. Two drawings from the year of her first incarceration, 1946, indicate the likelihood of such significance because he replaced his wife's head with open squares in both.

Kline might simply paint a square floating to the top of a field of thick white pigment, as happens in *Wotan,* 1950, but that square takes on the power of a person and the poignancy of personal emotion. One feels elation as it sails majestically through space. Though his square often seems to express release and freedom, it may also be tragic in feeling, or as repressive as a cage. Kline's profound romanticism approached sentimentality in the representational works, but it was transformed into an asset in an abstract context. He once said of Josef Albers, "It's a wonderful thing to be in love with the square," but he was nearly as possessed by the square as the German Constructivist was, and he was far more emotional about it. Never ruled, never perfect, Kline's square is thoroughly humanized by the painter's touch. Its edges cut under the whites here, brush over them there; its sides are thicker here than there, more assertive here, more tentative there. These humanlike imperfections breathe life into the geometric shape. One square is tightly compacted, another pulled out of shape like a grimace on a clown's face; one has wings, another the stability of a mausoleum. Albers varied only the colors of his squares—Kline varied their emotional content. If one asks why Kline's spare, abstract shapes seem amazingly filled with emotion, something he once said provides the answer: "If you meant it enough when you did it, it will mean that much."

The exact circumstances of Kline's conversion to the new way of painting and his simultaneous development of a forceful signature style still remain something of a mystery. The myth is that it happened one night in a blinding flash of insight, but from most reports by close friends, and from the evidence of extant datable works, it happened slowly in a logical and probing process of augmenting his strengths while eliminating his weaknesses. His stylistic changes seemed to come about too quickly to those of his friends still loyal to representation, but seemed overly delayed to the others. After that first "abstraction" in 1946, he cautiously worked his way through Cubism with the guidance of de Kooning's example during the next four years. Nevertheless, when his new "Abstract Expressionist" work made its debut in 1950 many

people thought he'd shot out of nowhere, largely because he hadn't shown the transitional work. Kline's new paintings were so powerful and so exactly dead center in the new style that their sudden appearance had the quality of a miracle.

The mythical notion of Kline's "total and instantaneous conversion" to the new style was not introduced until after his death in 1962, when Elaine de Kooning wrote the catalogue statement for his memorial exhibition at the Washington Gallery of Modern Art. She asserted that the pivotal element in Kline's conversion to the new American way of painting was the experience of seeing his small representational sketches magnified by an opaque projector one day in 1949 (or 1948, as she later thought possible). "From that day," she wrote, "Franz Kline's style of painting changed completely." She claims he immediately began tacking huge sheets of canvas on his walls and buying housepaint to put on that canvas and housepainter's brushes to apply it with. "Any allegiance to formalized representation was wiped out of his consciousness," she stated. "The work from this moment contradicts in every way all of the work that preceded it, and from which it had so logically and organically grown." His sketches in 1950 were "measuring in feet instead of inches," according to Ms. de Kooning, even though they were being "slashed out on the pages of telephone books." [38]

Such contradictions and incongruities run rampant through this colorfully hyperbolic description of an artist finding himself. The truth is less sparkling. Well into 1950 he was still working representationally, at least on commission: his poignant final portrait of Nijinsky was painted that year for his long-time patron I. David Orr, a friend and supporter who was never able to embrace his abstractions. Kline was also continuing to paint small-size colored semi-Cubist works, some built out of chunks of muddy color, others with the hues overlaid by calligraphic black-and-white brushwork. Both kinds of painting are visible in a photograph of his studio taken in the late summer or early fall of 1950. They appear to be works in progress, since one looks unfinished and the other is on the easel. And yet, a large black-and-white canvas is tacked to the painting wall beneath a strong ceiling light. This work is *Cardinal,* one of the paintings included in his first show, but in the photograph it is also unfinished and turned on its side. An oil-on-newspaper study for another painting in that show, *Drum,* is tacked between the windows. July 16, 1950, is the date of the sheet of *New York*

Franz Kline's Ninth Street studio in 1950. Cardinal in an unfinished state is tacked to the wall at left.

Times newsprint he used for the study. Kline was working in three different styles simultaneously just months before his breakthrough Egan show. Buy why?

One reason had to do with his solid grounding in academic art as a student in Boston and then in London. Conservatism is tough to overcome. Another was his incessant habit of drawing, which kept him loyal to representation; even in 1951 he was still drawing rocking chairs. A pocketful of scraps of paper with images of people and things on them somehow seems naturally more worth saving than a pocketful of doodles. His skills as a draftsman in the mixed, painterly tradition of Rembrandt, Hokusai, and Lautrec, as well as in the lower-level tradition of the caricaturist or quick-sketch artist, were very much appreciated by his friends, most of whom were either ambivalent about abstraction or opposed to it. Recognizability is essential to caricature, and he wasn't able to give it up until nearly the end of the forties, when he painted a

long series of free abstractions on large sheets of inexpensive paper. Once he was liberated from the need for his drawings to be about something, the other essential aspects of caricature—linear vitality, shorthand graphic gestures, an instinct for the unique, and a sure sense of scale with which to emphasize deviations from the norm—gave force to his abstractions.

In the forties Kline was far more familiar with the marginal world of Greenwich Village bohemia than he was with the important "underground" artists developing the new American painting. For example, only Kline among the Abstract Expressionists easily tolerated the self-proclaimed genius Joachim Probst, a drastically wall-eyed, red-bearded and red-haired man who painted gloomy religious paintings in the manner of Rembrandt via Rouault. Probst dressed in voluminous robes and claimed to sleep in a coffin at night. Another of Kline's friends was Sam Kramer, the "mad jeweler" of Eighth Street, whose Daliesque, razzmatazz window displays featuring giant bleeding seashells and other biological impossibilities attracted the burgeoning tourist crowd. Then, of course, there was his pal, old "Uncle" Earl Kerkam,[39] the cagy cadger of meals, who had given up making money on Wall Street in the twenties to devote himself to art he couldn't sell but would trade for picture frames and other necessities. Kerkam was, however, a marvelous painter, who, unfortunately for his career, never advanced beyond an infatuation with Cézanne and French Cubism. But it was his great skill with representational imagery that weighed in heavily against the pull toward abstraction for Kline. Kerkam painted in a dingy room lit by a single bare light bulb. His exquisite drawings were piled chaotically in a battered wicker basket in which various unpleasant insects also dwelt. When he worked on his many self-portraits he wore only pants and a T-shirt (gray with use, like the single towel by his sink), but when he had a sitter to paint he donned a suit jacket, tie, and snap-brim hat. Clearly Kline was not going to curry favor with the intellectual elite of the art world with friends like these. In the fifties these companions were augmented or replaced by various prizewinning poets and notorious beatniks, such as Jack Kerouac and Robert Creeley.

The main force on the other side pulling Kline into the new style was Willem de Kooning, though Kline was never comfortable with curving shapes the way De Kooning was. De Kooning's one-man show of abstractions at the Egan Gallery in 1948 was very well received; it undoubt-

edly made a tremendous impact on Kline. De Kooning's large black-and-white abstractions of 1946–48—*Light in August, Black Friday,* and *Orestes,* in which neither black nor white dominates—were never exactly imitated by Kline, but they were a conceptual model of lifelong relevance to him. Since he didn't share de Kooning's *horror vacui,* he abandoned the struggle to equal his Dutch friend's completely interactive surfaces after a short time. Kline's mature approach to black-and-white also has nothing in common with de Kooning's mostly white paintings of 1949–50, in which black functions variously, and intermittently, as outline, trajectory, nodule, shadow, or passage of transitional modeling. Though both artists use more white than black at this time, de Kooning disperses bits of black all over the surface, while Kline was beginning to mass it into linear units with thinglike weight and thrust.

Among the other important influences on Kline at this time were the examples of Pollock and Motherwell, plus the shifts his new friends Bradley Walker Tomlin and Philip Guston were making away from successful conservative styles and into abstraction.[40] Although black-and-white characterized much of the work being done in the late forties by all these artists, Motherwell in particular, it had long been one of Kline's preoccupations. In fact, he had told friends at the beginning of the forties that he thought of himself as a black-and-white artist. In addition to his drawing heroes among the masters of Western art, he also aligned himself with the illustrators he so much admired—John Leech, Charles Keene, Phil May, and even cartoonist John Held, Jr. One can readily see their influence in his representational work, but the subtle resemblance between Kline's mature abstractions and the interaction of black and white in the work of these men is even more fascinating and instructive. Years later the writer Pete Hamill recalled a conversation with Kline about Held's drawings of "Roaring Twenties" flappers that indicated how Kline appreciated the cartoonist's form and ignored his content: "He liked the way Held designed a page, placing a number of figures in the space but using blacks to establish a pattern that became the true structure of the page." Hamill recalled that Kline added, "You know I even like 'Orphan Annie.' The politics are Neanderthal. But the man knows how to use blacks."[41] Though later on he might have been thinking of modern artists such as Mondrian and Malevich along with these draftsmen, the primary stimulation to paint in black and white at the end of the forties undoubtedly came from the other New York School artists.

Seeing one of his sketches projected on a rough plaster wall where its accidents were incorporated in his image, may, as Tom Hess has suggested,[42] have served to make the white areas seem more substantial, more important. Kline did begin to use telephone book pages and newspapers as his drawing paper in 1950, and their irregularities created a similar effect.[43] He told Pete Hamill in 1958, when they were looking at some of his sketches on *New York Times* classified pages, that he "liked the grayness, that texture. It looks like a sidewalk. Besides, someday soon I might need a job."[44]

These drawings might contain as many deliberate gestures as casual paintbrush wipings, circular paint can stains, accidental spillages or "collages" of stuck bits of torn paper. Kline was more tolerant of the inadvertent formal element than any other Abstract Expressionist.[45] But these new, totally abstract, allover images translated very well into large-scale paintings, and it is the shift up in scale which is the crucial change in his work in 1950. The larger-size paintings have better equalized surfaces, which read as wholes rather than figures against a ground. The largest new paintings, like *Cardinal*, were started on freshly prepared canvases, but many of the medium-size works were made on top of older, rejected paintings. In these, the rough "accidental" surfaces were turned into field-activating assets. Having a marvelously accurate eye, Kline had for years been able to make spontaneous-looking murals out of very small sketches without first having to laboriously square them up on a grid, and this talent was now put to good use in his abstractions. Once he stopped responding to the pressures of representational subject matter, he was free to concentrate on the spatial dynamics of the picture.

Cardinal, one of the great paintings in his first show (October 16–November 4, 1950, at the Egan Gallery) is a symphony of concordances and echoes played both on strong elements and in slender nuances. Two vertical units in tandem lock the horizontal bands into place; each unit comes to a point, the left one with exquisite precision at the very top of the picture, the right one just at the top of the picture-within-the-picture in the upper right (which seems to be a miniaturized distant cousin of the left side). One strong curve dominates it, while two join on the left, the lower one taut, like unsprung steel, the other above it thick and ready to snap like a trigger. Along the right edge the blacks pass out of the picture space; along the left, they are held inside. Kline's control of open and closed form is no less certain or subtle than Mon-

drian's. Almost every line has a parallel somewhere and every form created on one side of a line seems to find an echo on the other. A few fragile horizontals exaggerate the scale, making you feel that the whole picture is like a close-up from which you cannot quite get enough distance. These tiny elements are more prominent in the painting than in the study, to which its likeness is otherwise almost miraculous. When working from a study and not "winging it" (which he did less often), Kline would tack the study to the wall near the canvas or hold it in his hand for constant reference.

Though much has been made of his use of housepaint and house-painter's brushes, he also did a great deal of work on the finished painting with small brushes to get the feeling along the edges just right. Where white rides over black is crucial, since all viewers naturally read black forms as though they were (positive) letters or numbers on a (negative) white ground. Achieving an equivalence of positive and neg-ative space therefore became a central problem for him to confront, and he frequently cited it as distinguishing his work from Oriental calligra-phy. Kline hated to hear people speak of his work as calligraphic. He was right, in the sense that it was not his intention to impart information through the marks he made on canvas, and calligraphy is writing meant to be read. But in the deepest, most profound sense, his work is about the communication of emotion, and that is very much what poetic Ori-ental picture writing is also about. One recalls David Smith's intuitive but sure grasp of the subject. For Smith the Chinese upside-down Y as a symbol of man reverberated with many-leveled meaning; a simple ver-tical line which means "to begin, to appear as one"[46] to the Chinese meant the same thing to Barnett Newman—and it sustained him through a lifetime of paintings and sculptures. The square Kline loved is the sun or the moon to a Chinese poet. Placing it above a horizontal line means sunrise in the Orient but expresses the same kind of feeling of release, of uplift, and the resurgence of hope that it does in one of Kline's paintings—*Wotan,* for instance, or *Suspended,* or his late work in color, *Scudera*—especially when it has been painted with a similar spirit. Kline was neither copying the symbol of the sun nor intending sunrise when he painted a square flying above a horizon. What he intended was to share a feeling through an image—just as the Chinese poet does.

The verbal idea of action lies at the root of the ideographic Chinese

language. "In reading Chinese," Fenollosa wrote, "we do not seem to be juggling mental counters, but to be watching *things* work out their own fate."[47] For instance man, an upside down Y, is a figure standing or running; seeing is represented by an eye above running legs (man) indicating that the eye moves through space. Thing and action are fused in the elemental Chinese characters; they are shorthand pictures of actions or processes. The image of speaking is a mouth with two words and a flame coming out of it. When noun, adjective, and verb are fused in a single active image, it is transformed into a visual metaphor, the very substance of poetry. The known and recognizable informs the unseen or obscure, and life is injected into inert matter. Poetry is a-logical, Fenollosa says.

> The more concretely and vividly we express the interactions of things the better the poetry. Poetic thought works by suggestion, crowding maximum meaning into the single phrase pregnant, charged, and luminous from within. In Chinese character each word accumulated this sort of energy in itself.[48]

Franz Kline's paintings are quintessential images of action. Confronting a typical mature painting by him is a little like being so close to a gigantic Chinese character that it overwhelms you, engulfs you in its energy field. You flow with its action, feelings diminishing as lines narrow, expanding as they swell. You leap, you reach, you are crushed at junctions and torn by shredding edges, you close in on yourself twisting into unnatural positions, or you fly. You may spring into the air like Nijinsky, miraculously maintaining levitation at the high point of the leap as he did, and then sail out the window. Analogies with dance come constantly to mind in front of Kline's paintings. (One astute collector, Mrs. Culver Orswell, placed her bronze of Rodin's flying figure, *Iris,* in front of her Kline, with which it has an amazing formal resemblance.) Felt connections with dance are surely appropriate for an artist whose wife was a dancer, who invited dancer friends to practice in his studio (both in New York and at Black Mountain College), who designed backdrops for their dance concerts, and who named some of his works for ballets and famous dancers (e.g. *Merce C*[unningham]).

Because you can't help sympathizing viscerally with Kline's forms, your body mimicking the sensations of movement created by his dy-

namic diagonals and bursting curves, you become one with his imagery
—you *are* visual poetry. Seeing Kline's paintings in the smallish spaces
of his studio or the gallery is essential to this emotional communion.
People think his works resemble buildings under construction or
bridges—and there is an architectural sense to his paintings—but who
ever saw such ragged, rough-edged I-beams, or such haphazard, lop-
sided, canted constructions? He didn't paint *things,* but rather the meta-
phoric, emotional, poetic states of mind engendered by being alive in
the world of things. "Malevich is interesting to me," he once said.
"Maybe because you are able to translate through his motion the endless
wonder of what painting could be, without describing an eye or a
breast." [49] "Through his motion"—Kline understood, as few have, how
crucial dynamism was to Malevich's apparently stable form-world. In-
stead of being a "drunken Mondrian" as his friend Kerkam once humor-
ously labeled him, Kline was Mondrian in action, full steam ahead.

Not that Kline didn't do more than his share of drinking, as we know.
Dozens of his portrait sketches of its patrons still line the walls of the
Minetta Tavern in Greenwich Village in mute testimony to the many
hours he spent in that watering hole alone. He didn't tend to drink
while he painted, but rather before and after. In his later years he was a
heavy drinker who preferred a social context. In the Village, and in his
summertime "Village"—Provincetown—there was practically always
some bar open to which he might repair to relax. He loved to listen to
the stories of the men he met there, but he also enjoyed taking the floor,
and he waxed more and more eloquent with every beer, never tiring
before closing time. Pete Hamill, who met him in the Cedar Tavern,
recently described his way of talking:

> He talked about Sugar Ray Robinson and Lester Young, Akira Kurosawa
> and Brigitte Bardot. He had an elaborate, writerly way of speaking,
> with that rare tone that combines irony with affection. Nothing he said
> ever sounded bitter, except his references to Walter O'Malley, who
> had led the Dodgers out of Brooklyn with the Giants following timidly
> in their wake. "That s.o.b. will find a private place in hell," he said. [50]

If shaggy dog stories hadn't come into existence, Kline would have
invented them, though jokes were not the mainstay of his style. His
humor was based on character and plot. It thrived on surprise twists,

**Franz Kline in the fifties, gesturing in his typically warm, openhanded
way. (Photo courtesy Life Picture Sales, © by Bert Stern)**

something in the manner of a verbal Krazy Kat cartoon in which the
brick comes flying in at unexpected moments. Put-downs, ethnic and
sick jokes were out; British style balloon-pricking, in. His conversation
abounded in Japanese haiku-like nutshell descriptions and ingenious
American analogies. Kline could create never-ending chains linking his
disparate subjects that suddenly made sense and seemed hilarious only
after the end had been reached. The momentum with which he swept
his audience along was very much like the force of his paintings in their
encompassing dynamism. Trying later to reconstruct those word chains
and to recover the surprising insights received along the way was as
impossible as trying to recall the notes in an improvised jazz solo. But
in the paintings they remain there, all laid out for you to jump into at
your wish.

For many in the fifties, Kline *was* the downtown New York art scene.
He was everyone's favorite guy. Among his friends and bar buddies

besides the artists were jazz musicians, writers of every sort, collectors, neighborhood drunks, and starstruck art students. The beat and the not-so-beat poets flocked around him. Jack Kerouac treated Kline's Fourteenth Street studio as his home away from home. Robert Creeley, Frank O'Hara, Charles Olson, Paul Blackburn, LeRoi Jones, Seymour Krim, and numerous others related to him in varying degrees that ranged from frank adoration through collaborative projects and "hanging out" together, down to simply seeing his artistic endeavor as a fine example of Zen and/or existentialism in operation.

Kline kept his radio tuned to WEVD, where he could pick up Symphony Sid after bar hours, though he also listened to a lot of Wagner. With the exception of Barnett Newman, who listened *only* to jazz, all the New York artists liked other kinds of music too, but they were true aficianados of jazz. They listened to it live in the Five Spot and other Greenwich Village and uptown clubs as well as at home. David Smith was the most rabid fan of live jazz, probably because of the influence of his friend Stuart Davis, who had been crazy about "hot jazz" ever since he heard his first ragtime piano playing as a boy. Kline also liked more traditional jazz and named four paintings after mainstream musicians—*King Oliver, Lester, Bigard, Hampton.* Like the other artists, Kline identified to some extent with both their unorthodox working procedures and their outside-the-establishment status.

The analogous improvisatory methods of the jazz musicians of the day and the Abstract Expressionist artists are enlightening: the way jazz musicians enter the material, develop it, and then exit without finishing off its possibilities is very much the way these painters functioned. Lee Konitz, one of the originators of "cool" jazz with Miles Davis's nonet in the now famous *Birth of the Cool* sessions in 1949–50, once described his approach:

> I think of improvisation as coming in ten levels, each one more intense than the one before. On the first level, you play the melody, and you should sound as if you were playing it for the very first time. Freshly. [This] gives you the license to vary it, embellish it, which is what you do on the second level. The melody is still foremost, but you add little things to it on the third level. Variation—displacing certain notes in the melody—comes in around the fourth level, and by the time you get to five, six and seven you are more than halfway to creating a new

song. Eight, nine and ten are just that. Sometimes, though, you never get past three, four or five, but that's O.K., because no one level is more important than any other.[51]

Kline and Pollock were the two painters closest to the hearts of the jazz musicians of their day because both painters and musicians were doing essentially the same thing—composing as they painted or played. The art-making process was active and interactive. Though parallels might be more instructively drawn between Charlie Parker and Jackson Pollock in terms of their addictions as well as their improvisatory brilliance, younger musicians like "Free Jazz" originator Ornette Coleman have compared their states of mind to Pollock's and said they were "doing the same thing." Some have even named jazz compositions for Pollock when inspired by his paintings.

Jackson Pollock felt personally closer to Kline than to any of the other painters. Dan Rice, a painter who knew them both, thinks that the attraction they felt toward each other as artists was probably due to their feeling like a couple of football players caught being sensitive.[52] In the last years of Pollock's life when his alcoholism was running rampant, he would repair to the Cedar right after seeing his psychiatrist. If the bartenders, two former Marines named Johnny and Sam, wouldn't let him in because of some recent misbehavior, Kline and he would often go out on the town. Pollock loved to bait people, and while Kline was talking to a fellow drinker in some dive, Pollock would be starting trouble somewhere else in the bar. Afterward, Kline used to complain that every time he went around town with Pollock, he ended up getting smacked in the face.

Safely among friends in the Cedar, Pollock would bait Kline, perhaps because he knew he could always plead, "Not so hard, Franz, not so hard" if he pushed him too far. One typical night he suddenly swiped Kline's neatly blocked fedora off his head—by way of saying hello—crushed it and tossed it up on the shelf over the bar where Kline couldn't retrieve it. Kline was laughing and angry at the same time—his attire was of considerable importance to him. Knowing this, Pollock was both pleased with himself and a little bit afraid. The next week Pollock appeared at the Cedar wearing a brand-new bowler hat. When Kline began eying the hat, Pollock crushed it and tossed it up on the shelf to join Kline's, which no one had yet bothered to remove.

In the summer of 1954, Elaine and Bill de Kooning, Kline and his friend Nancy Ward,[53] and Ludwig Sander, a painter in the Mondrian tradition, all shared the building known as the "Red House" in Bridgehampton and the partying was decidedly intense.[54] One such party day, while others bedecked the trees with balloons, Elaine dipped hundreds of pennies in gold paint and sprinkled them all over the lawn when they were dry. That night Elaine (or maybe Franz) stayed up late preparing the props for the next day's events, one of which would include two fake softballs in an elaborate practical joke at home plate. Painter-writer Fielding Dawson's version of the story is that Elaine

Franz Kline, Howard Kanovitz and Willem de Kooning in the first artists and writers softball game, East Hampton. (Photo by Thomas Hill Clyde)

. . . painted two—two—grapefruits white, painted the stitches around, and the Spaulding marks on each, and the next day in the game with [Esteban] Vicente pitching, Franz catching, and Philip Pavia at bat, Franz, in the pretense of going out to the mound for a little conference slipped one of the white grapefruits to Vicente, and returned behind the plate.

Everybody knew but Pavia. The players on both teams, the kids, the wives, the girl friends—de Kooning doubled up in laughter in center-field, Vicente threw, Pavia swung, and hit—

"All right," he said, after the mess was cleaned up and everybody calmed down, "let's play." [55]

The angry, citrus-bedecked Pavia naturally assumed the prank was over. "Just a second," Franz said, the other fake softball carefully concealed. "I want to talk to Vicente." And history hilariously repeated itself.

Franz Kline had been an athlete in his youth—his broad-shouldered, muscular body seemed built for physical action on the playing field. But even off the field he was athletic. One of his women friends remembers his coming into her studio one day soaking wet, his raincoat dripping water: he made a flying tackle that swept her off her feet and onto the bed, wet raincoat and all, where they dissolved in gales of laughter. Though his energy never seemed to flag, his body—specifically his heart—ultimately betrayed him. Before that happened, however, he had had his share of success, and some happiness. From 1956 on he was in the best gallery, Sidney Janis, he was selected for all the important exhibitions of the new American painting here and abroad, including the 1960 Venice Biennale, at which he took a major prize, and by then, unlike de Kooning in 1950, he even had enough money to make the trip to Europe for the show.

Beginning in 1956 his financial picture had brightened considerably. Not only could he stand the bar for drinks whenever he liked and generously help out his less fortunate friends, he also was able to walk into a Ford salesroom and buy a brand-new Thunderbird right off the floor. Sometime later, he traded with a collector for a silver Ferrari. Driving it on the highway one day he was pulled over by a policeman. Getting out of the car with great trepidation, he was relieved to find that the cop only wanted to look at the engine. He'd never seen a car like that, he said. When asked how much it cost, Kline mumbled that he

didn't know because he'd traded a painting for it, adding defensively, "But it was a big painting!" Sometime after that, but not too long before he died, he went to Pennsylvania for a high school reunion. After listening to various plumbers and insurance salesmen roll off the names of their wives and kiddies, and to housewives citing their families' accomplishments, Kline stood up and described himself this way: "I'm an artist, I live in New York, and I own a Ferrari." Then he sat down, satisfied.

He had reason to be. He was still able in the 1960s to produce black-and-white paintings that had the power and the momentum to sweep the viewer along with them the way his 1950 works had. *Shenandoah Wall,* 1961, is not only his last enormous painting, it is probably his best —a consummate statement. Despite their stark simplicity, his black-and-whites never became formulaic; the spirit in them is inimitable. By 1958 Kline had begun to orchestrate canvases in a range of subtle grays, succeeding in such paintings as *Siegfried* in finding a painterly equivalent for the Wagner operas he so often listened to while he worked. And, most importantly, he had also been able to reintroduce color on a large scale. Starting in 1952 with *Yellow Square* and continuing sporadically with paintings like *Green Cross,* 1956, he simply substituted color for black. But he also began to work more and more color against the black until ultimately he was able to eliminate black altogether and to construct the picture entirely in chords of color.

In these paintings Kline's palette has a raw, nerve-jangling edge to it that is often full of surprises. Most people don't like surprises, which may be why his color paintings were not well received during his lifetime. He tended not to show them, or if he did, to include only one or two amid his black-and-whites instead of featuring them. Not until after his death, when his color paintings were exhibited en masse in the late 1970s, was it possible to get a true sense of his work in this vein, and then it began to earn critical respect. Kline's color, in which purples and reds, yellows, oranges, and greens clash for dominance, isn't like anyone else's. Kline loved Matisse, but his color doesn't have the sparkling Mediterranean limpidity of the French master. Instead, some of New York City's grime, the gritty matter with which its inhabitants are constantly showered and which seemed to have solidified in Kline's blacks, clings to his color. *Mycenae,* 1960, is one of the few paintings completely orchestrated in color, but even here the whites are stained by pale pinks and yellows. In *Scudera,* 1961, the whites have been all but eliminated

and the black ascending square is read against a colored ground. The upward rush of this central form, the profundity of the deep blue around it, and the spurt of red celestial fire which seems to pull the square heavenward, all combine to give this painting a religious feeling. *Scudera* was Kline's last work. Its sacramental quality now seems inextricably connected with the artist's imminent death of heart failure, in May 1962, shortly before what would have been his fifty-second birthday.

Nineteen fifty marked yet another turning point in America's cultural development in that the country's artists and writers—the poets in particular—achieved a new level of mutual understanding. Just a year before, in a 1949 *Magazine of Art* symposium MOMA curator James Thrall Soby had decried the "painful American phenomenon [of] the almost total divorce between living literature and living art."[1] In an effort to remedy this situation, the Modern initiated a series of poetry readings at the museum in the spring of 1950. Capacity audiences turned out to hear W. H. Auden, e. e. cummings, Robert Frost, Dylan Thomas, and William Carlos Williams read their works. A second series was begun in November with Carl Sandburg and Wallace Stevens. And it so happened that two of the most thoroughly literate of the Abstract Expressionists—Robert Motherwell and Philip Guston—both exhibited their work in New York at this time. In fact, Motherwell's November show at the Kootz Gallery was probably the most self-consciously literary exhibition ever mounted by an Abstract Expressionist.

Robert Burns Motherwell's involvement with poetry began, it would seem, with his christening. This lifelong passion was very much in evidence in his large 1950 one-man show and its accompanying catalogue, an exhibition filled with paintings making reference to books by Hemingway and poems by Baudelaire and Federico García Lorca. By this point in his life Motherwell's dual allegiance to painting and writing was firmly established. As an artist-intellectual he always wore other hats besides the "painter's beret": he wrote critical essays and translated

others, lectured widely (largely supporting himself by lecturing in the later forties and the fifties), and edited magazines and books about art, including the vitally important *Documents of Modern Art* series. In 1949 he became co-editor with Ad Reinhardt of *Modern Artists in America,* a survey of current artistic developments and ideas published in 1951. It was intended to be the first in a series of "reports" on art history in the making.[2] To this end the photographer Aaron Siskind was commissioned to photograph the New York artists' works and exhibition installations throughout 1950.

Modern Artists in America is academically brilliant. It simultaneously defined advanced painting while it was in the process of advancing, and placed it in its historical framework. Besides listing the exhibiting locations of over five hundred artists, and reproducing works by more than a hundred of that number, it included edited transcriptions of the Artists' sessions at Studio 35 in April 1950, and of the Western Round Table of Modern Art held the previous year on the West Coast, as well as lists of modern works added to American museum collections in 1949–50 and international art publications during that period. This part of the book alone made it invaluable to the art world. Another section, "Art in the World of Events: A Calendar of Excerpts 1946–1950," which consisted of official pronouncements made about the current state of art by various authorities in Europe and America, filled in the art world's postwar communication gaps. It was divided into two parts—"What Is Past Is Prologue" and "The Stage Is Set." This kind of self-consciousness about one's place in art history is rare indeed. Through their editorial focusing lenses the editors were creating an art movement. To this end they reprinted Parisian critic Michel Seuphor's "Paris–New York 1951," an article he researched in New York during the 1950–51 season for the French periodical *Art d'aujourd'hui.*[3]

In his comprehensive piece Seuphor showed off his skills at drawing pithy word portraits of the artists he met during his visit. Of Pollock he wrote:

Pollock is sullen. What loads does this man carry on his shoulders? What is the remorse that gnaws at him so? Only once, for only an instant, have I seen him brighten: at the end of the showing of a color film in which he is seen painting under a blue sky in the way a peasant tills, sows, works.

Of de Kooning:

> quicksilver, frank, enthusiastic, every day torn with some new anguish
> which every day's act of painting relieves. Owns a rumpled second-
> floor studio on Fourth Avenue which almost merges with the life of
> the street.

But his portrait of Motherwell may be the most psychologically astute:

> Motherwell looks very gentle. Is he really as gentle as all that? Civi-
> lized. Too much so? A bit of decadence could not harm an art as subtle
> as his, like a rare viand gamy to just the right degree. He is impulsive,
> low-voiced, speaks a finical English. What is he dreaming of while he
> talks of other things?

In 1950 Motherwell was at midpoint between looking like a serious
graduate student—as he did when he entered the art world in the early
forties—and a college professor, complete with care-weighted shoul-
ders—as he did in the last decades of his life. His sartorial style was
always conservative and academic. It is virtually impossible to imagine
Motherwell wearing de Kooning's overalls or Pollock's cowboy boots.
Motherwell's halting manner of speech indicated that his thoughts were
being carefully weighed and measured as they were expressed. He
didn't rush. As he spoke, he deliberately emphasized important words
as if to underline them for italicization in a text. Reading the statements
he made in 1950 one can hear the way he sounded until his recent
death in 1991. The three words which most often passed his lips were
"precise," "passionate," and "profound." Add a fourth word, also often
heard and delivered with equal emphasis—"despair"—and one has a
word-portrait of the artist.

When an interviewer in 1951 asked Motherwell why he was thought
of as the "official dialectician" of the advanced painters, the artist an-
swered, "I'm the Irishman of the group. I talk the most."[4] The fact is that
Motherwell's high style of intellection had separated him sharply from
the cafeteria-Cedar Tavern artists from the very beginning. In that other
milieu everyone kept their insights and theories "within the family."
They completely understood Pollock's fury the morning he woke Kline
after having heard about his "traitorous" participation in a panel discus-

sion at The Museum of Modern Art the previous night. Pollock yelled up at Kline from the street, "I heard you *talked* last night. You *talked!*" They knew Pollock meant that Kline had ratted on them, spilled the beans to the enemy: the critics, the writers, the collectors, and the museum people. In effect, Motherwell had been doing that all along, and the Cedar crowd never forgave him for that.

Motherwell's upper-class background also served to separate him from the rough-and-tumble world of the other American artists for whom he was the self-appointed spokesman. He was a banker's son from golden California who'd been a sickly child with an often life-threatening asthmatic condition. He had been born on January 24, 1915, in Aberdeen, Washington, but the family moved progressively south over the years until 1923, when they relocated in Los Angeles. Motherwell loved that southern locale, the sere golden-brown land, the dry blue air and the sharp-shadow light. He has ever since identified with that landscape, which he thought of as both Mediterranean and Spanish.[5] His preoccupation with Mexico and things Spanish dated from these early years.

Motherwell taught himself to draw by copying reproductions of everything from cars and heraldic banners to Michelangelo and Rubens. No formal art instruction ever worked for him either in high school or in college. Part of the problem was a father who couldn't have cared less about the arts and who opposed his son's involvement with them. At the precocious age of eleven Robert won a scholarship to study at the Otis Art Institute, but his father forced him to stop attending classes there after a short while. His mother collected French antiques but failed to support her son's interest in art. Ironically, considering his last name, the artist's mother seems to have been decidedly abusive to him, both physically and mentally.[6] Motherwell's memory was of a violent and hysterical home life, which caused him to be moody and difficult at school and to set him apart from other boys. His sense of the human potential for brutality was thus firmly established in his youth. He also witnessed a lynching at some point in his boyhood.[7] Thoughts about mortality engendered by these events could only have been amplified by his frequent asthma attacks, any one of which might have been fatal.

The primary positive art experience Motherwell had before he made the grand tour of Europe in 1935 was his visit to the Michael Stein Collection in San Francisco with a schoolmate from Stanford University.

Whereas his sister, Gertrude Stein, favored Picasso, Michael responded more to Matisse's work and bought many excellent paintings. Seeing these canvases made such an impression on the young artist that, despite the brutality of some of Motherwell's later works, it can be said that Matisse's influence never completely left him. Because of paternal pressure not to become a painter, it took Motherwell until 1940, when he moved to New York, to make up his mind to be one; philosophy and art history were no longer enough to sustain him by then. What is quite amazing is that this novice, who hadn't painted anything truly his own before 1941,[8] suddenly, miraculously, began to create works of art which seem extremely original to this day. Two years later he was showing his very large and innovative collages at Peggy Guggenheim's Art of This Century, and a year after that he had a successful one-man show at this same prestigious gallery. He worked his way through modern European art during the forties, painting American versions of Miró's, Picasso's, Mondrian's, and Matisse's paintings, but each one was clearly Motherwell in its sensibility, scale, and inventiveness. (In the *Elegies* at the end of the decade, as we shall see, he finally distilled his own unmistakably personal image.[9]) Even those who dislike him because of his wealth, sophistication, and intelligence, recognize the value of Motherwell's 1941–43 paintings. The fact is that, like him or not, Motherwell came into art as a virtual "boy genius," with no apparent apprenticeship to anyone, and he managed to maintain an art life on the highest level for fifty more years.

Internal psychic need drove him, but his innocence helped. Having studied philosophy rather than art in school, he easily grasped abstraction. Not making the commitment to be an artist until the age of twenty-five, and taking up art history instead, he lived the life of the artist vicariously. He immersed himself in Eugene Delacroix's journals, and, in 1938, while in Paris developing his study of that artist, he spent a great deal of time in the cafés observing living artists. (He spent many hours, for example, watching Picasso make continually changing assemblages out of the objects on his table at the Deux Magots café.) Apparently Motherwell was trying to decide between spending his life thinking and writing about artists and being one himself. When the time came to become an artist, Motherwell knew what to do. Not having been classically trained in drawing, he easily and naturally fell into the automatist practices promulgated by his new Surrealist friends. Unlike many

artists with conservative schooling, he had no rigid habits to break; it was relatively easy for him to abandon control and let his marks respond instinctively to his impulses. Not knowing how to paint well by conventional art school standards, he more readily painted directly out of his own emotions and experiences.

In 1940, soon after his arrival in New York, the twenty-five-year-old Motherwell immersed himself simultaneously in the literary and the art scenes. He was probably introduced to both by art historian Meyer Schapiro, his teacher at Columbia University, where Motherwell did graduate work in art history. Schapiro wrote art criticism for *Partisan Review* and other radical periodicals. The literary world of that time, Motherwell has said, was precisely the one Saul Bellow described in *Humboldt's Gift,* a novel loosely based on the life of poet Delmore Schwartz. In this milieu a writer was faced with an immediate challenge: "knock the Village flat with your poems and then follow it up with critical essays in the *Partisan* and the *Southern Review."* As Bellow described them, poets talked about everything from Babe Ruth to Rosa Luxemburg: "[Humboldt's] spiel took in Freud, Heine, Wagner, Goethe in Italy, Lenin's dead brother, Wild Bill Hickok's costumes, the New York Giants, Ring Lardner on Grand Opera, Swinburne on flagellation, and John D. Rockefeller on religion." [10]

Within this lively and disputatious *Parisan Review* circle, the very young painter, translator, editor, and sometime art writer Robert Motherwell became as broad-ranging and as versatile a conversationalist as anyone. Unlike the writers however, his personal style lacked sparkle and wit. Always profoundly serious, he was not a joyful man, and he was not given to sarcasm. But his clear, open good looks and blond-haired, blue-eyed boyishness undoubtedly augmented his appeal to the jaded denizens of Greenwich Village, both intellectual and artistic. The branch of the art world Motherwell also fell into at this time was comprised of highly cultivated European exiles who met in each other's homes rather than in the cafeterias. Dominated by the French Surrealist poets and painters, this group to some degree became intertwined with the American literary milieu, but remained somewhat apart from the developing American avant-garde artists.

Transplanted to America when the war broke out in Europe, the Surrealist movement continued to be led by André Breton, the "pope" of Surrealism since its outgrowth from Dada in the mid-twenties. Him-

self a poet, Breton continued the movement's literary emphasis while in exile here, despite the fact that most of the emigrés were visual artists. Max Ernst, the painter of greatest repute among them, was married to Peggy Guggenheim, and her gallery became the New York center of Surrealist art activity in the early forties. "I would talk to Max Ernst," Motherwell recalled. "[He] probably was the first painter before me to have a degree in philosophy and [he] was willing to talk about intellectual things."[11] Among the other Surrealist emigré artists were Yves Tanguy, Matta Echaurren, André Masson, and Kurt Seligman. Matta was close to Motherwell in age and social position, and they became fast friends.

These, then, were the artists who shaped Motherwell's entry into the art world. Like him, they were intellectuals. Many were twice his age and as world-weary a group of people as ever lived. They saw Motherwell as a link to the Americans because of his literary and intellectual accomplishments. Breton refused to learn English, and although Motherwell didn't speak French, he could read and translate it easily. Breton chose Motherwell to edit the first issue of *VVV,* a periodical devoted to "imaginative works of universal interest, whether they be in poetry, the plastic arts, anthropology, psychology, sociology, the evolution of science, comparative religion, or what may simply be called the field of the wonderful."[12] Soon finding themselves unable to work together, however, Motherwell either resigned (his version) or was fired, long before the first issue appeared. (All three issues were ultimately edited by the sculptor David Hare.) Working with the Chilean Matta, Motherwell proselytized the benefits of Surrealist automatic procedures with great fervor in an attempt to raise the flag over an American bastion of the movement. As we have seen, he was sometimes overzealous in this endeavor, as when he tried to "explain" automatism to Gorky and Hofmann, who already knew all about it and had either embraced or rejected it for themselves.

Love, sex, and death—the perennial obsessions of the Surrealists[13]—were inextricably entwined in the subject matter of Motherwell's paintings from the very beginning. They permeate most of his work, not only the *Elegies.* His first significant oil, the radically severe striped canvas titled *The Little Spanish Prison,* 1941, was painted on his return from a summer in Mexico with Matta. He later said that Matta gave him "a ten year education in Surrealism in the three months of that summer."[14] Motherwell extended the trip to spend a few months with his new wife,

Maria Emilia Ferreira y Moyers, a fiery and beautiful Mexican actress once described as a "little, capricious Ariel floating about." Attending bullfights, unavoidably aware of the never-ceasing consciousness of death that pervades the Mexican culture, associating the light and the climate of Mexico with his California youth—a youth tainted by a continual fear of his own sudden death from asthma—all these factors became fused in his mind with finding love and passion in the person of Maria.

The Little Spanish Prison is comprised of rough vertical bands in yellow and white, a tiny, horizontal slit window,[15] an image which expresses something of the repression of the Mexican people, even though its colors are the bright ones of the aniline dyes used in peasant papier-mâché masks and other popular folk objects. The Mexican Revolution was essentially still going on in 1940–41, since the distribution of land among the peasants had been only partially carried out, and most of the other reforms had remained unexecuted. Maria's uncle, General Ferreira, had been in the Revolution, and she was steeped in its lore. Since the Spanish Civil War had naturally been linked in many Mexicans' minds with their own revolution, Maria must have been thrilled to be offered a screen test to play the female lead in Ernest Hemingway's *For Whom the Bell Tolls.* One can only imagine how powerful an effect this book, set in war-torn Spain, and published in 1940, might have had on Motherwell.[16] (While a student at Stanford in 1937, Motherwell had heard André Malraux's rousing call to aid the Loyalists, a Gauloise cigarette dangling romantically from his lips, and ever after, the Spanish civil war was *his* war in spirit, just as it was the Frenchman's.)

Motherwell recalls that his "constant companion" during the first years of the forties was Anita Brenner's book on the history of the Mexican Revolution, *The Wind That Swept Mexico,* with its nearly two hundred stark, sometimes gruesome, documentary photographs. One of these pictures, which shows a firing squad in action, its victim against a completely blood-spattered wall, was a crucial source for his 1943 painting-collage *Pancho Villa Dead and Alive,* one of the precursors of the *Elegy* series. When he created this picture commemorating the Mexican revolutionary leader, he had just returned from a second stay in Mexico with Maria. It was at this time, too, that Motherwell lost his father after a short, devastating battle with cancer. It cannot be without significance that Motherwell deliberately but ambiguously paired two abstract

"figures" in *Pancho Villa Dead and Alive*. One figure with healthy pink (but flaccid) genitals very much in evidence is seen against a densely blood-spattered wall; the other is either missing his sex organs or sporting them (erect) on the left of his blood-spotted body. In his doctoral dissertation on "Motherwell's Concern with Death in Painting . . ."[17] art historian Robert Hobbs attempted a complex Freudian analysis of this picture in terms of a symbolic Oedipal wish on the artist's part to replace a father with whom he had not come to terms. At any rate, the emotional turmoil that Motherwell the man must have felt at this time is expressed in the visual and symbolic confusion wrought by Motherwell the artist, and at this very early point he is already using abstract, sexually charged imagery to convey his emotions.[18]

Motherwell's feelings about Mexico are much the same as those expressed by a native such as Mexican painter Rufino Tamayo, who never fails to emphasize the direct connections living Mexicans feel with the ancestors buried below the streets on which they walk. An oppressive political system has always weighed the native Mexican down, and the people's consciousness of the closeness of death has roots that reach back through their incredibly bloody history to primordial times. Motherwell remembers it as central to his experience of Mexico:

> And death! The continual presence of sudden death in Mexico (I've never seen a race of people so heedless of life!). The presence everywhere of death iconography: coffins, black glass-enclosed horse drawn hearses, sigao skulls, figures of death, priests enclosed in glass cases, lurid popular wood-cuts, Posada . . . and many other things, women in black, cyprus trees in their cemeteries, burning candles, black-edged death notices . . . all of this contrasted with bright sunlight, white-garbed peasants, blue skies, orange trees and everything you associate with life—all this seized my imagination. For years afterwards, spattered blood appeared in my pictures—red paint.[19]

Even thirty-five years later he titled a painting *The Spanish Death*.

Maria Motherwell, who grew up in this drastic world, reacted to it in as reckless and wild a fashion as one might expect, but her behavior found ready acceptance in the Surrealist world where the bitch-goddess reigned over misogynist subjects.[20] (Lee Krasner used to say that the Surrealists treated their wives like French poodles."[21]) Motherwell de-

scribed Maria as a "Mexican Brigitte Bardot—part Indian, German, Spanish, and looking like a ballerina." Apparently she wasn't an especially faithful wife, which wouldn't have made waves among the Surrealists, who indulged in every imaginable kind of interpersonal experimentation—but it did among Americans. For instance, when Maria picked up Jackson Pollock for a ride in Motherwell's sporty little MG shortly after they met out on Long Island, Lee Krasner went into a jealous rage and "banished the Motherwells from Jackson's life." [22] Maria dealt Motherwell a crushing blow when she abruptly left in the fall of 1948. The profound depression into which he lapsed as a result of her departure lasted well into 1949. In such a situation, sexuality is inevitably linked with ideas of castration and suicide. This, then, was the emotional background against which Motherwell painted the *Elegies, The Voyage,* and the other pivotal paintings in his 1950 Kootz exhibition.

Ironically, in spite of Motherwell's intense involvement with his own literary generation, the poets who have had the most profound influence on his work over the years have not been his American friends such as Stanley Kunitz, but the early French modernists—Baudelaire, Rimbaud, Mallarmé, Verlaine—and the Spanish-speaking poets such as Federico García Lorca, Rafael Alberti, and Octavio Paz. The Spanish incantatory lyricists dominated his thoughts at the end of the forties just as his series of *Elegies to the Spanish Republic* began to emerge. When they were shown as a group in his November 14–December 4, 1950, exhibition at the Kootz Gallery, the power of these largely black-and-white paintings immediately established the *Elegies* collectively as the image with which he would be identified for life. *Seville, Granada, Málaga, Madrid, Barcelona,* and *Catalonia* and two versions each of *At Five in the Afternoon* and *Spanish Drum Roll* were included among the works he described in the catalogue as "funeral pictures, laments, dirges, elegies—barbaric and austere . . . [created in] an effort to symbolize a subjective image of modern Spain."

The development of Motherwell's *Elegy* image—bulbous black ovals pressed between massive black verticals in a horizontal procession across an activated field of white—was, in effect, the result of a collaboration between the painter and the work of two poets. The initiatory ink drawing, now titled *Elegy No. 1,* 1948, was intended to illuminate a poem, *The Bird for Every Bird,* written by his friend the poet-critic Harold Rosenberg for a future issue of *Possibilities.* It was drawn on a

letter-size sheet of paper beneath the following final lines of the poem scrawled on the page by the artist:

> I knew who had sent them in those green cases.
> Who doesn't lose his mind will receive like me
> That wire in my neck up to the ear.

Though Motherwell says there is no connection between the poet's image of a brutally invasive wire in the neck and the thin, taut vertical line between the two leftmost ovals in his sketch, the conjunction of images is nevertheless excruciating. Stashed away and forgotten when *Possibilities,* publication was aborted later in 1948, the *Elegy* image was reborn the following year when Motherwell moved into a new studio on Fourth Avenue near Tenth Street (the studio he later shared with

At Five in the Afternoon *by Robert Motherwell.*

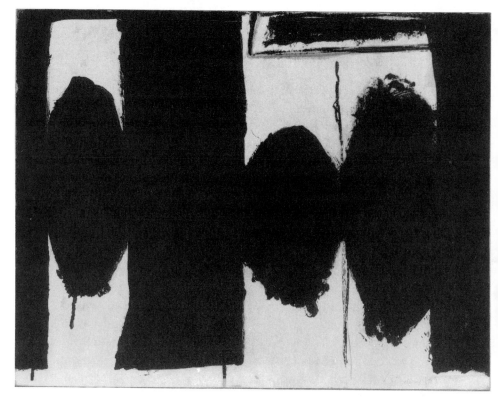

Bradley Walker Tomlin). Coming across the sketch one day when he was "looking around for a generating idea," Motherwell made a larger version of it in casein paint on board, eliminating the text but retaining the thin vertical line and the same configuration of three ovals and three heavy verticals suspended from the top, where a windowlike rectangle fills the upper right. Years later he recalled: "When I painted the larger version—*At Five in the Afternoon*—it was as if I discovered it was a temple where Harold's was like a gazebo, so to speak." He added that *"At Five*. . . struck me as a monument," and when he searched his mind for someone to whom he might consecrate such a temple he realized that person was Federico García Lorca. Motherwell later recalled:

> The "temple" was consecrated to a Spanish sense of death, which I got most of from Lorca [whose writing nearly always concerns death, and who died in the opening days of the Spanish Civil War], but from other sources as well—my Mexican wife, bullfights, travel in Mexico, documentary photographs of the Mexican revolution, Goya, Santos, dark Hispanic interiors.[23]

At Five in the Afternoon was titled from the words Lorca repeated twenty-seven times in the first fifty-two lines (the "Cogida and Death" segment) of his *Lament for Ignacio Sánchez Mejías,* the famous Spanish bullfighter who had died as the result of a goring.[24] The poem, written less than a year after Mejías's death in 1935, begins:

> At five in the afternoon.
> It was exactly five in the afternoon.
> A boy brought the white sheet
> *at five in the afternoon.*
> A frail of lime ready prepared
> *at five in the afternoon.*
> The rest was death, and death alone
> *at five in the afternoon.*[25]

The Spanish poet's heavy, measured beat, like a funeral march, is echoed in the repeated alternating forms moving in procession across the American painter's canvas. One can easily conceptualize the visual

rhythms and line lengths of this particular section of the poem in ways that resemble a Motherwell *Elegy,* and like the painting, the poem is solemn and brutally precise, its lucidity serving to reinforce the tragic tone.[26]

Of all the senses Lorca commands in his imagery, none is more important to him than vision. "The metaphor is always ruled by vision, which limits [it] and gives it reality," he said, adding that "it does not permit a shadow to blur the outlines of an image it has seen clearly drawn."[27] As the visual is crucial to Lorca, sound, a near-verbal sense of meaning, was equally vital to Motherwell. He always spoke of his search for the "right tone" in a painting. A note of joy sings forth at times, a sigh of satisfaction at others, but a cry of pain is the sound most often heard. Motherwell's Protestant temperament tries to keep his emotionalism in check but, as he once said, "It is not always possible to muffle the shriek that lies deep inside everyone." The Spanish poet and the American painter are both precise without being tidy or constricted. Each is specific as to number, and stark about shape.

> Seven cries, seven wounds,
> Seven big double poppies,
> Cast opaque moons
> In the big dark rooms.
> —Lorca, from *Dead of Love*[28]

In the *Elegies,* Motherwell usually employs two or three ovoids between either two or three vertical units. Painted solid black, they read clearly and flatly against the white ground, though their edges may be ragged or roughened; no gentle shading blurs their silhouettes. In an interesting parallel, the final image in Lorca's second stanza of the *Lament* concentrates everything into a single horror: "Death laid eggs in the wound"—thus foretelling Mejías's death from gangrene. If one were to insert the color black into Lorca's line—"black death laid black eggs in the black wound"—the image would virtually describe a Motherwell *Elegy* in which black egg-shaped[29] forms lie suspended between stiffened black bands. Motherwell turns his rhythmically alternating and obsessive shapes into concrete *things,* just as Lorca does with his obsessively repeated phrases, for example, the incantatory rhythm of the final stanza of his "Corrida and Death":

A coffin on wheels is his bed
at five in the afternoon.
Bones and flutes resound in his ears
at five in the afternoon.
Now the bull was bellowing through his forehead
at five in the afternoon.
The room was iridescent with agony
at five in the afternoon.
In the distance the gangrene now comes
at five in the afternoon.
Horn of the lily through green groins
at five in the afternoon.
The wounds were burning like suns
at five in the afternoon.
and the crowd was breaking the windows
at five in the afternoon.
At five in the afternoon.
Ah, that fatal five in the afternoon!
It was five by all the clocks!
It was five in the shade of the afternoon! [30]

In the *Elegies* and the other Spanish paintings from the late fifties, which were based on small studies in his 1950 exhibition, the black areas are so close to us, they loom so threateningly, that we feel personally disturbed by them. One can sense something of the terror of the inevitable that a bullfighter must feel beneath a bull's huge and inexorable animal bulk, hands powerless to turn away its goring horns. As well as being a generic cry of anger at death, the paintings in Motherwell's series of *Elegies to the Spanish Republic* are specifically intended to lament the death of the hope that was born in the hearts of Spaniards with the Republic—and the deaths of all the people lost in the effort to save it.

Motherwell makes obvious the connection between sexuality (specifically male sex organs) and death . . . [31] in some of his *Elegies,* such as the one which is perhaps the finest of them all, *Number 34,* 1953–54, in the collection of the Albright-Knox Art Gallery in Buffalo. In this work the silhouette of a penis clearly intervenes between the ovoid testicular forms. In most of the *Elegies* the same physiological implications are

unavoidable, just as they are in Georgia O'Keeffe's flowers, where the labial image of female sex organs is inescapable. Though the linkage of love with sexuality isn't made specifically in the *Elegies,* it is clear in Motherwell's *Je t'aime* ("I love you") paintings of the later fifties. There the testicular ovoids appear within a triangle in the "body" of the "male" or simply appear as stand-ins for a male. Some of Motherwell's paintings of the late fifties are so clearly sexual in a positive, physical way that in 1959 one reviewer described them "as records of orgiastic, joyous release [and as such] they are slightly embarrassing."[32] In fact, male organs and ejaculatory images are frequent in most of his work, with the exception of his collages and the large "color field" abstractions known as the "Opens," which he began painting in the late sixties, works marked by a stateliness and control that is the opposite of sexual abandon.

It is pertinent in this regard that in the same year the critic admitted to embarrassment by the painter's fervor, Motherwell wrote in a highly sexually charged way about Joan Miró, a painter almost as close to his heart as Matisse and Picasso. His article on "The Significance of Miró" appeared in *Art News,* and, as always, the writing artist reveals as much about his own concerns as he does about his subject:

[Miró's] two main subjects are sexuality and metamorphosis, this last having to do with identity in differences, differences in identity, to which he is especially sensitive, like any great poet. Miro is filled with sexuality, warm abandoned, clean-cut, beautiful and above all intense … he has no guilt, no shame, no fear of sex; nothing sexual is repressed or described circumspectly—penises are as big as clubs, or as small as peanuts, teeth are hack-saw blades, fangs, bones, milk, breasts are round and big, small and pear-shaped, absent, double, quadrupled, mountainous and lavish, hanging or flying, full or empty, vaginas exist in every size and shape in profusion and hair!—hair is everywhere, pubic hair, underarm hair, hair on nipples, hair around the mouth, hair on the head, on the chin, in the ears, hair made of hairs that are separate, each hair waving in the wind as sensitive to touch as an insect's antenna, hairs in every hollow that grows them, hairs wanting be caressed, erect with kisses, dancing with ecstasy.... Miro's torsos are mainly simplified shapes, covered with openings and protuberances—no creatures ever had so many openings to get into, or so many organs with which to do it.[33]

There were ten *Elegies* in Motherwell's 1950 Kootz Gallery exhibition, but there were seven paintings conceived of as "Wall Paintings" (rather than as easel paintings), and there were fourteen "Capriccios." The Capriccios were the freest, most spontaneous and various group of paintings in the show. In them fancy reigns, and sexual implications abound. They offered a brilliant counterpoint to the severely simplified Wall Paintings and brutally austere *Elegies* like *Granada,* 1949, which had been the first large-scale statement of the basic *Elegy* schema. Art critic Belle Krasne liked all three kinds of paintings by "one of today's most thinking painters," as she put it. Not surprisingly, given their ingratiating qualities, she singled out for praise "the harmonious, subtle color and excellently disciplined composition" in the Wall Paintings and the "sudden flights into color" in Capriccios like *Yellow Still Life. Granada* has only a few simple elements aligned across the surface in an A, b, A, bb, A procession—the "As" being vertical bands of black, the "bs" being black ovals. A thin vertical line runs between the joined ovals from the bottom of the canvas almost to the top, where a horizontal slitlike window of black is opened in the painting's airless space. Like the effect Mondrian's paintings can have, there is an imperative to stand up straight in front of this ungiving work.

The show, his first in three years, was a masterful one in which Motherwell established the themes and the formal schemas for decades of painting. The abundance of visual ideas in it is staggering, and he hadn't even exhausted all its possibilities when he died. It was the exact opposite of Franz Kline's experience where his October 1950 show typecast him as a black-and-white painter for life. Later, when Kline was famous and people began to clamor for his work, it was always the black-and-whites they wanted, never the works in color. "They won't let me leave the harbor," he complained.[34] Motherwell was able to sail out at will, no matter what the wind, on any of a number of different vessels thanks to the range of potential imagery this 1950 exhibition suggested.

Still, though not trapped by it, the *Elegy to the Spanish Republic* remains Motherwell's image in most people's minds. He painted a great many of them in the following forty years, though not, despite their numbering, the scores of them people thought he had. Perhaps the elegy's fascination for him was due in part to not having the most perfect initial version of it, the small casein painting, *At Five in the Afternoon,* around for much of that time.[35] This may have been a blessing in dis-

guise, as it freed him from obsessively trying to recapture its spontaneity on a large scale. He never mastered the trick of jumping from small to huge scale that came so easily to Franz Kline. For Motherwell it was an agonizing struggle to move from the security of small size where he felt eminently at home to the intimidating expanse of a huge canvas.[36] The difficulties of painting the large *Elegies* were compounded by the fact that the elements that comprise the *Elegies* are so objectlike that they demand comparison with whatever is around them outside the picture frame. Kline's forms, on the other hand, maintained an internal scale. When Motherwell does succeed, as happened after eleven years of doing battle with the 20-foot-long *Elegy 100* between 1963 and 1975, for instance, the victory is sweet indeed.

The simple, understated, and open-ended rectangularity of the "Wall Paintings" in Motherwell's 1950 show were to spawn many different kinds of offspring over the ensuing years. Their architectural forms ultimately led him to the *Open* series of canvases covered with a single expanse of color and articulated by only a few lines, often in a window-like squared U. This series wasn't begun until the late sixties, but Motherwell's description of his intentions for the Wall Paintings in the catalogue for the 1950 Kootz show indicates how his thinking at that time was as radical as the later *Opens* turned out to be:

> The "Wall Paintings" are not conceived of as easel paintings, but as enhancements of a wall, and so called; and their subject is not an image, whether subjective or "real," but the culture of modern painting. [The subject is] simply the character of a wall painted with style.[37]

Simply cutting an expanse of color with a black line did for Motherwell what it had done for Barnett Newman in 1950; it let him "declare" color instead of dividing it. Neither man is usually a "relational" colorist like Bonnard or Matisse, sparking light from the interaction of two adjacent hues. Instead, they are absolute colorists working with unbroken, saturated color-light, often with only one or two colors per painting. Unlike Newman, however, Motherwell in his *Opens* creates a form with the line instead of letting it simply pass through the space, a form with implications of door-ness or window-ness without being an object. Even though they distantly resemble Constructivist paintings by Mondrian and Malevich, they stem from the "throw of the dice" side of Motherwell's

esthetic personality that lets chance dictate form,[38] rather than the builder and constructor in him who created the *Elegies.* For these reasons, and because of their extreme size and drastically minimal articulation, the *Opens* depart from his customary "look," but not from his basic credo as a painter. Motherwell's ethic, his moral position on what he is willing to put into a picture and what he insists on keeping out, was succinctly stated in a filmed interview with David Sylvester in 1960, but it was already fully evident in his Kootz exhibition ten years earlier:

> I allow no nostalgia, no sentimentalism, no propaganda, no selling out to the vulgar, no autobiography, no violation of the nature of the canvas as a flat surface, no clichés, no illusionism, no description, no seduction, no charm, no relaxation, no mere taste, no obviousness, no coldness. On the contrary, I insist on immediacy, passion or tenderness, sheer presence, beingness as such, objectivity, true invention, and resolution, white, the unexpected, direct color—sky blue, grass green, English vermillion, the earth colors, ocher, sienna, umber, and black and white—and a certain broad masculinity, an emotional weight that is hard to describe.[39]

Motherwell's abilities as a colorist have been largely overshadowed by his fame as a painter of black and white, but they were fully evident in his 1950 exhibition. Perhaps in part because of the personal depression he was in when he painted them, the 1948–50 canvases like *The Voyage* have resonant color chords based in dark and light ochers and deep greens with black and white. This pivotal 1949 painting, the title of which refers to the last line in Baudelaire's poem of the same name about voyaging into the unknown to find the new, is very different in feeling from the Capriccios. In those he often used the glowing pinks, bright blues, and yellows he had learned to love in Mexican folk art. Color has been one secret of his artistic longevity, as Gottlieb understood and Kline had acutely surmised might be the case for himself.

In May 1950, when he was thirty-five, Motherwell married Betty Little, a woman from Levittown, Long Island, whom he met in Reno when they were both getting divorces. Betty Little had a daughter by her former husband, so for the first time Motherwell had the kind of stable home life (he would term it a *ménage*) he had long desired. They spent the summer in Motherwell's Quonset hut studio/home in East Hampton,

*Robert Motherwell in his Quonset hut studio in East Hampton in 1950.
(Photo by Peter Juley & Son, New York)*

which had been designed for him in the mid-forties by Pierre Chareau,
the noted French architect. Motherwell's mother helped them with the
money needed to finish the construction. He recalled that "she probably
thought her renegade son would settle down now that he had a wife
and child, and it would be worth the money to make it livable." The
Motherwells moved to Manhattan's Upper East Side after he began
teaching at Hunter College in the fall of 1950. The job paid a thousand
dollars a month, which enabled him to get a large apartment. It con-
tained a dining room ample enough for him to paint a twelve-foot mural
that had been commissioned for a synagogue in Milburn, New Jersey.

Motherwell was never completely comfortable living or working in
Chareau's radically modern buildings, and he often complained about

them. Some years later he bought a house on the bay in Provincetown, where he spent his summers from then on. In 1953, after the sale of the East Hampton property, he purchased a brownstone on the Upper East side, on Ninety-fourth Street, not far from where Mark Rothko, his friend since the mid-forties, would later live. Rothko and David Smith were Motherwell's closest friends for the rest of their lives. They saw each other often, families included, both in Manhattan and on the Cape, where Rothko also purchased a house. Motherwell's marriage to Betty Little ended after seven years, during which time their two daughters, Jeannie and Lise, were born.

Late in 1957, when he began a relationship with Helen Frankenthaler, Motherwell found someone more compatible in terms of ambition, social status, and worldliness than either of his first two wives had been. Frankenthaler was rich and attractive, a well-known painter, showing with a good gallery. She already had numerous collectors and friends in the art world, many of whom, like David Smith, were also close to Motherwell. In fact, both were so fond of Smith that he practically became a member of the family. Motherwell's and Smith's daughters were close in age as well. Frankenthaler loved to entertain and did so with style, which Motherwell thoroughly appreciated. They married in 1958 and went off to Spain and southern France for an extended work-holiday. This was Motherwell's first actual experience of Spain, and, even though he had to cut his stay short (he was persona non grata in Franco's country because of his *Elegies to the Spanish Republic*), the drawings he made while he was there were the germinating seeds for over eighty paintings and even more works in other media. In his *Iberia* and *Spanish* series paintings of 1958–59, blacks threaten to engulf all the space, literalizing the reading of the *Elegies* painted a decade earlier as "views" up at the underside of a black bull.

The post-Spain period saw his largest burst of productivity, and the next seven years were good ones in which the two artists exerted some measure of beneficial mutual influence on each other. Frankenthaler's amorphous, stained-in abstractions seemed to toughen up a bit, while Motherwell's work became more lyrical and experimental. He began to use larger-size canvases and a much wider range of formats. Working on the floor instead of the easel or wall, he stained the pigment into the canvas, poured, dripped, and splashed it on. He was freer and more expansive than he'd ever been, and, it would seem, happier. Toward the

end of his marriage to Frankenthaler, however, he went to the opposite end of the spectrum, producing little and destroying much of that. He also began to question the value of those free canvases of the early sixties and to destroy many of them, a series of actions he later came to regret.

The turning point in his life came in 1965, when he turned fifty. It was the year of his MOMA retrospective, which naturally precipitated a soul-searching reassessment of his life's achievement. Tragedy struck at the same time. In the midst of producing some of his most spontaneous work—a series of small, automatist, and patently ejaculatory splashed-ink drawings on rice paper titled "The Lyric Suite"—he received a phone call that his beloved friend David Smith had been badly injured in a car accident. He and Helen tore across New England to the hospital at life-threatening speed, only to arrive a few moments after Smith died. Smith's death from causes which might at any point be those of Motherwell's own demise—drinking and driving—brought him sharply face-to-face with the specter of his own mortality.

The loss of his dearest friend brought the morbid side of Motherwell back to the forefront at a time when the *Elegies,* his way to express that side by confronting death, no longer seemed as meaningful as they once had. And a serious miscalculation in the planning of his retrospective at The Museum of Modern Art added publicly to his woes. Motherwell, at the urging of the curator, poet Frank O'Hara, included an enormous new twenty-foot-long *Elegy* as the dominant, culminating work in his retrospective. But the painting was weak and quite unresolved (Motherwell eventually painted it out), and it effectively trivialized the other *Elegies* lined up in its presence. To many painters and critics this ostensibly monumental *Elegy* appeared inauthentic—even pompous—and seriously diminished what would otherwise have been a triumphant exhibition. Motherwell undoubtedly shared some of his public's disillusionment with the continued emotional resonance of the *Elegy* image. In years to come, however, he would go on to paint some of his finest *Elegies,* such as the staggering *Elegy 100,* 1963–1975, on this same twenty-foot canvas, but at this point he was clearly searching for a new image.

He didn't find it until 1968 when he happened to notice that a strong, windowlike composition was created when a smaller canvas resting against a larger one cut a rectangular shape out of its expanse. Chance

had brought him the solution to a painting problem he'd been wrestling with for a decade—how to create disparate elements within a unified field without disrupting its unity. It was almost as though he were starting out to be a painter all over again, taking a very austere, Mondrian-like rectilinear framework as his starting point just as he had done back in 1941 with *Little Spanish Prison* and *Spanish Picture with Window*. Those paintings concerned repression, and the feeling of being closed in behind barriers; his new *Open* series, as he called it, did the opposite.

Liberated by the new imagery and renewed in his personal life by his marriage to a beautiful German photographer, Renate Ponsold, Motherwell spent the last two decades of his life working hard and exhibiting widely. Retrospective exhibitions here and abroad, as well as numerous book-length studies of his work, occupied his nonpainting time. By keeping him constantly searching his soul for its esthetic essence—a what-kind-of-painter-is-it-that-I-really-am? syndrome—these art historical studies augmented his normally high level of anguish about his work. "Having a retrospective is making a will," he once said.[40]

Anxiety over one's artistic identity was not a problem shared by many of Motherwell's contemporaries. Newman, Rothko, Baziotes, Brooks, Still, Hofmann, even de Kooning, didn't make similarly radical shifts in their work or develop new imagery over the decades after 1950, though they may have painted masterpieces in idioms established by then. If anything, like Kline and Pollock, they complained about being trapped in a signature image instead. David Smith and Adolph Gottlieb did move about more freely in new territory, but the peer with whom Motherwell had the most in common in this regard was Philip Guston, whose long career, like Motherwell's, extended three decades or more past 1950. To cut off either man's record of accomplishment at mid-century would be to diminish them. These two were the youngest in the group, they began their careers early, and they lived long lives. For both men this lengthy work life was filled with major stylistic changes, each of which was accompanied by great emotional strain. Guston's changes were made in a succession of large moves, while Motherwell always explored many images simultaneously and continually doubled back to pick up earlier themes.

Motherwell and Guston first became acquainted during the 1950–51 season, a point of tremendous anxiety for Guston because he was beginning to commit himself to abstraction after years of figurative work.

Guston's personal life was also in upheaval. During the forties he had grown accustomed to a calm, provincial existence in the isolation of Woodstock and the quietude of various midwestern colleges where he had been teaching. But in the fall of 1950 he returned to the urban scene with such manic intensity that he was described by a friend as having "thrown himself into the maelstrom of New York with an alacrity bred of near despair."[41]

Surely Guston heard his desperate emotion echoed in Motherwell, who had been nearly suicidal the year before, after his wife left him. Both men were "night people," both smoked and drank to excess, and both were profoundly involved with literature and philosophy. Alone among their artist friends, they shared a genuine interest in and understanding of serious contemporary music. Arthur Berger, a composer well known for his austere, serial or tone-row pieces, had been Motherwell's original connection to Meyer Schapiro and the New York art world back in 1940, and John Cage, a close friend of Guston's, who had already made a name for himself with his avant-garde music, had been co-editor with Motherwell of the radical arts review *Possibilities 1,* in 1947–48.[42] Motherwell and Guston were also passionate and eloquent talkers, though their personal styles were not alike. Highstrung and irritable, Guston paced nervously as he spoke; Motherwell calmly and deliberately delivered his thoughts. They crystallized their ideas about art during nightlong discussions about Camus and Kierkegaard, Kafka and the Talmud, Wallace Stevens's and Rilke's poetry.

Poetry had always been a primary concern of Guston's, and of his wife, Musa McKim, whom he met in art school. Musa had subsequently turned to poetry as her main vehicle of expression. Guston was also close to Stanley Kunitz, Frank O'Hara, Harold Rosenberg, and many of Motherwell's other poet friends. The two painters' taste in writers was more divergent outside of their immediate circle, however, Motherwell's running to the French Symbolists, the Spanish modernists, and James Joyce, while Guston preferred Samuel Beckett, the French existentialists, and Kafka. Their preferences mirrored themselves: Motherwell, the thinker, who always took himself with the utmost seriousness; Guston, the brooder, whose self-deprecating humor could cut as deep as a flaying whip.

At this time, Guston was a darkly handsome man with a faintly haunted look, the brow below his receding hair furrowed with concern

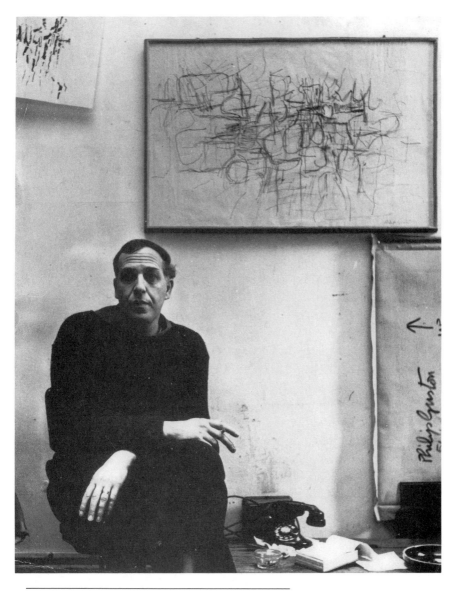

Philip Guston in his 10th Street studio in 1951.

and his sensuous mouth drawn down at the corners in sardonic resignation. In 1950 he was still emerging from a severe emotional depression, and the torment of the past three years was etched into his face. This state of mind—a paralyzing anxiety over his work—had overwhelmed him late in 1946 at the height of his success as a figurative painter, and it reached a point in the next few years bordering very

closely on mental breakdown. The prizes he had been winning and the adulation he was receiving in the press—including a May 27, 1946, *Life* magazine feature after he won the $1,000 first prize at the Carnegie International—had begun to seem hollow and his work escapist. He told his *Life* interviewer that he agreed with the critics who didn't particularly like the prizewinning picture, *Sentimental Moment.* He explained that it was too "literal" and that he preferred his more abstract paintings. During the next three years he battled his way through one painting failure after another as he struggled to come to terms with abstraction, a way of working he had become convinced was the only truthful, morally acceptable one in the postwar, post-Holocaust years.[43]

When he moved to Manhattan late in the summer of 1950 to take his new post as instructor of drawing at New York University, Guston was ready for a change. "I had worked for three years, and ended up with a kind of freedom," he later recalled.[44] When he couldn't paint, he would walk the city streets all night, indulge himself in an orgy of moviegoing in the all-night theaters on Fifty-second Street, sit in bars and talk with strangers, or go to The Club or the Cedar to find friends. It was during this, his first full season in New York since the Depression, that he began to try to make a painting in one go, without "constructing" it or stepping back to assess it at various stages. He wanted to suspend criticism and see if he had an innate sense of structure that he could count on. "It's like molding something with your hands," he explained later.[45] "You reach a different kind of sight . . . you're so deep into the middle of so many complex [painting] events that even though you may want to go right, your hand may go to the left, and you have the total freedom of no choice." In this way—on a free-branching path strewn with obstacles put there by chance—he finally made his breakthrough into the kind of jittery, small brushstroke, allover abstractions for which he subsequently became famous.

Red Painting, 1950, was the first of his new allover paintings. It had started out like the more constructed, consciously abstracted canvases of the late forties, in which recognizable elements were embedded within interlocked quasi-geometric forms. But by the time he decided it was finished, the structure had been almost completely buried beneath a welter of loose, painterly brush strokes. The dark brownish reds, which had dominated his palette before, lightened in *Red Painting,* and would pale to near pink in some of his future work. Red is the main

color in almost all of Guston's paintings, and, as Motherwell has so acutely pointed out, it is a color with certain unavoidable associations:

> The "pure" red of which certain abstractionists speak does not exist no matter how one shifts its physical contexts. Any red is rooted in blood, glass, wine, hunter's caps, and a thousand other concrete phenomena. Otherwise we should have no feeling toward red or its relations, and it would be useless as an artistic element.[46]

Whatever its ultimate source in the real world, Guston used red in the fifties so that it often seems like blood—not blood trickling or spurting out of the body, but blood in tissue, blood seen in a wound. It is as though the painter has been digging into the skin of the painting, probing it, locating pockets of emptiness, places of closure, and with each invasive flick of the brush, leaving a trail of paint lines for the viewer to follow. Upon doing so, one enters upon a journey into the spaces of the mind, the glance slipping into depth, returning to the surface somewhere else, meandering here and there in an intricate three-dimensional maze which keeps shifting in and out of focus.

When Guston exhibited his new abstractions at the Peridot Gallery November 27–December 23,[47] and the next year when Andrew Carnduff Ritchie included *Red Painting* in his landmark exhibition, *Abstract Painting and Sculpture in America,* at The Museum of Modern Art, the critical response was decidedly negative. Not only had this once-acclaimed figurative artist removed every trace of human presence from his work, he had gone even farther than most of his fellow Abstract Expressionists in the elimination of solid forms of any kind. Reduced to excruciatingly hesitant linear movements and to clusters of thin strips of pigment, Guston's work was seen as "the end, the abyss, the point of no return."[48] The critics soon found a way to pigeonhole Guston's new works, a way which he found extremely irritating, and that was to see them as abstracted Impressionist landscapes. From then on, even though Guston's brush strokes generally drifted along the horizontal and vertical axes that were much closer to Mondrian's "plus and minus" Cubism than to Monet's treatment of waterlilies, the appellation "Abstract Impressionist" stuck to Guston like the scarlet letter to Hester Prynne.

There is an oft-told story about Guston's predicament that demon-

strates not only the sensitivity of the New York painters to one another's pressure points, but their sense of comradeship in mutual defense against those they identified as the "philistines." Guston, Franz Kline, and art historian Sam Hunter were together on a panel discussion in Chicago in 1957. The three had juried an exhibition, and were now seated at a table for a serious public conversation about art. Hunter recalled that "Kline was hilarious once he was recovered from a neighborhood tavern and positioned upright on stage."[49] After Kline's elliptical and entertaining speech, Guston read a carefully written, impassioned, and intellectual statement detailing his commitment to both Piero Della Francesca and the Renaissance and to the new existential processes of Abstract Expressionism. Kline, in the meantime, had put his head down on his arms for what appeared to be a much needed nap while Guston delivered his lecture. As soon as the floor was opened for questions, someone from the audience, ignoring all that Guston had said, as audiences will do, asked, "Isn't it true, Mr. Guston, that you're really influenced by Monet and that you're not really an Abstract Expressionist but rather a sort of latter day *Im*pressionist?" Instantly, before Guston could respond, Kline's head shot up, and he said to his friend, "Don't answer that, Phil!" and to the audience, imperiously, "Next question!" He put his head back down, and once more closed his eyes.

Guston later referred to these early-fifties canvases as his "pink cluster paintings." "I remember I could never get to the edge in time. I kept trying to get more mileage out of the feeling, but suddenly the *satori* [the moment of enlightenment] came, and that was that!" Guston's choice of terminology is significant; he was genuinely involved with Zen ideas at the time. He witnessed some of the demonstrations of Japanese brush painting at The Club, where the Oriental artists put on spellbinding displays of balletic pictorial improvisation as they brushed ink onto papers spread out on the floor. He attended Zen Buddhist authority D. T. Suzuki's lectures at Columbia University with the avant-garde composer John Cage. Cage was in the process of developing his revolutionary ideas about aleatoric musical performance—chance music-generating procedures—and "nothingness"—the Void—out of his new understanding of Zen. Guston had met Cage in 1948 and, upon moving to New York two years later, found himself swept up in Cage's strange world, one in which Eastern thought prevailed. To Cage and his follow-

ers, interval was more important than the flanking notes, densities were preferred to themes, and touch was more admired than technical ability. All of this has a clear parallel in the kind of "all at one go," unplanned and unconstructed paintings Guston was feeling his way into that year.

The look of Guston's early abstract drawings of 1948–50 is remarkably similar to the visual appearance of Cage's outré musical scores, and even to the layout of his famous "Lecture on Nothing," delivered at The Club in 1950.[50] At the musical evenings in Cage's austere Grand Street studio, when the whirr of machinery in the surrounding lofts was stilled for the night, Cage might perform his "prepared piano" pieces in which the presence of foreign objects scattered at random inside his piano created unexpected, "chance" effects in an otherwise straightforward score. His procedures and Guston's open-ended responsiveness to pictorial accidents in the process of painting his 1950–51 red and white paintings are very much the same. The painting "events" in Guston's sparse, mystical abstractions are as minimal as those in the composer's music.

Guston's propensity toward the concepts of Oriental mysticism dated back to his California youth. He had been born Philip Goldstein in Montreal's Jewish ghetto in 1913,[51] but six years later his parents, Rachel and Lieb Goldstein, moved him and their other six children to Los Angeles.[52] Guston's parents were Russian-Jewish refugees from the Odessa pogroms. Though they no longer lived in great poverty, the Goldstein family did not fare well in L.A. Philip's father found that the only way he could make a living was as a junkman. He sank deeper and deeper into depression until a time in the mid-twenties, when he killed himself.

Young Philip, then only about eleven years old, discovered his father's body hanging from a rafter in their shed and suffered the kind of emotional trauma that lasts a lifetime. Deeply shaken, he found solace in drawing, burrowing into an inner world where he felt safe. When his mother saw that Philip was interested in art, she gave him a correspondence course in cartooning for his thirteenth birthday. Shortly afterward, he entered Manual Arts High School, where he met Jackson Pollock, and with him became involved with Ouspensky's spiritualism and the teachings of Krishnamurti. Both boys paid close attention to the Indian mystic's exhortations to resist authority and protect their individualism. The two would stay up all night, usually at Pollock's house, chewing over what they heard at Krishnamurti's meetings, or in their

teacher Schwankovsky's class, thus setting, at least for Guston, a lifetime conjunction of ideas and art that precluded sleep. They put what they had learned into practice and produced caricatural broadsides criticizing the administration of their high school for putting too much emphasis on sports and not enough on the arts. The results were unfortunate: they were both promptly expelled.

Guston never went back to Manual Arts, and he remained the rebel nonconformist when he was given a scholarship to Otis Art Institute. Bored with plaster casts, anatomy, and Franz Hals when he was thinking about Michelangelo and Picasso, he piled up all the plaster casts in a huge mound one day and began to draw that.[53] He and his friends pored over the contemporary French art magazines and taught themselves the history of art by copying the Old Masters from reproductions. He was introduced into the circle of poet Walter Arensberg and his wife, Louise, who lived with their great collection of Cubist, Dadaist, and Surrealist works, their pre-Columbian treasures, and their Brancusi sculptures in a Hollywood Hills mansion designed by Frank Lloyd Wright. The proto-Surrealist canvases by Giorgio de Chirico that Philip Guston saw there at the impressionable age of seventeen or eighteen had a lifelong effect on him.

Tall and ruggedly handsome, Guston did stunts and bit parts in the movies, including one appropriate role as the artist in *Trilby* and another prophetic one as the high priest in H. Rider Haggard's *She*. Various other jobs in factories and as a truck driver gave him an awareness of the desperation of the worker and the violence faced by the oppressed on all sides. In 1932 he and his friends painted a group of murals on the walls of the Marxist John Reed Club on the theme of the American Negro as victim. Guston's mural depiction of a bound Black man being whipped by white-robed and hooded members of the Ku Klux Klan was literally shot full of holes, particularly in the areas of the eyes and the genitals, by the "Red Squad" and members of the American Legion, abetted, it was rumored, by the police. When the artists sued the perpetrators of this outrage, the judge—in Guston's first personal exposure to American legal injustice—tried to throw the blame on the artists, and he let the brutal art defacers go free. Forty years later Guston returned to overt depictions of the KKK, but throughout his career, whenever his imagery is recognizable, hooded figures, bound and tormented victims, whips and ropes can usually be found.

There may, however, be other explanations for the persistence of flagellants in his work. Two clues to these could always be found on the wall by the kitchen table where he spent much of his non-studio time: reproductions of Piero della Francesca's *Flagellation of Christ,* Guston's favorite painting, and of Albrecht Dürer's *Melencolia I.* This print was Guston's personal talisman. Art historian Erwin Panofsky saw it as Dürer's spiritual self-portrait; for Guston it may have served a similar purpose. According to Panofsky, Dürer's work was deliberately fashioned as an "Artist's Melancholy . . . winged, yet cowering on the ground—wreathed, yet beclouded by shadows—equipped with the tools of art and science, yet brooding in idleness, she gives the impression of a creative being reduced to despair by an awareness of insurmountable barriers which separate her from a higher realm of thought."[54] Melancholics are traditionally seen as geniuses, according to Panofsky, geniuses "marked by a peculiar excitability which either overstimulates or cripples their thought and emotions . . . they walk, as it were, a narrow ledge between two abysses." Historically, during the Middle Ages melancholy was feared as a disease, and the treatment prescribed for it was careful diet, calming music, and, if all else failed, a flogging. Many times, particularly in the late work, Guston's figures are self-flagellants and clearly self-referential. He often spoke metaphorically of the need to whip himself into a working state of mind.

Painting for a cause, rather than making "art for art's sake" alone, served to keep Guston inspired to work without personal, "gut" necessity throughout the thirties. His Los Angeles mural experience, followed by working on a huge mural in Mexico, made him one of the best qualified and most effective artists to work in the WPA Mural Division when he arrived in New York in 1936. He was fully occupied with "the project" and related activities on behalf of the Artists Union for the rest of the decade. He and his wife both executed public commissions, but Guston became widely acclaimed for his. In 1940, when he decided to explore more private themes, announcing he'd "rather be a poet than a pamphleteer," he and Musa moved to the seclusion of Woodstock, New York. *Martial Memory,* 1941, his first completely personal statement in oil paint, was praised for the spiritual symbolism of its portrayal of a war-torn world. He went on to explore the theme of urban youth playing at war for the next five years, his claustrophobically packed canvases becoming increasingly introspective and dreamlike. *If This Be Not I* is

the culmination of this trend in 1945 with its brooding, poetic mood, its jumbled facades, broken furniture, and lost children (one of whom, the little girl right of center, is the artist's own daughter, Musa Jane).

Guston spent the mid-forties winning prizes for paintings he felt less and less secure about and being the artist-in-residence in universities far from New York. It was a very unsettled time during which he managed only to bring off a few completely successful near-abstractions such as *The Tormentors,* 1947–48. (Whips, a KKK hood, the sole of a shoe, and musical instruments are still indicated in these paintings, even if only by dotted lines.) He was separated from his wife and child in 1948–49 after winning the Prix de Rome.[55] During his year of residency at the American Academy in Rome he was at an impasse as far as oil painting was concerned. Instead, he studied the Old Masters and sketched the Italian hill towns. The agitated yet probing and suggestive style of these drawings led directly into his breakthrough abstractions. Guston's drawings of Forio, Ischia, in 1949—and the "pink cluster" abstractions of the next few years, which feel as though they were based on them—are evoked in the following lines of W. H. Auden's poem about the town, the poet's beloved summer home since the previous year:

> . . . What design could have washed
> with such delicate yellows
> and pinks and greens your fishing ports [56]

The highly abstract drawings Guston made of his loft in 1950 became increasingly aggressive, and those of the next few years even more so. The clean, smooth paper seems to have been lacerated by the sharp point of the pen, its white surface like a kind of skin that has been scratched and gouged open, the ink like blood. If one were to give parts of the human anatomy to various Abstract Expressionists, Kline would get the muscles and bones, Pollock the nerves, de Kooning the skin and all the other aspects of female sexuality, Motherwell the male aspects, and Guston the subcutaneous tissues. His is the diffuse, interconnective world between the outer and the inner surfaces of the body.

Ever anxious, Guston followed a lifelong pattern of teetering between periods of almost manic creativity and of paralyzing idleness. If anything, this pattern was exacerbated during his mid-century transition into abstraction. Mercedes Matter recalled that "there was a definite, regular

cycle of his state of mind, repeating itself over and over again" at this time:

> We'd see Philip for a few weeks and then he'd come in one night in an absolute gloom. He'd say, "I just scraped off months of work on the floor. I'm not a painter. It's no use." And he'd have everybody down. Everybody. He had this ability to project his mood onto the whole situation. Utter despair! . . . And it never failed that the following week he would float in, not touching the ground, and say, "I've just finished the first painting I've ever done!" And he'd take everybody, like the Pied Piper, and we'd go off for the whole night and have a terrific time, never stopping, close the bar and then go on for something to eat at Rappaport's. The whole night was just a great celebration.[5]

The raw, exposed quality of Guston's typical oil paintings from 1950 on makes them too urgent and painful to be compared to an idyllic

Autumn #18 *by Philip Guston.*

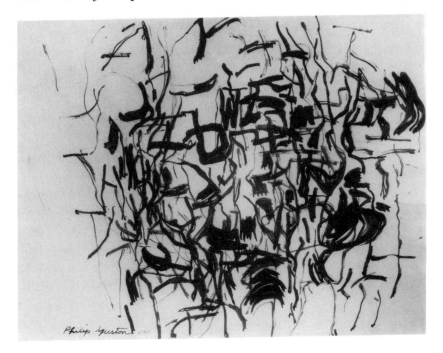

Impressionist journey through petals and primroses. In fact, these paintings come as close to the mythical image of the artist "bleeding on the canvas" as anything labeled Abstract Expressionist ever has. They transcribe feelings instead of illustrating them. His passion is no less diminished because he had to express himself in small moves of the brush or pen instead of large, violent gestures in the manner of Kline or de Kooning. One can readily sense the pain in such paintings, an anxiety expressed in quivering brushwork, indecisive scumbling, and in forms huddled together as if for protection, near the center of the canvas. He was, as he said, always trying to get to the edge, but his time of being totally one with the painting—in its thrall, instead of in control—always seemed too short. He anguished over that. One day when he went out to the Automat for breakfast at noon with de Kooning, who had a studio nearby, de Kooning said, "Well, Phil, they're imitating you now instead of me, putting all the paint in the middle. They always imitate the part you hate most about your own work."

Guston later claimed that none of his paintings was ever fully abstract, and shortly after this burst of "pure" painterliness, clumps of darker strokes began to form compact shapes in his pictures. No true figural silhouettes are discernible, but the way these forms are interwoven with the surrounding atmosphere in the paintings of the later 1950s suggests figures moving in space. By the time of his huge retrospective at the Guggenheim Museum in 1962, many of his paintings with suggestive titles like *Poet, Actor, Traveller,* and *Painter* seem to contain locatable figures. Heads, torsos, standing couples, became increasingly obvious until 1970, when he burst forth publicly with literal, albeit bizarre, imagery in his breakthrough Marlborough Gallery show.

At that time Guston said he'd just "gotten sick and tired of all that purity and wanted to tell stories," but he had actually gone through a second major crisis in his life, similar in many respects to the one he'd gone through twenty years before. He turned fifty in 1963, right after his retrospective, and this conjunction of biographical and art-historical turning points had the same kind of powerful effect on him that it would have on his friend Motherwell two years later. He felt he had no place to go in his work, and he was disgusted with the art world. His personal

Six caricatures by Philip Guston: Franz Kline, Barnett Newman, Willem de Kooning, Elaine de Kooning, Mark Rothko, Robert Motherwell.

life was in turmoil as well.[58] He had had affairs before, usually with women he'd see when he was in town overnight to teach, leaving Musa at home with their daughter in Woodstock. This time, however, he fell in love with the woman, a German portrait photographer on the New York art scene, and left his wife. An emotionally disastrous period ensued, during which his drinking reached the point of requiring hospitalization. Finally the affair ended, and he and Musa slowly returned to their marriage. He resumed work, again through the medium of drawing, but this time he moved in the opposite direction from that of the years just prior to 1950—away from abstraction.

People who had mistaken Guston for a gentle, lyrical painter were shocked in 1970 to see paintings filled with crude, cartoonish images of bottles, books, and boots, numberless clocks, dangling bare light bulbs, black-eyed Klansmen wielding whips or joyriding in convertibles. Guston's great facility at caricature came into play here as well. The Marlborough show was taken by many as a personal affront, a shoe lobbed in the face of good taste. Shocked but undaunted by the negative critical response (Hilton Kramer, then of *The New York Times,* called him a "mandarin pretending to be a stumblebum"[59]), Guston painted in a fury for the rest of the decade, unable to keep up with "all the images and situations . . . flooding in on me." "I'm in a place where I literally can't do anything else," he said in 1974. "How marvelous to be a victim."[60]

The Klansmen turned into portraits of the artist flagellating himself for his bad habits (the title of one of the 1970 canvases). Booze bottles, cigarette stubs, curtained windows at 6:00 A.M. tell the tale of his increasingly obsessive night-studio existence. Later the artist's bloated, bloodshot-eyed and stubble-chinned head seems unable even to raise itself off the pillow or the ground. In these later paintings he depicts himself as a man torn by doubts, who finds refuge in bed, books, and the goads that force him into action, and who, to put it simply, is at the mercy of his own art. "He has," Thomas Hess once wrote, "a romantic's fascination with death and violence—floggings, whips, corpses, blood—and like de Sade, identifies with both the victim and the tormentor."[61] A Charles Dickens quotation is ever present on his studio wall: "I hold my inventive capacity on the stern condition that it must master my whole life. . . ."

In his final years he identified more and more with Samuel Beckett

and his characters. His paintings almost seem to illustrate Beckett's plays, particularly *Endgame*. He often told with great relish a story he loved about Beckett:

> After landing a teaching job at a great English university with help from such friends as James Joyce, Beckett would sleep all day with a sheet over his head or arrive late for class dressed in clothes that could stand without him, a bottle of stout in his pocket. He would then proceed to take all the students pub-crawling with him instead of delivering a lecture. When the school's angry administrator demanded to know what it was that he really wanted out of life, Beckett answered, "To sit on my ass, fart, and think about Dante." [62]

Beckett's bleak, wall-like horizon is a continuous metaphorical presence in Guston's last work, much of which is unearthily illuminated in a manner close to Dante's infernal gloom. During these years Guston said he "felt more like Oblomov than ever." There's humor here, but it's black; the paint is sumptuously applied with masterful audacity in large, self-assured strokes, but its very gorgeousness seems to make a mocking challenge to the whole enterprise of painting itself. Philip Guston died on the brink of acceptance for his new work, which came in the wake of his 1980 retrospective. Having adamantly refused to change his bad habits after suffering a massive heart attack in 1979, he succumbed to a second attack shortly after the show opened—victim of a lifetime of anxiety and of the patent remedies for it—drink, cigarettes, and a driven obsession with work.

By 1980 a health-conscious, seltzer-drinking, exercise-biking world took a dim view of such self-destructive behavior, but back in 1950 it was still central to the romantic image of the artist. The expressionist was seen as a painterly parallel of a drug-taking or absinthe-drinking *poète maudit* like Verlaine or Rimbaud, an artist under a curse. Drink, dissipation, excess, self-doubt to the point of melancholic torment, attacks of anxiety, even violence—these were accepted as the constant companions of the tragic artist.

At the very moment when the New York artists were realizing how much they had in common with and how much they shared with this stereotypical image of the renegade expressionist, they were also being recognized in museums, galleries, and the press as this particular breed of artist. "Expressionism, Abstraction, Surrealism, Predominate at the

Whitney," was the headline of Belle Krasne's November 15, 1950, *Art Digest* review of the just-opened Whitney annual. She asserted that the curators had taken "extra measures to show the work of the insurgent group (including Rothko, Stamos, Pollock, Motherwell, Gottlieb and Baziotes) which refused to play ball with the Metropolitan Museum."[63] In fact, twice as many of the artists in the Whitney show were working abstractly as figuratively, a large percentage of them in the new expressionist manner. It was also apparent in the Whitney Annual that a number of the younger artists just coming onto the scene, such as Syd Solomon, Larry Rivers, Joseph Stefanelli, and Sideo Fromboluti, were already beginning to use the Abstract Expressionist approach to handling paint in the service of representation.

Clearly, expressionism was in the air everyone was breathing by the end of 1950. What is interesting is that the art coming out of the artists' studios five years after World War II was so completely different from what had been created five years after World War I. Except for anti-art manifestations like Dada, The First World War either sent the artists reeling back to the safety of conservative, premodern styles—Picasso's neo-Classicism, Matisse's pleasing Nice paintings, Braque's decorative still lifes—or it sent them off in the other direction, into a utopian future of total design where Mondrian's right angle ruled the world. But both Constructivism and neo-Classicism concerned stability and order; they marked a return to prewar verities. The feeling was one of getting back to normal. It was very different after World War II, after the bomb— everyone knew that things had changed forever. There was no going back. The zeitgeist of 1950, which was characterized by personal anguish, psychological ambivalence, and existentialist concerns, was reflected both in the contemporary artists' work and in the choice of artists from earlier periods for shows in the more prestigious galleries and the museums. It is no coincidence that three important exhibitions in New York this year reconfirmed the image of the introverted, psychically hyperactive expressionist artist: the Wildenstein Gallery mounted a benefit exhibition of Francisco Goya's paintings; another benefit was held to establish a museum for the work of Henri de Toulouse-Lautrec in his home town of Albi in southern France; and Chaim Soutine was given a retrospective at The Museum of Modern Art. All three were artists with whom the Abstract Expressionists identified themselves, but the latter show was of special importance, as Soutine was not one of MOMA's

canonized saints of Modernism, like Matisse or Picasso. Now Soutine was linked by MOMA curator Monroe Wheeler with such past figures of "melodramatic greatness" as Van Gogh and Gauguin.

The respect accorded these particular older masters by the art establishment encouraged the New York School at a critical point in its evolution. Even though only Gorky's death had thus far linked the Abstract Expressionists with these tragic heroes of the past, it is clear that the curators and critics were beginning to sense that here was another such generation. Goya (1746–1828) was described by art critic Howard DeVree of *The New York Times* as a hot-tempered revolutionary who lived out his last years in ferocious silence, painting his so-called "Black" paintings directly on the walls of his house like a man possessed. These terrifying images of humankind's elemental brutality were a prime factor in Motherwell's developing *Elegies to the Spanish Republic* and influenced his darker visions ever after. They were also cited by Guston as a continuous source of inspiration. One can certainly see this in his more macabre late paintings, where bugs crawl over a mountainlike torso and blood-red seas stream through the artist's studio washing everything along with them.

Toulouse-Lautrec (1864–1901) was Franz Kline's favorite artist. Kline imitated Lautrec's drawing style in his early years, and even used his logo, "T-L" within a circle, to model his own "F-K." The American kept a photoreproduction of the French artist at work in his atelier tacked on his own studio wall all his life. Reviewers of the November Lautrec exhibition, which was the first large-scale show of his work ever held in America, stressed the tragedy of his life—so successful, but so short—due to the excesses of drink and debauchery in which he had indulged. Kline was about to do the same with his own life—though, it must be said, nothing could have prevented his early death. He might only have perhaps prolonged his life a bit through moderation.

Chaim Soutine (1894–1943), too, was regarded as being a tragic, modern expressionist whose life story could have been compounded out of novels by Gorky and Dostoyevsky. Soutine's youthful poverty, his lifelong self-punishing ulcer condition, and his morbid destruction of his own work were cited by the *Times* reviewer, as was his ability to "infuse nature with the churning violence of his own emotions."[64] "Instead of relieving his mind," curator Wheeler wrote in the accompanying catalogue, "the intense seriousness of his artistic effort only dug

deeper the melancholy channels of his thought." Concerning Soutine's great, wildly writhing landscapes of the twenties, Wheeler even asks the question, "Was Soutine at this time what might be called an abstract expressionist?"[65]

De Kooning was the New York painter closest to Soutine in style if not in spirit, not being either Jewish or of Soutine's melancholy temperament, but de Kooning's close friend Jack Tworkov clearly identified with his fellow Eastern European. Tworkov stressed the similarity of Soutine to his generation of artists in his October 1950 *Art News* profile, "The Wandering Soutine." Saying he represented "the inward drama of the soul," Tworkov separated his subject from the more traditional influences which had dominated American art in the past, linking him instead with the "most original section of the new painting in this country," because Soutine's surfaces appeared as if they had "happened" rather than having been "made." Tworkov stated:

> Viewed from the standpoint of certain painters, like de Kooning and perhaps Pollock . . . certain qualities of composition, certain attitudes towards paint which have gained prestige here as the most advanced painting, are expressed in Soutine's unpremeditated form. These can be summarized as: the way his picture moves towards the edge of the canvas in centrifugal waves filling it to the brim; his completely impulsive use of pigment as material, generally thick, slow-flowing, viscous, with a sensual attitude toward it, as if it were the primordial material, with deep and vibratory color; the absence of any effacing of the tracks bearing the imprint of the energy passing over the surface.[66]

Even though he concentrated on formal parallels, it is surely significant that this, the only article Tworkov ever wrote about another artist, was about someone as distressed and tormented as the artists in his immediate circle.

J ackson Pollock fused an abstract style of expressionism forever in the public mind with the idea of the Great American Painter. For Americans he was Soutine, Lautrec, and Goya put together, but above all he was our Van Gogh—pure in spirit, psychologically out of control, but a painter whose psychic energy poured through him and onto the canvas for all to feel. His Parsons Gallery exhibition of huge expressionist abstractions came at the end of 1950 and confirmed his position as the dominant painter of the New York group. To many, he was the painter-equivalent of Ernest Hemingway, the Great American Writer. Pollock was our first media-made American artist, and we had been waiting for him a long time. On August 8, 1949, *Life* magazine had given us a picture profile of a tall, cocky young man named Jackson Pollock dressed in worker's paint-spattered jeans, a cigarette dangling from his mouth, and his arms defiantly crossed as he leaned nonchalantly back against an eighteen-foot abstraction. We were asked, headline style, "Is he the greatest living painter in the United States?" Now, with his impressive 1950 show in front of them, many answered yes.

Unlike de Kooning, Rothko, and many of the other foreign-born or second-generation immigrant Abstract Expressionist artists, Pollock was pure American. Born in Cody, Wyoming, on January 28, 1912, he grew up on a series of farms "in the land of cowboys and Indians." The picture profile in *Life* even showed him pouring sand onto his canvas like a Native American medicine man. He was tough and masculine—no sissy artist he. He didn't even care when his cigarette ashes fell into

his paintings. Impatient with traditional methods, he invented his own ways of putting paint on canvas, and he used ordinary household enamels instead of fancy tube colors. We liked both qualities, and we liked the fact that he didn't have a lot to say, and when he did say something he didn't beat around the bush or use highfalutin art jargon. His rugged, careworn good looks were also appealing. They surely meant that his thirty-seven years of life had not been easy. We didn't know that he had a serious drinking problem, but we probably wouldn't have blamed him if we had. Surviving the Great Depression and the Great War had taken its toll on everyone. The fact that he seemed troubled was fine—the world was, after all, a troubling place.

Although relationships with one's parents are always complex and often emotionally volatile, a striking pattern emerged from the biographies of Pollock and the other Abstract Expressionist artists that could provide interesting raw material for psychohistorians. Many of these artists' lives include a powerful mother and a weak or nonexistent father, a traumatic youth during which refuge is found in art, and an obsessive, work-driven adulthood characterized by potentially destructive habits such as excessive drinking, smoking, and womanizing. Guston and Kline both lost their fathers to suicide when they were adolescents; Rothko's father died when he was only ten, though the cause was apparently illness. Gorky, de Kooning, and Pollock lived with their mothers and away from their fathers, each of whom failed the family in some way. David Smith's mother terrorized him from the heights of her God-fearing, churchgoing moralism; Motherwell's mother beat him and his father always remained distant; Tomlin substituted fear of his sister for that of his mother and never managed to establish a lasting relationship with a woman. Pollock, Guston, Gorky, and Gottlieb each painted pictures of maternity in which the mother figure is enormous in comparison to the child she overwhelms, Pollock's perhaps the most shocking.

With the exception of de Kooning, whose most fearsome images of women emerged in his middle age, these artists tended to release their intense feelings toward their mothers in early work. Throughout the first decade of his art life Arshile Gorky worked intermittently on two similar portraits of himself, bouquet in hand, standing shyly beside his cool, implacable, seated mother. As we have seen, she had starved to death during the Armenian diaspora in order to keep her children alive,

and her son painted her as though she were the Virgin Mary or a Byzantine saint—aloof, unreachable, an icon for his, and our, worship. Gorky killed himself at the age of forty-four when his own "perfect" wife revealed her only too human failings, with needs and desires he felt inadequate to fulfill. Adolph Gottlieb once portrayed his mother as a giantess in modern dress, and, in an eminently practical response to his fear, as a child, of his mother, he married a small woman whom he could dominate for the rest of his life. In the thirties, Rothko painted a number of religious pictures in which the Virgin Mary predominates over her son, and most of his early depictions of women have a Stone Age-style bulkiness. Willem de Kooning's *Women* are composites of the women in his life, dominant among them his overbearing mother. His wife, Elaine, often said that all three mothers—Pollock's, Kline's, and her husband's—"looked as though they could walk through a wall." "These were domineering mothers," she told Jeffrey Potter, going on to say that the results of this domination were their sons' rebelliousness, their resistance, and their ambivalent attitude toward women. "Also, these were nondrinking mothers," she said, "straight-laced, hard, with ramrod backs."[1] She observed, too, that the sons rarely if ever mentioned their fathers and always went on extensive benders before and after their mothers came for visits.

Philip Guston—whose small dynamo of a mother bore seven children and raised them all but single-handedly—painted, when he was seventeen, a Mannerist, Michelangelesque mother whose baby is so intent on returning to her womb it seems to be climbing into her groin between her massive thighs. Pollock's mother image, painted in the early thirties, when he was in his early twenties, is a giant Earth Mother/whore, naked except for her earrings and high-heeled shoes. Her skull-like face denies her full-breasted fecundity, but it is one with the pale, half-size faces of the five male offspring ringed behind her huge shoulders. They are the ghostly issue of her bloodied loins, spread wide for all to see. The smallest of them (Pollock was the youngest of his mother's five sons) reaches out longingly but timorously toward one of her heavy, hanging breasts. A high charge of sexuality runs through this terrifying image.

Being the baby, the "Mama's boy" of the family, seems to have had most of the classic Oedipal effects on Jackson Pollock short of homosexuality.[2] Pampered and protected, his blond curls retained too long and

his entry into the masculine world of his elder brothers and father occurring too late, he grew up to be a cowboy who couldn't ride a horse, an inveterate drinker who couldn't begin to hold his liquor, and a macho blusterer, his hands reaching for every available bit of female flesh, but a man who was, by all accounts a less than accomplished lover. When as a little boy he "played house" with the girl next door, he always insisted on taking the mother's role, that being the one he knew best. The Pollocks lived on a farm in Phoenix, Arizona, where Roy Pollock spent much of his time tilling the land and bringing produce to market. After they left Phoenix in 1917, his father usually lived and worked away from home on some sort of construction-related job. Roy sent money home to support Stella and the family during these years, when they lived in one or another of the eight different Southwestern small-town or suburban situations to which she moved them to provide her boys with a better life. What his father actually did all day wasn't clear to Jackson until later when he joined him on the job during the summer. Then he found out that a western workingman's life involved hours of hard but more or less mindless work, punctuated by drinking and carousing with "the boys." His father and his friends would get the adolescent Pollock drunk and then sit back to be entertained by his antics. The lesson Pollock learned from his paternal role model—which lasted him a lifetime—was that all he had to do to be a man was to get drunk and to say the word "fuck"—both as often as possible.

The gender confusion that resulted from a dominant, powerful mother, no sisters, and a frequently absent father, and acted out in his "tea parties" with the girl next door, subtly reappeared in his work. (For that matter, one painting of 1946 is even titled *The Tea Cup*.) The configuration of upright, sexually ambiguous[3] figures flanking a horizontal, tablelike central area is basic to Pollock's semi-figurative paintings of the early forties—*Male and Female, Male and Female in Search of a Symbol, Stenographic Figure, Conflict, The Guardians of the Secret,* and *Pasiphae.* This configuration or this basic structure continues to be echoed in the compositional formats of such transitional semi-abstract works as *Night Mist,* c. 1944, *The Key,* 1946, and *The Blue Unconscious,* 1946, though it is sometimes "veiled" by an abstract linear matrix. Even though all traces of the figure disappear in his great "drip" abstractions of 1947–50, vertical areas of greater density are often massed on both sides of a central, slightly depressed horizontal section. Though this may

simply be a vestigial carryover from the earlier work resulting from years of attacking the canvas in a habitual manner, surely some of the tension and the energy in his "classic" poured paintings stems from this buried emotional wellspring. As he often said, "I paint the unconscious."

The tortured emotionalism of the old work gave way to an ecstatic, even orgasmic, sense of release and liberation in the new. His early rigidity was broken and his lines leaped with total abandon; no longer bound to the figure, he was free to operate in space. It's as though he'd burst from confinement to the out-of-doors. Viewers automatically associate the tangled webs of these paintings with landscape imagery— prairie grasses and tumbleweed-strewn western vistas—to which they do have a superficial resemblance, but Pollock is no more painting landscapes than he is painting figures or still lifes. Lee Krasner claimed that he never abandoned the figurative base of his work, that he always began with "more or less recognizable imagery" and then "veiled" it in a welter of overlaid lines, but if figures are present they are impossible to see. In any case, he didn't need them anymore. Whatever they meant to him, whatever psychic energies fueled his art, were in his cells, in his fingers, arm, and body.

With the high-power vision of hindsight we are able to discern the underlying emotional content of the huge abstractions that made him so famous. But when the critics confronted them in his November 28– December 16 exhibition at the Betty Parsons Gallery in 1950, they responded to the emotional force of the paintings but couldn't connect that fire with any spark. Five enormous paintings—*Lavender Mist, One: Number 1, 1950, Number 32, 1950, Autumn Rhythm,* and *Number 29,* the painting done on glass for Namuth's movie—and over two dozen small works were packed into the gallery, some of the paintings nearly covering entire walls. One reviewer commented on the "billboard proportions" of the works, saying that the effect was "dizzying," but decorative. Another reviewer also stressed the "luminous surface decorativeness" of the work despite its "rousing, reckless bravado," and wrote in *The Compass* that:

> This form of abstract art carries with it deadly limitations. By restricting itself so severely to an intense emotion through design and pattern, it creates designs for the eye to explore, but frustrates the mind. It seems to lead to a blind alley.[4]

Since the gallery walls were covered nearly floor to ceiling with painted lines, it is nevertheless surprising that none of the critics jumped at the chance to compare the work with wallpaper. *Times* critic Howard Devree did, however, say something about how the viewer sees things in Pollock's work that aren't there, like "daydreaming while staring at a wallpaper pattern and investing it with ideas."[5] A more sympathetic response to the content of the work was made by the young artist Robert Goodnough,[6] who wrote in *Art News* that Pollock's rhythms danced in "disturbing degrees of intensity, ecstatically energizing the powerful image in an almost hypnotic way." He added: "Pollock has found a discipline that releases tremendous emotive energy combined with a sensitive statement."[7]

No one at the opening could have seen the paintings very well, the small gallery being so densely packed with people. Unlike the usual art openings at the time where the artist could expect to see only family members, a few close friends, students, Club members, and perhaps that very rare bird, a collector, Pollock's opening was filled with strangers. The main reason for this was the *Life* article, but the combination of his inclusion in the Venice Biennale, a short *New Yorker* profile in August, and the unfortunate piece in *Time* (which stressed the chaotic nature of his work) just prior to the show, served to swell the ranks of the visitors. Only one family member showed up to battle the throngs to Pollock's side among the many who sought to meet "the *Life* painter" at the height of his fame. That person was his older brother, Jay, who lived in Manhattan with his wife, Alma. He reported the event to the Pollock family this way in a letter to his brother Frank on December 3, 1950:

> The big thing right now is Jack's show. Alma and I were there and it was bigger than ever this year and many important people in the art world present. Lee seemed very happy and greeted everyone with a big smile. Jack seemed at home with himself and filled the part of a famous artist. Must be great to be talked about in the newspapers and magazines and recognized by them as one of the leaders in the non-objective art field.[8]

The family had not been particularly impressed by his work from the outset, preferring his elder brother Charles's more conservative style,

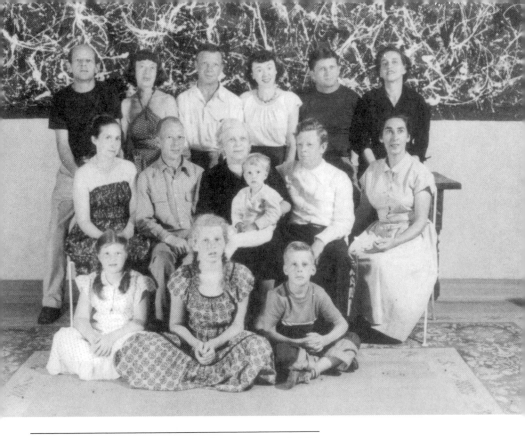

The Pollock family reunion in the summer of 1950.

but they had admired his fame. Even that had begun to wear, however. The previous July, Lee and Jackson had hosted a big family reunion, the first in seventeen years, at their Springs house, and when Jackson wasn't baking pies or opening clams, he was calling up whomever he could think of who might know Italian to get a translation of an article on his work he'd just received by Bruno Alfieri in *L'Arte Moderna*. The family apparently resented the time Jackson spent away from them in his fruitless quest for a translation. In his turn, Pollock may have resented the continual presence of his brother Sande's son, Jay (later Jason) McCoy on Grandmother Stella's lap during her visit. The boy's pretty face and blond curls exactly mirrored his own at the same age, a time when he had that lap and her attention all to himself.

Though Pollock's father had provided an example of sorts for some aspects of his personality, it was Jackson's talented older brother Charles who had introduced him to art, largely via magazine reproductions, and had provided him with a role model of the committed artist. A little later, Pollock's first art teacher at Manual Arts high school, Professor Schwankovsky (beloved Schwanny), introduced his students to modern

art and encouraged their originality and ideas. "I tried to speak to the permanent ego of my students," he said later. "I taught [them] how to expand their consciousnesses."[9] As we have seen, this included his bringing them to Krishnamurti's camp meetings at Ojai, outside Los Angeles, where Pollock got his first real taste of religion, albeit of a highly unorthodox sort. Since his mature work so exactly exemplifies Krishnamurti's idea that true freedom exists only in the present tense— that freedom is thought operating in action—it seems likely that Pollock found wisdom for a lifetime in those meetings. (Lee Krasner, Fritz Bultman, Tony Smith, and the others with whom Pollock felt free to speak in later years have confirmed his continued allegiance to these and other Eastern ideas.)

When he left high school and went to New York in 1930 at the age of eighteen to study with Thomas Hart Benton (as his brother Charles already had done), Pollock was introduced to the fundamentals of composition and technique. (Schwanny had been wildly experimental in his approach to getting pigment on canvas, but this influence wasn't felt until later.) The essence of Benton's own turbulently energized pictures of the American scene poured into Pollock. It was reinforced by the interlocked rhythmic units of Benton's hero, Albert Pinkham Ryder. Pollock later said that Ryder was the only American master who interested him. Before he came to Benton, Pollock had deplored his own "rotten drawing [that seemed to him to] lack freedom and rhythm [and to be] cold and lifeless."[10] Intensive drawing from reproductions of works by Michelangelo and El Greco in particular, which was encouraged by Benton, freed Pollock to get into his own extremely powerful rhythms. He never mastered academic drawing, but then neither did Motherwell, Rothko, Gottlieb, or Newman. Discussing Pollock's supposed inadequacy with the pencil, one critic quoted Giacometti recalling that Matisse once shouted at him: "You can't draw, I can't draw, nobody can draw!"[11] But because Pollock as a student had grasped Benton's plastic ideas so well, and because he had such winning ways despite his lack of control over alcohol, he was not only teacher's pet, but practically a member of the Benton family. (A fierce drinker himself, Benton could hardly condemn Pollock's inebriation.)

This relatively safe world fell apart for Pollock after Benton left for Kansas in 1935, and he spiraled down through round after round of drinking binges interspersed with attempts to pull himself together and

work, until he finally broke down completely in 1938 and had to be hospitalized at the age of twenty-six. During a second hospitalization the following year, a psychiatrist urged him to make three-dimensional art, sculptures, and decorated ceramics, as part of the therapy. This approach was reinforced after his premature discharge (and immediate return to the old behavior) when he was referred to a Jungian analyst named Dr. Joseph Henderson, who found his drawings to be the only successful way for them to communicate.

Between 1939 and 1941, while he was seeing Dr. Henderson, Pollock was working his way through the strong influence of the Mexican muralists (especially José Clemente Orozco) as well as trying to come to terms with Picasso, whose mural-size painting *Guernica* was on view in New York. The drawings Pollock brought to the analyst reflect his artistic struggles despite their ostensible source in his dreams and in the free flow of his thoughts. Violence runs rampant through the imagery— masks, daggers, spears, bared teeth, and horns; animals (usually horses and bulls) tearing into, and turning into, one another; snakes, birds, and human figures inextricably intertwined. As in the Northwest Coast Amerindian art he admired in Manhattan's Museum of Natural History and Museum of the American Indian, one body part might easily replace another, and images are often nested one within another. The visual incidents in many of these drawings prefigure those in the breakthrough paintings of 1942–43.

Just as Pollock's 1930–33 *Woman* invites a Jungian reading as an all-giving yet all-devouring Earth Mother—equally the male's source of sustenance and of his destruction, the object of his desire and of his fear —so did the drawings and the imagistic paintings of the early forties seem more concerned with archetypes than with Freudian symbols. Though he knew about Freud's ideas, Pollock's therapy, both with Dr. Henderson and later with Dr. Violet Staub de Lazlo, was Jungian in focus. He learned to read his artworks as symbols of archetypal, mythic, primal situations, and the "reading" lessons he learned when these analysts discussed his works with him were put to good use later when he looked at his friends' work. James Brooks and others have spoken of how clearly he saw the psychological import of the forms in their work. He may even have manipulated his doctors, giving them the images he knew they would interpret as indicating improvement on his part. Dr. Henderson was convinced his patient's personality was becoming more

integrated, but in fact Pollock's problems were not only unresolved, they seemed to be getting worse. Before Lee Krasner came into his life in 1941, his brother Sande McCoy[12] and Sande's long-suffering wife, Arloie, had done their best to care for him, carrying him home when he'd passed out somewhere, trying to get some food into him and to get him back to work. A personality like Pollock's that craves endless nurturance often uses alcohol to create situations in which someone is compelled to take care of him.

Years later Dr. Henderson said that he "wondered why [he] didn't seem to try to cure [Pollock's] alcoholism." The only explanation he had was that he felt "compelled to follow the movement of his symbolism as inevitably as [Pollock] was motivated to produce it."[13] Henderson saved the most valuable thing, Pollock's art, even though he couldn't cure the man.[14] Pollock was, if anything, drinking more than ever in the years between 1938 and 1941, but he was also working more, and better. He was beginning to be able to express his innermost emotions directly in paint, and he would continue to do so until nearly the end of his life. Appropriately enough, one of his first post-Benton paintings, a work that came more out of himself than his sources, was titled *Birth*. While one can sense echoes of Picasso's jewellike cloisonné Cubism of *The Girl Before the Mirror* in the painting, and even though the stacked circular glyphs recall totem poles, and the "faces" on those glyphs are very close to the asymmetrical, grimacing masks of the Northwest Coast and Alaskan Indians, nevertheless the wrenching brutality of the image as a whole, its impacted violence, has no direct counterpart in art history. *Birth*'s raw, unbearable urgency, which seems to scream "I need, I need," comes straight out of Pollock's gut. Perhaps it expresses his desperate first cry for life as he emerged into the world, choked by his own umbilical cord—surely a powerful and long-submerged primal emotion.

Pollock painted *Birth* shortly before 1941, the year his friend and mentor John Graham included it in an exhibition he organized at the McMillen Gallery, "French and American Painting." De Kooning and, as we have seen, Lee Krasner were also in that exhibition, proudly hanging beside Matisse, Picasso, and Braque. Graham was the first to discover Pollock as he had been the first to discover and to spread the word about so many interesting facets of the prewar art world. Fifty years old in 1939, when Pollock was twenty-seven, Graham served as another

substitute father for the younger artist. With his shaved head, dramatically angled eyebrows and mustache, his powerful musculature and his exotic apparel, Graham was literally one of the most colorful characters on the New York art scene. He had been born Ivan Dabrowsky in Russia and trained as a cavalry officer with the Czar's guards. He could still do somersaults on the back of a galloping horse for his son Nicholas and headstands—without hands—for his guests while in his fifties. A nudist, a mystic, a fetishist (for women's feet, blood, and crossed eyes), Graham was also one of the most erudite men in New York in the thirties and forties. For Pollock he was both a kind of guru and a good listener. He spoke to Pollock about Picasso and primitive art, about Uccello, the crucial role of the unconscious in creating art, and automatic writing; Pollock spoke to him about Eastern mysticism, Jungian symbols, Amerindian art, and the Mexican painters. They talked long into many nights.

In the 1930s John Graham had played a pivotal part in the varied developments of de Kooning, Gorky, and David Smith; now he was doing the same in Pollock's life. The young American would surely have thrilled to hear Graham denigrate technical perfection and representational accuracy in art while stressing the importance of spontaneity, accident, and feeling. In his pathfinding 1937 book, *System and Dialectics of Art,* Graham defined art in a way that presaged Abstract Expressionism: [15]

> A work of art is neither the faithful nor the distorted representation, it is the immediate, unadorned record of an authentic, intellecto-emotional REACTION of the artist set in space. Artist's reaction to a breast differs from his reaction to an iron rail or to hair or to a brick wall. This authentic reaction recorded within the measurable space immediately and automatically in terms of brush pressure, saturation, velocity, caress or repulsion, anger or desire which changes and varies in unison with the flow of feeling at the moment, constitutes a work of art. [16]

Graham urged artists to be wildly experimental, saying that by exercising care "you stampede yourself in a tea cup." He believed that the paint should flow spontaneously in direct response to the artist's emotional state and that the moment pigment or pencil touches the surface is of critical importance. "The authentic, unadulterated fateful contact," he

said, "bears all the evidence of artist soul's equipment for yearning, love and understanding."[17] None of the other artists in Graham's circle so completely put these ideas into practice as Pollock. The authenticity of his work, as well as the sense of vulnerability and personal exposure which marks it throughout the rest of his life, both stem in part from this source.

With Graham's seal of approval, Pollock had the respect of others in the New York avant-garde as well. Armed with this, Lee Krasner, who had fallen in love with Pollock, deliberately set out to establish a support group around him that could help her advance his career. Clement Greenberg, an old friend of Lee's from the Hans Hofmann School days, was enlisted, as were May and Harold Rosenberg. Krasner brought Pollock to meet the artists she knew such as Gorky and de Kooning, Bultman, and Hofmann, and she encouraged him to enter into joint endeavors with Gerome Kamrowski, Baziotes, Matta, and Motherwell.

Pollock's personality problems didn't make her campaign to integrate him into the New York avant-garde an easy one. Motherwell was shocked by the violence of Pollock's approach to the medium in 1943 when they worked together on collages for an upcoming exhibition at Peggy Guggenheim's gallery. The way Pollock tore the paper, mauled it, and even set it afire astonished Motherwell. Matta and his wife, Ann, often invited Jackson and Lee to evenings of dinner and word games in their Kiesler-designed apartment in Greenwich Village along with the Motherwells, Ethel and William Baziotes, Gerome Kamrowski, and Peter Busa. Pollock would sit silently in the corner, refusing to add revealing verbal images to the "Exquisite Corpse" everyone was constructing out of the words that popped into their heads. He would, however, spring to life when it came to making and analyzing automatic, or doodled, figural imagery. Things did not go smoothly, either, when Lee brought Hofmann to Pollock's studio. Unable to tolerate Hofmann's incessant art talk, Pollock said, "Your theories don't interest me. Put up or shut up! Let's see your work." Of course, as Pollock probably knew, showing his work to others was the one thing that Hofmann didn't like to do.

Hofmann's art school and studio were always immaculate with the kind of scrubbed-clean floors one saw in de Kooning's studio. Naturally, Hofmann was appalled by the "incredible mess" of Pollock's studio. According to Krasner, "In the middle of the devastation, with hundreds of coffee cans scattered about, filled with dried and drying paint, Hof-

mann found Jackson's palette with a brush lying on it [and] when he picked up the brush, the entire palette came with it. 'With this you could kill a man,' Hofmann muttered. 'That's the point,' Jackson replied."[18] Whatever he may have thought about Pollock's ways as a man and as a painter, Hofmann must nevertheless have been impressed by the raw energy in his work. Far from being influenced by Hofmann, as a few have suggested, it was more likely that Pollock's extremely exciting work had some effect on the older painter.

In the fall of 1942 Lee and Jackson began living together. She learned to cook and he learned about the benefits of domesticity. Pollock didn't quit drinking, but he kept it under better control, and he was working really well for the first time in his life. He even had a job as a custodian at the Museum of Non-Objective Painting. A conjunction of events occurred as if to reward him for his efforts. First, Lee introduced him to her friends Mercedes and Herbert Matter; they in turn brought curator James Johnson Sweeney to his studio. Sweeney put in a gentle good word for Pollock with his friend Peggy Guggenheim. Meanwhile, one of Pollock's high school buddies, Reuben Kadish, came to town from California for a visit and brought his friend Howard Putzel, Peggy's assistant, to Pollock's studio. Putzel was impressed by Pollock's work, declaring him a "genius" the moment he saw it. After Peggy and Max Ernst had a parting of the ways and the Surrealists were no longer the center of Guggenheim's life, she turned more and more to Putzel for advice, and began to think positively about showing his American friends in her gallery. When even Piet Mondrian, whose work occupied the far end of the spectrum from Jackson's, told her that he thought Pollock's work was the most interesting he'd yet seen in America, adding, "You must watch this man," Peggy was finally convinced. Critics responded favorably every time she exhibited one of Pollock's works in a group show, and finally she agreed to give him a show of his own. She also did a practically unheard of thing—she signed a year's contract with him for $150 a month in exchange for paintings, and she commissioned him to create a mural-sized painting for the entrance hall of her apartment.

To announce the shift to a more American focus in her gallery, Guggenheim placed an unattributed piece in *Art Digest* for Pollock's upcoming show which included a brief narrative bio and her statement that she considered him to be "one of the strongest and most interesting American painters." James Johnson Sweeney wrote a flamboyant intro-

duction for the exhibition catalogue in which he compared Pollock's talent to natural phenomena like the volcano and the wind, saying: "It has fire. It is unpredictable. It is undisciplined. It spills itself out in mineral prodigality not yet crystallized. It is lavish, explosive, untidy."[19] Pollock liked everything but the part about lacking discipline. In retrospect one sees why. Though far from controlled in a conventional sense, his early paintings are so densely packed with telling, emphasized incident that they have the impact of a singular or holistic image while remaining fascinating to examine from point to point. In a work like She-Wolf, the thick, scumbled paint is brusquely applied—gray over white, white over black, red on top here, under, there—in such rough-edged painterly profusion that a simple spatial reading of what is on top of what is impossible. Everything is inextricably intertwined, just as his later skeins of paint will be. Some species of hybrid animal bridges the painting space, a Ryderesque seascape visible beneath its many-teated belly: either "head" above the legs could be that of a bull or a wolf, or maybe something else. The packing of the images is so dense it implies a *horror vacui,* but all the contradicting, canceling brush strokes are necessary to keep the imagery ambiguous. Which marks would the disciples of discipline remove?

Both Lee and Peggy worked hard before and during the show to make sales and elicit promises to buy. One of their major successes was MOMA's purchase of *She-Wolf.* The reviews were largely favorable, ranging from the artist's being called an "authentic discovery" by Robert Coates of *The New Yorker* to "savagely romantic," though "obscure," by Edward Alden Jewell of *The New York Times.* Conservative Henry Mc-Bride likened the works to an insufficiently shaken kaleidoscope, while Clement Greenberg said Pollock was "original and ambitious." Many stressed the fact that the work had an American flavor in its "hell-bent" audacity. The work *is* violent, and it remains just as powerful today as it was then.

Just about all of the mixed blessings of Pollock's first show at the age of thirty-one—its promotion, its exceptionally favored status among collectors and museum people, its extensive critical press, including the emphasis on Pollock's unruliness—would be repeated again and again for the rest of the decade, and in many respects until the end of his life. His shows at Peggy Guggenheim's gallery in 1944, 1946, and 1947, with Betty Parsons in 1948, 1949, 1950, and 1951, and finally with Sidney Janis

in 1952, 1954, and 1955, went more or less along the same lines. Pollock would always resent being considered undisciplined and would always wish there were more sales. For all the attention he got in the press— articles that yielded approximately equal amounts of satisfaction and pain—the financial rewards remained skimpy until the year before his death in 1956—ironically, tragically, at a point when he was no longer capable of producing art.

Once he and Lee moved out of Manhattan in 1945 to an old farmhouse on Fireplace Road in The Springs, Pollock was a much happier man.[20] They moved in during a terrifying rainstorm, and the first time Pollock opened the back door to go outside, the wind took him and, as he wrote to a friend, "I never touched the ground until I hit the side of the barn five hundred yards away."[21] Restricted by lack of funds to a bicycle for transportation and beers from the local grocery store for alcohol consumption, Pollock was physically safer. He was emotionally safer, too, with a conversational diet of weather predictions, gardening and fishing tips, local Bonacker lore, and other small-town gossip and trivia, instead of the intellectual art talk that made him edgy. As he told Berton Roueché, an East Hampton neighbor interviewing him in the summer of 1950 for a *New Yorker* "Talk of the Town" piece:

> We wanted to get away from the wear and tear. Besides, I had an underneath confidence that I could begin to live on my painting. I'd had some wonderful notices. Also, somebody had bought one of my pictures. We lived a year on that picture, and a few clams I dug out of the bay with my toes.
>
> I've got the old Eighth Street habit of sleeping all day and working all night pretty much licked. So has Lee. We had to, or lose the respect of the neighbors. I can't deny, though, that it's taken a little while. . . . It's marvelous the way Lee's adjusted herself. . . . She's a native New Yorker, but she's turned into a hell of a good gardener and she's always up by nine. Ten at the latest.[22]

While Jackson slept in, Lee could paint. After a coffee-and-cigarette breakfast he would head out to the studio if it was warm enough to work, and she would do her chores. This at least was more or less their routine after Jackson stopped drinking completely at the end of 1948. A young local doctor named Edwin Heller, to whom he'd gone after falling

off his bicycle, told him that alcohol was "poison" to him. "Some people can't eat spinach," he said, "and you can't drink booze." He prescribed Dilantin and phenobarbital for Pollock to take "whenever he felt the urge for a drink" (to substitute for the calmness and the good feeling he got from liquor), but never to be taken along with alcohol. He also offered to talk to Pollock any time of the day or night he felt he couldn't resist the urge to drink.[23] The prescription worked miraculously. Pollock was even able to have liquor in his house for guests without giving in to the old temptation.

Pollock was always restless, especially in the winter when the studio was too cold for him to paint, and often spent hours riding his bike and later driving his Model-A Ford around the area's deserted woods and beaches or sitting alone in his room listening to jazz. The "cool" jazz of Miles Davis was coming into prominence, but Pollock liked his jazz hot and wildly rhythmic. Lee recalled:

> He would get into grooves of listening to his jazz records—not just for days—day and night, day and night for three days running until you thought you would climb the roof! The house would *shake*. Jazz? He thought it was the only other really creative thing happening in this country. He had a passion for music. He had trouble carrying a tune, and although he loved to dance he was an awkward dancer. He told me that when he was a boy he bought himself a violin expecting to play it immediately. When he couldn't get the sound he wanted out of it, he smashed it in a rage.[24]

He also liked to listen to recordings of Dylan Thomas and James Joyce reading their poetry and fiction. Joyce was better heard than read (especially *Finnegan's Wake,* which Pollock apparently liked), and Dylan Thomas's clear, resonant, masculine delivery interspersed with cheering bits of humor was highly appealing in its lack of pretension. A great believer in immediacy and spontaneity, Thomas tended to downplay craft, saying that "everything happens in a blaze of light." He claimed that one of the only languages besides English at his command was "saloon" talk. While on his highly acclaimed American tours in the early fifties Thomas spent a good deal of time in New York, much of it holding forth at the White Horse Tavern, where many of the artists met him, quite possibly including Pollock.

In 1947 Pollock began to experiment with ways to get paint onto the canvas without making brush strokes. Though he didn't abandon oil paint, he began using enamels or thinning his tube pigments to a liquid consistency. When, back in 1936, he, his brother Sande, and some friends had helped out in the Mexican revolutionary painter David Siqueiros's "experimental workshop" on Manhattan's Union Square, they had exploited the properties of colored lacquers. Axel Horn, one of these friends, recalls:

> We sprayed through stencils and friskets, embedded wood, metal, sand, and paper. We used it in thin glazes or built it up into thick gobs. We poured it, dripped it, splattered it, hurled it at the picture surface. It dried quickly, almost instantly, and could be removed at will even though thoroughly dry and hard. What emerged was an endless variety of accidental effects. Siqueiros soon constructed a theory and system of "controlled accidents."[25]

Ultimately, so did Pollock. He "denied" accidents by incorporating them, and he had, as he said, "total control" over his medium. In this he was like the Indian sand painter whose precision in directing thin streams of colored sand through his fingers Pollock had watched with amazement at a demonstration put on at The Museum of Modern Art in conjunction with a 1941 exhibition, "Indian Art of the United States."

Pollock's post-1947 process was necessarily additive; he couldn't make erasures or major changes that didn't involve covering up an area with more paint. If he lost control of the painting but kept on pushing it, it became clotted, muddy, incoherent. All he could do then was throw it out. The question of when to stop had to have been paramount in his mind at all times, with each new layer of lines, each additional color. The spatial properties of color resulting from our associations with it (blue far away over there, red near and hot, etcetera), the figure-ground implications of black and white all had to be taken into account, however intuitively, in order for the resultant canvas to have enough pictorial complexity to be an interesting painting without seeming illusionistic. Despite all the rude remarks about how "my kid could do better than that," what Pollock did with paint was far from easy to do and practically impossible to fake.

Once he was free of the constraints of the brush, Pollock flew. The

Number 32 *by Jackson Pollock.*

marvelous works of 1947 like *Lucifer, Cathedral,* and *Alchemy* were only barely surpassed by the great paintings of 1948, like MOMA's *Number 1A, 1948, Number 13A, 1948: Arabesque,* and *Number 7A.* These, in turn, were only equaled the following year by *Number 8, 1949* in the Neuberger Museum, and surpassed the next by the supersized, super-ambitious canvases of 1950. One of the 1950 paintings, *Lavender Mist,* is densely covered with fragile silvery gray, white, and black lines interwoven with thin sprays and pale washes of lovely colored pigments— pinks, occasional blue-greens, and lavender-grays. It is among his prettiest and most delicate pictures despite its huge seven-by-ten-foot size. *Number 32, 1950* has a completely different feel. It is the sparest abstraction of this year, being only black enamel on an eight-by-ten-foot canvas. The spatial interplay between reaching, arcing, echoing forms takes on something of the character of a dance. Without overlays of color to veil them, one can imaginatively turn the forms in and out of interacting quasi-figures, birds, plants, and animals at will. When Pollock said, "I choose to veil the image," he undoubtedly meant that the image was too clear and easy to read and therefore needed to be hidden in exactly the same way and for the same reason that Kandinsky "veiled" his images of horses and church steeples in his early so-called abstractions. This seems to be what happens in the next and largest painting of

the summer, *One: Number 31, 1950,* (over 8½ by 17½ feet) where skeins and puddles of blue, green, silver, brown, white, and more black overlay a buried black that is impossible to pick out and follow within the matrix of lines. *One* is the crowning achievement of this, his finest painting year, for the following reasons: its airiness is maintained in spite of its paint density; its color is relatively rich; and its units have the greatest range of line width and scale of any Pollock from 1950. *Autumn Rhythm* is slightly smaller, more lyrical, but less dense and less colorful. It is closer to *Number 32* in openness, its underlying compositional armature relatively accessible to the formally trained eye, and, in fact, one might easily mistake it for *Number 32* in Namuth's photographs of its early stages.

When these paintings were exhibited at the end of 1950, a year that had seen one breakthrough exhibition after another, there could be no doubt in any art-knowledgeable person's mind that an incredibly important thing had happened in the world of art. That it had happened in the U.S. instead of in Europe, in abstraction instead of in one of the more readily acceptable representational modes, and in a physically aggressive expressionist style, was not lost on anyone. Art would never be the same, and everyone knew it. Even Pollock, who proceeded to go on a post-opening bender of frightening proportions, knew it. He also probably realized he couldn't paint that way again, and he may not even have wanted to. Throughout the year he had become less and less involved with color and more intense about drawing with his thrown lines. In fact, the drawings he did in 1950, such as the long thin panel reproduced on his exhibition announcement, are his best ever. Unwilling to bury his leaping, twirling, ecstatic forms—modern dancers of the most outré sort—he wanted to flaunt them, and to flaunt his ability to make line sing and dance. There had been precious few drawings between his "psychoanalytic" phase of the early forties and 1950, and most of them were quasi-figurative. But in 1950 he suddenly began to pour and splash ink onto smooth sheets of paper with the most spontaneous and yet apparently intentional results. The darting, swooping movements of the black forms put one in mind of the excitement of Matisse's *Swimming Pool* and, although Pollock's imagery is totally organic instead of rectilinear, of Franz Kline's balletic movement.

In 1951 Pollock began deliberately to draw recognizable figures with his poured paint. Perhaps he was feeling trapped in the net of his own

abstract form-world, perhaps he was jealous of de Kooning's freedom to work in both abstract and figurative modes, perhaps he was just terrified of "painting Pollocks" for the rest of his life. The best of his new drawn paintings, like *Echo* and *Elegant Lady,* retain the alloverness and the airy openness of his "classic" poured paintings, but add a measure of human vulnerability because of the fragile presence of the figures. It might be said though, that a sense of vulnerability hovers over all Pollock's paintings. It may be one reason for their appeal. The desperate problems he had in being able to paint in his last years only serve to validate the authenticity of his earlier work.

The Pollock people came to know in the fifties because of his fame was not the Pollock who painted the great works of 1943–51. With increasingly rare exceptions, after 1951 he was simply a drunk. Photographs mercilessly record his physical decline. They are excruciating to view, as painful as being close to him in those years must have been. Besides his wife, a few old friends remained by him, like Tony Smith and Franz Kline—his main drinking buddy when Pollock paid his weekly visit to Manhattan to see his therapist—and out on Long Island, Conrad Marca-Relli, Alfonso Ossorio and Ted Dragon, the Matters and the Littles, Jeffrey Potter,[26] and Nick Carone. New friends were made among the adoring young writers and painters who flocked to the Cedar Tavern to see the famous artist. Some like Paul Brach, David Budd, and novelist-collector B. H. Friedman[27] stuck by him, but others couldn't tolerate that much tumult in their lives.

A typical early fifties night in town might include a discussion at the Cedar, recalled by painter Fielding Dawson in his *Emotional Memoir of Franz Kline,* where he, Pollock, Kline, de Kooning, and Guston heatedly argued the merits of various cartoonists, George Price ultimately losing out to George Herriman's *Krazy Kat:*

> The bar closed and we stood on the sidewalk until dawn drinking from Jackson's fifth of Scotch, and I yet see Philip leaning against the building, face contorted, swallowing, gnashing his teeth and handing the bottle to me, "God how can anyone drink this shit."
>
> But Jackson was chasing Franz around a parked car. De Kooning was bent over in laughter as Jackson and Franz met and wrestled, broke away and began the chase again, and Jackson came around and I grabbed him but he cast me away and pursued Franz; they locked, and wrestled again.[28]

De Kooning, who rarely joined in the roughhousing but loved to watch it, recalled another night:

> We were at Franz's place. Fantastic. It was small, very warm and packed with people drinking. The windows were little panes of glass. Pollock looked at this guy and said "You need a little more air" and he punched a window out with his fist. At the moment it was so delicious —so belligerent. Like children we broke all the windows. To do things like that. Terrific.[29]

At home in The Springs, the situation was deplorable and highly dangerous. Most of his old friends had banned him from their homes as a result of previous misdeeds. He drove around and around in his Oldsmobile convertible, a case of beer on the seat beside him, looking for a welcoming light in someone's house. Lee tried to keep liquor at home so he wouldn't drive out for it, but he was also becoming increasingly abusive to her. She hadn't aged well, becoming what could only be termed homely. Pollock asked people on more than one occasion, "Can you imagine being married to that face?" He became more and more insulting to her in the presence of others, and more violent when they were alone. She always denied that he hit her (as battered wives do), but friends began to notice bruises on her face and body. Pollock hated being touched when he was very drunk, which made it difficult, and finally impossible, for her to get him up to bed after he returned from a drunken spree. Sitting at the kitchen table night after night, waiting for him to come home, sipping coffee to stay awake, she was sick with worry that the phone would ring and he'd be dead somewhere, but equally apprehensive about what would happen when he came in the door. During his last year she tried to have people he hadn't already hit stay with her at night to help her put him to bed.

Pollock accomplished next to nothing in the last year of his life, while Lee was just beginning to make real progress in her work. He resented that. He got back at her by claiming affairs with other women, and he did manage to acquire one actual girlfriend, though she threw herself at him. (His usual approach, "Wanna fuck?" mouthed while breathing alcoholic fumes into the face of some girl he'd just met wasn't the most effective come-on.) But Ruth Kligman found him at the Cedar Tavern in March 1956 and hung in there with him until his death. Judging by her memoir, *Love Affair,* Pollock seems to have spent most of their time

together on his weekly visits to the city dissolved in tears about every-thing from a character in a B movie to Beckett's *Waiting for Godot,* but mostly he cried in sorrow for himself. The sparseness of Beckett's play was surely congenial to Pollock for he tried to sit still through it twice. When Vladimir says, "Astride of our grave and a difficult birth. Down in the hole, lingeringly, the grave-digger puts on the forceps. We have time to grow old," Pollock must have seen himself in the lines, especially as Vladimir added that all we have to fill this time with is "our cries." [30]

In the summer Kligman moved to nearby Sag Harbor on Long Island, which was the last straw for Krasner. Warning Pollock that "the girl had better be gone" by the time she returned, Krasner went off to Europe for a vacation-escape from the horrors of life at home with Jackson. Although rudely snubbed by Peggy Guggenheim, Krasner enjoyed her first trip to Europe immensely until the morning of Sunday, August 12, when the phone call she had always dreaded came through: Clement Greenberg was on the line saying that Jackson had died in a car accident near their house on Fireplace Road the night before. He didn't mention that Pollock had driven Ruth's friend Edith Metzger to her death with him, and had injured Ruth very badly.

De Kooning was on Martha's Vineyard visiting Herman Cherry when he heard the news. They went over to tell Thomas Hart Benton, who was sitting on his porch. Pollock's Cedar bar pals stayed up all that night telling stories about Jackson, crying, laughing, crying again, and drinking to him. By the end of the following day Kline was exhausted. Fielding Dawson, who was drinking a beer in silence beside him, quietly asked Kline what he thought Jackson had accomplished. "Franz responded softly as tears ran down his cheeks, 'He painted the whole sky; he rearranged the stars, and even the birds are appointed.' He looked up in misery," Dawson recalled, "and pointed down at the front door of the bar and said huskily, 'The reason I miss him—the reason I'll miss him is he'll never come through that door again.' Then he really let it come." [31]

People in the art world who are old enough remember exactly what they were doing when they heard the news about Pollock's death. After the initial shock of finding out that this forty-four-year-old painter who was so central to art life in New York was dead, people began to wonder how he had managed to live so long. One person remembered him jumping out of a moving taxi, another recalled him walking over broken

glass in his stocking feet. There were a number of previous car accidents too, including one involving the Model-A and another in which his Cadillac was totaled. There was also the time Kline drove head-on into oncoming traffic while Pollock was giving him a driving lesson. Only Jackson was hurt. Budd Hopkins once watched helplessly as Pollock darted into the middle of two-way traffic on Madison Avenue in a drunken effort to prove that he could walk a straight line. "He walked right down the middle of the street," Hopkins recalled, "down the white line between lanes of traffic. Horns were blowing. I didn't want to look because I was sure he was going to be hit any second. It was like Russian roulette."

Pollock lies in the Green River Cemetery in The Springs beneath a huge boulder that would have pleased him. He already had a pile of boulders in his backyard, put there because he liked them, and he always claimed he was going to do something with them someday. None were quite big enough for the purpose, though. On the stone friends found elsewhere is a bronze plaque with his signature in relief. Nearby, old friends and other art world acquaintances have also come to lie forever as if in silent recognition of his central role in their lives, whether they were close to him or not. How many times one hears: "When Pollock died, that was the beginning of the end." It is as though the loss of its center sent the New York School spinning centrifugally off in all directions.

Prophetically, Pollock is at the center of "The Irascibles" in the photograph *Life* ran with its January 15, 1951, feature piece on "The Metropolitan and Modern Art." The collective portrait had been taken at *Life*'s West Forty-fourth Street studio by Nina Leen on November 24, 1950, four days before Pollock's show was to open, and just a day or two before he would begin drinking again after the Namuth film shoot. *Life* had originally wanted the artists to be photographed on the steps of the museum with their paintings under their arms, a suggestion that was immediately rejected by Adolph Gottlieb. With his customary acuity, Gottlieb saw that such a picture would imply their works' rejection by the museum instead of their own rejection of the museum's stated policies. The artists are all conservatively dressed in the photo, and, if some look more like bankers than painters, perhaps that is due in some part to Barnett Newman, who intended just that look to prevail. None of the artists wanted to appear foolish, of course, since they were in deadly earnest. Only Clyfford Still has the faintest trace of a smile on his face, and that may be at the irony of his own presence in a group from which he claimed such total detachment. Hedda Sterne recalls that the German photographer was all prepared with name cards for their placement,[1] and that in arranging her shots she had a decidedly harsh, no-nonsense manner. Motherwell later said he was sure they'd never have been able to get Mark Rothko to the session if he'd had any idea what a self-important dictator the photographer would turn out to be.

The photo ostensibly pictured the advanced artists of America, the

signers of the open letter to the president of the Metropolitan Museum, Roland L. Redmond, which was printed on the front page of the previous May 22 *New York Times*. But three of the signers are missing—Hans Hofmann, who didn't want to leave Provincetown at that point, Weldon Kees, who had already left for San Francisco—from which he was never to return—and Fritz Bultman, who was in Rome. No sculptors were asked to the photo session, nor were any of the other nonsigning painters in the same generation with whom the New York School would come to be identified, such as Franz Kline, Jack Tworkov, and Philip Guston. Four of the artists included in the photograph were there for reasons of friendship, support, or a conjunction of interests, but not necessarily because they shared the esthetic position of the other Abstract Expressionists. Hedda Sterne's futuristic machine-creatures and Jimmy Ernst's abstract linear matrixes had been shown in March 1950 and were warmly accepted by the critics—but both artists produced "well-made pictures" characterized by the kind of careful outlining and pictorial finesse that the Abstract Expressionists were out to jettison. Theodoros Stamos (born in 1922), the very young Greek-American acolyte of Rothko and Baziotes, painted creditable pictures in their manner, but had not yet been able to fully differentiate his own personal style from theirs. His dreamy "innerscapes" of the time have the undersea look of Baziotes without his anguish, and the softness of Rothko without his passion. Despite his youth—he was only twenty-eight when the picture was taken—Stamos seemed more like a late Surrealist than an Abstract Expressionist.

The presence of Ad Reinhardt needs a bit more explication since no one, least of all Reinhardt himself, would have considered him an expressionist though he did work abstractly all of his life. Reinhardt had been a faithful card-carrying member of the exclusive American Abstract Artists group since it was organized in the mid-thirties, and he hewed the party line with hard-edged, carefully crafted abstractions of interlocked rectangles in the tradition of Mondrian his entire life. Toward the end of the forties, however, he allowed himself some blurry edges and an occasional stressed brush stroke. These minor deviations from his norm were probably caused, in spite of himself, by the pull of the new American way of painting. Like a compass needle in a magnetic storm, he temporarily lost his polar reference point. But he soon recovered his bearings, and from then until the end of his life in 1967, he

became steadily more formal, orderly, and reductive—and more resolute in his opposition to Abstract Expressionism. He was, however, very much a part of the New York avant-garde group in 1950 and highly involved in its politics—such as the drafting of the protest letter.

By the end of 1950, and with the article in *Life* giving it a helpful shove, the Abstract Expressionist juggernaut was starting to move. Jackson Pollock was its spearhead. Hans Namuth's summertime photographs of Pollock "in action" were featured in *Portfolio* magazine around the same time the *Life* article appeared, and *Art News* proclaimed Pollock's December exhibition to have been one of the three best shows of the year. In the spring, Pollock's *Autumn Rhythm* and *Lavender Mist* were used as backdrops in a *Vogue* fashion spread by Cecil Beaton, and *Art News* finally published Robert Goodnough's article "Pollock Paints a Picture," with Namuth's photographs. Pollock's work was being included in just about every American and overseas exhibition of contemporary art, and suddenly the new American painting he epitomized was becoming ubiquitous. The typical practitioner of that style was described the following year as an "action painter" when Harold Rosenberg, partially inspired by a recent MOMA screening of Namuth's film of Pollock painting, wrote the following:

> At a certain moment the canvas began to appear to one American painter after another as an arena in which to act. . . . What was to go on the canvas was not a picture but an event. . . . The painter no longer approached his easel with an image in his mind: he went up to it with material in his hand to do something to that other piece of material in front of him. The image would be the result of this encounter. . . .[2]

As Wallace Stevens said of poetry, painting was now seen as a "process of the personality." In Rosenberg's view, the gesture on the canvas was one of liberation and near-religious rebirth. "The tension of the private myth is the content of every painting of this vanguard," he wrote. "The act on the canvas springs from an attempt to resurrect the saving moment in his 'story' [the moment of self-discovery] and the attempt to . . . realize [finally] his total personality." Rosenberg saw the painter as acting out a dramatic allegory of consciousness. Though he may have been inspired initially by Pollock, he was personally closer to de Kooning, whose Kierkegaardian uncertainty, his ever-becoming, never-complet-

ing refusal to decide "either/or," was an equally potent model for Rosenberg's action painter as existential hero.

However, Rosenberg conveniently ignored the fact that each encounter with the canvas did not produce an image that was radically different from the one before it, or the one after it, because the artists all had their own individual subconscious images or clusters of feelings to express and they naturally repeated themselves. For this and other reasons, many artists objected to Rosenberg's concept of their way of working, Rothko most vehemently, but they didn't like the alternatives that emerged in the critical writing of the fifties much better. And yet, as we have seen, they had steadfastly refused to name themselves—except for Motherwell, who was so enamored of the School of Paris that he wanted to see the group called the New York School. In 1951 he wrote the following in an exhibition catalogue for a group show at the Frank Perls Gallery in Beverly Hills:

The recent "School of New York"—a term not geographical but denoting a direction—is an aspect of the culture of modern painting. The works of its artists are "abstract" but not necessarily "non-objective." They are always lyrical, often anguished, brutal, austere and "unfinished," in comparison with our young contemporaries of Paris. Spontaneity and lack of self-consciousness is emphasized; the pictures stare back as one stares at them; the process of painting them is conceived of as an adventure without preconceived ideas on the part of persons of intelligence, sensibility and passion.[3]

Clyfford Still, from the West Coast, was not alone in his dislike for Motherwell's New York focus. The Museum of Modern Art tended to use "The New American Painting" to designate the movement, others liked "American-Type Painting," but William Seitz, the first art historian of the movement, preferred the more generic "Abstract Expressionism." Since Seitz's 1955 doctoral dissertation was the first such work on the subject,[4] his term has remained the most commonly used, this despite Philip Pavia's article in the spring 1960 issue of the Tenth Street artists' magazine, It Is: "The Unwanted Title Abstract Expressionism."

Efforts to define the new American painting in exhibitions and in books went on throughout the fifties. Motherwell's and Reinhardt's *Modern Artists in America* and Thomas Hess's *Abstract Painting,* as we saw

earlier, were the first to appear—in 1951—along with Andrew Carnduff Ritchie's booklike catalogue for MOMA's exhibition, *Abstract Painting and Sculpture in America.* The highlight of this show was a symposium on February 5, 1951, "What Abstract Art Means to Me." Typically, de Kooning stated at the symposium that "painting is a way of living today." "Art," he said, never made him feel "peaceful or pure, [he] always seemed to be wrapped in a melodrama of vulgarity." Motherwell, also typically, had a loftier view of what art meant to him:

> Abstract art represents the particular acceptance and rejections of men living under the conditions of modern times ... It is a fundamentally romantic response to modern life—rebellious, individualistic, unconventional, sensitive, irritable—[that arises from] feeling ill at ease in the universe. One's art is just one's effort to wed oneself to the universe. . . . For make no mistake, abstract art is a form of mysticism ... that grew up in the historical circumstance that all mysticisms do, from a primary sense of gulf, an abyss, a void between one's lonely self and the world. Abstract art is an effort to close the void that modern men feel."[5]

This same year, 1951, the French critic Michel Seuphor's article on "Painting in the United States," which stressed the Abstract Expressionist group, appeared in a special American issue of *Art d'aujourd'hui.* Also in 1951, the Sidney Janis Gallery mounted an exhibition of "American Vanguard Art for Paris" which included Pollock, Kline, Motherwell, Guston, Brooks, de Kooning, Gottlieb, Baziotes, Gorky, Tomlin, Vicente, Hofmann, and Tworkov. In a few months some of these American artists would hold a timely symposium on the subject "Is the French Avant-Garde Overrated?"

The artists also defined themselves outside of the museum-gallery system in the so-called Ninth Street Show,[6] which was intended, in part, as a continuation of the protest against the Met's pseudo-roundup of American modernism. This exhibition started the trend which would ultimately become the artists' downtown alternative to the establishment, the Tenth Street co-op gallery.

As this second-generation ABEX exhibition alternative came into existence in the middle 1950s, however, the first-generation Abstract Expressionists were themselves becoming the establishment, showing

in the best galleries and beginning to get decent prices for their work. Early in 1952 Pollock, Rothko, Newman, Still, and a few other of Betty Parsons' artists met with her to give her one last chance to remain their dealer. They were fed up with her failure to publicize their work or produce catalogues for their shows, and with her poor sales record. They also felt she had too many lightweight artists in her stable whose work they didn't feel was up to their level. Newman had already removed his paintings from the premises in protest over his noninclusion in the "15 Americans" exhibition at MOMA, for which he blamed her in part, and since Pollock's contract was up, he, too, wanted his paintings out. Parsons was shocked by their disloyalty, but wouldn't agree to drop her "lesser" artists to concentrate more effort on promoting their work, probably because some of those artists provided basic financial support for the gallery. As a result, Pollock and Rothko switched over to Sidney Janis, where they were joined by Kline, Guston, and de Kooning, defectors from Charlie Egan's foundering gallery. Except for a Marlborough show in 1969, Still dropped out of the gallery system and devoted his self-promotional efforts to wooing museums for exhibitions as well as purchases.

The collection history of The Museum of Modern Art, which was the primary American museum to be centrally involved with the new American painting as it emerged, mirrors the movement's development. Prior to 1950 MOMA had fewer than a dozen paintings by the Abstract Expressionists in its collection, two of which were by Gorky, who had already died. In 1950 MOMA bought one of Gorky's masterpieces, *Agony*, Motherwell's Picassoid *Western Air*, and Pollock's great *Number 1A, 1948*. In 1952, partly through the stimulus of its "15 Americans" exhibition in which Baziotes, Pollock, Rothko, Still, and Tomlin were included, it acquired six more examples of this work—two of them by Pollock. This was the same year it acquired *Chief*, the sole work by Kline to grace its walls until 1967. In the years just after Pollock's death, which somehow seemed to confirm the idea of the value of ABEX paintings in general, MOMA acquired five more Pollocks, two David Smiths, and at least one example by each of the other Abstract Expressionists except Kline.

Despite its hesitations, MOMA was far ahead of all the other American museums in acquisition of this work, and, aside from the continued lack of a really major work by Kline, MOMA has a sizable proportion of first-rank Abstract Expressionist works. It has *the* masterpieces by Pollock—

The She-Wolf, 1943, *Number 1A, 1948, One: Number 31, 1950,* and *Echo,* 1951, each the finest (or close to the finest) example of his work at that particular stage. MOMA owns the two biggest and best of Tomlin's paintings: the monumental *Number 20,* 1949, and the lyrical *Number 9: In Praise of Gertrude Stein,* 1950. It may be more conducive to appreciating Rothko's work to see it in the chapel-like setting in the Phillips Collection in Washington, D.C., but MOMA has superior paintings, especially *Number 10,* 1950, and *Red, Brown, and Black,* 1958, one of the best of his glowing dark red canvases. The Modern bought de Kooning's great black-and-white, *Painting,* 1948, out of his first Egan show, but it was never surpassed in grandeur by any of the others that came later in that series. It also has *Woman I,* 1950–52, the most powerful of the *Women* paintings, but you have to go to the Art Institute of Chicago to experience *Excavation* and to the Met to see *Attic,* formerly in Muriel Newman's collection. *Vir Heroicus Sublimis,* 1950–51, is at the top of the list of major Newmans in the MOMA collection where its availability allows one the experience of being engulfed by the intensity of its color-light. In addition to the pivotal *Garden in Sochi* painting series in which one can trace Gorky's transition from European to American modernism, MOMA owns *Agony,* 1947, the great *Diary of a Seducer,* 1945, and *Summation,* 1947, the latter an enormous drawing/painting which may someday rival Leonardo's large drawing of the *Saint Anne with the Virgin and Child* in London for the world's admiration. MOMA also owns Baziotes's weirdly fascinating painting *Dwarf,* 1947, and David Smith's greatest open steel sculpture *Australia,* 1951, both at the top of each artist's oeuvre. Excellent and historically important examples of Motherwell's, Hofmann's, Guston's, and Still's work are always hanging on the Modern's walls as well, and its collection is rich in Abstract Expressionist sculptures by Herbert Ferber, Theodore Roszak, Seymour Lipton, David Hare, Peter Grippe, and Ibram Lassaw. But for a great painting by Franz Kline you have to go to the Chicago Art Institute to see *Horizontal II,* 1952, or to the Metropolitan Museum of Art to see *Nijinsky,* 1950. The Los Angeles Museum of Contemporary Art now has many of the great Klines collected by Giuseppe Panza di Biumo of Milan, and historically important California collections of Hofmann's and Still's works are at the Berkeley Museum and the San Francisco Museum of Art, respectively. To see the single best among Motherwell's works in this series, the *Elegy to the Spanish Republic Number 34,* 1953–54, you

have to visit the Albright-Knox Art Gallery in Buffalo, which also has a large holding of Stills.

Some of the masterpieces of Abstract Expressionism went directly from the artists' studios into private hands, and are only recently—now that the prices are astronomical—coming up at auction for museum purchase. Prices for all of these artists' works began to rise only after Pollock's death, but even then the rise was slow. The sale of Pollock's enormous *Blue Poles* in 1954 for six thousand dollars had been a major event in the New York art world, one not to be matched for some time. Years later the sale of the same painting to an Australian museum for $3 million was a similarly mind-boggling benchmark. Now canvases by Kline, Motherwell, Rothko, and Newman routinely bring seven figures, but in the 1950s, when collectors were just learning their way around the New York scene, no one could have imagined such a thing.

At the time, dealers were ready to remind the collectors how well off they'd be if they'd bought a Pollock back in 1947 and to guide them to a still available "good deal." Whether or not they benefited from this guidance, the collectors were often more astute about quality and more eager to own these still unpopular works than many of the museums seemed to be. Money is power, and the museums largely let the power go to the dealers. As a result, the curators put themselves in an essentially passive position, spending more energy wooing collectors for the eventual donation of their works than they did by aggressively acquiring the best examples they themselves could find. Collectors like Ben Heller, Philip Johnson, David Solinger, and Sidney and Harriet Janis have filled important gaps in even MOMA's model Abstract Expressionist collection, and the Metropolitan Museum's holdings wouldn't be exceptional if it weren't for the contributions made by the great Chicago collector Muriel Kallis Newman. The Met, like the Whitney, didn't begin to acquire Abstract Expressionist works in any systematic way until very late in the fifties. The National Gallery has only recently begun to collect in this area, but many fine works have come within its walls, if only on an extended loan basis. It should always be remembered that the very nature of what these artists were endeavoring to do, the risks they took, caused even more than the normal degree of unevenness in their total output. As a result, there is a greater range from masterpiece to relative failure in these works than, say, among late Cubist or Impressionist paintings.

Historically, the French people's lack of appreciation for the innovative modern art being created on their own soil resulted in their losing many of the greatest works of the last hundred years to other countries. Seeing the disastrous results of lagging too far behind the artists, American collectors and curators did not make the same mistake. We kept the best for ourselves, and we even went one step further: we proudly showed our artistic assets off to the world in a series of large-scale exhibitions of "The New American Painting," starting in 1956 and continuing for the rest of the decade. At first it was a rare voice that recognized our artists as "an international force capable, even, of exerting an influence in Paris,"[7] as did the English critic Patrick Heron. But by 1959, American art was being seen as "central to the present time," by another English critic, Lawrence Alloway, and New York as the place "where the pace- and standard-setting authority that used to be located in Paris had gone."[8] Even relatively conservative overseas critics were saying that the new American art had "captured" Europe.

While Europe was getting its first taste of this raw new art, Americans had begun the process of getting to know each of their increasingly famous artists in depth. Of the group, Arshile Gorky had the first memorial exhibition at a museum, in the beginning of 1951 at the Whitney; Jackson Pollock had the second in 1956, and Bradley Walker Tomlin the third the following year. But Pollock was the first important living Abstract Expressionist to be given a retrospective exhibition, at Bennington College in 1952.[9] Willem de Kooning had one in Boston a year later, and most of the others followed in the ensuing years.

Recently Pollock has had the first catalogue *raisonné* compiled of his work (a mammoth four-volume opus) and has been the subject of four biographies and a memoir. The first monograph on a New York School artist, however, was Thomas Hess's 1958 study of Willem de Kooning. This fact is indicative of the high standing de Kooning had by that time, Pollock's reputation having fallen off among the critics with his personal decline and his failure to produce major works during the last years of his life. De Kooning, Gottlieb, Guston, Krasner, Motherwell, Brooks, Bultman, and David Smith continued to evolve in the sixties, some finding additional "signature" images, others changing their scale and their ways of dealing with color and surface, and successfully remaining viable Abstract Expressionists. De Kooning continues to do so, as did Motherwell until his death in 1991. Rothko, Still, and Newman were less

successful in escaping the trap of their name-brand imagery, but Newman's foray into sculpture gave him a whole new arena in which to display his genius. Franz Kline did succeed in making two major transitions in his work—into tonalism and into color, both of which immensely broadened his range—before his unexpected death in 1962.

When Pollock died, Abstract Expressionism lost its heart; the year Kline died, 1962, the life that was still left in it as a movement also died. Some people had been saying that it had been over for years, but suddenly it was clear to everyone that Abstract Expressionism was not the leading edge, the avant-garde of American art any longer. As with all collective movements, its moment had passed. Pop art became the "in" thing, and it stood for everything Abstract Expressionism was dead set against—it celebrated triteness, humor, playfulness, representation, banal subject matter, commercial-art techniques, and a systematized dehumanization of the art process. Andy Warhol said that he wanted to be a machine. What could be further from the emotional excesses of Pollock, the muscular dynamism of Kline, the transports of Rothko, the savage grandeur of Still and de Kooning, and the transcendentalism of Newman? Actually Thomas Hess had used the past tense as early as 1960 when he wrote the following in "The Many Deaths of American Art," an editorial in which he tried to deny that the end was near for his beloved art movement:

> The New American experience in art was a philosophical revolution. It produced no unity of style . . . What the paintings had, and still have in common, is what the artists hold in common: The experience of a breakthrough, of a revolutionary moment in which all esthetic, and thus ethical, values and premises were re-invented.[10]

Abstract Expressionism was a very different phenomenon from previous art movements such as Cubism or Constructivism, which were dominated by a few artists whose work looked very much alike. Abstract Expressionism has more in common with Impressionism, a movement in which a large group of artists with very different styles interacted intensely for a short while and then went their separate ways again. However vast the gulf between Degas's obsession with drawing figures in action and Monet's with capturing the momentary fall of light on matter, both were intent on painting the fleeting impression, on stop-

ping time for an instant. Likewise, Pollock's drip and Newman's "zip," de Kooning's knife-edge line and Rothko's light-suffused blur, Still's turgid impasto and Kline's sweeping strokes, voice far different feelings, but they come out of a shared desperation to speak through the medium of paint alone. Impressionism was concerned with the outside world, Abstract Expressionism with the inner, but both focused on the immediate moment. Harold Rosenberg discussed this focus in his description of an "action painter":

> A painting that is an act is inseparable from the biography of the artist. The painting itself is a "moment" in the adulterated mixture of his life —whether "moment" means the actual minutes taken up with spotting the canvas or the entire duration of a lucid drama conducted in sign language. The act-painting is of the same metaphysical substance as the artist's existence.[11]

We treasure art because it is made by human hands. Our lives are filled with mechanized work, standardized objects, dehumanized interpersonal encounters. In contrast to this, a work of art that occasions passion is full of spontaneity and feeling, and thus becomes humanly valuable. Meyer Schapiro wrote about the new American painting in 1957 saying that it "symbolized an individual who realizes freedom and [a] deep engagement of the self":

> The consciousness of the personal and spontaneous in the painting and sculpture stimulates the artist to invent devices of handling, processing, surfacing, which confer to the utmost degree the aspect of the freely made. Hence the brush, the drip, the quality of the substance of the paint itself, and the surface of the canvas as a texture and field of operation—all signs of the artist's active presence. The work of art is an ordered world of its own kind in which we are aware, at every point, of its becoming.[12]

The very openness and fluidity of these artists' works, Schapiro continues, "impress us as possessing the qualities not so much of things as of impulses, of excited movements emerging and changing before our eyes." Chance plays an important role in the work, and in its opposition to the characteristics of industrial production. Chance, the spontaneous

and unpredictable, lets the human unconscious into the work of art. As Schapiro said:

> The impulse . . . becomes tangible and definite on the surface of a canvas through the painted mark. We see, as it were, the track of emotion, its obstruction, persistence or extinction. But all these elements of impulse which seem at first so aimless on the canvas are built up into a whole characterized by firmness, often by elegance and beauty of shapes and colors. A whole emerges with a compelling, sometimes insistent quality of form, with a resonance of the main idea throughout the work. And possessing an extraordinary tangibility and force, often being so large that it covers the space of a wall and therefore competing boldly with the environment, the canvas can command our attention fully like monumental painting in the past.[13]

And that, of course, is precisely what these artists intended. Their lives were marked by much pain and anguish. Though some lived long enough to enjoy the full flowering of success, most had only a short experience of its pleasures, and that came quite late in their lives. They understood that they couldn't maintain the emotional intensity of their art lives at the same high pitch for very long, and they knew their work would live on *as* them far into the future. Most of them even stopped making statements about their work by the end of the fifties, preferring to let the art speak for itself. In order for that to happen, though, someone has to listen. Like all great works of art, the ones by the American Abstract Expressionists must be experienced in person, and preferably over time. Whether we go to these artworks for confirmation of our world view, be it harmonious or chaotically complex; whether for exaltation, as we formerly went to church; or whether we simply seek the esthetic pleasures of the senses—whatever our reasons—we go on a pilgrimage of sorts, for we seek something outside of ourselves.

It seems fitting that three centuries after the religious pilgrims who founded America launched themselves on a voyage into the unknown, trusting only their God to bring them safely to a new world, our artists used the same terminology as a metaphor for their adventure into a whole new territory of art making. The Abstract Expressionists broke the stranglehold of tradition on every aspect of art: on form—by smashing the Cubist grid; on space—by liberating it from formulas of depth

and decorative flatness; on color—by setting it free of form; on technique—by simply saying "Anything goes"; and, perhaps, most importantly, on content—by allowing it to emerge simply and directly from the artist's own internal reality. The Abstract Expressionists didn't enter upon their voyage into the unknown lightly, and it wasn't an easy trip. But they held nothing back, kept nothing in reserve. They fervently believed—knowing that their lives-after-life depended on it—that, as Franz Kline once said, "If you meant it that much when you did it, it will mean that much."

Notes

Having known many of these artists personally, and having heard innumerable tales by and about them over the course of my twenty plus years in the art world, there are many uncitable quotations, statements, and stories in these pages which are only attributable to my personal sources. All others are duly identified.

INTRODUCTION

1. Sandra Knox, "Competition for American Artists Planned by Metropolitan," *New York Times,* January 1, 1950, p. 1.

2. Surrealism was defined, poetically, as the chance meeting of a sewing machine and an umbrella on a dissecting table, because it involved the irrational juxtaposition of unlike elements in a context foreign to them both; it is epitomized by Meret Oppenheim's fur-lined teacup.

3. William Laurence, "Nagasaki A-Bomb Belched Pillar of Purple Fire 10,000 Ft. in 45 Sec.," *New York Times,* September 8, 1945, p. 1.

4. Willem de Kooning, Letter to the Editor, *Art News,* January 1949, p. 6.

5. Søren Kierkegaard, *Either/Or,* Part 1, trans. Howard V. Hong and Edna H. Hong (Princeton: University Press, 1987), pp. 38–39.

6. Barnett Newman, *The Ideographic Picture,* Betty Parsons Gallery exhibition catalogue, January 20–February 8, 1947.

7. Mark Rothko and Adolph Gottlieb, with Barnett Newman's assistance, Letter to the Editor, *New York Times,* June 13, 1943, section 2, p. 9.

8. John I. H. Baur, *Bradley Walker Tomlin,* Whitney Museum of American Art exhibition catalogue, 1957, p. 32.

9. Robert Motherwell, quoted in John I. H. Baur, *Bradley Walker Tomlin* (New York: Whitney Museum of American Art, 1957), p. 11.

JANUARY

1. On January 1, 1950, the *New York Herald Tribune* reproduced a cartoon from an 1880 French newspaper which predicted that 1950 would be a year of

"telephonoscopes" (television), bomber planes, penthouses, and female politicians. In fact, the number of TV sets in America jumped from 1.5 million in 1949 to 15 million by 1951, and color television came into existence as well. Bombs and bomber planes became even more of a national obsession that year, when Truman gave the go-ahead for production of the H-bomb. Bomb shelters were promoted, bomb drills practiced, and we began our quest for a mutually verifiable nuclear arms treaty with the Russians. Truman signed the NATO pact, while Stalin signed an accord with Mao, who had begun a campaign to have his Communist dominion over mainland China recognized in the U.N. Then, in the summer, the Korean conflict heated up this already intense "Cold War." In addition to fulfilling these predictions, 1950 bore out the last two parts of the French prophecy as well. Manhattan, the penthouse capital of the world, moved a lot closer to overtaking London's global lead in city population with a rapid rise to 7.8 million people in the five boroughs in 1950. And last, but perhaps not least, that year a woman named Margaret Roberts (soon to be Thatcher) became the youngest candidate ever to run for election to the English Parliament. The "Trib" itself predicted, a good deal less accurately, that 1950 would be a year of prosperity, lower prices, healthier kids, and no war!

2. *New York Times,* "Catholics Hail Start of Holy Year 1950 as Protestants Conduct Special Services," January 1, 1950, p. 3.

3. Alfred Kazin, "On Melville as Scripture," *Partisan Review,* vol. 17, no. 1, January 1950, p. 70.

4. Rothko, quoted in Seldon Rodman, *Conversations with Artists* (New York: Capricorn, 1961), pp. 93–94.

5. The friend was Sally Scharf, who, with her husband, the painter William Scharf, were two of Rothko's closest friends.

6. Later in the twenties he drew maps for Lewis Browne's popularized biblical history before taking a teaching job at Brooklyn Jewish Center, his main means of support until 1952.

7. Sally Scharf, an actress who talked about the theater with Rothko for hours on end, believes it more likely that Rothko was Gable's understudy.

8. Rothko, "The Romantics Were Prompted," in *Problems of Contemporary Art: Possibilities 1,* Winter 1947/8, eds. Robert Motherwell, Pierre Chareau, Harold Rosenberg, and John Cage (New York: Wittenborn, Schultz, Inc., 1947), p. 84.

9. If turned on their sides these armatures resemble the tiered formations of his mature abstractions.

10. Rothko and Gottlieb, with Newman, Letter to the Editor.

11. Rothko, quoted in Sidney Janis, *Abstract and Surrealist Art in America* (New York: Reynal & Hitchcock, 1944), p. 118.

12. Søren Kierkegaard, *Fear and Trembling and Sickness Unto Death,* trans. Walter Lowrie (Garden City, NY: Doubleday, 1954), pp. 51–53.

13. Rothko, "The Romantics Were Prompted," p. 84.

14. Ibid.

15. Ibid.

16. Rothko, "A Symposium on How to Combine Architecture, Painting and Sculpture," *Interiors,* vol. CX no. 10, May 1951, p. 104.

17. Only the Rothko room in the Phillips Collection in Washington, D.C., comes

close to the kind of gallery or studio situation Rothko preferred for viewing his work.

18. Mark Rothko said this to Dore Ashton in January 1957. Dore Ashton, "Rothko's Passion," *Art International*, February 1979, p. 7.

19. Herbert Ferber, interview with Phyllis Tuchman, June 2, 1981, Archives of American Art, Smithsonian Institution, Washington, D.C., p. 3.

20. Playwright Jack Gelber told the author that many people understood the play to have a subtext about Jewish life in America, which Rothko conceivably sensed, but it was not generally seen in that way.

21. See *Weldon Kees and the Mid-Century Generation: Letters 1935–1955*, Robert E. Knoll, editor (Lincoln: University of Nebraska Press, 1986), p. 126.

22. Howard Devree, "In New Directions: Current Shows Reveal Steady Expansion of Modern Movement's Horizons," *New York Times*, January 8, 1950, p. 10X.

23. In fact the book review section of the same paper featured an article on "Einstein's Daring Mind" which attempted to explain the unified field theory linking gravitation and electromagnetism. Not long afterward *The Listener*, an English review, published J. Bronowski's elucidating article on "Dr. Einstein's New Theory."

24. Rothko, quoted in Elaine de Kooning, "Two Americans in Action: Franz Kline and Mark Rothko," *Art News Annual*, 1957, p. 177.

25. The following quotations are from Clinton Hill, *Ladders and Windows*, Zabriski Gallery exhibition catalogue, November–December 1955.

26. Elaine de Kooning, "Two Americans in Action," p. 176.

27. Budd Hopkins, interview with the author, October 10, 1988.

28. He would not have liked the chapel's later ecumenical designation.

29. Once, when this confirmed urbanite was artist-in-residence for ten weeks in Colorado, he sent a postcard to the Scharfs saying he felt like one of those exiled Greeks whose writings he enjoyed.

30. Søren Kierkegaard, *Either/Or*, Part 1, trans. Howard V. Hong and Edna H. Hong (Princeton University Press, 1987), p. 28.

31. Stanley Kunitz, conversation with the author, summer 1988.

32. Barnett Newman was in a similar position in the sixties.

33. Rothko, quoted in John Fischer, "The Easy Chair," *Harpers Magazine*, vol. 241, July 1970, p. 22.

34. Kierkegaard, *Fear and Trembling*, p. 51.

35. John Gruen, *The Party's Over Now* (New York: Viking, 1967), p. 254.

36. Gottlieb, Rothko, and Newman were all supported to a great extent by their wives. One day when their friend William Baziotes was complaining about his desperate financial condition, Newman said to him, "Why on earth don't you put your wife to work?" But Baziotes's fierce Greek pride would never allow him to do so.

37. Weldon Kees, "Art," *The Nation*, vol. 170, January 7, 1950, p. 20.

38. Belle Krasne, "Gottlieb Through the Magnifying Glass," *Art Digest*, January 15, 1950, p. 16.

39. Actually smalts, a silica material used by sign painters.

40. Weldon Kees, "Art," *The Nation*, vol. 170, January 7, 1950, p. 20.

41. Krasne, "Gottlieb Through the Magnifying Glass," p. 16.

42. T. S. Eliot, *The Waste Land,* in *Collected Poems, 1909–1935* (New York: Harcourt, Brace 1930), p. 67.

43. Mark Rothko eulogy for Milton Avery delivered on January 7, 1965, New York Society for Ethical Culture, New York, excerpted in Diane Waldman, *Mark Rothko 1903–1970, A Retrospective,* the Solomon R. Guggenheim Museum, New York, 1978, p. 27.

44. Gottlieb, interview with Dorothy Seckler, October 25, 1967, Archives of American Art, Smithsonian Institution, Washington, D.C., p. 21.

45. Gottlieb, an interview with David Sylvester, *Living Arts,* vol. 2, 1963, pp. 4–5.

46. Gottlieb and Rothko, "The Portrait and the Modern Artist," *Art in New York* radio series, WNYC, October 13, 1943.

47. Gottlieb, quoted in Gladys Kashdin, "Abstract Expressionism: An Analysis of the Movement Based Primarily on Interviews with Seven Participating Artists" (Ph.D. diss., Florida State University, 1965), p. 33.

48. Gottlieb, "My Painting," *Arts and Architecture,* vol. 68, September 1951, p. 21.

49. Ezra Pound, "In a Station of the Metro," *Personae, The Shorter Poems of Ezra Pound,* Lea Baedhler and A. Walton Litz, eds. (New York: New Directions, 1990), p. 111.

50. Joint 1943 Letter to the Editor, *New York Times,* p. 9.

51. Pound, "Middle-Aged, A Study in Emotion," *Personae,* p. 250.

52. Motherwell, quoted in Kashdin, "Abstract Expressionism," p. 75.

53. Gottlieb, in "The Ides of Art: The Attitudes of Ten Artists on Their Art and Contemporaneousness," in *The Tiger's Eye,* vol. 1, no. 2, December 1947, p. 43.

54. Joint 1943 Letter to the Editor, *New York Times,* p. 9.

55. Adolph Gottlieb, *Selected Paintings by the Late Arshile Gorky,* Kootz Gallery exhibition catalogue, March 28–April 24, 1950.

56. Gottlieb, interview with Dorothy Seckler, p. 25.

57. His early mentor Milton Avery had been fond of such extreme landscape simplifications, of course, though his divisions are often at an angle, and Rothko's rectangles would bear reading as landscapes if he didn't purposely counteract that interpretation.

58. Gottlieb, interview with Andrew Hudson, May 1968, Adolph and Esther Gottlieb Foundation, New York.

59. One might speculate about a connection between the Hebrew proscription of graven images and the iconlike spirituality of these Jewish artists' paintings.

60. Laurence, "Nagasaki A-Bomb," p. 1.

FEBRUARY

1. *Weldon Kees and the Mid-Century Generation,* ed. Knoll, p. 128.

2. Laurence, "Nagasaki A-Bomb," p. 1.

3. Emile de Antonio, director, "Painters Painting, New York," a film interview with Barnett Newman (among others), April 4, 1970, distributed by Turin Film Corporation, New York.

4. Annalee Newman, conversation with the author, November 1, 1988.

5. Thomas Hess, "Barnett Newman," *Art News,* vol. 49, no. 1, March 1950, p. 48.

6. Annalee Newman, conversation with the author, November 1, 1988.

7. Alice Louchheim (unsigned), "By Extreme Modernists," *New York Times,* January 29, 1950, p. X9.

8. Judith Kaye Reed, "Newman's Flat Areas," *Art Digest,* vol. 24, no. 9, February 9, 1950, p. 16.

9. Philip Guston, quoted in Musa Mayer, "My Father, Philip Guston," *New York Times Magazine,* August 7, 1988, p. 24.

10. This according to Tom Hess. Philip Pavia said he "cried like a baby," but Mrs. Newman denies the tears. Mercedes Matter thought Newman was angry at the panel she made with white tape.

11. Willem de Kooning, interview with James T. Valliere, "De Kooning on Pollock," Pollock papers, Archives of American Art, Smithsonian Institution, Washington, D.C.

12. Jack Tworkov, journal excerpt of April 26, 1952, quoted in B. H. Friedman, *Jackson Pollock: Energy Made Visible* (New York: McGraw-Hill, 1972), p. 107.

13. This was probably the main reason Pollock rarely went to The Club—he hated just such talk. He did go once during the early months of its existence while he was staying in Manhattan, but left after a short while.

14. Robert Goldwater, "Reflections on the New York School," *Quadrum,* no. 8, 1960, pp. 24–26.

15. This is an often-told story. Thomas B. Hess published his version of it in his monograph, *Barnett Newman* (New York: Museum of Modern Art, 1971), pp. 89–90.

16. Ibid., p. 88.

17. For this information and other related insights into connections between Newman's art and anarchism, I am indebted to Ann Schonfeld, who is writing her doctoral thesis on Newman's early life.

18. John P. O'Neill, editor, *Barnett Newman, Selected Writings and Interviews* (New York: Alfred A. Knopf, 1990), p. 178. However, the editor places this statement in Newman's second show while most other scholars place it in the first exhibition. See the 1971 Hess monograph, p. 58.

19. He probably meant the nongambling sort of casino where meetings, dances, and other events might be held.

20. Newman, quoted in A. J. Liebling, "Two Aesthetes Offer Selves as Candidates to Provide Own Ticket for Intellectuals," *New York World-Telegram,* November 4, 1933.

21. Three New York University instructors, Hale Woodruff, Robert Inglehart, and Tony Smith established Studio 35 in the same loft at 35 East Eighth Street and continued the Friday night sessions for another year. The Artists Club was located nearby, and this has caused some confusion between the two.

22. Motherwell, conversation with the author, summer 1987. No tape recording was made so the quotations are as I remembered them later, fleshing out my notes. Any infelicities of phrasing are mine; Motherwell always spoke beautifully.

23. Barnett Newman, "The Sublime Is Now," *The Tiger's Eye* vol. 6, no. 1, December 15, 1948, p. 51.

24. Hess, *Barnett Newman,* p. 73.

25. Hess, *Barnett Newman,* p. 81. It may be speculated that the lances are echoed in the vertical units of Pollock's *Blue Poles,* a painting which Newman is said to have been involved in executing to some degree.

26. R. Coughlan, "The Dark Wine of Genius," *Life,* January 16, 1950, pp. 86–101.

27. Orville Prescott, "Book of the Times," *New York Times,* January 25, 1950, p. 25.

28. Harold Rosenberg, *Barnett Newman* (New York: Abrams, 1978), p. 83.

29. Note the use of the terminology of nuclear explosions.

30. Newman, interview with Dorothy Seckler, "Barnett Newman: Frontiers of Space," *Art In America,* vol. 50, no. 2, Summer 1962, p. 84.

31. Ad Reinhardt, on the other hand, painted some relatively soft edges around 1950, albeit on his customary neo-Constructivist rectangles and squares, but he was totally opposed to any form of artistic Expressionism.

32. William Baziotes, from "Beauty and Lethality: A Collage Portrait of William Baziotes in Words and Images by Ethel Baziotes," *William Baziotes: Paintings and Works on Paper, 1952–1961,* exhibition catalogue, BlumHelman, March 1984.

33. Baziotes, letter, April 25, 1949, Baziotes Papers, Archives of American Art, Smithsonian Institution, Washington, D.C.

34. Baudelaire, "The Moon's Favors," In *Paris Spleen,* trans. Louise Varese (New York: New Directions, 1947), p. 79.

35. Kees, "Art," *The Nation,* February 4, 1950, p. 113.

36. David Hare, quoted in "William Baziotes, 1912–1963," *Location,* vol. 1, no. 2, Summer 1964, np.

37. Mumblety-peg was played with ice picks and may therefore have been the source of his imagining an ice pick flying to its target when he felt things were right in his world.

38. Jimmy Ernst, *A Not So Still Life* (New York: St. Martin's/Marek, 1984), p. 187.

39. Ibid.

40. Motherwell, quoted in Mona Hadler, "William Baziotes: Four Sources of Inspiration," catalogue, *William Baziotes: A Retrospective Exhibition,* Newport Harbor Museum, March 24–June 4, 1978, p. 77.

41. Ibid.

42. Motherwell, letter, September 6, 1944, Baziotes Papers, Archives of American Art, Smithsonian Institution, Washington, D.C.

43. A statement to this effect seems to have accompanied Baziotes's contribution to an exhibition in 1945 at the David Porter Gallery in Washington, D.C., "Painting 1950: A Prophecy."

44. Eric Newton, "Churchill: 'Painting a Picture Is Like Fighting a Battle'," *New York Times,* Book Review Section, February 12, 1950, p. 3.

45. Baziotes, "I Cannot Evolve Any Concrete Theory," *Possibilities,* p. 2.

46. Jackson Pollock, "My Painting," ibid, p. 79.

47. Baziotes, from Donald Paneth, "Literary Portrait" (unpublished), Baziotes Papers, Archives of American Art, Smithsonian Institution, Washington D.C.

48. It is remotely possible that Baziotes may have suffered from Ménière's Syndrome, a disorder of the inner ear which can cause similar symptoms. Apparently Van Gogh had the same disease. A clipping in the Baziotes Papers at the Archives of American Art on Ménière's Syndrome supports the idea that he may have seen some connection between his symptoms and the disease.

49. Baudelaire, "Artist's Confiteor," *Paris Spleen,* p. 3.

50. *Weldon Kees and the Mid-Century Generation,* p. 11.

51. Weldon Kees, "Art," *The Nation,* January 7, 1950. pp. 19–20.

52. Judith Kaye Reed, "New Artists Honored, Abstraction Crowned at Whitney," *The Magazine of Art,* January 1, 1950, p. 7.

53. Jeanne Bultman, telephone conversation with the author, December 1988.

54. *Weldon Kees and the Mid-Century Generation,* p. 131.

55. Henry McBride, "An American Newcomer," *Art News,* March 1950, p. 11.

56. Belle Krasne, "Fritz Bultman Bows," *Art Digest,* February 19, 1950, p. 15.

57. Kees, "Art," *The Nation,* February 4, 1950, p. 113.

58. The Bauhaus was a school of art, design, and architecture which revolutionized art education in the West by combining the teaching of the pure arts with the study of crafts. Architects Gropius and Breuer were on the faculty along with the painters Klee and Kandinsky.

59. Motherwell, *Black Or White,* Kootz Gallery exhibition catalogue, February 28–March 20, 1950.

60. Franz Kline, quoted in Frank O'Hara, "Introduction and Overview (Franz Kline Talking)," in catalogue for *Franz Kline, a Retrospective Exhibition,* Whitechapel Gallery, London, May–June 1964, p. 13. The friend who sponsored his trip to teach at Schroon Lake in August 1950 was I. David Orr, his longtime patron.

61. Willem de Kooning, "What Abstract Art Means to Me," speech delivered at a February 5, 1951, Museum of Modern Art symposium, in *The Museum of Modern Art Bulletin,* vol. 17, no. 3, Spring 1951, p. 7.

MARCH

1. This amazingly foresightful book was the inspiration for my own, and has sustained me both visually and verbally throughout this endeavor.

2. His text for the June issue of *Art d'aujourd'hui* was translated for publication in *Modern Artists in America* by Francine du Plessix and Florence Weinstein, pp. 118–22.

3. David Hare, conversation with the author, May 8, 1988.

4. Mary Abbott, interview with the author, March 14, 1988.

5. Yvonne Thomas, conversation with the author, March 14, 1988.

6. Stuart Davis, "Arshile Gorky in the 1930s: A Personal Recollection (1951)," *Stuart Davis,* ed. Diane Kelder (New York: Praeger, 1971), p. 179.

7. Rosaline Bengelsdoff Browne, quoted in Karlen Mooradian, *The Many Worlds of Arshile Gorky* (Chicago: Gilgamesh Press, 1980), p. 114.

8. Raoul Hague, quoted in ibid., p. 149.

9. Willem de Kooning, quoted in Harold Rosenberg, *Arshile Gorky: The Man, the Time, the Idea* (New York: Grove, 1962), pp. 25–26.

10. Jacob Kainen, "Memories of Arshile Gorky," *Arts,* March 1976, p. 97.

11. Ibid.

12. Gorky, letter of February 25, 1941, in Karlen Mooradian, "A Special Issue on Arshile Gorky," *Ararat*, vol. 12, no. 4, Fall 1971, pp. 25–26.

13. Willem de Kooning, quoted in ibid., p. 51.

14. Willem de Kooning, quoted in Mooradian, *The Many Words of Arshile Gorky*, p. 130.

15. Gottlieb, *Selected Paintings by the Late Arshile Gorky*.

16. Meyer Schapiro, "Introduction" in Ethel Schwabacher, *Arshile Gorky* (New York: Macmillan, 1957), p. 13.

17. Howard Devree, "By Contemporaries: Museum Shows Its Recent Acquisitions—Gorky, Lebrun, de Martini, Dozier," *New York Times*, Sunday, April 2, 1950, p. 8.

18. For a detailed analysis of Gorky's uses of this painting see the author's article, "Arshile Gorky's Absolute Ambiguity," *Re-Dact, An Anthology of Art Criticism*, Peter Frank, ed. (New York: Willis, Locker & Owens, 1984).

19. Gorky, quoted in Julien Levy, *Arshile Gorky* (New York: Abrams, 1966), p. 34.

20. André Breton, *Arshile Gorky*, Julien Levy exhibition catalogue, March 6, 1945.

21. Margaret Osborne, "The Mystery of Arshile Gorky: A Personal Account," *Art News*, February 1963, p. 60.

22. Gorky, quoted in Mooradian, *The Many Worlds of Arshile Gorky*, p. 206.

23. Kierkegaard, *Either/Or*, Part 1, p. 310.

24. Ibid., p. 306.

25. Ibid.

26. Ibid., p. 307.

27. Willem de Kooning, quoted in Mooradian, *The Many Worlds of Arshile Gorky*, p. 130.

28. James Brooks, transcript of the Studio 35 sessions, in *Modern Artists in America*, ed. Robert Motherwell and Ad Reinhardt (New York: Wittenborn, Schultz, Inc., 1951), p. 18.

29. Ironically, this advanced mural, a satisfying fusion of abstraction with futuristic figuration 12½ by 235 feet long, was painted over in 1950, the year the new abstraction took hold.

30. Brooks, in *James Brooks*, Dallas Museum of Fine Arts exhibition catalogue, May 10–June 25, 1972, n.p.

31. Brooks, in "James Brooks," *Art Now*, vol. 3, no. 2, New York, 1971, n.p.

32. Brooks, interview with James T. Valliere, excerpted in Elayne H. Varian, "Introduction," *James Brooks* (New York: Martha Jackson Gallery, 1975), p. 9.

33. Brooks, quoted in Jeffrey Potter, *To a Violent Grave: An Oral Biography of Jackson Pollock* (New York: Putnam, 1985), p. 95.

34. Brooks, interview with Valliere, excerpted in Varian, "Introduction," *James Brooks*, p. 9.

35. S[tuart] P[reston], "Trio of Art Shows Marked by Variety," *New York Times*, April 7, 1950, p. 23.

36. Lawrence Campbell, *Art News*, April 1950, p. 56.

37. Ibid.

38. Herbert Ferber, interview with the author, May 2, 1991.

39. Belle Krasne, "Ferber on His Metal," *Art Digest,* March 15, 1950, p. 14.

40. Alfonso Ossorio, interview with Judith Wolfe, Guild Hall Museum exhibition catalogue, *Alfonso Ossorio,* 1980, p. 15.

41. Early in the fifties the Pollocks found "The Creeks," a large estate in East Hampton, for Ossorio and Dragon after their return from the Orient via Europe; they lived there until Ossorio's death in 1990. Ossorio apparently believed that his Victorias drawings influenced Pollock in turn to draw figures with his poured paint a year later. However, de Kooning's celebrated "return to the figure" in 1950 when he started the *Women* series was surely a far more important influence on Pollock's decision to do so.

42. Lee Krasner and Jackson Pollock, D83, in "Documentary Chronology," *Jackson Pollock: A Catalogue Raisonné,* eds. Francis V. O'Connor and Eugene V. Thaw (New Haven: Yale University Press, 1978), vol. 4, p. 247.

APRIL

1. This three-day symposium was suggested and organized by one of the students at Studio 35, Robert Goodnough, who was writing his master's dissertation on the Abstract Expressionists. The April symposium was intended as a kind of summary of the year's Friday night sessions. Goodnough drastically edited the stenographically recorded proceedings for publication in *Modern Artists in America.* Both his dissertation and the unedited version of the transcript of the proceedings have been lost.

2. All quotations are from the transcript as it appeared in *Modern Artists in America.*

3. Clyfford Still, quoted in Thomas Albright, "The Painted Flame," *Horizon,* November 1979, p. 33.

4. Richard Pousette-Dart, quoted in Judith Higgins, "To the Point of Vision: A Profile of Richard Pousette-Dart," *Transcending Abstraction: Richard Pousette-Dart, Paintings 1939–1985,* exhibition catalogue, Museum of Art, Fort Lauderdale, Florida, 1986, pp. 17–18.

5. This painting belongs stylistically with the later, post-1947 works. Whether Still deliberately changed the dates of his pictures in order to make it seem that he did this or that before other painters of the New York School—which many knowledgeable members of the art world believe to be the case—is not going to be settled here. However, Still has publicly admitted to making copies more or less exactly like earlier pictures, although sometimes the dimensions were radically different. His copies enabled him to continue to have a picture and sell it, too, or to destroy a picture but continue to have it. He sold a painting to Alfonso Ossorio which he later decided to take back by force. It isn't clear what caused Still to make a raid on his fellow artist/collector/supporter/ friend's house to get the painting, but in the basic version of this oft-told story, he cut the picture out of its frame in Ossorio's sunken living room in East Hampton, Long Island. As Still whipped the painting into a waiting cab, his wife, Pat, allegedly told Ossorio, "Don't be concerned. He's got another one exactly like it."

6. Pousette-Dart, quoted in Higgins, "To the Point of Vision," p. 19.

7. Motherwell, conversation with the author, summer 1987.

8. These were precisely the problems which later beset discussions at The Club, where no such rules controlled verbal wrangling, interruptions, or staying on the point.

9. In fact, Hedda Sterne remembers Motherwell telling everyone at a dinner party about explaining Surrealism to Gorky, who kept saying "Tell me more, tell me more." The others at the dinner (David Hare, Ad Reinhardt, and Harold Rosenberg) knew Gorky well, and recognized his favorite "put-down" expression at once. Motherwell obviously hadn't. From a conversation with the author, March 1, 1989.

10. Rothko's friend Hedda Sterne said that Rothko was always "messy" until his second wife, Mel, made enough money working to dress him well. His first wife hadn't been so concerned. "She treated him badly," Sterne said. "She thought he was a failure. But later, after their divorce, when the Modern bought one of his pictures, she called him up and asked him what the pictures she had of his were worth now." From a conversation with the author, March 1, 1989.

11. Buffie Johnson, conversations with the author, winter 1988–89.

12. Yet another "salon" of a highly informal sort was held at the home of sculptor-mosaicist Jeanne Reynal and her husband, the painter Thomas Sills. They also collected art and were thus in a position to be of some financial assistance to their artist friends, Gorky in particular. All three women, Reynal, Johnson, and Sterne, exhibited their work in March 1950, though none were working in the expressionist vein that characterized the New York School. Reynal showed mosaic paintings at the Hugo Gallery which were praised for their decorativeness, subtlety, and linear wit in *Art News,* the critic recognizing the artist's debt to Gorky's transcription of Surrealism. Buffie Johnson showed dense, scrawled, and scratched images at the Betty Parsons Gallery. Her imagery had the look of mystical graffiti, something like spirit writing. It is not surprising, then, that Pollock enjoyed them. Hedda Sterne's show closed at Parsons just before Johnson's opened. Thomas Hess began his review ("Hedda Sterne," *Art News,* March 1950, p. 47) of her exhibition by defining her as "the wife of the brilliant cartoonist Saul Steinberg" and saying that "she mirrors her husband's fantasies in more complex mediums." The large reproduction may have helped atone for this, and he did go on to praise her color and her content. *Life* was more supportive, featuring her, Theodoros Stamos, and Jimmy Ernst among the "younger" abstract painters in its March 1950 survey of American art.

13. Hedda Sterne, conversation with the author.

14. Stanley Kunitz, conversation with his wife, the painter Elise Asher, and the author, summer 1985.

15. Donald W. Goodwin, M.D., *Alcohol and the Writer* (Kansas City: Andrews and McMeel, 1988).

16. Baziotes's handwritten notes, Baziotes Papers, Archives of American Art, Smithsonian Institution, Washington, D.C., n.p.

17. William James, quoted in Goodwin, *Alcohol and the Writer,* p. 188.

18. Richard Maney, "Blackmer's Big Scene: Actor in 'Come Back Little Sheba' Discusses the Techniques Involved in Playing a Maniacal Drunkard," *New York Times,* April 2, 1950, p. X3.

19. Still, entry of February 11, 1956, in "Notes by Clyfford Still," *Clyfford Still,* exhibition catalogue, San Francisco Museum of Modern Art, 1976.

20. Author unknown, "Contemporary Art of the United States: Washington," in *Collection of IBM* exhibition at the Palace of Electricity and Communication, Golden Gate Exposition, 1950, n.p.

21. A[lonzo] L[ansford], *Art Digest,* vol. 21, April 15, 1947, p. 22.

22. Still, letter to a friend, May 1951, in the 1976 San Francisco Museum of Modern Art exhibition.

23. All quotations in this section unless otherwise noted are from McChesney, who interviewed all the surviving teachers and students at CSFA in 1945–50: Mary Fuller McChesney, *A Period of Exploration: San Francisco 1945–1950* (San Francisco: Oakland Art Museum, 1973), p. 48.

24. Still, letter to Gordon Smith, Director of the Buffalo Fine Arts Academy, Albright Art Gallery, Buffalo, New York, January 1, 1959, published in the catalogue of the exhibition, *Paintings by Clyfford Still,* November 5–December 13, 1959. Interestingly, the last two lines of Blake's stanza concerning Heaven and Hell were left out of the Albright catalogue, and yet Hubert Crehan, who knew Still well, dwelt on Still's religio-philosophy in these terms in his article, "Clyfford Still: Black Angel in Buffalo," *Art News,* December 1959, which was obviously timed to come out with the show.

25. Ti-Grace Sharpless wrote the following in her introduction to Still's exhibition at the Institute of Contemporary Art, University of Pennsylvania, Philadelphia, October 18–November 29, 1963:

> And so the legend or myth about Still. He is quite rational. So lucid, so tightly logical, that we must say that he is mad, and if madness is to stand outside one's own time and its premises, then perhaps he is.

In the version of this catalogue introduction which Sharpless wrote for the November *Art News,* she put it this way: "Despite the many legends and myths about Still, he is quite rational. . . ."

26. Elisabeth Zogbaum, interview with Garnett McCoy, December 2, 1981, Archives of American Art, Smithsonian Institution, Washington, D.C.

27. Eadie and Ed Dugmore, conversation with the author, winter 1988–89. The painter Ed Dugmore had been a CSFA student of Still's who managed miraculously to maintain his friendship with Still from then through most of Still's years in New York in the fifties.

28. Katharine Kuh, interview with the author, winter 1988–89.

29. John Grillo, conversation with the author, spring 1988.

30. Still, quoted in Thomas Albright, "The Painted Flame," *Horizon,* November 1979, p. 32.

31. Still, from his own "Biographical Chronology," in *Clyfford Still,* ed. John P. O'Neill (New York: Metropolitan Museum of Art, 1979), p. 177.

32. Still, quoted in McChesney, *A Period of Exploration,* p. 36.

33. The dissertation is on file at the Archives of American Art, Smithsonian Institution, Washington, D.C.

34. Clyfford Still, "Cezanne: A Study in Evolution," Masters thesis, State College of Washington, Pullman, Washington, 1935, pp. 4–5.

35. Ibid., p. 6.
36. Ibid., p. 15.
37. Ibid.
38. Ibid., pp. 24–25.
39. Ibid., p. 30.
40. However, the so-called Gothicism of Arthur Dove and Charles Burchfield was a potent presence on the American scene in the thirties, and had to have had an effect on Still. The mystical nineteenth-century American painter Albert Pinkham Ryder must also be considered an important inspirational source for Still.
41. Eugene Goossen, "Painting as Confrontation," *Art International,* vol. 4, no. 1, 1960, p. 39.
42. William Gaw, interview with Lewis Ferbrache, March 6, 1964, Archives of American Art, Smithsonian Institution, Washington, D.C.
43. Still's thoughts parallel those of Barnett Newman, who was equally extreme about creative freedom. The idea of total responsibility for one's actions, one's life, of course, is right in line with then-current Existentialist thinking.
44. Still statement in *15 Americans* exhibition catalogue, The Museum of Modern Art, New York, 1952, p. 22.
45. Rothko also had Turner's situation in mind both when he donated some of his finest paintings to the Tate Gallery, where they were to be shown under conditions he set, and when he tried to establish a fund for older, less successful artists in his will.
46. A few paintings were left to his wife, Pat, and daughters, Sandra and Diane, which they might sell to sustain their lives. It is an option they do not seem to want to entertain.
47. Kuh interview.
48. Albright, "The Painted Flame," p. 26.

MAY

1. Motherwell, interview with Christopher B. Crosman and Nancy E. Miller, in "Speaking of Tomlin," *Art Journal,* Winter 1979, p. 111.
2. Genauer was the only writer at the paper who could have conceivably written the piece, though she has subsequently lost any recollection of having done so. She did, however, phone Jimmy Ernst (one of the few signatories whose work she liked) the day the *Times* scooped her to ask if it had been a publicity stunt.
3. Kees, "Art," *The Nation,* vol. 170, June 3, 1950, p. 556.
4. Mable Dodge, quoted in Janet Hobhouse, *Everybody Who Was Anybody: A Biography of Gertrude Stein* (New York: Putnam, 1989), p. 96.
5. Ibid.
6. Gottlieb, letter to John Baur, curator of the Whitney Museum of American Art when Baur was planning Tomlin's 1957 retrospective, October 23, 1956, Tomlin Papers, Archives of American Art, Smithsonian Institution, Washington, D.C.
7. Ibid.
8. Motherwell, conversation with the author, summer 1987.

9. Motherwell, statement in the exhibition catalogue for *Bradley Walker Tomlin,* Whitney Museum of American Art, 1957, p. 11. Motherwell lost not a few friends as a result of his repeated use of the terms "dandy" and "dilettante" in this statement. Many artists loved Tomlin and resented this disparagement of his profound seriousness about art. Motherwell had told Baur by telephone that he was planning to write about how Tomlin wasn't truly an expressionist, about how little his work had changed in quality despite the change in style, and about his work being "élan into light" since "he was one of the rare joyous spirits in the Abstract Expressionist school."

10. This was his own school of "painting, drawing and theory" at 61 Fourth Avenue, which he opened after The Subjects of the Artists School closed and Studio 35 took over the Eighth Street space.

11. Motherwell, interview with Crossman and Miller, "Speaking of Tomlin," p. 111.

12. Ibid.

13. The nurses who tended him in the hospital after his major heart attack in 1952 noted that he talked about his mother constantly when he was delirious.

14. Excerpted from a very short unfinished undated story by Tomlin, Tomlin Papers, Archives of American Art, Smithsonian Institution, Washington, D.C. Another of three more short drafts of unfinished stories in the Archives of American Art is dated April 24, 1932, Woodstock.

15. Eugene Goossen, "Painting as Confrontation," *Art International,* vol. 4, no. 1, 1960, p. 39.

16. Motherwell, statement *Bradley Walker Tomlin,* p. 11.

17. Kees, "Art," *The Nation,* vol. 170, April 8, 1950, p. 130.

18. Meyer Schapiro does not remember visiting Kline's studio. Kline's *Clockface,* a great 1950 black-and-white painting that was included in his October show at Egan, was reproduced in *Modern Artists in America* with a caption indicating that it was in the Kootz New Talent show, but that is denied by friends of his who remember seeing the show, including Grace Hartigan, who was also included in it.

19. The use of George as a name was also in homage to the great nineteenth-century women writers George Sand and George Eliot.

20. Hartigan in Robert Saltonstall Mattison, *Grace Hartigan: a painter's world* (New York: Hudson Hills Press, 1990), p. 13.

21. David Smith, quoted in Elaine de Kooning, "David Smith Makes a Sculpture," *Art News,* September 1951, p. 47.

22. Smith, interview with Thomas B. Hess, quoted in *David Smith,* ed. Garnett McCoy (New York: Praeger 1973), p. 177.

23. Smith, "Sculpture Is," in McCoy, *David Smith,* p. 200.

24. Smith, filmed interview with Frank O'Hara at WNDT-TV, New York, October 5, 1964. On file at Museum of Modern Art, New York.

25. Dehner was a student at the Art Students League at the time, and she convinced Smith to enroll there, which he did the day after they met. She introduced him not only to the other advanced young artists in her circle but also to the cultural life of the city, taking him to dance recitals, concerts, and the opera. Dance was her special love, and she continued, even at the age of

eighty-seven, to practice it. When they were alone on the farm at Bolton Landing, Smith would ask her, as a special treat, to dance for him. Perhaps something of the lightness, the sense of defying gravity, in his work as well as in hers, was inspired by dance.

26. Dorothy Dehner material is from an interview with the author, spring 1989.

27. Smith, letter to Emmanuel Navaretta, November 1959, in McCoy, *David Smith*, p. 208.

28. Smith, Letter to Edgar Levy, September 1, 1945, in ibid., p. 196.

29. Motherwell, interview with the author, summer 1987.

30. James Joyce, *Finnegans Wake* (New York: Viking, 1939), p. 127.

31. Smith, quoted in McCoy, *David Smith*, pp. 67–68.

32. Ibid., p. 67.

33. Pound completed Fenollosa's "practically finished" manuscript and made a few needed alterations (San Francisco: City Lights, 1936).

34. This is an image painted more than once by Franz Kline, who, unlike David Smith, probably never read Fenollosa's book, but his intuitive grasp of the visually powerful symbol led him to its use anyway.

35. Smith quoted in McCoy, p. 68.

36. Ibid., p. 82.

37. In fact, in this position the "Y" is an equivalent for the Chinese character for man.

38. Smith, quoted by Dehner in Joan Marter, "Dorothy Dehner: Journeys, Dreams and Realities," exhibition catalogue, *Dorothy Dehner, A Retrospective of Sculpture, Drawings and Paintings,* Baruch College, City University of New York, March 15–April 16, 1991.

39. After the dealer's commission, Smith netted three hundred and thirty-three dollars from this sale. It is enormously more difficult for sculptors to sell their work than painters. Even after the general rise of both prices and sales that followed Pollock's death in 1956, Smith was unable to sell some of the best of his small-to-medium-size pieces of the forties for nine hundred dollars. He was even in the red after money was deducted from sales to pay for shipping and moving the work into the gallery for his very last show at the Marlborough Gallery before his death in 1965.

40. "For David Smith 1950," in *David Smith,* Willard Gallery exhibition catalogue, 1950.

41. Margaret Breuning, "Smith's Genetic Metal," *Art Digest,* May 1, 1950, p. 11.

42. Charles Z. Offin, *Pictures on Exhibit,* April–May 1950, p. 12.

43. Smith, "Language Is Image," in McCoy, *David Smith,* p. 79.

44. Thomas Hess, "David Smith," *Art News,* May 1950, p. 50.

45. Herman Cherry, quoted in "David Smith," ed. Cleve Gray, *Art in America,* March–April 1966, p. 44.

46. Gray, "David Smith: Last Visit," *Art in America,* March–April 1966, p. 23.

47. Gray, "Last Visit," p. 26.

48. Smith, quoted in McCoy, *David Smith,* p. 25.

SUMMER

1. Dealer Sam Kootz had begun to export exhibitions of his artists' work to Paris and other European cities in the late forties, but since the work chosen tended to be fairly conservative (Byron Browne and Lee Gatch were his "stars"), the European audience instantly saw it for what it was—late Cubism—and continued to prefer their own versions of this genre.

2. Douglas Cooper, quoted in *The Listener* (London) vol. 44, July 6, 1950, pp. 12–14.

3. Giorgio Morandi, quoted by American painter Nicholas Carone, who viewed the American pavilion with Morandi, Segarini, and Fontana, in Potter, *To a Violent Grave,* p. 125.

4. Bruno Alfieri, "A Short Talk on the Pictures of Jackson Pollock," *L'Arte Moderna* (Venice), June 8, 1950, translation included among the Betty Parsons Papers, Archives of American Art, Smithsonian Institution, Washington, D.C.

5. Perhaps in part because of this line, Alfieri's article was reprinted in the first of the two catalogues Peggy Guggenheim published to accompany the Pollock retrospective exhibition she mounted at the Museo Correr in Venice to coincide with the Biennale. Presumably she had second thoughts about its negative aspects and did not use it in the second catalogue.

6. Pollock, telegram to the editor, *Time,* December 11, 1950, p. 10, after the exhibition to which he refers was opened.

7. Quotations from Rothko's letters to Newman in Newman Papers, Archives of American Art, Smithsonian Institution, Washington, D.C.

8. Newman, filmed interview with Frank O'Hara, WNDT-TV, December 6, 1964, on file at Museum of Modern Art, New York.

9. Eighteen is two nines and it is 1½ feet. The interior surfaces of Newman's last studio were covered with nine-inch linoleum squares. Perhaps this facilitated his proportional number juggling. In addition, since Newman apparently thought in terms of feet rather than inches, 1½ feet would be a handy measurement for him to use.

10. Thomas B. Hess, *Barnett Newman* (New York: Walker, 1969), p. 55.

11. De Kooning has always used housepainter's brushes in his fine art, particularly those short squarish ones about two inches wide.

12. De Kooning's recent, very spare abstractions look amazingly like curvilinear Mondrians. In them the largely uncovered white space of the canvas is articulated by only a few colored units of yellow, blue, and pinkish red.

13. How much de Kooning actually read is not clear. Artist Pat Passlof reported hearing Elaine reading passages of Kierkegaard aloud to de Kooning and pointing out the many parallels between the two men's thinking. Passlof, "1948," *Art Journal,* Fall 1989, p. 229.

14. Willem de Kooning, quoted in Storm de Hirsch, "A Talk with de Kooning," *Intro Bulletin,* vol. 1, no. 1, October 1955, p. 3.

15. Willem de Kooning, quoted in Martha Bourdrez, "De Kooning: Painter of Promise. A Dutch Rebel on His Way to the Top," *The Knickerbocker,* May 12, 1950, p. 8.

16. Willem de Kooning, quoted in Curtis Bill Pepper, "The Indomitable de Kooning," *New York Times Magazine,* November 20, 1983, p. 86.

17. E. de Wilde, *Willem de Kooning,* Stedjlik Museum catalogue of MOMA traveling retrospective exhibition, October 9–November 17, 1968, n.p.

18. Willem de Kooning, quoted in Joseph Liss, "Willem de Kooning Remembers Mark Rothko: His House Had Many Mansions," *Art News,* vol. 78, January 1979, p. 43.

19. Edwin Denby, *Willem de Kooning,* (Madras & New York: Hanuman Books, 1988), pp. 10–12.

20. William MacKay, "Edwin Denby, 1903–1983," *Edwin Denby, Dance Writings,* eds. Robert Cornfield and William MacKay (New York: Knopf, 1986), p. 23.

21. Denby, *Willem de Kooning,* p. 49.

22. The closest paintings to these strange de Koonings are some of the sparest "Metaphysical" paintings done in the teens by the Italians, and the softer, more mystical of the "Purist" abstractions done in Paris in the late twenties and early thirties by Jeanneret and Ozenfant.

23. For the good reason that he used acrobat friends he'd met through Denby as models, as well as because he is here, as always in these years, thinking of Picasso's work. The Russian artist John Graham, whom de Kooning met on one of his pilgrimages through the Metropolitan Museum, also had a decided influence on these paintings, as did Arshile Gorky.

24. Both in Holland and when he first arrived here, de Kooning had a great deal of experience arranging window displays.

25. Willem de Kooning, quoted in Sally Yard, "Willem de Kooning's Men," *Arts,* vol. 56, no. 4, December 1981, p. 137. A photograph of his studio shows it still hanging there in 1950.

26. The poem opens, "The shoulder of a man is shaped like a baby pig," and in the second stanza Denby wrote, "The shoulder hung from his neck (half orchid, half tumor)." All these images flow from de Kooning's paintings and into them. *Edwin Denby: The Complete Poems,* ed. Ron Padgett (New York: Random House, 1986), p. 4.

27. Denby and Burckhardt owned a large painting by a Puerto Rican artist named Valdes who solved this problem the way de Kooning did, by putting the leg in profile parallel to the picture plane while keeping the body frontal. De Kooning liked the picture.

28. Edwin Denby, "My Friend de Kooning," *Art News Annual,* vol. 29, November 1963, p. 88.

29. Elaine de Kooning, quoted in Pepper, "The Indomitable de Kooning," p. 90.

30. They paid his electric bills at times and bought paintings when they could. He also gave them works.

31. The Fried sisters had psuedo-relatives in Arshile Gorky's female subjects, all of whom seem to have enormous soft round eyes.

32. Willem de Kooning, statement at symposium, "What Abstract Art Means to Me," p. 7.

33. Willem de Kooning, quoted in Pepper, "The Indomitable de Kooning," p. 90.

34. Both of these paintings are predominately curvilinear, whereas *Excavation* is full of jagged angles. In its earlier stages, however, curves abounded.

35. Katharine Kuh, "The Story of a Picture," *Saturday Review,* vol. 52, March 29, 1969, pp. 38–39. This is a discussion of *Excavation* and its acquisition by the Chicago Art Institute where Kuh was curator.

36. Bourdrez, "De Kooning . . . ," p. 8.

37. Willem de Kooning, quoted in Pepper, "The Indomitable de Kooning," p. 88.

38. *Attic* may similarly refer to this accumulation of knowledge.

39. Leo Steinberg, "The Eye Is a Part of the Mind," *Partisan Review,* March–April 1953; reprinted in Steinberg, *Other Criteria: Confrontations with Twentieth-Century Art* (New York: Oxford University Press, 1972), pp. 305–6.

40. A 1950 publication *trans/formation,* a "world review" of arts, communication, and environment, espoused the idea that advanced thinkers must see the world openly, dynamically, interactively, and unprovincially in order that the syntheses crucial to the age may be made. This was nuclear age, post-A-bomb, one-world thinking for positive purposes rather than for defense. Words like integrative, whole, organic, community, interdependence, group, relationship, ecological, and cooperative stream through *trans/formation*'s pages, whether it is Laura Thompson writing on self-government in the third world, Buckminster Fuller on his Dymaxion Projection Map of world energy, Hayakawa on the analogy between art and semantics, or Le Corbusier on his "modulor," a new unit of measure based on the human figure and the golden section which he was proposing as a universal replacement for the foot-inch and metric systems which cannot be reconciled. Harry Holtzman and Martin James co-edited *trans/formation: arts communication environment,* 1, 1950.

41. Steinberg, "The Eye Is a Part of the Mind," p. 304.

42. Denby, "Groups and Series," *Complete Poems,* p. 48.

43. Denby, "My Friend de Kooning," pp. 90–93.

44. Willem de Kooning, "The Renaissance and Order," first printed in *trans/formation,* vol. 1, no. 2, 1951; reprinted in Thomas B. Hess, *Willem de Kooning* (New York: Museum of Modern Art, 1968), pp. 141–43.

45. Denby, "Mid-day Crowd," *Complete Poems,* p. 75.

46. Willem de Kooning, interview with David Sylvester, excerpted in "Content Is a Glimpse . . ." *Location,* Spring 1963, p. 50.

47. Jane Bowles, *Two Serious Ladies* (New York: Farrar, Strauss & Giroux, 1943).

48. Probably the most compelling image in *Two Serious Ladies* is that of a female "basket baby," a lady who is "like a broken doll. She has neither arms nor legs." Andy, the man telling Miss Goering about her, said she was a natural blonde with marcelled hair who was "nicely made up and wearing a very pretty, clean blouse pinned in front with a brooch shaped like a butterfly." Andy hears the "broken doll" tell someone that her appetite improves all the time and that she sleeps fourteen hours a day. "After that I began to notice her mouth," he says. "It was like a rose petal or a heart or some kind of a little shell. It was really beautiful." Then he becomes obsessed with curiosity about her body. By the time he finally satisfies this curiosity his life has been ruined by his obses-

sion, and, as a result of the sex act which was consummated, he comes down with syphilis. It's impossible not to think that de Kooning would have been fascinated by the "basket baby."

49. De Kooning quoted in E. de Wilde, Stedjlik catalogue, n.p.

50. Of course there is also Rembrandt's touching portrait of his beloved wife Saskia wading in water with her chemise lifted above her knees.

51. Elaine de Kooning, quoted in Pepper, "The Indomitable de Kooning," p. 70.

52. Willem de Kooning, quoted in ibid., p. 66.

53. Elaine de Kooning, quoted in ibid., p. 66.

54. Rudy Burckhardt, interview with the author, October 1989.

55. Elaine de Kooning, quoted in Pepper, "The Indomitable de Kooning," p. 70.

56. Willem de Kooning, quoted in ibid., p. 90.

57. Kligman went on to have an affair with Franz Kline.

58. Milton Resnick, a painter de Kooning had known since 1938, was so in thrall to de Kooning at mid-century that his paintings can easily be mistaken for de Kooning's. Toward the end of the fifties Resnick detached himself sufficiently to make forceful statements in his own manner. Another artist, Harold Shapinsky, who seems to have studied at the Subjects of the Artists School before becoming an acolyte of de Kooning, also worked in an extremely imitative way in the early fifties. Unlike that of Tworkov or Resnick, however, the quality of his work never came close to de Kooning's, and he was never able to evolve out of his "de Kooning phase" into an effective personal style. Artists as currently diverse as Michael Goldberg, Al Leslie, Joseph Stefanelli, Robert Beauchamp, Grace Hartigan, and Larry Rivers were all dramatically affected by de Kooning's paint handling at some point as well.

59. Tworkov's sister, Biala, who named herself after the town in which they were born, is a painter who lives in Paris. She took part in the artist's roundtable discussions at Studio 35 in April 1950.

60. Willem de Kooning, interview with James T. Valliere, "De Kooning on Pollock," *Partisan Review,* vol. 34, Fall 1967, p. 604.

61. Elaine de Kooning, quoted in Potter, *To a Violent Grave,* p. 122.

62. Willem de Kooning, interview with Valliere, pp. 104–5.

63. Willem de Kooning, quoted in Potter, *To a Violent Grave,* p. 163. Actually, Equanil, the tranquilizer Dr. Heller gave Pollock, did seem to help. It was the only treatment Pollock had, besides talking with Heller, that kept him on the wagon for those crucial two years, 1948–50. We recall Kline's remark in defense of Still, that, no matter what, he was a painter.

64. Quoted in Steven Naifeh and Gregory White Smith, *Jackson Pollock: An American Saga* (New York: Clarkson Potter, 1989), p. 658.

65. Nick Carone, quoted in Potter, *To A Violent Grave,* p. 195.

66. Nick Marsciano, interview with the author, February 29, 1987.

67. Carone, quoted in Potter, *To a Violent Grave,* p. 195.

68. Robert Motherwell, quoted in ibid., p. 220.

69. Robert Creeley, "Bill the King," *Art Journal,* Fall 1989, p. 237.

70. The only larger canvas was a backdrop he once created for a dance perfor-

mance—and backdrops don't count in this battle over painting size. Kline also painted a backdrop which was even larger than his "painting wall" paintings. These works are not on canvas, but were painted directly on the homosote studio walls, usually in a burst of nighttime creativity like that of *New Year's Night Wall* which he started and finished one New Year's night after the art-supply stores were closed. Much has been written about the influence of the Mexican muralists and the WPA mural projects on the immense scale of the Abstract Expressionists, but Kline is the only one to paint true wall-size pictures on the walls themselves, and he did not come under either influence. He did, however, paint a number of barroom murals in his youth.

71. De Kooning had taken it off the stretcher and rolled it up for storage in complete disgust with it, but art historian Meyer Schapiro begged to see it, and upon doing so, pronounced it a worthy painting. De Kooning came to agree with him, though more changes of a minor nature were made up until the very moment the restretched canvas was being loaded on the truck for its exhibition at the Sidney Janis Gallery in 1953.

72. Henri Matisse, quoted in Alfred H. Barr, *Matisse: His Art and His Public* (New York: Museum of Modern Art, 1951), p. 260.

73. Interestingly, Pollock's white-on-black paintings of this period almost look like imitations of Gjon Mili's photographs of Picasso with the light.

74. Hans Namuth, "Photographing Pollock," *Pollock Painting* (New York: Agrende Publications, 1978), n.p. Unless otherwise indicated, all further quotations by Namuth come from this source. Krasner's statement that Namuth was the first outsider to watch Pollock paint is not true. In fact, both Arnold Newman and Martha Holmes had taken pictures of Pollock at work in 1949. Holmes's photographs appeared in the August 8 article in *Life* titled, "Jackson Pollock: Is He the Greatest Living Painter in the United States?" Rudolph Burckhardt also took pictures of Pollock in the studio just before Namuth did in the summer of 1950. *Number 32, 1950,* is visible against one wall of the studio in Namuth's subsequent photographs. It was already finished when Burckhardt arrived at the studio to photograph Pollock working on a painting for a projected *Art News* article, "Pollock Paints a Picture," with its author, Robert Goodnough. They went into the studio to look at the picture, which was then still lying on the floor. Pollock said he wasn't sure it was finished, but he didn't work on it. Instead he pretended to do so with a can of black paint in one hand and a stick in the other, no paint on the stick. Since it is next to impossible to see the paint coming off the stick anyway, the pretense worked, but the results don't have the emotional power of Namuth's real action pictures. Only if one compares the finished work with Burckhardt's photographs can it be seen that Pollock changed nothing. Namuth's photographs of Pollock painting *Autumn Rhythm* early that fall were used in the article instead.

75. Namuth, quoted in Friedman, *Jackson Pollock,* p. 162.

76. Parker Tyler, "Jackson Pollock: The Infinite Labyrinth," *Magazine of Art,* March 1950, pp. 92–93. It might be worth noting here that during the only genuinely happy period in Pollock's youth, the four years the family lived on a farm outside Phoenix, he and his brothers slept outside under the stars every night it didn't rain, when the weather was warm.

77. Ibid., p. 93.

78. Actually, this is two statements D89 and D90, since the first two parts are on a separate sheet. "Documentary Chronology," O'Connor, *Catalogue Raisonné,* vol. 4, p. 253.

79. Jackson Pollock, "My Painting," *Possibilities 1,* p. 79.

80. Lawrence Shainberg, "Finding the Zone," *New York Times Magazine,* April 9, 1989, pp. 36, 39.

81. Lee Krasner was very interested in these subjects as well and probably also read these books. They apparently talked a great deal about mysticism and Oriental religions.

82. D. T. Suzuki, "Introduction," in Eugen Herrigel, *Zen in the Art of Archery* (New York: Vintage, 1989), p. viii–ix.

83. Herrigel, "Zen in the Art of Archery," p. 55.

84. Krasner, quoted in Barbara Rose, "Jackson Pollock at Work: An Interview with Lee Krasner," *Partisan Review,* no. 1, 1980, p. 90. Interesting in this regard is that Namuth's black-and-white "test" film shows that the paint formed trailing patterns that hovered over the canvas before falling down and settling on it to leave traces of their passage. See his friend Jim Fasanelli's description in Namuth "Photographing Pollock," in *Pollock Painting* (New York: Agrende Publications Ltd., 1978), n.p.

85. The Vashtis were deeply involved with Hindu dance and philosophy.

86. Betty Parsons, interview with Francine du Plessix and Cleve Gray, in "Who Was Jackson Pollock?" *Art in America,* vol. 55, May–June 1967, p. 55.

87. Tony Smith, interview with du Plessix and Gray, "Who was Jackson Pollock?" p. 54. Tony Smith had met Pollock at Fritz Bultman's Eleventh Street apartment. Tennessee Williams and "Fred" were there at the time as well. Smith had seen Pollock's paintings and thought they were "schmaltz" (too expressionistic). When he saw Pollock, "he was so sullen and intense, so miserable, that I said to myself, 'I've got to get out of here. I can't stand that guy.'" But when they met again in 1949, it was the start of a close, lifelong friendship. Despite a diabetic condition, Smith became at least as intense an alcoholic as Pollock, but they were more than drinking buddies. Smith, a fount of esoteric information, sometimes interpreted Pollock's dreams for him, and he introduced him to books that might answer some of his questions, like D'Arcy Thompson's *On Growth and Form.* When Bultman first met Pollock through fellow Hofmann student Lee Krasner, he thought that "here is a human being in anguish; there was always a plea for help in his behavior." Bultman said,

> Tony was the man I feel I handed Jackson over to when I introduced them. With his knowledge as an architect, he was the perfect person for Jackson; also he was a person Jackson could relate to, a man equally tormented, equally in hell. (Potter, p. 123.)

88. Pollock's numbering system was not consecutive. *Number 32* and *One: Number 31* can be seen against the walls while he begins working on *Autumn Rhythm: Number 30.*

89. With his back to the window as he faced the canvas before him on the floor,

Pollock had *Number 32, 1950* on his right, *One, Number 1, 1950* on his left and *Number 1, 1949* is adjacent to it on the opposite wall next to the door. *Lavender Mist,* completed early in the year, was moved sometime during the summer from in front of *One* to the lean-to entrance area. The big ladder, which was the only way to get to the hayloft or to view the painting from above, and other studio paraphernalia are on the other side of the door.

90. Frank O'Hara, *Jackson Pollock* (New York: George Braziller, 1959), p. 26.

91. Allan Kaprow, "The Legacy of Jackson Pollock," *Art News,* October 1958, p. 56.

92. Namuth is no longer certain that the last day of filming was in late October, as he had thought, instead of November, as most of the other participants insist. He does remember a turkey, but is sure it wasn't Thanksgiving. Others present say the dinner was a few days after Thanksgiving because Namuth wasn't able to be there on that Thursday. Some of the convincing recollections which tie the event to late November are cued to recalling Pollock's negative reactions to the November 20 piece in *Time* in which the Italian critic Bruno Alfieri was quoted saying that Pollock's work is all about chaos.

93. Hans Namuth in telephone conversation with the author, spring 1989.

94. Much disagreement exists about the date of this party and its guest list. I have omitted Elisabeth and Wilfred Zogbaum because Mrs. Zogbaum denies that they were present, though every other account includes them.

95. Arthur Rimbaud, *A Season in Hell & The Drunken Boat,* trans. Louise Varese (New York: New Directions, 1961), p. 15.

96. Krasner, quoted in Eleanor Munro, *Originals: American Women Artists* (New York: Simon & Schuster, 1979), p. 112.

97. Ibid., p. 112.

98. Krasner, quoted in Barbara Rose, *Lee Krasner: A Retrospective* (New York: Museum of Modern Art, 1983), p. 98.

99. Krasner, quoted in Munro, *Originals,* p. 114.

100. Krasner had begun psychoanalysis in an effort to deal with the effect Pollock's drinking was having on her.

101. Krasner, quoted in Rose, *Lee Krasner,* p. 95.

OCTOBER

1. William Faulkner, quoted in Paul Boyer, *by the Bomb's Early Light* (New York: Pantheon, 1985), p. 251.

2. Boyer, ibid., p. 15.

3. "Westerners in Berlin for Culture Parley," *New York Times,* June 26, 1950, p. 12.

4. The alliance of liberal intellectuals with Communism in the thirties and forties was now deemed "twenty years of treason." In fact, on September 23, 1950, Congress overrode President Truman's veto of the Mundt-Nixon Bill and the McCarran Act, which placed severe restrictions on Communists, particularly during emergencies, but also requiring them to register and forbidding their immigration into the U.S. (Truman thought the law unconstitutional as well as impractical. It would be like trying to get thieves to register with the sheriff, he said.)

5. James Agee, "Religion and the Intellectual I," (a three part symposium with many participants) *Partisan Review,* February 1950, p. 110.

6. Auden, ibid., pp. 126–27.

7. Arthur B. Carles, an American Hofmann met in Paris in the first decade of the century, was an early disciple of Fauvism and a marvelous colorist. He was very important to Hofmann, who later dedicated a painting to him. (Unfortunately for Carles, few in American art were as astute as Hofmann in evaluating his abilities.)

8. Typewritten statement in author's files accompanying the exhibition "Post-Abstract Painting 1950—France—America," Provincetown Art Association, August 6–September 4, 1950.

9. A reciprocal exhibition of sorts, *Réalités Nouvelles,* including many of the artists in the Provincetown show, was held in Paris in the summer of 1950 at the Palais des Beaux-Arts de la Ville de Paris.

10. Henry McBride, "International Revival," *Art News,* October 1950, pp. 15–17.

11. The moderator was Theodore Brenson, a painter who worked in the Abstract Expressionist mode, whose son, Michael, was later an art critic for *The New York Times.*

12. Hans Hofmann, *The Painter and His Problems,* a manual dedicated to painting, March 23, 1963, a typescript of which is in the author's library.

13. Lillian Kiesler, conversations with the author, November 1989.

14. Though his earliest biographer, Bartlett H. Hayes (the source for most of this information on Hofmann's early life), claims they were married at this time, all subsequent chroniclers give their wedding year as 1929.

15. Wassily Kandinsky, "Autobiography," *In Memory of Wassily Kandinsky,* exhibition catalogue, Solomon R. Guggenheim Museum, March 15–May 15, 1945, p. 65.

16. Peg Weiss, "Wassily Kandinsky: The Formative Munich Years (1896–1914): From Jugendstil to Abstraction" (Ph.D. diss., Syracuse University, 1973), p. 41.

17. Hans Hofmann, "Excerpts from the Teaching of Hans Hofmann," *Search for the Real and Other Essays by Hans Hofmann,* eds. Sara T. Weeks and Bartlett H. Hayes, Jr. (Cambridge, Mass.: MIT Press, 1967), p. 50.

18. Ibid.

19. For an excellent overview of these theories see Linda Dalrymple Henderson, *The Fourth Dimension and Non-Euclidean Geometry in Modern Art* (Princeton: University Press, 1983).

20. Delaunay's group also termed themselves Simultaneists and Synchronists to stress the simultaneous or synchronous fusion of colored light and movement in their work.

21. Hofmann, "Art in America," *Art Digest,* August 1930, p. 27.

22. Hofmann's esthetic philosophy suggests the Germanic concepts of spirit, or *Geist,* and *Einfühlung,* which involved intuition or profound insight—ideas embodied in Worringer's fascinating 1908 study of the psychology of style, *Abstraction and Empathy,* trans. Michael Bullock (New York: International Universities Press, Inc., 1948.). Worringer defined esthetic enjoyment as "objectified self-enjoyment":

To enjoy aesthetically means to enjoy myself in a sensuous object diverse from myself, to empathize myself into it. What I empathize into is quite generally life. And life is energy, inner working, striving and accomplishing. In a word, life is activity. (p. 5)

By activity Worringer meant a willed expenditure of energy, and the word had substantially the same import for Hofmann.

23. Hofmann, "Excerpts from the Teaching," p. 59.

24. This function lessened in importance over the years as his command of English improved.

25. Kiesler conversations with the author.

26. Hofmann dedicated one of his finest paintings, *Memoriam in Aeternae,*1962, to Carles, Gorky, Tomlin, and Pollock—the deceased American artists he respected the most. Mercedes Carles whom, Hofmann's friends believe, he would have liked to marry, developed into a fine painter and a marvelous draftsman, obviously inspired by Hofmann's style. She married Herbert Matter, a photographer.

27. He purchased works by Miró and encouraged his students to do so as well. Many of his protégés acquired watercolors by the Spanish painter for a mere ten dollars each as a result.

28. Various non-ABEX artists used and exhibited "drip paintings" prior to Pollock, among them Janet Sobel and David Alfaro Siqueiros, both of whom may well have inspired Pollock to try the technique. Many of the Surrealists who used automatist methods, including Miró, Masson, Ernst, and Matta, influenced the young Americans to try it in the early forties. Pollock, Baziotes, Kamrowski, Motherwell, and their wives even got together to work on a collaborative painting in the tradition of the "Exquisite Corpse" where each added to a previously done section they hadn't seen.

29. Mike Doyle paints big pictures—ten by fifteen feet and curling out on the floor. A kind of discontented existential hero, probably based on Jackson Pollock, he struggles constantly but loses out again and again to drink and to the dark, brutal forces in his psyche. *Evil Under the Sun* is chockful or 1950 psychojargon about phallic symbols, paranoias, phobias, complexes, and neuroses, words which each of the protagonists uses to bait the others in theatrically clashing dialogues. Doyle, for example, is described by a fellow art student as having "a Van Gogh complex with a *New Masses* inversion." The vicious banter never ceases, whether the setting be studio, beach, or bayside deck. Male intellectual and artistic superiority is rampant in the book. It is linked to the idea of freedom—free sex (to the point of justifying rape), free genitality (one shouldn't be so ashamed of one's body that one closes bathroom doors), and freedom of action (no matter what the consequences for others). Some people are simply superior and deserve to have power over others, to wreak their will at will. These extremes of self-centeredness seem to be engendered by the constant self-analysis going on among the characters. Today it is next to impossible to believe that one person might berate another for hiding behind his neurotic inhibitions by asking, "How on earth are you ever going to transcend the Oedipus legacy unless you free your own psyche?" Yet, Myrer isn't likely to

have made up the dialogue out of whole cloth. We've forgotten how drenched in Freud those days were. Most art students, and artists for that matter, read Freud's *Totem and Taboo* when its translation appeared in 1950, but they were familiar with his early work and many were in analysis themselves. Pollock was, for most of his life, and even Robert Motherwell semi-seriously considered making a choice between moving to Europe and entering analysis when he was disgusted with life in America, just after the war.

30. Elaine de Kooning, "Hans Hofmann Paints a Picture," *Art News,* vol. 48, February 1950, pp. 38–41, 58–59.

31. John Coplans writes in his introduction to *Andy Warhol* (England: New York Graphic Society, 1978), p. 12, that Warhol was "desperate" to get into the Pop scene in 1962, but couldn't find New York representation, all the major galleries interested in this work having already taken on their Pop artists. His breakthrough Campbell's soup can paintings were shown in July at Irving Blum's Ferus Gallery in L.A. instead, and the stir they caused there put him on the Pop map anyway.

32. Here is Jean Cocteau's description of Nijinsky in this ballet: "Exulting in his rosy ecstasy he seems to impregnate the muslin curtains and take possession of the dreaming girl. It is the most extraordinary achievement. By magic he makes the girl dream she is dancing and conjures up all the delights of the ball. After he has bid a last farewell to his victim he evaporates through the window in a jump so poignant, so contrary to all the laws of flight and balance, following so high and curved a trajectory, that I shall never again smell a rose without this ineffaceable phantom appearing before me." Quoted in Richard Buckle, *Nijinsky* (New York: Simon & Schuster, 1971), p. 189.

33. James Fitzsimmons, "Franz Kline,"*Art Digest,* November 1, 1950, p. 20. He went on to denigrate the paintings, but his feelings were not shared by the artists, and doing so only served to make Kline a hero in their eyes.

34. Kline probably didn't even meet de Kooning until 1943, when a mutual friend, the painter Conrad Marca-Relli, introduced them. They didn't become close until the later forties.

35. Kline gave up the elaborate frames he liked so well around his early works when he shifted into abstraction. At that point his sensitivity to the function of the frame resulted in his invention of a simple metal strip to cover the stretcher edges fashioned out of kitchen countertop edging. Later this basic approach was transformed into the flat aluminum strip frame that has become ubiquitous on contemporary art.

36. Apparently Kline was very much involved with Elisabeth Zogbaum at this time and was torn between his love for her and his feelings of marital responsibility to Elizabeth. It was Elizabeth Kline who made the decision not to attempt to reestablish a marital relationship with Kline.

37. Squares also figure in the construction of both the rocking chair and the easel, of course.

38. Elaine de Kooning, "Franz Kline," *Franz Kline Memorial Exhibition,* Washington Gallery of Modern Art, Washington, D.C., October 23–December 27, 1962, p. 15.

39. Herman Somberg, a close friend of both Kerkam and Kline, was in and out

of their studios frequently in these years. He was also a good friend of Willem de Kooning. Somberg was a very talented artist who was helpful and supportive to Kline in his transition from representation to abstraction. Conversations with him about Kline over the years have provided some of the material in this chapter.

40. Kline became friendly with them when he put his carpentry skills into practice in 1949 by building a partition between their studios in a loft they were sharing on University Place in the Village.

41. Pete Hamill, "Beyond the Vital Gesture," *Art & Antiques,* May 1990, p. 113.

42. Tom Hess, "The Convertible Oyster," *New York,* April 7, 1975, pp. 68–69.

43. It may or may not be significant that he used the Brooklyn telephone directory more often than the Manhattan book in light of the personal sadnesses associated in his mind with Brooklyn.

44. Kline, quoted in Hamill, "Beyond the Vital Gesture," p. 115.

45. Perhaps there is a parallel to be drawn here between his take them as they come attitude toward people and this open acceptance of accident in his work.

46. Ernest Fenollosa, *The Chinese Written Character as a Medium for Poetry,* ed. Ezra Pound (San Francisco: City Lights, 1936), pp. 42–43.

47. Ibid., p. 9.

48. Ibid., p. 28.

49. Kline, quoted in Frank O'Hara, "Franz Kline Talking," *Evergreen Review,* Autumn 1958, pp. 58–64. Reprinted as "Introduction and Interview" in O'Hara's *Art Chronicles 1954–1966* (New York: George Braziller, 1975), p. 50.

50. Hamill, "Beyond the Vital Gesture," p. 112.

51. Lee Konitz, quoted in Whitney Balliett, "Ten Levels (Lee Konitz)," *American Musicians, 56 Portraits in Jazz* (New York: Oxford University Press, 1986), p. 379.

52. Dan Rice, conversation with the author, January 1990.

53. Joan Ward, Nancy's twin sister, had been romantically involved with de Kooning for a couple of years before this and was probably staying somewhere nearby. Kline and de Kooning took quite a bit of ribbing for this brotherly closeness.

54. The "Red House" was an old brownish-red building on Main Street in Bridgehampton, Long Island, where Kline and de Kooning spent the summer of 1954. The outhouse three-hole privy seat was "marbelized" in their fashions by de Kooning and Kline as a joke one day during a croquet party on the lawn. It is now the subject of considerable controversy as to its value as an art object mainly because Pollock is alleged to have painted it as well.

55. Fielding Dawson, *The Black Mountain Book* (New York: Croton Press, 1970), footnote pp. 151–52.

NOVEMBER

1. James Thrall Suby, quoted in Robert Goldwater, "A Symposium: The State of American Art," *Magazine of Art,* March 1949, p. 83.

2. The series was terminated with the loss of its financial support when Schultz of Wittenborn-Schultz suddenly died.

3. Michel Seuphor, "Paris-New York 1951," *Art d'aujourd'hui,* June 1951, reprinted in *Modern Artists in America,* p. 121.

4. Motherwell, quoted in P.B., "Motherwell: A Profile," *Art Digest,* October 1, 1951, p. 6.

5. He didn't visit Spain until 1958, but had spent a great deal of time in Mexico (like many California artists) and the three locales seemed to fuse in his mind. Esteban Vicente, a Spaniard and fellow Abstract Expressionist excoriated Motherwell in print for his adoption of things Spanish—causes as well as climate and color—when he had no real experience of them. Motherwell responded as one might expect, by saying, in effect, that you don't have to be Jewish to paint movingly about the Holocaust. He might have added that Leonardo wasn't present at the Last Supper, but we don't value his painting of the subject any less for that.

6. Jonathan Feinberg, "Death and Maternal Love: Psychological Speculations on Robert Motherwell's Art," *Artforum,* September 1978, pp. 52–57.

7. Motherwell, conversation with the author, 1979 or 1980. The artist did not want to elaborate on it, saying he didn't remember the incident clearly.

8. He did paint small landscapes and still lifes in the French post-Impressionist manner while in Paris and actually exhibited them in a gallery there, but he subsequently disowned and/or destroyed them.

9. If Motherwell happened to have seen his friend Matta's 1944 painting, *The Onyx of Electra,* he may have noticed the black form floating in the foreground —a "roof" supported by two verticals, each of which sports a bulbous black protuberance. It, and a "painting" located deep in the background featuring ovals between verticals, are very close to Motherwell's *Elegy* schema. It is highly unlikely, however, that he would have recalled them four years later when he was designing the first *Elegy* image to accompany an American poet's words and his friendship with the Surrealist was a thing of the past.

10. Saul Bellow, *Humboldt's Gift* (New York: Penguin, 1975), pp. 12–13.

11. Motherwell, interview with Paul Cummings, quoted in Naifeh and Smith, *Jackson Pollock,* p. 424.

12. Unattributed original prospectus for *VVV,* quoted by Kynaston McShine, in his "Chronology," in Frank O'Hara, *Robert Motherwell* (New York: Museum of Modern Art, 1965), p. 74.

13. A favorite pastime of the Surrealists was observing praying mantises as they copulated. Following the act, the females devoured the males. A 1934 painting by André Masson of this subject was actually titled *Summer Divertissement.*

14. Motherwell, quoted in Naifeh and Smith, *Jackson Pollock,* p. 423.

15. The likeness of the window to the apertures in Trotsky's fortified house in Coyoacán, Mexico, may be significant. Motherwell was surely aware of the role artists Frida Kahlo and Diego Rivera had played in the Russian's Mexican exile.

16. Hemingway's 1932 novel about bullfighting, *Death in the Afternoon,* can only have reinforced the connections between love, sex, and death at this time.

17. Robert Hobbs, "Motherwell's Concern with Death in Painting," (Ph.D. diss., University of North Carolina at Chapel Hill, 1975).

18. Another factor in the development of Motherwell's "Spanish" style was

seeing Sergei Eisenstein's film, *Thunder Over Mexico*. As Robert Hobbs has pointed out in his dissertation, there are many parallels between Eisenstein's stylizations and Motherwell's *Elegies*: powerful black and white contrasts; a well-developed sense of ritual; an interest in atavism; and, lastly, Eisenstein's habit of prolonging the focus on "compositions" in which dark plant forms are silhouetted across the foreground in front of the action.

19. Motherwell, quoted in Hobbs, "Motherwell's Concern with Death in Painting," p. 127.

20. For an inside look at this world see Max Ernst's son Jimmy Ernst's account of his father's milieu in *A Not So Still Life* (New York: St. Martin's/Marek, 1984).

21. Motherwell, quoted in Naifeh and Smith, *Jackson Pollock*, p. 426.

22. Roger Wilcox's remembrance in Naifeh and Smith, p. 531.

23. Motherwell, quoted in E. A. Carmean, Jr., "Robert Motherwell: The Elegies to the Spanish Republic," *American Art at Mid-Century: The Subjects of the Artists*, exhibition catalogue, National Gallery of Art, Washington, D.C., 1978, p. 98 and n. 14.

24. A color postcard of Mejías, Motherwell's most prized souvenir, was always tacked up in his studio.

25. Lament for Ignacio Sánchez, in *The Selected Poems of Federico García Lorca*, trans. Stephen Spender and J. L. Gili (New York: New Directions, 1955), pp. 134–36.

26. Mejías was a much beloved matador whose period of fame lay between the great Joselito, who died in 1920, and Manolete, who first appeared in 1939. Mejías was somewhat overshadowed by a third bullfighter of the period, Belmonte, whose crude courage made Mejías's more traditionally elegant style seem slightly out-of-date, but he was admired almost as much as those three greatest of all great matadors. The ritual of man against bull—human courage against animal brutality, life against death—is directly linked with ancient pagan sacrifices. The matador wears a "suit of lights" to battle the black bull and when he falls beneath the massive darkness of the animal's bulk he is usually gored in the groin, the area of his greatest vulnerability. In parallel symbolic ritualization, the testicles of a bull that had been especially difficult to kill are cut off and hung on the bullring wall. The fleeting beauty of the matador's dance of death redeems the brutality of life. Ignacio Sánchez Mejías was one of the last of the heroic, refined matadors, and so his death took on a poignant as well as mythic quality for Lorca.

27. Lorca, quoted in L. R. Lind, Introduction to *The Gypsy Ballads of Federico García Lorca*, trans. Rolfe Humphries (Bloomington: Indiana University Press, 1953), p. 11.

28. Lorca, *Dead of Love*, in *The Gypsy Ballads*, p. 46.

29. Motherwell was a member of the Longpoint cooperative gallery in Provincetown, where the artists, all mature and with extensive bodies of work behind them, liked to challenge themselves with stimulating exhibition themes. When they were supposed to select some objects (artistic or otherwise), which they felt were especially important to their esthetic, Motherwell's inclusion was a confectioner's silver mold for casting chocolate Easter eggs.

30. Lorca, Lament for Ignacio Sánchez, in *Selected Poems*, p. 139.

31. The connection between love and sexuality generally goes unquestioned, but the link between death and sexuality passes reason to enter the realm of the unconscious and mythic explored by Freud and Jung and so many others. Sir James George Frazer makes it central to all mythology in *The Golden Bough,* a book Motherwell has said he and his contemporaries regarded as virtually a sacred text. In fact or in effect, sexual rites precede or accompany sacrificial ceremonies in most of the world's "pagan" religions. Surrealists like André Breton, Michel Leiris, and George Bataille were obsessed with the extremes of love and death: sex and violence. Years later, when Bataille compiled his life-long researches in this area into a book entitled *Death and Sensuality,* he made the Marquis de Sade's statement that "there is no better way to know death than to link it with some licentious image" the touchstone of his text. Salvador Dali's jeweled putrescences, Andre Masson's praying mantises devouring their mates after coition, Max Ernst's terrifying 1927 canvas, *One Night of Love,* Victor Brauner's bizarre anatomical metamorphoses, Hans Bellmer's mutilated dolls—almost all the Surrealists, even Picasso, when he passed through this phase, and gentle Miró—explored the "licentious image."

32. Dore Ashton, "Art," *Arts and Architecture,* vol. 76, no. 5, May 1959, p. 6–7.

33. Motherwell, "The Significance of Miró," *Art News,* vol. 58, no. 4, May 1959, p. 65.

34. Kline, quoted in Harry Gaugh, *The Vital Gesture* (New York: Abbeville Press, 1985), p. 88.

35. He lost it in the settlement of his divorce from Helen Frankenthaler.

36. Perhaps his security on a small scale goes back to the fact that the very first paintings he made were tiny. These were done in the late thirties of traditional subjects, landscape and still life, and are no longer extant. In 1940, when he declared his commitment to the artist's life, he abruptly and completely jettisoned this former conservative approach.

37. Motherwell statement in *Motherwell: First Exhibition of Paintings in Three Years,* Kootz Gallery exhibition catalogue, November 14–December 4, 1950.

38. In 1950 Motherwell edited the "Documents of Modern Art" publication *Dada Painters and Poets: An Anthology,* a book about artists whose work was often based on chance. His familiarity with chance as a generating tool for art dated back even before his involvement with the Dadaists and the Surrealists, however; it dated to his study of the French Symbolist poets. Mallarmé's title *"Un coup de des"* was obviously the source for his frequent use of the phrase in French about his own work.

39. Motherwell, filmed interview by David Sylvester, British Broadcasting Corporation, October 22, 1960.

40. "Letter from Robert Motherwell to Frank O'Hara dated August 18, 1965," *Robert Motherwell* (New York: Museum of Modern Art, 1965), p. 70.

41. Dore Ashton, *Yes, but . . . A Critical Study of Philip Guston* (New York: Viking, 1976), p. 87.

42. In a Woodstock concert hall in 1952, John Cage's *4' 33"* was performed. It consisted of four minutes and thirty-three seconds of silence, punctured three times by the seated pianist making certain arm gestures at the keyboard which suggested the ends of movements. Accidents of ambient noise provided the

unintentional musical sounds of the piece. This concert and his book, *Silence,* are the two things for which Cage is best known.

43. The Holocaust offered much more stimulation to literary than to visual artists; for them the bomb provided a monolithic image of power and violence which was more profoundly metaphorical.

44. Philip Guston, quoted in Ashton, *Yes but . . . ,* p. 84.

45. This and all subsequent unattributed statements by Guston are from an interview with the author, February 1980.

46. Robert Motherwell, "Beyond the Aesthetic," *Design,* vol. 47, 1946, pp. 14–15.

47. Guston's November 1950 exhibition at the Peridot Gallery was not officially a one-man show. For the holidays, the gallery put on a group of mini-exhibitions by some of its artists, including, besides Guston, his friend James Brooks, and Esteban Vicente. Vicente's exhibition seems to have been a carryover from a larger show the previous month.

48. Quoted from an unknown source in H. H. Arnason, *Philip Guston,* exhibition catalogue, Solomon R. Guggenheim Museum, 1962, p. 20.

49. Sam Hunter, quoted in Gaugh, *The Vital Gesture,* p. 179.

50. This talk was written, Cage claims, in the same rhythmic structure as his music, and it caused a similar reaction in his audience. At one point halfway through the literally spaced-out, highly repetitive "talk," mosaicist-sculptor Jeanne Reynal, a friend of Cage's, stood up and screamed. Then, while he continued speaking, unperturbed, she said, "John, I love you dearly, but I can't bear another minute," and walked out.

51. He changed his name later, around the time of his marriage to Musa McKim, perhaps to please his non-Jewish future in-laws or because of the rising anti-Semitism he sensed around him. He later regretted having done so, and felt quite guilty about it.

52. The Montreal of Guston's first six years was recaptured by Saul Bellow in *Herzog;* the Los Angeles in which he grew up was pictured by Nathanael West in *The Day of the Locust.* Guston and West became acquainted during Guston's years as a Hollywood extra.

53. Toward the end of his life Guston painted piles of limbs, albeit complete with wristwatches and footwear, which hark back to this art school misbehavior.

54. Erwin Panofsky, *The Life and Art of Albrecht Dürer* (Princeton: University Press, 1971), p. 168.

55. Musa joined him there for a few months, repairing whatever estrangement they might have felt, but, by leaving her daughter home, opened up a wound in her daughter that doesn't seem, from Musa Mayer's memoir, ever to have completely healed.

56. W. H. Auden, "Ischia," *Auden: Collected Poems,* Edward Mendelsohn, ed. (New York: Vintage International, 1976), p. 543.

57. Mercedes Matter, quoted in Musa Mayer, *Night Studio: A Memoir of Philip Guston by His Daughter* (New York: Knopf, 1988), pp. 65–66.

58. According to Musa Mayer, the writer Philip Roth, Guston's close friend, based the first of his Zuckerman novels and his 1979 book *The Ghost Writer* in part on her parents. Roth admitted to her that what he was thinking of was their

situation. "I did know something about being alone with a mate and this art obsession," he said. "It's like being a religious zealot," (pp. 176–77).

59. Kramer, "A Mandarin Pretending to Be a Stumblebum," *New York Times,* October 25, 1970, p. B27.

60. Guston, quoted in Kay Larsen, "From Abstraction to the Absurd: The Transformation of Philip Guston," *Real Paper* (Boston), April 3, 1974, p. 21.

61. Hess, "The Abstractionist Who Came In from the Cold," *New York Magazine,* December 9, 1974, p. 102.

62. Guston told the author this story during an interview shortly before his death.

63. Belle Krasne, "Expressionism, Abstraction, Surrealism Predominate at the Whitney," *Art Digest,* November 15, 1950, p. 12.

64. Soutine's fevered depictions of dead fowl and hanging sides of beef were being discussed on the art pages (Howard Devree, "A Memorable Week: Soutine at The Museum of Modern Art—Masterpieces in Philadelphia," p. 10X) while Bosley Crowther was praising *Les Sang de Bêtes* on the film pages of the November 5, 1950, *Times* (Bosley Crowther, "Nothing Daunted: New Documentary Pictures Show Power and Progress in That Field," p. 9X). *The Blood of the Beasts* was a contemporary documentary film then showing at Cinema 16, an "increasingly successful" experimental movie house situated near the artists' other Village haunts. This shocking film was not for those without strong stomachs, he said, but he recommended it nevertheless. Award-winning *Guernica* and *The Titan,* the film about Michelangelo, were two other films in the new documentary genre Crowther singled out for praise.

65. Monroe Wheeler, *Soutine* (New York: Museum of Modern Art, 1950), p. 50.

66. Tworkov, "The Wandering Soutine," *Art News,* October 1950, p. 31.

DECEMBER

1. Elaine de Kooning, quoted in Potter, *To a Violent Grave,* pp. 67–68.

2. In the recent (1989) biographical study by Steven Naifeh and Gregory White Smith, *Jackson Pollock: An American Saga,* the authors, apparently convinced of Pollock's homosexuality, tried hard to establish it as fact, but they were unable to produce one person who either participated in such activities with him or witnessed them. Despite the enormity of their interviewing endeavor, they only managed to find people who "always thought he must have" or "assumed he did" and homosexuals who "were sure he would have, if they'd wanted to." Tennessee Williams, for example, claimed to have found Pollock to be just a little overweight for his taste, which seems odd for a man with a notoriously omnivorous appetite for sex with men.

3. David Freke, unlike many critics who try to establish the gender absolutely, also sees the figures as unclearly differentiated: "Both appear to have opposite sexual attributes incorporated in them and it is this which is characteristically Jungian. Jung's theory of the 'anima' and 'animus' suggests that the conscious must have the opposite sexual characteristics of the unconscious. Because the masculine consciousness represses any female components of the mind, they gain in strength and rule the unconscious and become the 'anima.' The multiple masculine identities of the unconscious of a woman's mind Jung calls the 'ani-

mus.'" "Jackson Pollock: a Symbolic Self-portrait," *Studio International,* December 1972, pp. 217–21.

4. Unsigned review, *The Compass,* December 3, 1950, reprinted in Francis V. O'Connor, *Jackson Pollock,* Museum of Modern Art exhibition catalogue, 1967, p. 57.

5. Howard Devree, "Artists Today: One Man Shows Include Recent Paintings by Jackson Pollock and Mark Tobey," *New York Times,* December 3, 1950, section 2, p. X9.

6. Goodnough's own work, automatically derived watercolors and ink and tempera sketches, had been shown at Wittenborn's in October.

7. Goodnough, "Jackson Pollock," *Art News,* December 1950, p. 47.

8. Jay Pollock, D92 in O'Connor, "A Documentary Chronology," in *A Catalogue Raisonné,* vol. 4, p. 255.

9. Frederick John de St. Vrain Schwankowsky, quoted in Francis V. O'Connor, "The Genesis of Jackson Pollock," *Artforum,* vol. 5, no. 2, May 1967, pp. 16–17.

10. Pollock, quoted in ibid., p. 17.

11. Alberto Giacometti, quoted in Thomas B. Hess, "Pollock: The Art of a Myth," *Art News,* vol. 63, no. 9, January 1964, p. 63.

12. Sande (Sanford) Pollock changed his name to McCoy during the WPA days when he and Jackson shared living quarters because two people with the same last name living at the same address were not both eligible for the monthly stipend.

13. Joseph Henderson, quoted in C. L. Wysuph, *Jackson Pollock: Psychoanalytic Drawings* (New York: Horizon Press, 1970), n.p.

14. Certain recent trends of thought in psychiatric circles, particularly the one that revolves around James Hillman, would say that Dr. Henderson had inadvertently found the treatment of choice. Hillman seeks to de-medicalize psychiatry, to change its focus from curing ills (which he thinks is a fantasy) to seeing the symptoms as revelations of the psyche, or soul. What others would deem pathology, he sees as the precious expression of the person's unique, unconscious, imaginal world, a world whose integrity must be preserved. On pages 18–19 of his 1989 Harper & Row book, *A Blue Fire,* Hillman wrote:

> Because symptoms lead to soul, the cure of symptoms may also cure away soul, get rid of just what is beginning to show, at first tortured and crying for help, comfort, love, but which is the soul in the neurosis trying to make itself heard. . . . The right reaction to a symptom may as well be a welcoming rather than laments and demands for remedies, for the symptom is the first herald of an awakening psyche which will not tolerate any more abuse. . . . To get rid of the symptom means to get rid of the chance to gain what may one day be of greatest value. . . .

15. Unfortunately, Graham never followed his own guidelines into Abstract Expressionism. Instead he made a complete about-turn during the forties, rejecting all of modernism and returning to classical figuration. His work became increasingly hermetic and iconographically bizarre, with wounded, cross-eyed women and gesticulating nudes covered with diagrams and spirit writing predominating.

16. *John Graham's Systems and Dialectics of Art,* annotated and introduced by Marcia Epstein Allentuck (Baltimore: Johns Hopkins Press, 1971), pp. 134–35.
17. Ibid., p. 166.
18. Krasner, quoted in Naifeh and Smith, *Jackson Pollock,* p. 398.
19. James Johnson Sweeney, quoted in ibid., pp. 462–63.
20. Lee Krasner talked Peggy Guggenheim into lending them the two thousand dollars needed for the downpayment on the five thousand dollar property on the Acabonac marshes so they could get a mortgage. The extensive work needed to make the house livable in the winter was done with money made largely from the 1949 exhibition. They moved the barn studio themselves, and finally were able to have it winterized the year before Pollock died.
21. Lee and Jack Pollock, letter to Ed and Wally Strautins of November 2, 1950, D61, in O'Connor, "A Documentary Chronology," *Catalog Raisonné,* vol. 4, p. 236.
22. Pollock, quoted in Berton Roueché, "Talk of the Town," *The New Yorker,* in ibid., p. 247.
23. Edwin Heller, quoted in Naifeh and Smith, *Jackson Pollock,* pp. 576–77. Equanil, or Miltown, which came into wide use in 1950, was apparently prescribed for Pollock in later years.
24. Krasner, interview with Francine du Plessix and Cleve Gray, "Who Was Jackson Pollock?" *Art in America,* vol. 55, May–June 1967, p. 51.
25. Axel Horn, quoted in Laurence P. Hurlburt, "The Siqueiros Experimental Workshop: New York 1936," *Art Journal,* Spring 1976, pp. 241–42.
26. Potter later wrote a biographical oral history of Pollock which has the advantage of being in the words of the interviewees and of being written by someone who knew Pollock before 1950.
27. B. H. Friedman didn't know Pollock in his heyday, but his biography of Pollock, *Jackson Pollock: Energy Made Visible,* is the most sensitive, respectful, and art-sophisticated of any thus far. Deborah Solomon's *Jackson Pollock: A Biography* (New York: Simon & Schuster, 1987) is a thoughtful, well-researched, and psychologically penetrating study by a non–art historian who didn't personally know her subject. Naifeh and Smith's exhaustive 934-page study, *Jackson Pollock: An American Saga,* won the 1990 Pulitzer Prize for biography.
28. Fielding Dawson, *An Emotional Memoir of Franz Kline* (New York: Pantheon, 1967), pp. 85–86.
29. "De Kooning on Pollock," interview by James T. Valliere, *Partisan Review,* vol. 34, Fall 1967, p. 605.
30. Samuel Beckett, *Waiting for Godot,* quoted in Eugene Webb, *The Plays of Samuel Beckett* (Seattle: University of Washington Press, 1972), p. 40.
31. Dawson, *An Emotional Memoir of Franz Kline,* pp. 87–88.

AFTERWORD

1. This is in contradiction of B. H. Friedman's information in " 'The Irascibles': A Split Second in Art History," *Arts,* September 1978, pp. 96–102, which is otherwise the definitive account of the proceedings.
2. Harold Rosenberg, "The American Action Painter," *Art News,* vol. 51, no. 8, December 1952, pp. 48–50.

3. Motherwell, "The School of New York," Frank Perls Gallery, Beverly Hills, exhibition catalogue, January 11–February 7, 1951.

4. Robert Goodnough had written a master's thesis in the Department of Education at New York University in 1950 on these artists, based on extensive interviews with them. This potentially invaluable document has since, unhappily, been lost.

5. Motherwell "What Abstract Art Means to Me," *The Museum of Modern Art Bulletin,* vol. 18, no. 3, Spring 1951, p. 12.

6. It is often erroneously reported that Leo Castelli selected this show. He didn't. It was organized by the artists themselves, and he helped with the arrangements for the showing space and the hanging.

7. Patrick Heron, "The Americans at the Tate," *Arts,* March 1956, p. 15.

8. Lawrence Alloway, "The New American Painting," *Art International,* vol. 3, nos. 3–4, 1959, p. 21.

9. Actually Hofmann had been given a retrospective at the Addison Gallery in 1948 due to his senior position in the art world and his importance as a teacher. He was not being honored as a leader of the New York School, however.

10. Thomas Hess, "The Many Deaths of American Art," *Art News,* October 1960, p. 25.

11. Rosenberg, "The American Action Painter," p. 23.

12. Meyer Schapiro, "Recent Abstract Painting," *Modern Art, 19th and 20th Centuries* (New York: George Braziller, 1978), p. 218.

13. Ibid., p. 219.

Index

Page numbers in *italics* refer to illustrations.

Edward Tyler Nahem Fine Arts, New York, for Grace Hartigan's painting *The King Is Dead,* 1950, oil on canvas, 65 x 96½ inches.

Hans Namuth, Ltd., for the photographs of Jackson Pollock painting during the summer of 1950, of James Brooks in his Montauk studio in 1950 discussing a recent painting with Pollock, and of Lee Krasner with one of her canvases in 1950.

New Jersey State Museum, Trenton, New Jersey, and Ouida B. Lewis for Norman Lewis's painting *Ritual,* 1950, oil on canvas, 43½ x 50½ inches, New Jersey State Museum Collection, purchase, FA1986.17.1.

Annalee Newman for the photograph of Barnett Newman in his 1950 Betty Parsons Gallery exhibition.

The Pollock-Krasner Foundaton/ARS, N.Y., and the Robert Miller Gallery for Lee Krasner's painting *Gothic Frieze,* 1950, oil on Masonite, 36 x 48 inches; and the Metropolitan Museum of Art for Jackson Pollock's painting *Autumn Rhythm (Number 30, 1950),* 1950, oil and enamel on canvas, 8 feet 10½ inches x 17 feet 8 inches, George A. Hearn Fund, 1957; and The Museum of Modern Art for Jackson Pollock's painting *One (Number 31, 1950),* 1950, oil and enamel on canvas, 8 feet 10 inches x 17 feet 5⅝ inches, Sidney and Harriet Janis Collection (by exchange), photograph © 1992 The Museum of Modern Art, New York; and the Kunstsammlung Nordrhein-Westfalen, Düsseldorf, for Jackson Pollock's painting *Number 32, 1950,* 1950, oil on canvas, 180 x 106 inches, photo by Walter Klein.

Kate Rothko Prizel and Christopher Rothko/ARS, N.Y., and The Museum of Modern Art for Mark Rothko's paintings *Number 10,* 1950, oil on canvas, 90⅜ x 57⅛ inches, gift of Philip Johnson, photograph © 1992 The Museum of Modern Art, New York; and *Number 22,* 1949, oil on canvas, 9 feet 9 inches x 8 feet 11⅛ inches, gift of the artist, photograph copyright © Jan 6 1992 The Museum of Modern Art, New York; and Denise and Andrew Saul, New York, for Rothko's painting *Green, Red on Orange,* 1950, oil on canvas, 93 x 59 inches.

Candida and Rebecca Smith/VAGA, N.Y., and Mr. and Mrs. Harold E. Rayburn for David Smith's sculpture *Sacrifice,* 1950, steel, painted red, 31⅝ x 19⅝ x 20⅞ inches; and the Munson-Williams-Proctor Institute, Utica, New York, for David Smith's sculpture *The Letter,* 1950, welded steel, 37⅝ x 22⅞ x 9¼ inches.

Mrs. Clyfford Still and the Metropolitan Museum of Art for Clyfford Still's painting *1950 – E (PH-372),* 1950, oil on canvas, 91¼ x 69 inches, gift of Mrs. Clyfford Still, 1986, photo by Lynton Gardiner; and the Hirshhorn Museum and Sculpture Garden, Smithsonian Institution, Washington, D.C., for Clyfford Still's painting *1950 – A No. 2,* 1950, oil on canvas, 108¾ x 92 inches, gift of Joseph H. Hirshhorn, 1972.

Yvonne Thomas for the untitled work she painted at The Subjects of the Artist school, 1948–49, casein on paper, mounted, 48 x 66 inches. Photo © 1991 Sarah Wells.

Esteban Vicente and Smithsonian Institution for Vicente's *Brown Paper Collage,* 1950, paper collage and watercolor, 22½ x 27¹⁵⁄₁₆ inches (irregular), Hirshhorn Museum and Sculpture Garden, Smithsonian Institution, Washington, D.C., gift of Joseph H. Hirschhorn, 1966.

Walker Art Center, Minneapolis, Minnesota, for Jack Tworkov's painting *Sirens,* 1950–52, oil on canvas, 44 x 36 inches, gift of Alexander M. Bing, 1953.

Grateful acknowledgment is made to the following for permission to reprint previously published material:

Indiana University Press; an excerpt from "Dead of Love" in *The Gypsy Ballads of Federico Garcia Lorca.* Copyright 1940 by W. W. Norton & Co., copyright 1953 by Rolfe Humphries.

New Directions Publishing Corporation: two excerpts from the "Cogida and Death" section of "Lament for Ignacio Sanchez Mejias" in *Selected Poems* by Federico Garcia Lorca, copyright 1955 by New Directions Publishing Corporation; the poem "In a Station of the Metro" and a three line fragment of "Middle-Aged, A Study in Emotion" in *Personae* by Ezra Pound, copyright 1926 by Ezra Pound.

Random House, Inc., Alfred A. Knopf, Inc.: an excerpt from "Groups and Series" in *The Complete Poems* by Edwin Denby, edited by Ron Padgett, copyright © 1986 by Full Court Press; and an excerpt from "Ischia" in *W. H. Auden: Collected Poems* by W. H. Auden, ed. by Edward Mendelson, copyright © 1950 by W. H. Auden.